Van Gogh in Arles

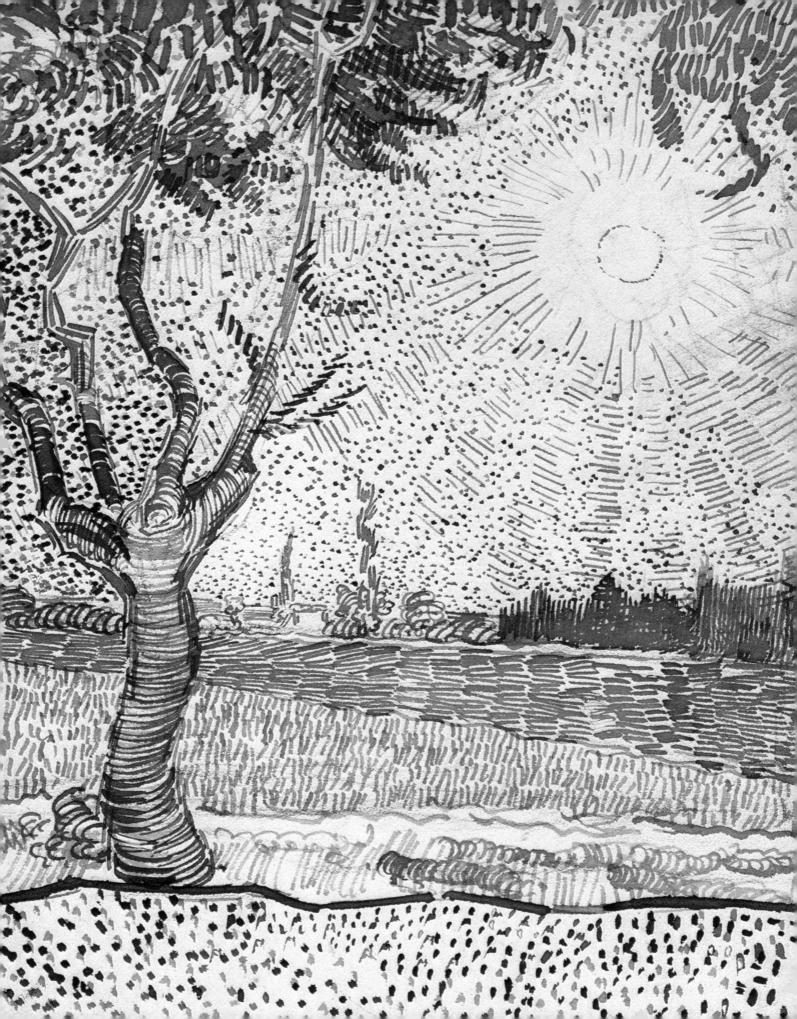

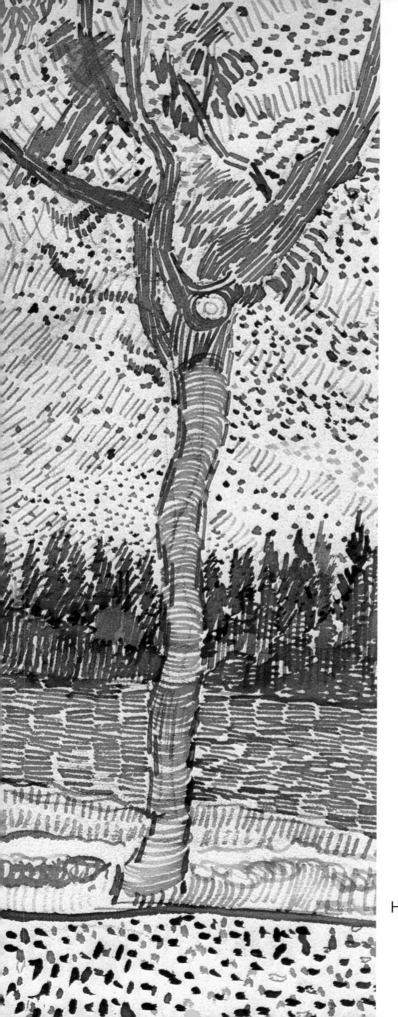

VAN GOGH
IN
ARLES

RONALD PICKVANCE

THE METROPOLITAN MUSEUM OF ART

HARRY N. ABRAMS, INC., PUBLISHERS

Published in conjunction with the exhibition *Van Gogh in Arles* held at
The Metropolitan Museum of Art, New York, 18 October–30 December 1984.

Excerpts from the letters of Vincent van Gogh are reprinted from *The Complete
Letters of Vincent van Gogh*, 3 vols. (Boston, 1958), by permission of
New York Graphic Society Books/Little, Brown and Company (Boston).

The exhibition has been made possible, in part, by Manufacturers Hanover
Corporation and the Robert Wood Johnson, Jr. Charitable Trust.

Library of Congress Cataloging in Publication Data

Gogh, Vincent van, 1853–1890.
 Van Gogh in Arles.

 Bibliography: pp. 266–267.
 1. Gogh, Vincent van, 1853–1890—Exhibitions.
2. Gogh, Vincent van, 1853–1890—Homes and haunts—
France—Arles—Exhibitions. 3. Arles (France) in art—
Exhibitions. 4. Painters—Netherlands—Biography.
5. Arles (France)—History—19th century. I. Pickvance,
Ronald. II. Metropolitan Museum of Art (New York, N.Y.)
III. Title.
ND653.G7A4 1984 759.9492 84-1191

ISBN 0–87099–376–3
ISBN 0–87099–375–5 (pbk.)
ISBN 0–8109–1727–0 (HNA)

Published by
The Metropolitan Museum of Art, New York
Bradford D. Kelleher, Publisher
John P. O'Neill, Editor in Chief
Emily Walter, Editor
Gerald Pryor, Designer
Henry von Brachel, Production Manager

Map drawn by Kathleen Borowik

Type set in Trade Gothic Medium and Sabon by U.S. Lithograph, New York
Printed by Imprimeries Réunies Lausanne S.A., Lausanne, Switzerland
Bound by Mayer & Soutter S.A., Renens, Switzerland

Cover/jacket
Flowering Garden (cat. 61), details

Contents

Director's Foreword

Vincent van Gogh spent fifteen months in Arles in the South of France, from February 1888 to May 1889; his production during this time marks the zenith in the development of his art. This is the first major exhibition to be devoted to van Gogh's stay in Arles. It affords the opportunity to participate in his artistic journey during this extraordinarily focused and prolific period. Van Gogh wrote to his brother Theo: "It is not easier, I am convinced, to make a good picture than it is to find a diamond or a pearl: it means taking trouble, and you risk your life on it." This exhibition is a testament to that risk.

An exhibition of van Gogh's work from Arles was the inspiration of Charles S. Moffett, formerly Curator in the Department of European Paintings at the Metropolitan Museum and now Curator-in-Charge, Department of Paintings, The Fine Arts Museums of San Francisco. Plans to create the exhibition began as far back as the 1978 exhibition *Monet's Years at Giverny*, organized by Mr. Moffett; an exhibition of van Gogh in Arles seemed a logical progression.

We were most fortunate indeed to enlist the expertise of Ronald Pickvance, who agreed to serve as Guest Curator when we learned of Charles Moffett's new position. We are deeply indebted to Professor Pickvance, who assumed the responsibility of making the final selection of all the paintings and drawings to be included in the exhibition, and who undertook to write the catalogue. Its clarity and perspicuity, in addition to the carefully structured presentation of information, attest to the author's profound understanding of the artist.

At the Metropolitan Museum, Susan Alyson Stein proved invaluable to the exhibition from its conceptual stages under Charles Moffett to its conclusion under Ronald Pickvance, to whom she provided efficient, intelligent, and resourceful assistance in every respect. The exhibition has profited greatly from the curatorial expertise of Katharine Baetjer and Gary Tinterow. For the complex editorial work, we are greatly indebted to Emily Walter, Associate Editor.

The paintings and drawings in this exhibition occupy a very special place in the many private and public collections in which they reside. Because van Gogh is himself so poignantly present in each of his works, it is particularly difficult to part with them. We are therefore immensely grateful to the lenders for the considerable sacrifice they have made in enabling this exploration of van Gogh's oeuvre as he conceived it—sequentially, and in series.

The generosity of the Dutch museums has been exceptional, especially in light of the fact that the exhibition will not travel; numerous and major loans have been contributed notably by the Rijksmuseum Vincent van Gogh, Amsterdam, and the Rijksmuseum Kröller-Müller, Otterlo. It is unfortunate that despite prolonged effort, we were unable, because of loan and travel restrictions, to obtain any paintings of sunflowers, so much a part of van Gogh's imagery during his stay in Arles.

Included in this volume are eight major works from Soviet collections. Regrettably, permission to lend has been withheld. We have decided, nevertheless, to retain them in the catalogue, including the owners in the list of lenders, because the paintings are integral to the conception of the exhibition.

The exhibition has been sponsored, in part, by grants from Manufacturers Hanover Corporation and the Robert Wood Johnson, Jr. Charitable Trust, without whose generosity the exhibition would not have taken place.

Philippe de Montebello

Acknowledgments

Many individuals and institutions have contributed to making this exhibition possible. Charles S. Moffett began preparations before his move from New York to San Francisco, and it was he who suggested in March 1983 that I be invited to act as Guest Curator. I am extremely grateful to him. Philippe de Montebello, Director of The Metropolitan Museum of Art, has been a constant source of guidance and support at every step, and I owe him a profound debt of gratitude. Sir John Pope-Hennessy, Consultative Chairman, Katharine Baetjer, Curator and Administrator, and Gary Tinterow, Assistant Curator, of the Department of European Paintings, have provided invaluable advice and professional expertise throughout the genesis of the exhibition. Many other colleagues in the Metropolitan Museum have advised, coordinated, and organized on a wide variety of fronts: James Pilgrim, Deputy Director; Emily K. Rafferty, Manager, Development Office; Richard R. Morsches, Vice President for Operations; Linda M. Sylling, Assistant Manager for Operations; John Buchanan, Registrar; Ashton Hawkins, Vice President, Secretary, and Counsel; William S. Lieberman, Chairman, Department of Twentieth Century Art; Bradford D. Kelleher, Vice President and Publisher; John P. O'Neill, Editor in Chief and General Manager of Publications; Henry von Brachel, Production Manager, Editorial Department; Jeffrey L. Daly, Chief Designer, Design Department; John M. Brealey, Chairman, and Gisela U. Helmkampf, Conservator, Paintings Conservation; Helen Otis, Conservator, Paper Conservation; and Constance Lowenthal, Assistant Museum Educator, Department of Public Education. Lucy Oakley, Research Assistant, Department of European Paintings, and Fern Wachter provided information and much-needed typing assistance. Thanks are due to Alison de Lima Greene, who researched catalogue and illustrative material. I owe a special debt of gratitude to the designer of the catalogue, Gerald Pryor, and to the designer of the exhibition, Roy G. Campbell.

In the Netherlands, I have received innumerable kindnesses from Johannes van der Wolk, who, as Director of the Rijksmuseum Vincent van Gogh, Amsterdam, gave the concept of the exhibition his sympathetic backing. Han van Crimpen, Curator of the Rijksmuseum Vincent van Gogh, allowed me to look at van Gogh's paintings, drawings, and letters much longer than normal curatorial tolerance should have permitted. Fieke Pabst, Librarian of the Rijksmuseum Vincent van Gogh, was equally generous in patiently producing books, catalogues, and articles; while Inge Kreemer and Betsy Raymakers were unfailingly helpful. I am enormously grateful to Dr. S. H. Levie, Generaldirektor, Rijksmuseum, Amsterdam; Dr. R. W. D. Oxenaar, Director, Rijksmuseum Kröller-Müller, Otterlo; and Dr. W. A. L. Beeren, Director, Museum Boymans-van Beuningen, Rotterdam, for allowing such a galaxy of major works to cross the Atlantic.

Every institutional and private owner deserves our unending gratitude. Their names appear in the list of lenders. I must single out, however, those lenders who have made special concessions to allow crucially important paintings, drawings, and letters to be in the exhibition: Hortense Anda-Bührle, President, Foundation E. G. Bührle Collection, Zurich; Jorge de Barandiarán, Director, Museo de Bellas Artes, Bilbao; John Elderfield, Director of Drawings, The Museum of Modern Art, New York; Michel Laclotte, Inspecteur Général des Musées Chargé des Collections du Musée d'Orsay, and Françoise Cachin, Conservateur, Musée d'Orsay, Paris; Thomas M. Messer, Director, The Solomon R. Guggenheim Museum, New York; Franklin Robinson, Director, Museum of Art, Rhode Island School of Design, Providence; John Rosenfield, Acting Director, Fogg Art Museum, Harvard University, Cambridge, Mass.; and James N. Wood, Director, The Art Institute of Chicago. I owe a very special debt of gratitude to Baron Serge le Bailly de Tilleghem, Conservateur, Musée des Beaux-Arts, Tournai, who made the "discovery" of the missing Montmajour drawing such a memorable occasion.

Two friends in New York shared with me their deep knowledge of van Gogh. John Rewald was as generous as ever, willingly passing on information culled from his fifty years' affair with Vincent, and making available his unique collection of photographs of Arles, especially those of the mid-1930s, three of which are reproduced in this catalogue. Artemis Karagheusian has freely exchanged opinions about van Gogh's letters; it is gratifying to be able to record that her painstakingly thorough work on the text of the letters was published in May of this year. In The Hague, Martha

Op de Coul of the Rijksbureau voor Kunsthistorische Documentatie answered many requests with unfailing courtesy and efficiency. I have greatly benefited, for over two decades, from innumerable conversations and exchanges with Annet Tellegen. I owe a special word of thanks to Marianne, Maria, and Walter Feilchenfeldt, who have combined friendship, hospitality, and the most helpful advice in exactly the right proportions. In Arles, I have received many kindnesses and much assistance from Raymond Rousset, René Garagnon, and the staff of the Bibliothèque Municipale, in particular Régine Bard.

My debt to many scholars is enormous, even where there is clear disagreement with their findings. I should like, however, to record my special gratitude to the following: Douglas Cooper (especially for his work on van Gogh's letters to Emile Bernard, and on Gauguin's letters to the van Gogh brothers), Jan Hulsker (especially for his long, devoted, and fruitful labors on all van Gogh's letters), John Rewald (especially for his writings on the Post-Impressionists), Mark Roskill (especially on the van Gogh–Gauguin partnership and the dating and ordering of the letters from October to December 1888), and Bogomila Welsh-Ovcharov (especially for her contributions to the Paris period and to Cloisonnism).

The following individuals helped greatly in the negotiations to secure essential loans: William R. Acquavella, Acquavella Galleries, New York; Alexander Apsis and Lucy Dew, Sotheby Parke Bernet, London; C. Apsis, Lausanne; Dr. Felix A. Baumann, Kunsthaus, Zurich; Harry A. Brooks and Ay-Whang Hsia, Wildenstein and Co., New York; Christopher J. Burge, Christie, Manson & Woods International, New York; Paul C. Guth, Executive Secretary of the Robert Lehman Foundation, New York; Dr. Margrit Hahnloser, Fribourg; Paul Josefowitz and Ellen Melas Kyriazi, London; Samuel Josefowitz, Lausanne; J. Patrice Marandel, The Detroit Institute of Arts; David Nash, Sotheby Parke Bernet, New York; Eugene V. Thaw, E. V. Thaw and Co., New York; Dr. Paul Vogt, Director, Museum Folkwang, Essen; Daniel Wildenstein, Fondation Wildenstein, Paris; and Claus Wolf, Embassy of the German Democratic Republic.

Warmest thanks are due to the following individuals, who very kindly provided documentation or helped in locating works: Heinz Berggruen, Philippe Brame, Lily Couvée-Jampoller, Desmond Corcoran, Elfy Dieffenbacher, Joan Hazlitt, John and Paul Herring, Dr. J. M. Joosten, Nancy Little, Pierre Matisse, William McNaught, Dr. A. W. F. M. Meij, Alexandra Murphy, Dr. Peter Nathan, Dr. J. W. Niemeijer, Arleen Pancza-Graham, Harry S. Parker III, Simon de Pury, John Rowlands, David Somerset, George Wachter, and Jorge Wille.

Finally, three special people without whom neither the exhibition nor this catalogue would have been realized. Emily Walter, of the Editorial Department of The Metropolitan Museum of Art, has edited the manuscript with imaginative flair and scrupulous attention to detail. Susan Alyson Stein, of the Department of European Paintings, has coordinated the complex strands of the exhibition with elegant ease, making the administrative tasks seem simple, and constantly contributing invaluable suggestions. My debt to them both is immeasurable. My wife has been cajoler, censor, critic—and so much more. It is to her that I should like to dedicate this catalogue: Für G. R. P.

Ronald Pickvance

Lenders to the Exhibition

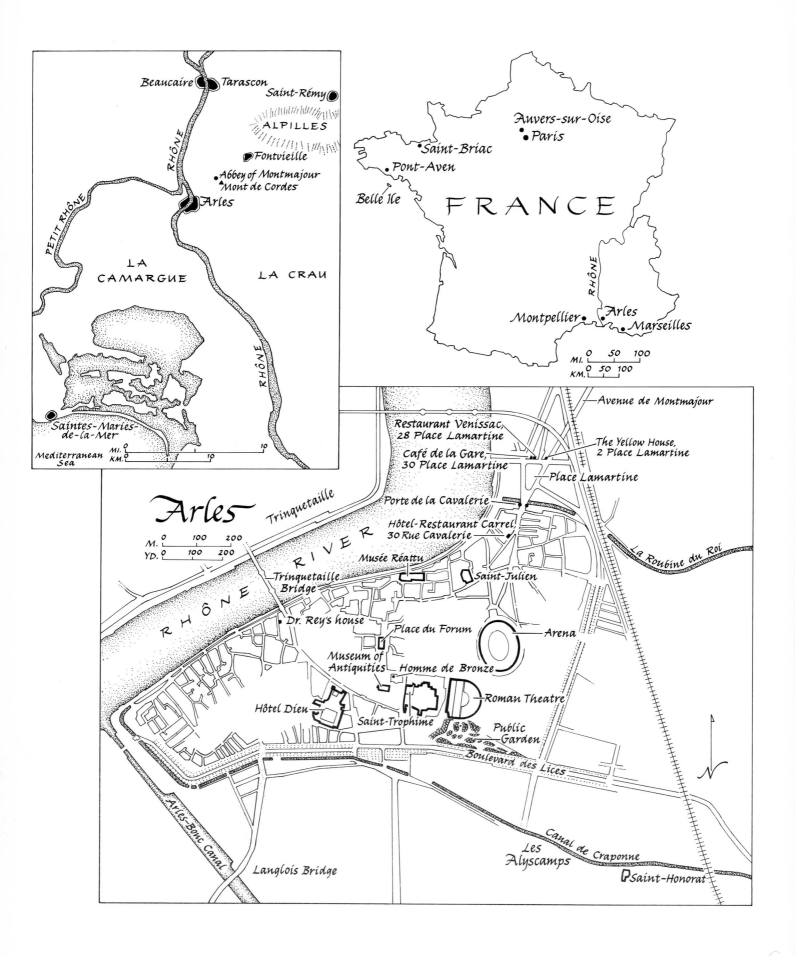

Van Gogh in Arles

Vincent Willem van Gogh (30 March 1853–29 July 1890) lived in Arles from 20 February 1888 to 8 May 1889. That is almost 15 months, over 63 weeks, precisely 444 days. During his stay, he produced some 200 paintings, made over 100 drawings and watercolors, and wrote some 200 letters. The vast majority survive—a prodigal and quite astonishing outpouring, sustaining a pace that no other artist of the nineteenth century could match.

This period in Arles is frequently called the zenith, the climax, the greatest flowering of van Gogh's decade of artistic activity. Yet there has been no monograph, few articles—and no exhibition. This exhibition is an unashamedly one-man, one-place show. The only additions are a brief Paris prologue and some of the works executed by Paul Gauguin during his two-month stay with van Gogh in Arles.

To suggest phases within this short period may seem unduly artificial. Yet the amazing rate of van Gogh's activity should not blind us to his very conscious and often carefully planned development. There is an organic raison d'être for each of the five sections into which the catalogue is divided. The components are partly season, partly where and with whom van Gogh lived, partly his work patterns, partly his sending of batches of paintings to his brother Theo (which brought to a conclusion phases one and two). Each section is prefaced by a detailed biographical chronology.

Considerable redating of letters from late May to late July has created a radically new biographical framework (e.g., the dates of van Gogh's visit to Saintes-Maries), which in turn affects the datings of the paintings and drawings. Because of these redatings, certain parts of the catalogue have short introductory essays to help clarify the revisions.

The most hypothetical redatings concern the sequence of events —and therefore of letters and paintings—during Gauguin's stay in Arles. These are presented in an introductory essay in section IV (pp. 201–204). The proposed new order of letters is given in Appendix I.

I. WHY ARLES?

Van Gogh already had a vision of Provence in the fall of 1886. "In spring—say February or even sooner—I may be going to the South of France, the land of the *blue* tones and gay colors" (LT459a), he wrote to his English painter-friend Horace Mann Livens (1862–1936). In the event, he spent another year in Paris before doing so.

Why did he then decide upon Arles and not Avignon, or Martigues, or Aix-en-Provence? There is no single, certain reason. Van Gogh greatly admired the Provençal artist Adolphe Monticelli (1824–1886), whose bold color and richly encrusted handling he believed derived from Eugène Delacroix. His own flower still lifes, painted in Paris, were much influenced by Monticelli, and he and his brother Theo were building up a collec-

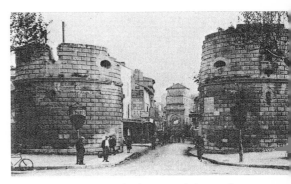

I. Entrance to the city of Arles, Porte de la Cavalerie. Postcard. c. 1900. Bibliothèque Nationale, Paris

tion of Monticelli's work. Arles was to be a brief stopover, en route to Marseilles.

Other artists may have influenced his decision to go to Arles. Edgar Degas visited Arles in 1855 as a young man. Henri de Toulouse-Lautrec may have talked of it in Paris. The Australian John Russell, who had painted van Gogh's portrait in Paris in 1886, was a friend of Dodge MacKnight, the American painter who in 1885 had stayed in the village of Fontvieille, only six miles from Arles.

Japanese prints certainly conditioned van Gogh's view of the South. As he wrote to Emile Bernard in March 1888: "This country seems to me as beautiful as Japan as far as the limpidity of the atmosphere and the gay color effects are concerned. Water forms patches of a beautiful emerald or a rich blue in the landscape, just as we see it in the crépons [a type of Japanese woodblock print]" (B2).

Van Gogh's reading of the Provençal novelist Alphonse Daudet also colored his vision of the South. In particular, he was very much taken with the "gaiety" of *Tartarin de Tarascon* (1872), a novel to which he often referred in his letters. And he had, of course, read all the novels of Emile Zola, who, like Paul Cézanne, came from Aix.

The legendary beauty of the Arlésiennes was frequently remarked upon in periodicals, guidebooks, and novels. Even a novel by a Dutch author, Multatuli's *Max Havelaar*, which van Gogh may have read, contained a chapter on the beauty of the women of Arles.

Retrospectively, from Saint-Rémy in September 1889, van Gogh wrote to Theo: "My dear brother, you know that I came to the South and threw myself into my work for a thousand reasons. Wishing to see a different light, thinking that looking at nature under a bright sky might give us a better idea of the Japanese way of feeling and drawing. Wishing also to see this stronger sun, because one feels that one could not understand Delacroix's pictures from the point of view of execution and technique without knowing it, and because one feels that the colors of the prism are veiled in the mist of the North. All this is still pretty true. Then added to this is the natural inclination toward this South which Daudet described in *Tartarin*, and that occasionally I have also found friends and things here that I love" (LT605).

Before van Gogh's arrival, no one artist had made Arles his base. There was no artistic tradition and no colony of artists, as there were at Pont-Aven in Brittany. Van Gogh hoped to celebrate Arles, to help start an artistic tradition, and, above all, to found a studio in the South.

II. ARLES

"Arles en France," it was frequently called. But more specifically, Arles is in the South of France, in the Midi, in Provence. It is situated on the Rhône some twenty-five miles from its estuary on the Mediterranean. Near Arles, the Rhône splits into the Great and the Small, and the courses taken by each create the triangular area to the southwest of Arles called the Camargue. In the nineteenth century, the Camargue was still largely a sterile salty plain of lagoons and marshes, with wild bulls, white horses, and flamingos. On the Mediterranean itself was Saintes-Maries-de-la-Mer, some thirty-one miles from Arles, where the annual pilgrimage to

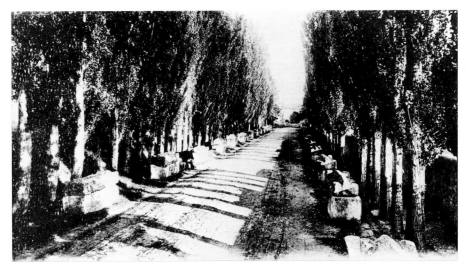

II. The Alyscamps. Postcard. c. 1905

worship the relics of the two Marys and their servant Sarah took place on 24–25 May.

To the south and east of Arles another flat plain extended, that of the Crau, which, while marshy like the Camargue, was essentially stony. It contained large rocky outcrops, and was limited to the north by the range of mountains called the Alpilles, which separate Arles from Saint-Rémy, some fifteen miles to the northeast. Reclamation of the marshes of the Crau and the construction of canals from the sixteenth century on led to the cultivation of vines and wheat, which guaranteed a reasonable sprinkling of *mas*, or farmhouses, on its stony base.

Arles was a major Roman town, founded by Julius Caesar in 46 B.C. It rivaled Marseilles, and was called the Rome of Gaul. Its Roman remains are extensive, dominated by the arena, the largest in France, and the theatre, of which much less survives. Arles was a considerable town in medieval times, with many churches distinguishing its skyline, the most prominent being Saint-Trophime, with its large tower, its superb west front (twelfth century), and its enchanting cloister (twelfth and fourteenth centuries). In the same square, the Place de la République, is the town hall, built in 1673 but incorporating the clock tower of 1547, which supports a bronze statue of Mars, always known locally as the Homme de Bronze. Both the tower of Saint-Trophime and the Homme de Bronze appear often in van Gogh's paintings and drawings, but always seen at a distance from the fields outside the confines of the town.

Outside the town's walls are two important monuments. To the southeast are the Alyscamps (i.e., the Elysian Fields or Champs-Elysées), described by Augustus J. C. Hare in his *South-Eastern France*, published in 1890, as a pagan cemetery that was kept almost intact "from a belief that when the first bishop of Arles was about to consecrate the old cemetery for Christian burial, Christ Himself appeared and blessed the pagan burial-place." Hare goes on to remind us that such was the desire in medieval Europe to be buried in the Alyscamps that "it was sufficient to embark a coffin on the Rhône for Aliscamps, with money for the burial, and it arrived at its destination." Unfortunately, the making of the railroad in 1848 destroyed a great part of the cemetery.

The other important monument lay some three miles to the northeast,

dominating the Crau from its rocky eminence. This was the medieval Abbey of Montmajour, founded in the sixth century, and rebuilt in the eleventh and twelfth centuries. Hare tells us: "It is one of the most romantically beautiful spots in the south of France, and a paradise for artists. A hill, wooded on one side and precipitous on the other, rises abruptly from the plain, overgrown in part by the curious laburnum, which flowers in the winter, and is said to have been introduced by the Saracens." A fortress tower was built in 1369, and a large palatial addition was made in the eighteenth century. During the French Revolution and after, the massive buildings were reduced to ruins, but the Romanesque church and crypt remain intact.

Nineteenth-century visitors to Arles would see the sites and monuments—the arena, the Roman theatre, Saint-Trophime and opposite Sainte-Anne (since 1805 the museum of antiquities), the Alyscamps, and the Abbey of Montmajour. They would also be aware of the widespread fame of the beauty of the Arlésiennes. Augustus Hare sums it up: "The women of Arles are perhaps the most beautiful of any European city. With dark eyes and raven locks, they are generally majestic in carriage and figure. They are greatly adorned by the becoming costume of Arles—which is still, happily, almost universal—a black dress and shawl, with full white muslin stomacher, and a very small lace cap at the back of the hair, bound round with broad black velvet or ribbon, fastened with gold or jewelled pins."

But there were four significant events in the nineteenth century that tourists tended to ignore. The first was the cutting of a canal from Arles to Bouc on the Mediterranean, begun in 1805 and completed in 1835, which produced a series of bridges and locks along its route. The very first one, situated at the southwest tip of Arles, was the Pont Réginelle, known later in the century as the Pont Langlois after its keeper.

Earlier, in the seventeenth century, the drainage of much of the marshy land of the Crau continued. Canals such as the Roubine du Roi (*roubine* is Provençal for a waterway or canal that affords drainage and irrigation), the Canal du Vigueirat, and the Canal de la Vidange created their own patterns in and around the town. Their bridges, banks, and ditches set up vantage points, whether for looking back at the town itself, looking out toward Montmajour, or providing a seven-foot bank to view the Alyscamps obliquely. Clearly no Dutchman, whether engineer or landscape painter, could ignore them.

Second, the Rhône River and its system of canals was insufficient in itself to guarantee the continued prosperity—or even prevent the decline—of the town of Arles. In 1842, Alphonse de Lamartine, as politician not as poet, spoke in the Chamber of Deputies, arguing persuasively that the bringing of the railroad to Arles could alone save the city from total decline. His oratory won the day; and in recognition of his achievement, a large square to the north of the town, immediately outside the ramparts, was named the Place Lamartine. It was here that van Gogh would find his studio, the Yellow House, in 1888.

The railroad came to Arles: Paris was 482 miles away; the journey in 1888 took fifteen to sixteen hours. But to create the railroad, much of the Alyscamps had to be destroyed. For in addition to the railroad itself, a vast series of workshops was built, where engines and rolling stock

were produced. Over 1,000 employees made this the major industrial concern in Arles. And its chimneys became as prominent on the skyline as some of the more venerable monuments of the town.

Third, the town's gasworks were erected in 1867 on a triangular plot adjacent to the Roubine du Roi. That, too, gave Arles a more industrial appearance, with its utilitarian buildings and, of course, its two chimneys, which from certain vantage points could also rival the spires and towers of the old town.

Finally, in 1875, a new iron bridge was erected across the Rhône, connecting Arles with its suburb of Trinquetaille. Known as the Trinquetaille Bridge, it facilitated easy passage by horse traffic and by foot between the two townships and also led directly to the Camargue and ultimately to Saintes-Maries.

The population of Arles in the 1880s was 23,000, with a small colony of Italians (generally between 500 and 800), but, according to the census returns of 1881, 1886, and 1891, not a single Dutchman.

III. TWO AMERICAN VIEWS OF ARLES IN THE 1880s

Arles, for all the grandeur of its Roman remains, was never part of the Grand Tour. It rarely attracted British visitors in the eighteenth century, and distinguished French visitors were few. In the nineteenth century, however, there was a steady flow of renowned literary figures who either published their impressions of Arles or confined them to the privacy of their journals. The momentum really began in the 1830s with Prosper Mérimée, who was directly involved with the ancient monuments, and Stendhal, whose *Mémoires d'un touriste* (1838) established the idiosyncratic vein of the seasoned man-of-letters' response. They were followed by Alexandre Dumas, Gustave Flaubert, Alphonse de Lamartine, George Sand and Frédéric Chopin, Victor Hugo, and the Goncourt brothers.

Then there were the local Provençal writers—Amédée Pichot, Jules Canonge, and Alphonse Daudet—who extolled the beauty of the Arlésiennes and of the town itself. There were national guides published by Joanne, Baedeker, and Murray, which could be more critical, especially of hotels and the lack of cleanliness in the town; and local guides, where Provençal pride overlooked such touristic shortcomings.

These genres bred their own traditions and produced their own stereotypes. Rather than analyze and exemplify them at length here, it is sufficient to say that two elements united them: the importance of the Roman and Christian heritage and the beauty of the Arlésiennes.

It is against this rapidly sketched background that one can set the published impressions of two Americans who visited Arles in the 1880s.

In February 1884, *The Atlantic Monthly* published Part VI of "En Province," a series of essays by Henry James on the provinces of France, which later appeared as *A Little Tour in France*. The sixth in the series was titled "The Country of Arles."

Henry James (1843–1916) had visited Arles in 1882. Or rather, as he reminded his readers, revisited Arles, for he had been there once before, in 1876. His essay is a pleasantly meandering, nonsequential, almost fictional account of his three-day stay. He begins on a note of mystery:

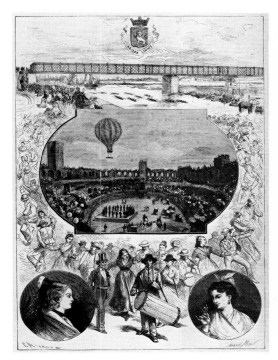

III. The celebration of the opening of the Trinquetaille Bridge. "Fêtes données à Arles," *L'Illustration* (8 May 1875). General Research Division. The New York Public Library. Astor, Lenox and Tilden Foundations

15

There are two shabby old inns at Arles, which compete closely for your custom. I mean by this that if you elect to go to the Hôtel du Forum, the Hôtel du Nord, which is placed exactly beside it (at a right angle), watches your arrival with ill-concealed disapproval; and if you take the chances of its neighbor, the Hôtel du Forum seems to glare at you invidiously from all its windows and doors. I forget which of these establishments I selected; whichever it was I wished very much that it had been the other. [It was in fact the Hôtel du Nord.]

And he continues:

The two stand together on the Place des Hommes, a little public square of Arles, which somehow quite misses its effect. As a city, indeed, Arles quite misses its effect in every way; and if it is a charming place, as I think it is, I can hardly tell the reason why. The straight-nosed Arlésiennes account for it in some degree; and the remainder may be charged to the ruins of the arena and the theatre. Beyond this, I remember with affection the ill-proportioned little Place des Hommes; not at all monumental, and given over to puddles and to shabby cafés. I recall with tenderness the tortuous and featureless streets, which looked like the streets of a village, and were paved with villainous little sharp stones, making all exercise penitential.

The point is repeated:

Arles has no general physiognomy, and, except the delightful little church of Saint Trophimus, no architecture, and . . . the rugosities of its dirty lanes affect the feet like knife-blades.

Nonetheless he produced accounts of the Roman arena ("The whole thing is superbly vast, and as monumental, for place of light amusement —what is called in America a 'variety-show'—as it entered only into the Roman mind to make such establishments") and the few remains of the Roman theatre ("The Roman theatre at Arles seemed to me one of the most charming and touching ruins I had ever beheld; I took a particular fancy to it. It is less than a skeleton—the arena may be called a skeleton; for it consists only of half a dozen bones"); the museum ("This little Museum at Arles, in short, is the most Roman thing I know of, out of Rome") he expatiated on at greater length. Evidently he didn't visit the Musée Réattu—he who loved painting.

In this Roman world, James found Saint-Trophime

very remarkable, but I would rather it were in another place. Arles is delightfully pagan, and Saint Trophimus, with its apostolic sculptures, is rather a false note. These sculptures are equally remarkable for their primitive vigor and for the perfect preservation in which they have come down to us. The deep recess of a round-arched porch of the twelfth century is covered with quaint figures, which have not lost a nose or a finger.

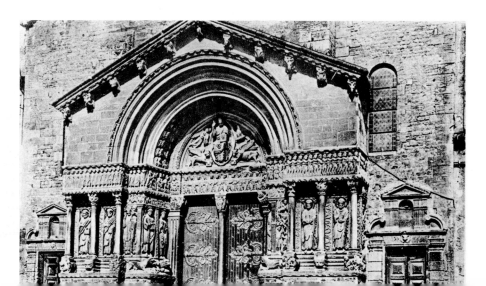

IV. Portal of the Church of Saint-Trophime. 12th century. Postcard. c. 1900

He extols the beauty of the Arlésiennes, whom he observed earlier at Tarascon, noting "the purity of feature for which the women of the *pays d'Arles* are renowned. The Arlesian head-dress was visible in the streets; and this delightful coiffure is so associated with a charming facial oval, a dark mild eye, a straight Greek nose, and mouth worthy of all the rest, that it conveys a presumption of beauty which gives the wearer time either to escape or to please you." He reserved his greatest admiration for "a splendid mature Arlésienne" who sat "enthroned" behind the counter of a café. She was "a large and quiet woman, who would never see forty again; of an intensely feminine type, yet wonderfully rich and robust, and full of a certain physical nobleness." And he was captivated by her headdress, "the sweet and stately Arlesian cap, which sits at once aloft and on the back of the head; which is accompanied with a wide black bow covering a considerable part of the crown; and which, finally, accommodates itself indescribably well to the manner in which the tresses of the front are pushed behind the ears." Unwittingly, James's "admirable dispenser of lumps of sugar"—for coffee or for absinthe—takes us straight to Gauguin's *Night Café* (cat. 123).

James visited Montmajour, and found it "very impressive and interesting." And finally, on his last afternoon, he visited

the Aliscamps, the old Elysian Fields, the meagre remnant of the old pagan place of sepulture, which was afterwards used by the Christians, but has been for ages deserted, and now consists only of a melancholy avenue of cypresses, lined with a succession of ancient sarcophagi, empty, mossy, and mutilated. An iron-foundry, or some horrible establishment which is conditioned upon tall chimneys and a noise of hammering and banging, has been established near at hand.

He had not realized that this intrusive piece of nineteenth-century industry was the railroad workshops.

Now Henry James was a well-seasoned European traveler, a cultivated savorer of England, France, Germany, Italy. He prepared himself beforehand, so that we find him referring to Stendhal's account of Arles, and to the guidebooks of the Frenchman Joanne and the Englishman Murray.

Six years later, another American writer visited Arles. This was Harriet Waters Preston (1836–1911), who had already achieved some distinction as the translator of Frédéric Mistral's poem *Mireille* (1859). She published her translation in 1872, evidently without having visited Provence.

She arrived in Arles in May 1888, and stayed in the same Place du Forum as Henry James—but at the other hotel, the Hôtel du Forum. She was therefore in Arles at precisely the same time that van Gogh was beginning to establish himself in his studio in the Yellow House on the Place Lamartine. But the Place Lamartine was outside the town's ramparts; it was a recent creation: neither the square, nor its buildings, nor its gardens attracted her interest.

She sums up Arles thus:

The Arles of to-day troubles itself very little about either its ancient glories or its possibilities of modern improvement. It is a city of dreams, where visible

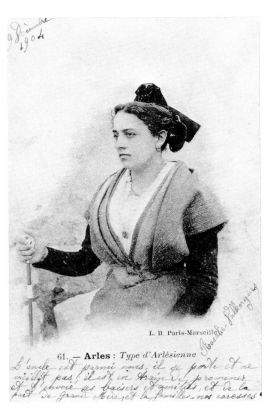

V. Arlésienne. Postcard. c. 1904

relics of all the ages group themselves with careless grace and a result of perfect unity.

And then follows the obligatory description of the Arlésiennes:

The farfamed beauty of the Arlésiennes is of a distinctly Greek type, straight-featured, low-browed, and delicate. It is enhanced by their graceful black costume, with swelling fichu of white lace and coquettish little cap of the same material set high on the head and bound with a broad black ribbon, one end of which is left free and falls to the shoulder. Young and old, these women, almost without exception, have luxuriant hair, curling lightly about the temples. The smallness of the head as compared with the size of the neck—another strikingly classic feature—accounts in part, no doubt, for their superb carriage. This, too, is a beauty which they seem never to lose. I have seen a heavy woman of sixty, with the marks of severe toil about her person and carrying a big burden, who crossed the central square of the town with the step of an empress.

Miss Preston extols the museum of antiquities: "Inside the museum one's adjectives fail." A brief reference to the Roman theatre is followed by a lengthier description of Saint-Trophime, where "the deep portal is like a cavern lined with intricate sculpture, the cloister is of matchless loveliness." She refers to the "narrow streets which invite the artist's pencil at every turn," leading "to the great amphitheatre," which she describes at length.

And then she describes the Alyscamps, quoting Ariosto and Dante and reminding her readers:

Five crumbling chapels are here out of the nineteen which the Aliscamps once contained. A long avenue of whispering poplars leads from an iron gateway to the best-preserved of these—the church of St. Honorat. . . . And what are these rows upon rows of strange, rude troughs or basins which flank the poplar avenue? They are the massive stone coffins of the first Christian centuries, empty now save for the soft shower of Provençal rose petals which are shed into them from the tangled bushes running riot over all the place.

Miss Preston joined the pilgrims to Saintes-Maries for the annual fête of 24–25 May (after all, it was in Saintes-Maries that Mistral's heroine, Mireille, died). Her description of leaving Arles is the more interesting in that van Gogh himself took the same route a few days later, on Wednesday 30 May.

The distance across the Camargue is twenty-five miles, and we were off at seven o'clock of the sweet summer morning. We crossed the Rhône to the suburb of Trinquetaille by an iron bridge, which replaces the famous bridge of boats on which the fairies danced in exultation the night after they had lured to his destruction the would-be assassin of Mirèio's lover. No sooner were we out upon the level country than we began to overtake parties of pilgrims, more pious than ourselves, who were on their way, many of them evidently from great distances, to celebrate the festival of the morrow.

Harriet Waters Preston's account, "A Provençal Pilgrimage," was published in *The Century Magazine* of July 1890. The delay was caused by her illustrator, Joseph Pennell (1857–1926), who visited Arles in September 1888, but who was slow in getting his illustrations to the magazine's editor. Some of his views can be compared with van Gogh's (see cat. 20, fig. 17); but obviously he was tied to the august sites and preferred monuments. He must have been unaware of van Gogh's existence in September 1888. It was almost forty years later, in his autobiographical *Adventures of an Illustrator* (1925), that he recalled: "And

while I was in Arles, Van Gogh was there—le fou—who every month or so had a mission to cut off somebody's ears, and when the devil entered into him he would be locked up in his room with his paints. There he would make masterpieces that were not wanted, till one day in Auvers nobody was round to have their ears cut off, so he cut his own throat or shot himself"—not the most enlightened statement to come from the pen of Whistler's biographer.

IV. VAN GOGH ON ARLES

That coquettish little town of the pretty women. [B5]

Van Gogh was neither tourist nor seasoned traveler, and least of all was he litterateur writing for those special breeds. His responses to architecture and to the past tended to be muted wherever he was. He did not give long descriptions of the Roman monuments, or comment on the august sites, or pick out the most favored views. He mentioned only once the Musée Réattu, the museum of antiquities, and the west front of Saint-Trophime. He never referred to the Roman theatre. He visited the arena for the bullfights that took place on Sundays from early April on. He never named the Alyscamps, not even when he used the sarcophagi and the lines of poplars for his representation of the fall of the leaves —"tree trunks...lined like pillars along an avenue where there are rows of old Roman tombs" (LT559). But he did devote words to the Abbey of Montmajour, evoking the ruin and decay in one of his finest descriptive passages (LT506).

His response to Arles—its past and present, its surrounding landscape, its inhabitants and their customs—was wide-ranging, rarely conventional, penetrating and observant, sometimes terse and dismissive. To collect and categorize his observations does not reduce their vital energy and idiosyncratic flavor.

The Town, Its Monuments, and Its Museums

The museum in Arles [the Musée Réattu] is a horror and a humbug, and ought to be in Tarascon. There is also a museum of antiquities, but these are genuine. [LT464, c. 25 February 1888]

It is a filthy town this, with the old streets. [LT482, 4 May 1888]

There is a Gothic portico here, which I am beginning to think admirable, the porch of Saint-Trophime.
But it is so cruel, so monstrous, like a Chinese nightmare, that even this beautiful example of so grand a style seems to me to belong to another world, and I am as glad not to belong to it as to that other world, magnificent as it was, of the Roman Nero.
Must I tell the truth and add that the Zouaves, the brothels, the adorable little Arlésiennes going to their first Communion, the priest in his surplice, who looks like a dangerous rhinoceros, the people drinking absinthe, all seem to me creatures from another world? That doesn't mean that I'd feel at home in an artistic world, but that I would rather fool myself than feel alone. And I think I should feel depressed if I did not fool myself about everything. [LT470, 18 March 1888]

Yesterday I saw another bullfight, where five men played the bull with darts and cockades. One toreador crushed one of his balls jumping the barricade. He

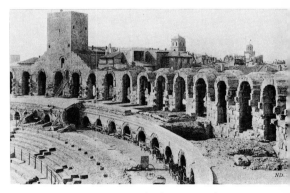

VI. The arena with the Church of Saint-Trophime. Postcard. c. 1900. Bibliothèque Nationale, Paris

19

was a fair man with gray eyes, plenty of sang-froid; people said he'll be ill long enough. He was dressed in sky blue and gold, just like the little horseman in our Monticelli, the three figures in a wood. The arena is a fine sight when there's sunshine and a crowd. [LT474, 9 April 1888]

By the way, I have seen bullfights in the arena, or rather sham fights, seeing that the bulls were numerous but there was nobody to fight them. However, the crowd was magnificent, those great colorful multitudes piled up one above the other on two or three galleries, with the effect of sun and shade and the shadow cast by the enormous ring. [B3, 9 April 1888]

I saw a brothel here last Sunday—not counting the other days—a large room, the walls covered with blued whitewash—like a village school. Fifty or more military men in red and civilians in black, their faces a magnificent yellow or orange (what hues there are in the faces here), the women in sky blue, in vermilion, as unqualified and garish as possible. The whole in a yellow light. A good deal less lugubrious than the same kind of offices in Paris. [B4, c. 21 April 1888]

The Arlésiennes

The women here are beautiful, no humbug about that. [LT464, c. 25 February 1888]

The way the women dress is pretty, and especially on Sundays one sees some very naïve and well-chosen combinations of colors on the boulevard. And no doubt this too will become even gayer in summer. [B2, 18 March 1888]

As for the women of Arles that there's so much talk about—there is, isn't there?—do you want to know my real opinion of them? They are, no question about it, really charming, but no longer what they must have been. As things are now, they are more often like a Mignard than a Mantegna, for they are in their decadence. That doesn't prevent them from being beautiful—very beautiful, and I am talking now only of the type in the Roman style—rather boring and commonplace. But what exceptions there are!

There are women like a Fragonard and like a Renoir. And some that can't be labeled with anything that's been done yet in painting. The best thing to do would be to make portraits, all kinds of portraits of women and children. But I don't think that I am the man to do it. I'm not enough of a M. Bel Ami for that. [LT482, 4 May 1888]

What pleases me very much is the gaily multicolored clothes, the women and girls dressed in cheap simple material, but with green, red, pink, Havanah-yellow, violet or blue stripes, or dots of the same colors. White scarfs; red, green and yellow parasols. A vigorous sun, like sulphur, shining on it all, the great blue sky—sometimes it is as enormously gay as Holland is gloomy. [W5, 31 July 1888]

I am now beginning to see the beauty of the women here better, and then again and again I must think of Monticelli. Color plays such a tremendous part in the beauty of the women here. I do not say that their shape is beautiful, but that is not their special charm. That lies in the grand lines of the costume, vivid in color and admirably worn, in the *tone* of the flesh rather than the shape. But I shall have some trouble before I can do them as I begin to see them. . . .

I think that the town of Arles has been infinitely more glorious once as to the beauty of its women and the beauty of its costumes. Now everything has a battered and sickly look about it.

But when you look at it for long, the old charm revives. [LT542, 24 September 1888]

Some Inhabitants

I have to get my paints and canvas either at a grocer's or at a bookshop, and they haven't got everything I want. I shall really have to go to Marseilles to see how they are off for this sort of thing there. [LT464, c. 25 February 1888]

Saturday evening I had a visit from two amateur artists, a grocer who sells painting materials as well, and a magistrate who seems a nice fellow, and intelligent. [LT467, c. 9 March 1888]

One must know the local patois, and learn to eat bouillabaisse and garlic, then I feel sure one could find an inexpensive middle-class boardinghouse. Then, if there were several of us, I am inclined to think one could get more advantageous terms. It might be a real advantage to quite a number of artists who love the sun and colors to settle in the South. [B2, 18 March 1888]

Foreigners are exploited here, and from their point of view the natives are in the right; they consider it a duty to get whatever they can. [LT485, c. 10 May 1888]

I am in need of a book—the *ABCD of Drawing* by A. Cassagne. I asked for it in the bookshop here, and after waiting a fortnight, they told me that they must have the name of the publisher, which I do not know. I'd be very grateful if you could send it to me. The carelessness, the lazy happy-go-lucky ways of the people here are beyond belief; you have trouble getting the most trifling things.... I see nothing here of the Southern gaiety that Daudet talks about so much but, on the contrary, all kinds of insipid airs and graces, a sordid carelessness. [LT502, 23 June 1888]

A thousand apologies for my not putting enough stamps on my letter, although I put the stamps on in the post office; and it is not the first time that it has happened to me here that, when in doubt and inquiring at the post office, I got wrong information about the amount of stamps. You have no idea of the slackness and the nonchalance of the people here. [B7, c. 18 June 1888]

Something you've already suspected—people are often good-looking here. In a word, I believe that life here is just a little more satisfying than in many other spots. However, I have the impression that people are getting slack here, a little too much affected by the decadence of carelessness, indifference, whereas if they were more energetic the land would probably produce more. [W4, c. 16 June 1888]

You know, if I could only get really strong soup, it would do me good immediately: it's preposterous, but I *never* can get what I ask for, even the simplest things, from these people here [in the Hôtel-Restaurant Carrel]. And it's the same everywhere in these little restaurants.

But it is not so hard to bake potatoes?

Impossible.

Then rice, or macaroni? None left, or else it is messed up in grease, or else they aren't cooking it today, and they'll explain that it's tomorrow's dish, there's no room on the stove, and so on. It's absurd, but that is the real reason why my health is so low. [LT480, 1 May 1888]

This restaurant where I am [Restaurant Venissac, 28 Place Lamartine] is very queer; it is gray all over; the floor is of gray bitumen like a street pavement, gray paper on the walls, green blinds always drawn, a big green curtain in front of the door which is always open, to stop the dust coming in. So it already has a Velásquez gray—like in the "Spinning Women"—and even the very narrow, very fierce ray of sunlight through a blind, like the one that slants across Velásquez's picture, is not wanting. Little tables of course, with white cloths. And behind this room in Velásquez gray you see the old kitchen, as clean as a Dutch kitchen, with floor of bright red bricks, green vegetables, oak chest, the kitchen range with shining brass things and blue and white tiles, and the big fire a clear orange. And then there are two waitresses, both in gray, a little like that picture of Prévost's you have in your place—you could compare it point for point. [LT521, 9 August 1888]

The Landscape: Sun, Color, and Light

This country seems to me as beautiful as Japan as far as the limpidity of the atmosphere and the gay color effects are concerned. Water forms patches of a

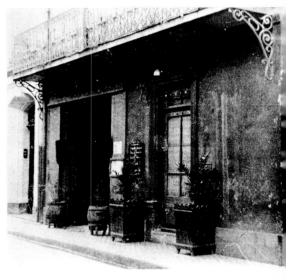

VII. Hôtel-Restaurant Carrel, 30 Rue Cavalerie. c. 1935. Photograph by John Rewald

beautiful emerald or a rich blue in the landscape, just as we see it in the crépons. The sunsets have a pale orange color which makes the fields appear blue. The sun a splendid yellow. And all this though I have not seen the country yet in its usual summer splendor. [B2, 18 March 1888]

I think very often of Renoir and that pure clean line of his. That's just how things and people look in this clear air. [LT481, c. 3 May 1888]

You will remember that we saw a magnificent garden of roses by Renoir. I was expecting to find subjects like that here, and indeed, it was that way while the orchards were in bloom. Now the appearance of things has changed and become much harsher. But the green, and the blue! I must say several landscapes of Cézanne's which I know render this very well, and I am sorry not to have seen more of them. The other day I saw a subject exactly like the lovely Monticelli landscape with the poplars which we saw at Reid's.

You would probably have to go to Nice to find Renoir's gardens again. I have seen very few roses here, though there are some, among them the big red roses called Rose de Provence. [LT488, c. 15 May 1888]

The sun in these parts, *that* is something different, and also if over a period of time one drinks wine, which—at least partly—is pressed from real grapes....

It is my impression that you would *not* think the sun here unpleasant at all; I feel it is excellent for me to work in the open air during the hottest part of the day. It is airy, clean heat.

Essentially the color is exquisite here. When the green leaves are fresh, it is a rich green, the like of which we seldom see in the North. When it gets scorched and dusty, it does not lose its beauty, for then the landscape gets tones of gold of various tints, green-gold, yellow-gold, pink-gold, and in the same way bronze, copper, in short starting from citron yellow all the way to a dull, dark yellow color like a heap of threshed corn, for instance. And this combined with the blue—from the deepest royal blue of the water to the blue of the forget-me-nots, cobalt, particularly clear, bright blue—green-blue and violet-blue.

Of course, this calls up orange—a sunburned face gives the impression of orange. Furthermore, on account of the many yellow hues, violet gets a quick emphasis; a cane fence or a gray thatched roof or a dug-up field makes a much more violet impression than at home. [W4, c. 16 June 1888]

Nature here, however, must be very different from what it is at Bordighera, Hyères, Genoa, or Antibes, where there is less mistral, and where the mountains have an entirely different character. Here, except for an intenser coloring, it reminds one of Holland: everything is flat, only one thinks rather of the Holland of Ruisdael or Hobbema or Ostade than of Holland as it is.

What surprises me is the scarcity of flowers; there are no cornflowers in the wheat, and seldom poppies. [LT502, 23 June 1888]

I must tell you that I made a very interesting round of the farms with someone who knows the country. But you know in the real Provence there is more poor peasantry à la Millet than anything else....

In a cottage garden I saw a figurehead of a woman carved in wood, from the bow of a Spanish ship. It was in a little grove of cypresses, and absolutely Monticelli.

Oh, these farm gardens, with their lovely big red Provençal roses, and the vines and the fig trees! It is all a poem, and the eternal bright sunshine too, in spite of which the foliage remains very green.

There is a cistern running clear water which irrigates the farm along trenches in a complete little system of canals. A horse, an old white animal from the Camargue, sets the machinery in motion.

No cows on these little farms. [LT519, 8 August 1888]

There is still a great deal of Greece all through the Tartarin and Daumier part of this queer country, where the good folk have the accent you know; there is a Venus of Arles just as there is a Venus of Lesbos, and one still feels the youth of it in spite of all....

When we have the mistral down here, however, it is the exact opposite of a sweet country, for the mistral sets one on edge. But what compensations, what compensations when there is a day without wind—what intensity of color, what pure air, what vibrant serenity. [LT539, c. 17 September 1888]

What he [Gauguin] tells me about Brittany is very interesting, and Pont-Aven is a most marvelous country. Certainly everything there is better, larger, more beautiful than here. It has a more solemn character, and especially purer in its totality and more definite than the shriveled, scorched, trivial scenery of Provence. [LT558b, 28 October 1888]

The Yellow House

I have one less big worry now that I have found the little white studio. I looked in vain at heaps of rooms. It will sound funny to you that the lavatory is next door, in a fairly big hotel which belongs to the same proprietor. In a southern town I feel I have no right to complain of it, since these offices are few and dirty, and one cannot help thinking of them as nests of microbes. For another thing, I have water laid on. [LT480, 1 May 1888]

I live in a little yellow house with a green door and green blinds, whitewashed inside—on the white walls very brightly colored Japanese prints, red tiles on the floor—the house in the full sunlight—and over it an intensely blue sky, and—the shadows in the middle of the day much shorter than in our country. [W4, c. 16 June 1888]

My house here is painted the yellow color of fresh butter on the outside with glaringly green shutters; it stands in the full sunlight in a square which has a green garden with plane trees, oleanders and acacias. And it is completely whitewashed inside, and the floor is made of red bricks. And over it there is the intensely blue sky. In this I can live and breathe, meditate and paint. [W7, 9 and 16 September 1888]

Montmajour

I have come back from a day in Mont Majour, and my friend the second lieutenant was with me. We explored the old garden together, and stole some excellent figs. If it had been bigger, it would have made me think of Zola's Paradou, high reeds, and vines, ivy, fig trees, olives, pomegranates with lusty flowers of the brightest orange, hundred-year-old cypresses, ash trees, and willows, rock oaks, half-broken flights of steps, ogive windows in ruins, blocks of white rock covered with lichen, and scattered fragments of crumbling walls here and there among the green. [LT506, c. 9 July 1888]

The Camargue and the Crau

The Camargue, grass plains where there are herds of fighting bulls and also herds of little white horses, half wild and very beautiful. [LT495, 29 May 1888]

If you saw the Camargue and many other places, you would be surprised, just as I was, to see that they are exactly in Ruisdael's style. [LT496, c. 12 June 1888]

I hope to go for a trip into the Camargue next Friday with a veterinary surgeon; there are bulls there and wild white horses, and pink flamingos, too. [LT501, c. 21 June 1888]

I have already said more than once how much the Camargue and the Crau, except for the difference in color and in the clearness of the atmosphere, remind me of the old Holland of Ruisdael's time. [LT509, c. 13 July 1888]

If you saw my canvases, what would you say of them? You won't find the almost timid, conscientious brushstroke of Cézanne in them. But as I am now painting the same landscape, the Crau and Camargue—though at a slightly different spot—there may well remain certain connections in it in the matter of

VIII. The Yellow House, 2 Place Lamartine. c. 1935. Photograph by John Rewald.

IX. The Place Lamartine with the Yellow House at left, and the Avenue de Montmajour leading to the railroad bridges. Postcard. c. 1900

color. What do I know about it? I couldn't help thinking of Cézanne from time to time, at exactly those moments when I realized how clumsy his touch in certain studies is—excuse the word "clumsy"—seeing that he probably did these studies when the mistral was blowing. As half the time I am faced with the same difficulty, I get an idea of why Cézanne's touch is sometimes so sure, whereas at other times it appears awkward. It's his easel that's reeling. [B9, 24 June 1888]

Some Final Thoughts

It seems that people here have some superstition that makes them afraid of painting, and that they have been talking about it in the town. Very good, I know it is the same thing in Arabia, but nevertheless we have loads of painters in Africa, haven't we....

The advantages I have here are what Rivet [van Gogh's doctor in Paris] used to say, "They are a sickly lot, all of them," so that at least I do not feel alone.

Then, as you well know, I am so fond of Arles, though Gauguin has uncommonly good reason to call it the dirtiest town in the whole South. [LT577, c. 17 February 1889]

Now it is not uncommon, it seems, to see even a whole population in these parts seized with panic, as at Nice during the earthquake. Just now the whole town is uneasy, no one rightly knowing why, and I saw in the papers that actually there have again been slight earthquake shocks in places not far from here. [LT578, c. 22 February 1889]

Roulin said, or rather hinted, that he did not at all like the disquiet which has reigned in Arles this winter, considered even quite apart from what has befallen me.

After all, it is rather like that everywhere, business not too good, resources exhausted, people discouraged and... as you said, not content to remain spectators, and growing ill-natured from being out of work—if anybody can still make a joke or do some work, down they come on him.... I tell you I have no right to complain of anything whatever in Arles when I think of some things I have seen there which I shall never be able to forget. [LT583, early April 1889]

V. HEALTH

I myself should always regret not being a doctor. [LT571, 17 January 1888]

I have made portraits of a whole family . . . and it consoles me up to a certain point for not being a doctor. [LT560, c. 4 December 1888]

Just now I am reading Balzac's *Médécin de Campagne*, which is splendid. [LT590, c. 3 May 1889; this was the last book van Gogh reported reading in Arles]

My God! Shall we ever see a generation of artists with healthy bodies! Sometimes I am perfectly furious with myself, for it isn't good enough to be either more or less ill than the rest; the ideal would be a constitution tough enough to live till eighty, and besides that, blood in one's veins that would be right good blood. [LT467, c. 9 March 1888]

When van Gogh left Paris for Arles in February 1888, he was escaping from the rigors of a particularly hard winter. It was a season he never enjoyed, even at its mildest. Its relentless presence, with surprising amounts of fog—which forced Parisians to liken their city to London—as well as snow, ice, and low temperatures, added an almost intolerable burden to the already low state of van Gogh's health, induced by excessive smoking and drinking. He hoped the South would provide sun and warmth, restorative walks in the country, and some solitude. That he was greeted by snow and, for Arles, a persistent run of abnormally low temperatures —freezing or just below—during his first three weeks did not enable him easily to attain his goal.

During van Gogh's first months in Arles, he constantly referred to the horror of the previous winter in Paris, and to his battle to recover his health. His major problems seem to have been his "blood" (anemia and what he described as problems of circulation) and his stomach (an inability to eat or to digest properly). He talked also of nerves and melancholy: his attempts to cut down on tobacco and alcohol caused him indescribable melancholy about the end of March. He referred to "breakdown" and "stroke" in relation to Paris. He spoke of a "tired brain" and "tired eyes" after long, exhausting painting sessions. He talked of "bad wine" in Paris and of taking brandy in Arles, but he never actually mentioned absinthe.

Van Gogh's health is almost always discussed in terms of his illness, which too often means his so-called madness. This "madness" is usually dated from its first overt manifestation: the cutting off of part of his ear on 23 December 1888. It is also connected with Gauguin's presence, and the two artists' temperamental and artistic incompatibility. Gauguin's arrival in October may, however, have prevented a breakdown, his presence then helping to calm van Gogh.

Diagnoses of his health are as numerous and as contradictory as stylistic explanations of his work: epilepsy or schizophrenia, caused by absinthe, syphilis, lack of food, the "disease of the area," and the need to reach the "high yellow note" in summer 1888.

So much attention has been focused on the late Arles period (i.e., from 23 December 1888 to May 1889) and van Gogh's subsequent stay at the asylum in Saint-Rémy that the first ten months tend to be overlooked. Have we bothered to ask what his health was like in late March, in mid-June, or in mid-October, when he was never so exhausted as when he painted the *Bedroom* (cat. 113)?

Was the painting of the orchard series (see cat. 8–13) affected by his deep depression? Do the brushstrokes, or the choice of colors, or the "faults" in the composition show odd deviations from the "norm" that can be attributed to his pervasive melancholy at this time?

Were the harvest pictures (see cat. 43–49) painted when he was "high," and are they therefore more frenzied in brushstroke, extreme in composition, disturbing in space?

Does *La Mousmé* (cat. 91, fig. 41) show signs of labor, changes of mind, confusions in decision making, even of odd additives to the medium?

And is the *Bedroom* as controlled, as restful, as flat as he claimed? Here we have to take into account on the one hand the relining and retouchings of 1889, and on the other the elementary question of the ground plan of the Yellow House and the odd shape of the bedroom.

What of the sheer pace and pressure of the painting activity from mid-August to mid-October? Van Gogh wanted to finish thirty size 30 canvases for several reasons: to decorate the Yellow House, and especially Gauguin's room; to have them available for exhibition at the time of the Paris World's Fair of 1889; to create a series of autumn effects; and to paint with enormously thick strokes, producing a relieflike impasto, in emulation of Adolphe Monticelli.

These and other questions can be raised if one takes a broader view of van Gogh's health—physical as well as psychological—during his entire stay in Arles, by allowing him, a frustrated doctor, to report his case more fully.

I have thought now and then that my blood is actually beginning to think of circulating, which is more than it ever did during that last period in Paris. I could not have stood it much longer. [LT464, c. 25 February 1888]

Are you well? I am better myself, except that eating is a real ordeal, as I have a touch of fever and no appetite, but it's only a question of time and patience.... Here I am seeing new things, I am learning, and if I take it easy, my body doesn't refuse to function. [LT469, c. 14 March 1888]

The air here certainly does me good. I wish you could fill your lungs with it; one effect it has on me is comical enough—one small glass of brandy makes me tipsy here, so that as I don't have to fall back on stimulants to make my blood circulate, there is less strain on my constitution. The only thing is that my stomach has been terribly weak since I came here, but after all that's probably only a matter of time.... I hope that [by the end of the year] I shall be less bothered with breakdowns. At present I feel pretty bad some days, but I don't worry about it in the least, as it is nothing but the reaction from last winter, which was out of the ordinary. And my blood is coming right, that is the great thing. [LT474, 9 April 1888]

For the moment I am still lying low and keeping very quiet, for first of all I must recover from a stomach disorder of which I am the happy owner, but after that I shall have to make a lot of noise.... It won't do to come here with a damaged stomach and deteriorated blood. This was the case with me, and although I am recovering, I am recovering slowly, and I regret not having been a bit more careful beforehand. But not such a damnable winter as the past one—what was there to be done?—for it was a superhuman winter. [B4, c. 21 April 1888]

My stomach is very weak, but I hope to be able to get it right; it will take time and patience. In any case I am *really* much better already than in Paris. [LT478, c. 21 April 1888]

Last week I had such a fierce toothache that much against my will I had to waste time.... I should be afraid of nothing if it wasn't for my cursed health. All the same, I am better than I was in Paris, and if my stomach has become terribly weak, it's a trouble I picked up there and most likely due to the bad wine, which I drank too much of. The wine is just as bad here, but I drink very little of it. And so it comes about that by eating hardly any solid food and hardly drinking I am pretty weak, but my blood is getting healthier instead of getting poisoned. [LT480, 1 May 1888]

I was certainly going the right way for a stroke when I left Paris. I paid for it nicely afterward! When I stopped drinking, when I stopped smoking so much, when I began to think again instead of trying not to think—Good Lord, the depression and the prostration of it! Work in these magnificent natural surroundings has restored my morale, but even now some efforts are too much for me: my strength fails me. [LT481, c. 3 May 1888]

They have calculated yesterday's bill from a time when I was paying them more because I was sick, and had asked them for better wine. [LT486, 10 May 1888]

I am in better health now. [LT487, 12 May 1888]

Remember how last winter I was stupefied to the point of being absolutely incapable of doing anything at all, except a little painting.... I am feeling infinitely better, blood circulation good and my stomach digesting. [LT489, c. 20 May 1888]

I am feeling decidedly better, and my digestion has improved tremendously during the past month. Some days I still suffer from unaccountable involuntary fits of excitement or else utter sluggishness, but that will pass as I get calmer. [LT492, 28 May 1888]

As for myself, I feel much better here than I did in the North. I work even in the middle of the day, in the full sunshine, without any shadow at all, in the wheat fields, and I enjoy it like a cicada.... This is the very reason why I love this country, because I have less to fear of the cold, which, as it prevents my blood from circulating, prevents me from thinking, from doing anything at all.... My God, I had reached a state where my blood would no longer flow at all—I tell you, what they call not at all—literally. However, after four weeks here, it began to flow again; but, my dear comrade, in that very same period I had a fit of melancholy like yours, which I should have suffered over as much as you if I had not welcomed it with great pleasure, as a sign that I should recover—which in fact happened. [B7, c. 18 June 1888]

My dear brother, if I were not broke and crazy with this blasted painting, what a dealer I'd make just for the impressionists....

After the crisis which I went through when coming down here, I can make no plans or anything; I am decidedly better now, but *hope*, the *desire to succeed* is gone, and I work *because I must*, so as not to suffer too much mentally, so as to distract my mind. [LT513, c. 22 July 1888]

The more I am spent, ill, a broken pitcher, by so much more am I an artist—a creative artist—in this great renaissance of art of which we speak....

Not only my pictures but I myself have become haggard of late, almost like Hugo van der Goes in the picture by Emile Wauters. [LT514, c. 25 July 1888]

Here I am afflicted now and then with an inability to eat, something of the sort you suffered from.... But on the whole I manage to steer clear of the rocks. [W5, 31 July 1888]

I am feeling very, very well these days. [LT519, 8 August 1888]

I am happier to feel my old strength returning than I ever thought I could be. I owe this largely to the people at the restaurant where I have my meals at the moment, who really are extraordinary. Certainly I have to pay for it, but it is

something you don't find in Paris, really getting something to eat for your money. [LT521, 9 August 1888]

Fortunately my digestion is so nearly all right again that I have lived for three weeks in the month on ship's biscuits with milk and eggs. It is the blessed warmth that is bringing back my strength, and I was certainly right in *going at once* to the South, instead of waiting until the evil was past remedy. Yes, really, I am as well as other men now, which I have never been except for a short while in Nuenen for instance, and it is rather pleasant. [LT520, 11 August 1888]

The sun here counts for a good deal. As it is, I am going to pieces and killing myself. [LT523, c. 18 August 1888]

All the same, far from losing my physical strength, I am regaining it, and my stomach especially is stronger. [LT530, 1 September 1888]

And it seems to me that I might go still farther into the South, rather than go up to the North again, seeing that I am greatly in need of a strong heat, so that my blood can circulate normally.

Here I feel much better than I did in Paris. [W7, 9 and 16 September 1888]

But [Gauguin's] stomach is all wrong, and when one has a stomachache and indigestion, one has no willpower.

Now I myself have nothing wrong with my stomach at the moment, consequently my brain is freer and, I hope, clearer. [LT536, c. 11 September 1888]

I am coming to believe more and more that the cuisine has something to do with our ability to think and to make pictures; as for me, when my stomach bothers me it is not conducive to the success of my work.... In the South one's senses get keener, one's hand becomes more agile, one's eye more alert, one's brain clearer, however, on condition: that all this is not spoiled by dysentery or something else of a debilitating nature. [B17, c. 24 September 1888]

I suffer from vertigo. [B18, 3 October 1888]

I have been and still am nearly half-dead from the past week's work. I cannot do any more yet.... I have just slept sixteen hours at a stretch, and it has restored me considerably. [LT553, 14 October 1888]

I am not ill, but without the slightest doubt I'd get ill if I did not eat plenty of food. [LT556, c. 21 October 1888]

As you learned from my wire, Gauguin has arrived in good health. He even seems to me better than I am.... For a while I had a feeling that I was going to be ill, but Gauguin's arrival has so taken my mind off it that I'm sure it will pass. I must not neglect my food for a time, and that is all, absolutely all there is to it. [LT557, 24 October 1888]

About falling ill, I have already told you that I did not think I should, but I'd have fallen ill if my expenditure had continued. [LT558, 28 October 1888]

My brain is still feeling tired and dried up, but this week I am feeling better than during the previous fortnight. [LT558b, 28 October 1888]

I hope I have just had simply an artist's fit, and then a lot of fever after *very* considerable loss of blood, as an artery was severed; but my appetite came back at once, my digestion is all right and my blood recovers from day to day. [LT569, 7 January 1889]

But I feel weak and rather uneasy and frightened. That will pass, I hope, as I get back my strength.

Rey told me that being very impressionable was enough to account for the attack that I had, and that I was really only anemic.... Whatever happens, I shall see my strength come back little by little if I can stick it out here. [LT571, 17 January 1889]

I am still very weak, and I shall have difficulty in getting my strength back if the cold continues. [LT572, 19 January 1889]

Only a few words to tell you that my health and my work are not progressing so badly.

It astonishes me already when I compare my condition today with what it was a month ago. Before that I knew well enough that one could fracture one's legs and arms and recover afterward, but I did not know that you could fracture the brain in your head and recover from that, too.

I still have a sort of "what is the good of getting better?" feeling about me, even in the astonishment aroused in me by my getting well, which I hadn't dared hope for....

Since it is still winter, look here, let me go quietly on with my work; if it is that of a madman, well, so much the worse. I can't help it.

However, the unbearable hallucinations have ceased, and are now getting reduced to a simple nightmare, in consequence of my taking bromide of potassium, I think....

You will perhaps understand that what would reassure me in some fashion as to my illness and the possibility of a relapse would be to see that Gauguin and I had not exhausted our brains for nothing, but that some good canvases have come out of it. [LT574, 28 January 1889]

From what I am told, I am very obviously looking better, inwardly my heart is rather too full of so many feelings and divergent hopes, for I am amazed to be getting better....

It has been a magnificent day with no wind, and I have such a longing to work that I am astonished, as I did not expect it anymore.

I will finish this letter like Gauguin's, by telling you that there certainly are signs of previous overexcitement in my words, but that is not surprising, since everyone in this good Tarascon country is a trifle cracked. [LT575, 30 January 1889]

I am feeling very well, and I shall do everything the doctor says, but...

When I came out of the hospital with kind old Roulin, who had come to get me, I thought that there had been nothing wrong with me, but *afterward* I felt that I had been ill. Well, well, there are moments when I am twisted by enthusiasm or madness or prophecy, like a Greek oracle on the tripod.

And then I have great readiness of speech and can speak like the Arlésiennes, but notwithstanding all this, I am feeling so weak.

It will be all right when my bodily strength comes back, but I have already told Rey that at the slightest grave symptom I would come back and put myself under the treatment of the mental specialists in Aix, or under his....

I must tell you this, that the neighbors, etc., are particularly kind to me, as everyone here is suffering from either fever, or hallucinations, or madness, we understand each other like members of the same family. Yesterday I went to see the girl I had gone to when I was out of my wits. They told me there that in this country things like that are not out of the ordinary. She had been upset by it and had fainted but had recovered her calm. And they spoke well of her, too. [LT576, 3 February 1889]

I feel quite normal so often, and really I should think that if what I am suffering from is only a disease peculiar to this place.... [LT577, c. 17 February 1889]

While I am absolutely calm at the present moment, I may easily relapse into a state of overexcitement on account of fresh mental emotion. [LT579, 19 March 1889]

M. Rey says that instead of eating enough and at regular times, I kept myself going on coffee and alcohol. I admit all that, but all the same it is true that to attain the high yellow note that I attained last summer, I really had to be pretty well keyed up. [LT581, 24 March 1889]

These last three months do seem so strange to me. Sometimes moods of indescribable anguish, sometimes moments when the veil of time and the fatality of circumstances seemed to be torn apart for an instant. [LT582, 29 March 1889]

I am well just now, except for a certain undercurrent of vague sadness difficult to define—but anyway—I have rather gained than lost in physical strength, and I am working....

And now, my dear boy, I believe that soon I shall not be ill enough to have to stay shut up. [LT583, early April 1889]

From the physical point of view my health is better than it used to be....

Sometimes, just as the waves pound against the sullen, hopeless cliffs, I feel a tempest of desire to embrace something, a woman of the domestic hen type, but after all, we must take this for what it is, the effect of hysterical overexcitement rather than a vision of actual reality. [LT587, 28 April 1889]

However, my health is very good and I am working a little.... I have been "in a hole" all my life, and my mental condition is not only vague *now*, but *has always been so*, so that whatever is done for me, I *cannot* think things out so as to balance my life. Where I *have* to follow a rule, as here in the hospital, I feel at peace. [LT589, c. 2 May 1889]

It is amazing how well I am physically, but it isn't enough to be the basis of any hope for its being the same with me mentally.... I say this very, very seriously; physically I am better than I have been in years and years, and I could quite well be a soldier. [LT590, c. 3 May 1889]

As for myself, I am going to an asylum in Saint-Rémy, not far from here, for three months. I have had in all four great crises, during which I didn't in the least know what I said, what I wanted and what I did. Not taking into account that I had previously had three fainting fits without any plausible reason, and without retaining the slightest remembrance of what I felt.

Well, this is bad enough, though the fact is that I have been much calmer since then, and that I am perfectly well physically....

I am unable to describe exactly what is the matter with me; now and then there are horrible fits of anxiety, apparently without cause, or otherwise a feeling of emptiness and fatigue in the head.

I look upon the whole thing as a simple accident. There can be no doubt that much of this is my own fault, and at times I have attacks of melancholy and of atrocious remorse; but you know, the fact is, that when all this discourages me and gives me spleen, I am not exactly ashamed to tell myself that the remorse and all the other things that are wrong might possibly be caused by microbes too, like love.

Every day I take the remedy which the incomparable Dickens prescribes against suicide. It consists of a glass of wine, a piece of bread with cheese and a pipe of tobacco. This is not complicated, you will tell me, and you will hardly be able to believe that this is the limit to which melancholy will take me; all the same, at some moments—oh dear me... [W11, 30 April 1889]

CATALOGUE

Explanatory Notes

The catalogue is divided into five sections on Arles itself, preceded by a Paris Prologue (cat. 1–5). A detailed chronology opens each section.

Dating

Dates in the chronologies and of the works themselves are based largely on van Gogh's letters. The dating and ordering of many of the letters have been changed from those previously proposed. For a complete list incorporating these changes, see Appendix I.

Titles

Van Gogh rarely gave consistent titles to his paintings and drawings. Some works are inscribed with titles (e.g., *Le Café de Nuit*, *La Berceuse*). Titles in de la Faille (see Selected Bibliography) have been modified in the present volume in the interest of simplicity.

Dimensions

Dimensions are given in inches (centimeters in parentheses), height preceding width.

Abbreviations

	LT	Letter to his brother Theodorus (Theo)
	W	Letter to his sister Wilhelmien (Wil)
	B	Letter to Emile Bernard
	T	Letter from his brother Theodorus (Theo)

Guérin	Guérin 1927
SG	Scherjon and de Gruyter 1937
Lord	Lord 1938
H	de la Faille 1939
WC	Wildenstein 1964
F	de la Faille 1970
Pickvance	Pickvance 1970
Dorra	Dorra 1978
JH	Hulsker 1980
GAC	Cooper 1983

See Selected Bibliography for full references.

Provenance and Exhibitions

No details of previous owners or of previous exhibitions have been given. They can be found in the most recent edition of de la Faille (1970; see Selected Bibliography).

References to the Literature

These are confined as much as possible to catalogues raisonnés and to the published letters of van Gogh and Gauguin. Related works are cited by their de la Faille (F) catalogue number. A list of these works and their present owners is given in Appendix II.

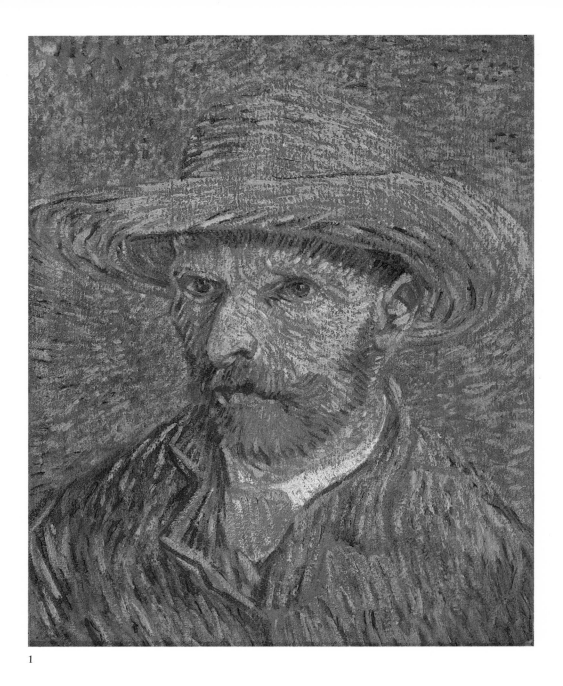

1

1. Self-Portrait

Oil on canvas, 16 × 12½ in. (40.6 × 31.8 cm.)
Unsigned
The Metropolitan Museum of Art, New York. Bequest of
 Miss Adelaide Milton de Groot (1876–1967), 1967

F365v H409 JH1354

Van Gogh painted some thirty-seven self-portraits, all of them concentrated in the last five years of his life. At least twenty-four were done during his two-year stay in Paris, whereas only five were done in Arles (see cat. 99, 124, 145).

The Paris self-portraits were, like many of his still-life subjects, exploratory exercises in color theory and brushstroke. Through them he tested his apprehension of the color practices of such artists as Eugène Delacroix and Adolphe Monticelli and such movements as Impressionism and Pointillism, as well as those developed in Japanese prints. The Metropolitan's *Self-Portrait* is a perfect instance of this exploration: form and structure are created through a buildup of dots, near-dots, small hatchings, and commalike strokes, none of them having much substance. There is a disparity between sunlight (creating a horizontal ridge of shadow across the brow) and studio light (effecting a vertical contrast of light and shadow on the face). The use of complementaries (the contrast between the golden yellow-orange

of the face and hat and the blue-lavender of the coat) is restrained. The halo effect around the head, here an incipient suggestion, is far more deliberate in a later self-portrait (F344) and in the portrait of the Scottish art dealer Alexander Reid (F343).

Van Gogh painted himself in a straw hat on seven different occasions. None of these paintings is dated, and none is mentioned in a letter. Here the straw hat provides a sign and a symbol: a sign of summer and a symbol of van Gogh's admiration for Monticelli. In an uncharacteristic moment of would-be sartorial dandyism, he confessed to his sister Wil in August 1888 his "firm intention to go saunter in the Cannebière [the fashionable street in Marseilles] . . . dressed exactly like him, Monticelli, as I have seen his portrait, with an enormous yellow hat, a black velvet jacket, white trousers, yellow gloves, a bamboo cane, and with a grand southern air" (W8). Further, the straw hat is a painterly challenge. It is trapped, as if in a vise, by the vertical edges of the canvas, a slice of its lateral extent cut at each side. This creates a tension, echoed in the contemplative and troubled stillness of the wearer, as if a potential gyration were being held in check.

2. A Pair of Boots

Oil on canvas, 13⅜ × 16⅜ in. (34 × 41.5 cm.)
Signed and dated, lower right: Vincent 87
The Baltimore Museum of Art. The Cone Collection, formed by Dr. Claribel Cone and Miss Etta Cone of Baltimore, Maryland

F333 H251 JH1236

In the ninety or so still-life paintings van Gogh produced in Paris, he tended to ignore commonplace objects from the kitchen or dining room, concentrating instead on flowers and fruit. He also painted books and boots on several occasions. The books he chose to represent—by the Goncourt brothers, Maupassant, and Zola—may be an indication of what he was reading at the time or of his commitment to modern Realist literature, or they may function as symbols. Hobnailed boots, on the other hand, are anonymous, generalized, not easily amenable to iconographic interpretation or rational analysis. Yet controversy has raged over their meaning and their significance in van Gogh's oeuvre. They have been interpreted as an expression of the artist's empathy with peasants; as the rejects of an urban

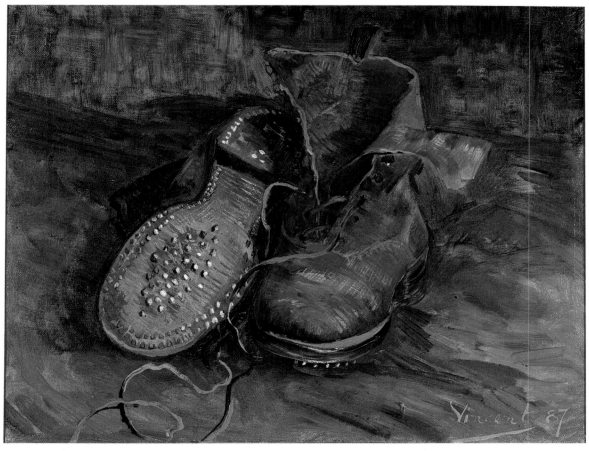

2

ragpicker; as a symbol of the brothers' relationship, the sturdy Theo at right supporting a fallen Vincent at left; as a surrogate self-portrait; and as a statement of the artist's defiance of bourgeois convention.

Another area of ambiguity is the placement of the boots in the composition. One cannot discern whether they are on a shelf or a table or, like a still life of fruit, simply set upon a cloth as objects to be painted. In contrast, *A Pair of Shoes* (cat. 94), produced in Arles, depicts shoes in a specific spatial context—on the red-tile floor of the Yellow House.

In Paris, van Gogh made five paintings of boots, a motif that appears infrequently in European still-life painting. The pictures F255, F331, F332a, and the present canvas, from Baltimore, show a single pair of boots; F332, in the Fogg Art Museum, Cambridge, shows three pairs. The Fogg painting combines three of the pairs from the other pictures. This suggests that van Gogh followed a working process similar to that by which he arrived at the composition of the *Sunflowers* painted in Paris (cat. 3), where elements from small paintings are combined in a large "final statement" picture. However, in the paintings of the boots it seems more likely that the image in the Baltimore canvas was extracted, as it were, from the larger Fogg picture. The use of the contrasting complementaries of orange and blue (with a minor key of red and green) suggests that it was painted in the fall of 1887. It could well be one of the many still lifes exhibited at the Grand Bouillon-Restaurant du Chalet in Paris in November–December 1887.

3. Sunflowers

Oil on canvas, 17 × 24 in. (43.2 × 61 cm.)
Signed and dated, lower left: Vincent 87
The Metropolitan Museum of Art, New York
 Rogers Fund, 1949

F375 H278 JH1329

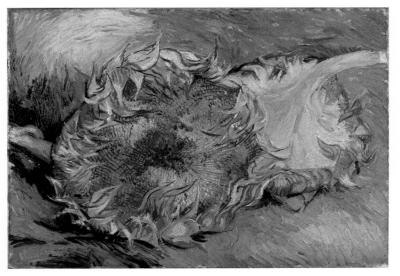

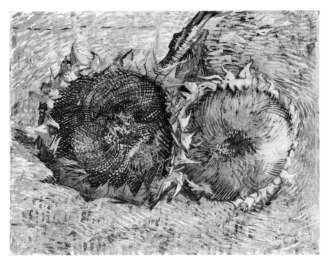

Fig. 1. *Sunflowers* (F376). Oil on canvas, 19⅝ × 23⅝ in. (50 × 60 cm.). Kunstmuseum, Bern

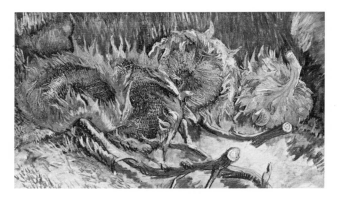

Fig. 2. *Sunflowers* (F452). Oil on canvas, 23⅝ × 39⅜ in. (60 × 100 cm.). Rijksmuseum Kröller-Müller, Otterlo

Sunflowers and van Gogh are irrevocably linked through the sunflowers of Arles. Yet already in Paris he was painting sunflowers. They grow almost unnoticed in a Montmartre garden of 1886 (F274) and far more prominently in three other Montmartre landscapes of 1887 (F264a, F388v, F1411); and they tower above a strolling couple in a small drawing (F1720).

They also appear in still lifes with flowers. Van Gogh used them first in a mixed bunch of flowers in a vase, painted in the fall of 1886 (F250). A year later, dried seed heads become the sole motif of four paintings: a small oil sketch (F377) forms the basis for the Metropolitan canvas; a related oil, also showing two sunflower heads but against a vermilion-hatched ground, is in the Kunstmuseum, Bern (fig. 1); and in a large canvas of four sunflowers, in the Rijksmuseum Kröller-Müller, Otterlo (fig. 2), elements of the two images recur. Only the New York and Bern paintings are signed, and they are both dated 1887.

In these works the artist is following a time-hallowed academic procedure, progressing from a rapid oil sketch to a more considered painted study and finally

to a large picture. He is also concerned with color theory, brushstroke, and the flattening of the picture space. Complementary contrasts—red and green—are more apparent in the Bern canvas, where two closeup flower heads compete for scrutiny. The hatchings assume a rhythmic spread on the painted ground, producing, with very little yellow, a warm halo around the cooler center of the twinned flowers.

The upside-down head in the New York canvas, lacking complementary contrasts, does not invite such scrutiny. But the single facing head is enlarged until it almost bursts its containing frame. Paradoxically, its expanding form is conveyed by small hatched and crosshatched, quill-equivalent, maroon-contoured brushstrokes. The gently licking flames are contained by the cool blue, emphatically stroked, and by the caverns of dark violet shadow and sudden explosions of near-incandescent light.

The Bern and New York canvases were exhibited sometime in November–December 1887 at the Grand Bouillon-Restaurant du Chalet on the Avenue de Clichy, where many of van Gogh's still lifes were shown. Gauguin chose these two canvases for an exchange with van Gogh; his painting was a Martinique landscape (WC222). This exchange was recalled later by van Gogh in letters from Arles (W5, LT571). The art dealer Ambroise Vollard recalled seeing them in Gauguin's Paris studio in 1893–1894. He eventually acquired both, and later sold the Bern version to Edgar Degas.

Gauguin's profound admiration for van Gogh's sunflowers was kindled by the exchange. He expressed it in his Arles portrait *Van Gogh Painting Sunflowers* (cat. 142, fig. 70); and he paid his final homage to van Gogh in three still lifes of sunflowers painted in Tahiti in 1901 (WC602, WC603, WC606).

4. Basket of Apples

Oil on canvas, 18¼ × 21¾ in. (46.5 × 55.2 cm.)
Signed and dated, lower left: Vincent / 87
The Saint Louis Art Museum. Gift of
 Sidney M. Shoenberg, Sr.

F379 H322 JH1341

This canvas was almost certainly painted in the apartment occupied by Vincent and Theo van Gogh at 54 Rue Lepic in September–October 1887. It is very close to another still life of apples (fig. 3), which van Gogh dedicated to Lucien Pissarro (the son of the artist Camille) and which he exchanged with Pissarro for some of his wood engravings. The present canvas seems to have been painted first. Its original owner, the Glasgow-born art dealer Alexander Reid, told his son that after he gave van Gogh some apples, the artist presented him with a still life of them in a wicker basket.

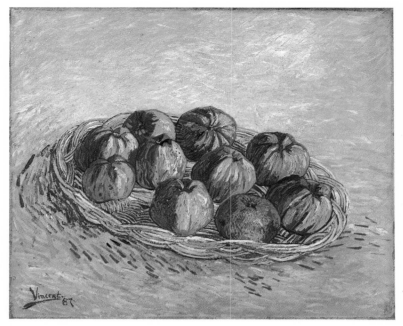

4

The differences in placement make it evident that both pictures were painted from the motif. There are also differences in the background: in the present canvas it is indeterminate, with a warmish yellow tonality; in the one given to Pissarro some distinction is made between cloth and presumed wall, with a cooler bluish tonality.

Both pictures were recalled in letters from Arles. In early March 1888, van Gogh wrote to Theo: "I have just finished a study like the one Lucien Pissarro has of mine, but this time it is oranges" (LT467). And in early April, when he was talking of dedicating some of his pictures to Dutch friends, he wrote, "I have one exactly like the study which I exchanged with L. Pissarro and the one Reid has, of oranges, foreground white, background blue" (LT473). For this still life of oranges, see cat. 7.

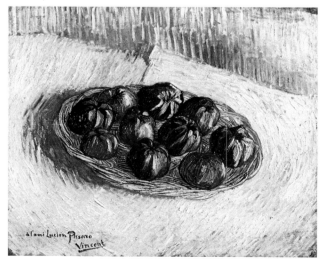

Fig. 3. *Basket with Apples* (F378). Oil on canvas, 21¼ × 25⅜ in. (54 × 64.5 cm.). Rijksmuseum Kröller-Müller, Otterlo

Fig. 4. "Le Japon," cover of *Paris Illustré* (May 1886). Rijksmuseum Vincent van Gogh, Amsterdam

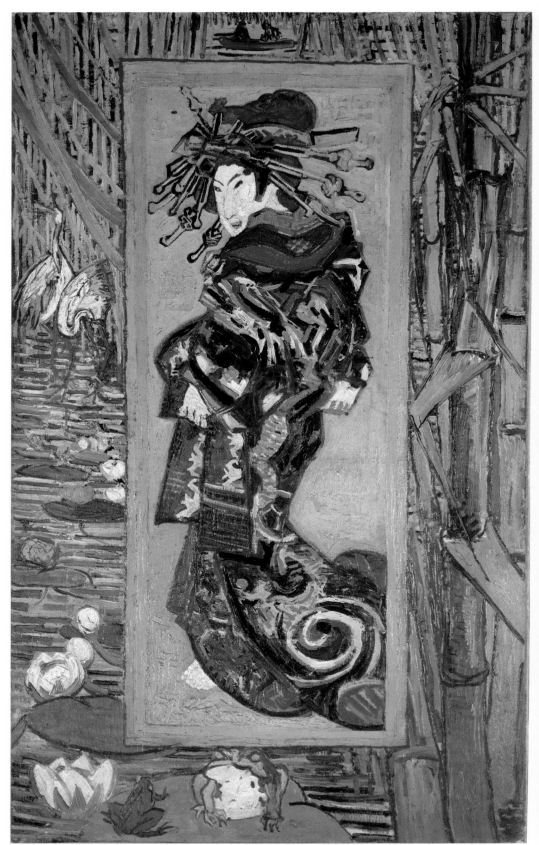

Fig. 5. Tracing of "Le Japon," cover of *Paris Illustré* (May 1886). Rijksmuseum Vincent van Gogh, Amsterdam

5

5. Japonaiserie: The Courtesan (after Kesai Eisen)

Oil on canvas, 41⅜ × 24 in. (105 × 61 cm.)
Unsigned
Rijksmuseum Vincent van Gogh, Amsterdam

F373 H234 JH1298

Van Gogh's interest in Japanese prints first manifested itself in Antwerp in 1885. In a letter to Theo of 28 November, he wrote: "My studio is not bad, especially as I have pinned a lot of little Japanese prints on the wall, which amuse me very much. You know those little women's figures in gardens, or on the beach, horsemen, flowers, knotty thorn branches" (LT437).

During his stay in Paris, van Gogh collected Japanese prints by the hundreds, mostly from the shop of Samuel Bing, a dealer in Oriental art. In the spring of 1887, he hung a large number of them in the café Le Tambourin on the Boulevard de Clichy; they can be seen in the background of the portrait of Agostina Segatori, the café's proprietress (F370). In the fall of 1887, he began making copies of some of these prints. Two of them are taken from well-known examples by Hiroshige: *The Flowering Plum Tree* (F371) and *The Bridge in the Rain* (F372). We know that he transferred the image of the former print to canvas since the tracing paper he used as a guide has survived; and presumably he adopted the same procedure for the latter. In both cases, he added Japanese characters to serve as decorative borders, space fillers dictated by the size of the standard French canvases he used (21⅝ × 18⅛ in. and 28¾ × 21¼ in.).

For *Japonaiserie: The Courtesan*, van Gogh chose a much larger format, 41⅜ × 24 in. And rather than working from a Japanese print, he made his tracing from a reproduction on the cover of *Paris Illustré*, a special Japanese number of May 1886 (fig. 4). After he squared up the tracing, he transferred it to the canvas at exactly twice its original size (fig. 5). But instead of the calligraphic borders, he added in the surround motifs derived from a variety of sources. The frogs were copied from a page in Yoshimaro's *A New Book of Insects* (fig. 6); the cranes were derived from a page of bird studies in Hokusai's *Manga* and are related to *Geisha in a Landscape* (1858) by Toyokuni III; and the prototypes for the bamboo stalks are found in Hokusai's print *Fuji Seen Through a Bamboo Thicket*, in volume two of *One Hundred Views of Fuji* (1835). The only motif that has escaped the source hunter's net is the small European boat with two figures at the top center of the painting, which must be van Gogh's own invention.

In this seemingly haphazard borrowing of sources, van Gogh had a quite definite iconographical purpose. The figure after Kesai Eisen (1790–1848) is not an actor, as has been generally assumed, but a high-ranking cour-

Fig. 6. Yoshimaro. Page from *A New Book of Insects*. 1883. Rijksmuseum Vincent van Gogh, Amsterdam

Fig. 7. H. Gray. *Bal de La Grenouillère*. c. 1890. Poster

tesan, or *oiran*, whose many tortoiseshell hair ornaments, or *kogai*, signify her profession. The narrow vertical format suggests a Japanese wall hanging. Van Gogh surrounds the *oiran* with symbols that, like the *kogai* in her hair, refer to her profession. This is achieved by a kind of transformation of the meaning of certain words understood in a French rather than a Japanese context. Both *grue* (crane) and *grenouille* (frog) were popular Parisian terms for prostitutes. Van Gogh himself used these terms in Arles in September 1888, at which time he was painting a portrait of the Zouave Milliet (see cat. 100). He thought Milliet would be an ideal model for the picture of a lover. "But you know," he wrote to Theo, "he cannot keep still. Besides, he hardly has any time to spare, seeing that he must take a tender leave of all the *grues et grenouilles de la grenouillère* of Arles" (LT541a).

The Japanese courtesan with her *grues* and *grenouilles* in their water setting and the European couple in the small rowboat bring to mind the posters for La Grenouillère, the famous restaurant and bathing place on the outskirts of Paris at Bougival. La Grenouillère had been painted by both Monet and Renoir in 1869 and was frequently drawn and written about in the French illustrated press of the 1880s. It was also described by Maupassant in his short stories. A favored format for posters of La Grenouillère was the inner framing of a bathing belle seen against a watery background, with allusions to the establishment in the surrounding borders (fig. 7).

The same Kesai Eisen print appears in the lower right of the late 1887 *Portrait of Père Tanguy* (F363). There, together with five other Japanese prints on the background wall, its function is more purely decorative.

Sunday 19 February
Visits the studio of Georges Seurat (1859–1891) with his brother Theo (Theodorus van Gogh, 1857–1891). Leaves Paris by train for Arles, a journey of some fifteen to sixteen hours.

Monday 20 February
Arrives in Arles, probably about midday, to find snow, which has been falling since Sunday evening. Van Gogh estimates 24 inches, a local reporter 15 to 18 inches, the local weatherman 10 to 12 inches— whatever the amount, an unexpectedly heavy fall for the "country of the sun."

Takes a room in the Hôtel-Restaurant Carrel, 30 Rue Cavalerie, not far from the northern ramparts of the town. An antiques dealer on the same street indicates he knows of a painting by Adolphe Monticelli (1824–1888).

Tuesday 21 February
Writes to Theo in the morning (during the course of which the snow ceases). Frost and freezing temperatures continue unabated from 17 February to 9 March— the coldest February in Arles since 1860.

Wednesday 22–Friday 24 February
Buys paints and canvas. Paints three studies: an old Arlésienne (F390), a landscape in the snow (F290), and a pavement with a pork butcher's shop (F389).

Visits the Musée Réattu ("a horror and a humbug, and ought to be in Tarascon"—a reference to *Tartarin de Tarascon*, 1872, by Alphonse Daudet), and the museum of antiquities ("but these are genuine").

Finds Arles more expensive than he had hoped. Initially pays 5 francs a day at the Hôtel-Restaurant Carrel; later gets rate reduced to 4 francs.

Saturday 25 February
More snow falls: 3 to 4 inches.

Probably paints a snowscape (cat. 6) the following day.

Late February
Anxious not only to find Monticelli paintings in Arles and Marseilles but also to help Theo arrange exhibitions of the Impressionists in London and The Hague. Writes a draft letter for Theo to approve and send on to H. C. Tersteeg (1845–1910), manager of the Hague branch of Boussod & Valadon.

Early March
Letter (forwarded by Theo) from Paul Gauguin (1848–1903), who is in Pont-Aven: he has been ill in bed for two weeks.

Writes a line to Gauguin in reply.

Writes to the Australian painter John Russell (1858–1931), hoping to persuade him to buy a picture from Gauguin.

Theo invites the Dutch artist Arnold Hendrick Koning (1860–1944) to share his Paris apartment after van Gogh's departure. Koning will eventually come in mid-March and stay until late May.

Still freezing cold. Paints two small studies of an almond branch (F392, F393).

Saturday 3 March
Visited by two amateur artists, a grocer who also sells paints and other art supplies and an "intelligent" magistrate. (This is van Gogh's only recorded contact with local artists.)

Friday 9 March
Weather at last turns milder. Has already taken several walks in the country, but unable to work outdoors because of the mistral. Instead, paints a still life (cat. 7), which "makes eight studies so far."

Finishes reading Daudet's *Tartarin sur les Alpes* (1885).

Saturday 10 March
Letter from Theo, enclosing 100 francs, with news of his purchase—for 17 francs—of a Seurat café-concert drawing at the Pillet sale of 2–3 March. Still no reply from Tersteeg.

Improvement in weather enables him to finish two more landscape studies (neither identified) and encourages him to buy 50 francs' worth of paints and canvas.

Meets the Danish artist Christian Vilhelm Mourier-Petersen (1858–1945), who will be his constant companion for the next two months.

Monday 12 March
Present at the inquiry into the murder of two Zouaves by two Italians at the door of a brothel. "Seized the opportunity to go into one of the brothels. . . . That is the extent of my amorous adventures among the Arlésiennes."

Mid-March
Paints three more landscapes, all of bridges and done with the help of a perspective frame: a drawbridge (F397), a stone bridge over a canal (F396), and a railroad bridge (F398).

Evenings are spent with Mourier-Petersen, who has read Emile Zola, the Goncourts, and Guy de Maupassant. "His work is dry, correct and timid," but he is "young and intelligent."

Sunday 18 March
Letter from Gauguin: bad weather at Pont-Aven; still unwell; no money.

Having promised to do so before leaving Paris, writes to Emile Bernard (1868–1941) and to Henri de Toulouse-Lautrec (1864–1901). Frequent exchanges with Bernard follow. Toulouse-Lautrec, it seems, does not reply, and van Gogh never writes to him again.

Forced by wind and rain to remain at home; works on another study of a drawbridge (F544).

Reading Maupassant's *Pierre et Jean* (1888).

Saturday 24 March
At long last, Theo hears from Tersteeg, who agrees to take work by the Impressionists in his gallery in The Hague. Van Gogh congratulates Theo "on the rebirth of your business relations in Holland." In Paris, Theo has arranged for three pictures to be shown at the Salon des Indépendants (22 March–3 May).

Letter from John Russell. In his reply, van Gogh will propose an exchange of pictures.

Feels he has completely ruined the "sunset with figures and a bridge": only a fragment of two figures has survived (F544). Does the same subject again on the spot, but in gray weather and without figures (F400).

Reports the completion of his first canvas of a blossoming orchard of apricot trees (F556).

Thursday 29 March
The highest recorded temperature of the month. Four days of superb weather follow, coinciding with Easter.

Friday 30 March
Van Gogh's thirty-fifth birthday.

Enraptured by the blossoming orchards, has already begun four or five more paintings since 24 March, including a study of two peach trees, which he has just completed. Moved by receiving a Dutch obituary notice of Anton Mauve (1838–1888), who had been his mentor in The Hague in 1881–1882, writes on this study, "Souvenir de Mauve. Vincent & Theo" (F394).

Sunday 1 April
Easter Sunday. Goes to the opening at the arena of the bullfighting season and is greatly impressed by the colorful crowd.

Monday 2 April
Having inscribed one picture to the memory of Mauve, wishes to expand the revived Dutch connection: dedicates a still life to George Hendrik Breitner (1857–1923), a painter with whom he had worked in The Hague in 1882; and gives one study to his sister Wil (Wilhelmien Jacoba van Gogh, 1862–1941), two views of Montmartre exhibited at the Salon des Indépendants to the "modern museum" in The Hague, and his first drawbridge picture (F397) to Tersteeg.

Coincidentally, this is the day that Theo sends off his consignment of ten paintings to Tersteeg in The Hague. Among them are one by Edgar Degas (1834–1917), *A Woman with Chrysanthemums* (Metropolitan Museum of Art, New York); one by Gauguin, *Marine, Dieppe*, 1885 (probably WC167); and one by van Gogh, *Pont de Clichy* (F303), which the artist had suggested—and sketched—in LT471. The consignment arrives in The Hague on 6 April, and is returned to Paris on 9 June; none of the pictures are sold.

c. Wednesday 4 April
After buying all his paints and canvases locally, and being irritated by the slowness in preparing canvases and the lack of certain colors, sends a large order to Tasset and Lhote, his suppliers during his stay in Paris. In future, will send orders to Paris—either to Tasset or to Père Tanguy (Julien Tanguy, 14 Rue Clauzel), supplementing these from time to time with purchases in Arles.

Sunday 8 April
Sees another bullfight in the arena—"a fine sight when there's sunshine and a crowd."

Monday 9 April
Sends Theo two watercolor sketches after the paintings intended for Jet Mauve, widow of Anton Mauve (F1469), and Tersteeg (F1480).

Still working furiously on orchards in bloom—one canvas of apricot trees, another of plum. April will be the month of orchards; already has eight, and plans ten more. Plans to work on many other subjects and series once the orchards are finished: the arena, a starry night with cypresses or perhaps seen above a field with ripe wheat. Also expects to concentrate on drawing.

Mid-April
Consignment of paints arrives from Tasset.

Spends one morning working on an orchard of plum trees during a fierce mistral (F403); in the evening begins a copy after the drawbridge earmarked for Tersteeg.

Conceives of his blossoming orchards as the first design for a final scheme of decoration consisting of a series of triptychs of up to twelve canvases. These decorations will be continued in spring 1889.

Friday 20 April
Blossoming virtually finished in orchards. "I have ten orchards now, not counting three little studies, and one big one of a cherry tree, which I've spoiled." The last one in the series (sketched in letters to both Theo and Bernard) is planned for Theo's birthday on 1 May (cat. 13).

Disturbed about Theo's difficulties with Boussod & Valadon (caused by his efforts to promote the Impressionists at the expense of the academic painters) and his impending business trip to Brussels.

As an economy measure, decides to stop painting and work on a group of reed pen drawings (cat. 14–26), two of which he sends to Theo.

Sunday 22 April
Visited by Dodge MacKnight (1860–1950), an American-born painter staying at the nearby village of Fontvieille. MacKnight is a friend of John Russell's.

Wednesday 25 April
Buys two pairs of sturdy shoes for 26 francs and three linen shirts for 27 francs, in case he should visit Marseilles, where he wants not only to do a series of seascapes but also to "get hold of a window to show the impressionists" and to try to find work by Monticelli.

Unwell during last week of April: a weak stomach and a fierce toothache. Feels he is being overcharged at the Hôtel-Restaurant Carrel and wants to move.

Tuesday 1 May
Theo's thirty-first birthday.

Rents four rooms, at 15 francs a month, in a small house—the famous Yellow House. It is situated at 2 Place Lamartine in the large square with gardens immediately outside the northern ramparts of the town. The house "had been shut up and uninhabited for a considerable time" and is "in a very poor condition." Continues to live at the Hôtel-Restaurant Carrel and intends to do so until he can make the house habitable. For the moment, hopes to find a bed or mattress. Already has the idea of sharing the new studio: "Perhaps Gauguin will come south? Perhaps I could come to some arrangement with MacKnight."

Wednesday 2 May
Visits furniture dealer but is unable to rent a bed or pay for one in monthly installments.

Thursday 3 May
Visits MacKnight at Fontvieille and for the first time sees some of his work: a pastel, two watercolors, and a charcoal head of an old woman. "It is not impossible that he may come to stay for some time with me here."

Friday 4 May
Looks in the market for a case in which to send his first batch of paintings to Theo.

Puts off doing any repairs on or furnishing of the house.

Monday 7 May
Dispute over the bill at the Hôtel-Restaurant Carrel. Van Gogh thinks it should be 40 francs; the patron says it is 67 francs and that he will keep van Gogh's trunk in his possession until he has paid. Forced to take another hotel, chooses the Café de la Gare, run by Joseph Ginoux and his wife Marie, at 30 Place Lamartine, where he pays 1 franc a night. Will stay there until 17 September.

Despite these difficulties, has recently done two large drawings and five small ones, completing his planned series of landscape drawings (cat. 14–26). Also packs up his first batch of paintings to send to Theo: "In the case [are] all the studies I have except a few that I have destroyed, but I am not signing them all; there are a dozen that I have taken off the stretchers and fourteen on stretchers." He concludes, "Now that the first studies are gone, I'm beginning another series."

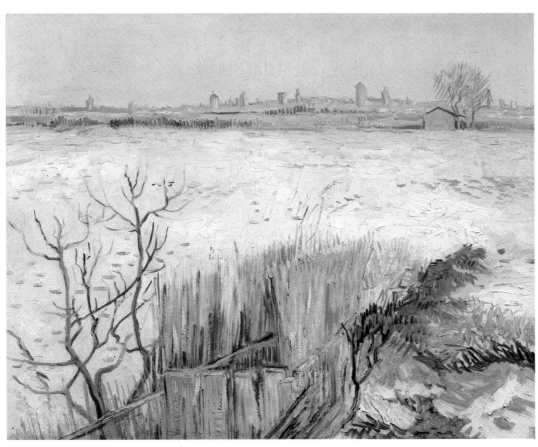

6

6. Snowy Landscape with Arles in the Background

Oil on canvas, 19⅝ × 23⅝ in. (50 × 60 cm.)
Signed, lower center: Vincent
Private collection

F391 H430 SG2 JH1358

When van Gogh arrived in Arles on Monday 20 February, he had expected to find the color and limpidity of Japan; instead he found the town and its surrounding landscape covered in snow. The snow continued until the next morning; in all, some twelve inches fell. Temperatures remained around freezing, but by Saturday 25 February, the snow had almost disappeared. However, on that day there was a fresh fall of some four inches.

Van Gogh made two references to painting snowscapes. Already about 25 February, he was able to tell Theo that "a landscape in the snow" was one of three paintings he had completed (LT464). And about 3 March he wrote: "Down here it is freezing hard and there is still some snow left in the country. I have a study of a landscape in white with the town in the background" (LT466).

It is usually assumed that the present canvas is the one referred to in both letters. However, it seems much more likely that another snowscape (F290) was painted first, probably by 24 February, and is one of the three completed paintings cited in the letter of the following day. The present canvas was then most probably painted on Sunday 26 February, after the second fall of snow: with its "town in the background," it clearly corresponds to the description in the letter of early March.

The planar arrangement sets a compositional formula that recurs in later paintings (see cat. 40, 48). The distant view of Arles also recurs (see cat. 48, 69); here the cold weather, the hazy light, and van Gogh's relative unfamiliarity with the motif conspire to produce a generalized silhouette rather than sharply recognizable identities of tower and spire. Unique to this painting is the wooden construction in the foreground—perhaps a blind for a wildfowler.

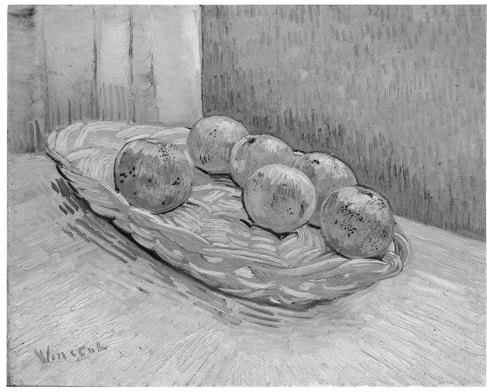

7

7. Basket with Oranges

Oil on canvas, 17¾ × 21¼ in. (45 × 54 cm.)
Signed, lower left: Vincent
Private collection, Lausanne

F395 H433 SG6 JH1363

"I have just finished a study like the one Lucien Pissarro has of mine, but this time it is oranges," van Gogh told Theo about 9 March. "That makes eight studies so far. But this doesn't really count, because I haven't yet been able to work in any comfort or warmth" (LT467).

Then, in early April, in an attempt to reestablish, with Theo, their various Dutch connections with family, dealer, and artists, he considered "[dedicating] a study to Breitner (I have one exactly like the study which I exchanged with L. Pissarro and the one Reid has, of oranges, foreground white, background blue)" (LT473).

Van Gogh had befriended the artist George Hendrik Breitner (1857–1923) in The Hague in 1882. They had gone on outings and sketched landscapes together. In any event, *Basket with Oranges* remains without an inscription.

For a comparison with the still life owned by Lucien Pissarro, see cat. 4.

Orchards in Blossom

Van Gogh's paintings of orchards in blossom were begun five weeks after his arrival in Arles, and completed in less than a month. The first was described without fuss or fanfare on 24 March: "I have just finished a group of apricot trees in bloom in a little orchard of fresh green" (LT471). By about 20 April, he was able to tell Theo: "I have ten orchards now, not counting three little studies, and one big one of a cherry tree, which I've spoiled" (LT478).

These fourteen canvases were van Gogh's heightened response to the pellucid atmosphere and limpid colors of a Provençal spring, joyous celebrations of pure visual enchantment. After the death of the Paris winter, they symbolized his own rebirth. They were also vindications of his vision of Japan in the South.

Van Gogh's aim, he told his brother, was to create "a Provençal orchard of outstanding gaiety" (LT473). And he constantly sought that gaiety by depicting a single orchard—whether of apricot, peach, plum, cherry, pear, or apple. Moreover, he maintained an insider's view of the characteristic Provençal orchard, with its enclosing cane fence and line of cypresses, protection against the mistral. Only one canvas (cat. 8) allows a glimpse beyond the orchard, showing an adjacent field with willows and a ploughman, as well as a factory chimney.

Van Gogh's concentrated attempts to capture the essence of a Provençal orchard had a quite literal corollary. Probably with the consent of the owner, he actually worked a great deal in one recognizable orchard. He painted the peach trees there (F394, F399, F404; cat. 12); he painted the pear trees and the cypresses (cat. 10, 11); and it is possible that his last orchard painting of 1888 (cat. 13) shows yet another view of the same large orchard. Such containment in the selection of a motif would become typical of his work pattern; he rarely dissipated his energies indiscriminately searching for motifs.

These paintings have one other unifying feature. Each orchard is silent and unpeopled, with only hints in two of them of labor: the rake and scythe left to rest in the one (cat. 9), and the ladder lying on the ground in the other (cat. 11). They become immense still lifes of blossom *en plein air*, vivid contrasts to two small still lifes painted in early March of a sprig of almond blossom in a glass (F392, F393).

Enclosure, confinement, and restricted views characterize the 1888 series of blossoming orchards. By contrast, in the handful painted in spring 1889, van Gogh frequently took open and extensive views, often including several orchards. He stood outside them, observed them from a short distance, and allowed greater vistas beyond, either of the town itself (cat. 148; F516) or of the Crau (F514). This may reflect something of his increasing sense of alienation in 1889, his own distancing from people and town alike.

These distillations of orchards are not uniform in style or technique. Some are almost perversely thin and discreet in brushstroke, even with

untouched areas; others have a structural density with impetuously applied impasto; and in one instance (cat. 12) an adapted pointillism is used, echoing Seurat's refined harmonies of color. Some canvases functioned as small oil sketches (cat. 10); others were completed in one session on the spot (cat. 13); yet others were reworked in the studio (cat. 9). The subtle relationship of color sequence is not deliberately heightened, nor the play of complementaries imposed.

Only the motif of blooming orchards is related to Japanese prints. Pictorial space is carefully plotted. In many instances van Gogh must have used his perspective frame, as he mentioned doing in several landscapes finished just before he started the orchards (F396–F398); the only exception is *Blossoming Pear Tree* (F405). Paintings of orchards by Daubigny he may well have known, and Millet's famous *Spring* entered the Louvre in 1887. Whether he actually saw examples by Monet, Pissarro, Sisley, and Renoir during his stay in Paris is uncertain.

Van Gogh varied format and size. He actually produced seven vertical and seven horizontal canvases. For some inexplicable reason, he frequently referred to size 30 canvases during his early months in Arles when he clearly meant size 25. The confusion abounds in the letters, and is graphically illustrated in a letter drawing after the *Still Life with Coffeepot* (cat. 29, fig. 20). His very first size 30 canvas was *The Harvest (Blue Cart)* (cat. 65, fig. 36). In the orchard paintings, he chose the sizes with some deliberateness, as he consciously moved toward the notion of a scheme of decoration consisting of a series of triptychs of one upright central canvas flanked by two horizontals (fig. 8). These triptychs, intended for Theo, would, he hoped, be continued in the spring of 1889.

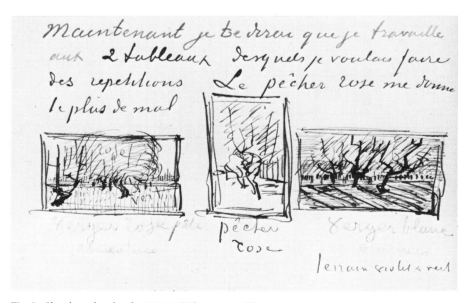

Fig. 8. Sketches of orchards (LT447). Rijksmuseum Vincent van Gogh, Amsterdam

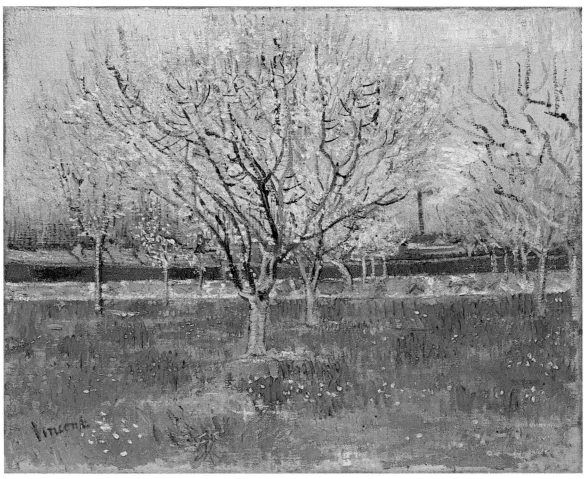

8

8. Orchard in Blossom (Plum Trees)

Oil on canvas, 21⅝ × 25⅝ in. (55 × 65 cm.)
Signed, lower left: Vincent
National Gallery of Scotland, Edinburgh

F553 H576 SG16 JH1387

On 9 April 1888, van Gogh wrote Theo that he was "working on some plum trees, yellowish white, with thousands of black branches" (LT474). A day or so later, he wrote that he was working on a painting of "an orchard of plum trees in bloom" (LT476). It is likely that both references are to the same painting and, further, that it was the painting which in subsequent letters van Gogh always called "the white orchard" (F403).

The present picture is not mentioned in the letters, but in all probability it preceded *The White Orchard*. It is discreetly painted, with a predomination of thin touches and some impasto areas in the blossoms. As with several of the orchard paintings, it was probably done with the help of the perspective frame (see page 55, fig. 12, 13).

The painting is unique among the orchards in the 1888 series in showing views beyond the usually enclosed orchard. Here the factory chimney is an unexpected intrusion in the idyllic setting (although factory chimneys will appear increasingly in van Gogh's work in Arles; see cat. 48). In contrast to this sign of modern life, barely discernible in the left background is a ploughman at work, a symbol of traditional rural activity (he looms larger in a small landscape drawing, F1517). Willows can also be seen; they will figure more prominently in a May painting (cat. 27).

It seems possible that this painting and *Apricot Trees in Blossom* (F556), a canvas of similar dimensions, were meant to be the outer wings of one of the planned triptychs of orchards (LT477). Van Gogh signed the present canvas in carmine and red, giving a sculptural quality to the signature, before sending it to Theo in early May.

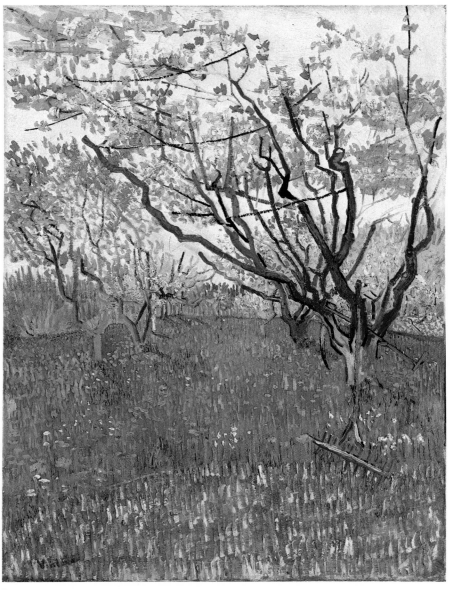

9

9. Flowering Orchard

Oil on canvas, 28½ × 21⅛ in. (72.4 × 53.5 cm.)
Signed, lower left: Vincent
The Metropolitan Museum of Art, New York
 Mr. and Mrs. Henry Ittleson, Jr., Fund, 1956

F552 H577 SG22 JH1381

This painting is often associated with a reference van Gogh made in a letter to Emile Bernard: "Yesterday I overdid one [canvas] of a cherry tree against a blue sky; the young leaf shoots were orange and gold, the clusters of flowers white, and that against the green-blue of the sky was wonderfully glorious" (B4). And to Theo he wrote on 21 April of having ten orchards and "one big [painting] of a cherry tree which I've spoiled" (LT478).

But in the Metropolitan's *Flowering Orchard* there is no cherry tree, the sky is not green-blue, and the canvas is not "big."

The orchard is probably the same one depicted in the large drawing *Orchard with Arles in the Background* (cat. 19). In the painting, van Gogh has shifted his viewpoint, thereby losing the two distinctive towers visible in the drawing.

The blossoming orchards in the series done in the spring of 1888 do not contain figures, and rarely show evidence of human presence. The ladder in the painting *Orchard Bordered by Cypresses* (cat. 11) is one exception, and the prominent scythe and rake in the present painting the other. The red signature was added just before the painting was dispatched to Theo in early May.

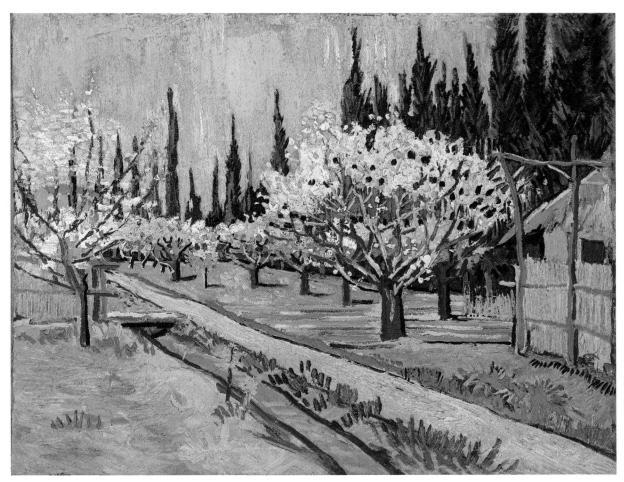

10

10. Orchard Bordered by Cypresses

Oil on canvas, 12¾ × 15¾ in. (32.5 × 40 cm.)
Unsigned
Private collection

F554 H581 SG25 JH1388

In a revealing letter to Emile Bernard of 9 April 1888, van Gogh wrote: "At the moment I am absorbed in the blooming fruit trees, pink peach trees, yellow-white pear trees. My brushstroke has no system at all. I hit the canvas with irregular touches of the brush, which I leave as they are. Patches of thickly laid-on color, spots of canvas left uncovered, here and there portions that are left absolutely unfinished, repetitions, savageries; in short, I am inclined to think that the result is so disquieting and irritating as to be a godsend to those people who have fixed, preconceived ideas about technique. For that matter here is a sketch [fig. 9], the entrance to a Provençal orchard with its yellow fences, its enclosure of black cypresses (against the mistral), its characteristic vegetables of varying greens: yellow lettuces, onions, garlic, emerald leeks.

Fig. 9. Sketch of *Orchard Bordered by Cypresses* (B3). Present location unknown

"Working directly on the spot all the time, I try to grasp what is essential in the drawing—later I fill in the spaces which are bounded by contours—either expressed or not, but in any case *felt*—with tones which are also simplified, by which I mean that all that is going to be soil will share the same violetlike tone, that the whole sky will have a blue tint, that the green vegetation will be either green-blue or green-yellow, purposely exaggerating the yellows and blues in this case" (B3).

The enclosed sketch is loaded with color notes; and, contrary to what is generally assumed, these color notes are much closer to the present canvas than to the larger version (cat. 11). For example, the "pink" peach tree at the left, the "emerald green" at the edge of the path, the "heavy blue sky," the "blue-green" of the small ditch. Compositionally, there is more foreground; the small footbridge is much more distinctly shown; and the placement and silhouette of the cypresses are also closer. It would therefore appear that the present *Orchard Bordered by Cypresses* was the *pochade* done on the spot to serve as a study for the larger work, which is exactly twice the size.

11. Orchard Bordered by Cypresses

Oil on canvas, 25⅝ × 31⅞ in. (65 × 81 cm.)
Unsigned
Rijksmuseum Kröller-Müller, Otterlo

F513 H535 SG19 JH1389

In a letter written about 13 April, van Gogh told Theo of the series of triptychs he planned as a scheme of decoration for the orchard pictures. Two of these triptychs existed, and he included a sketch of one of them in the letter. The pictures for the third triptych, however, had "got no further than embryos or fetuses. . . . They should represent a very big orchard surrounded by cypresses and great pear trees and apple trees" (LT477). The two horizontal canvases that van Gogh envisaged for this triptych are the present one and *Orchard with Peach Blossom* (cat. 12).

The present painting was done after the *pochade* (cat. 10); it is exactly twice as large, and several changes have been made. There is now less foreground; the silhouette and disposition of the cypresses differ; the water

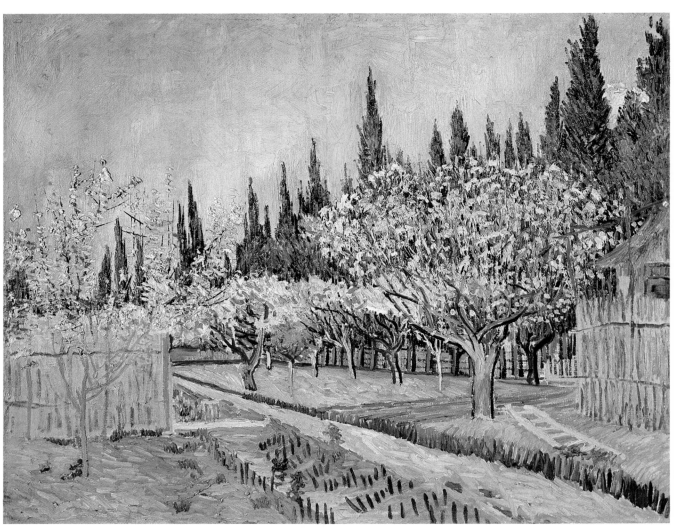

is hardly noticeable; the footbridge is lower; no shadows are thrown by the fruit trees; and the ladder lying flat on the ground has been added.

Van Gogh mentioned this painting, and its pendant (cat. 12), on three occasions after he sent it to Theo early in May 1888 with the first batch of twenty-six works. On 10 May he called them "unfinished, which I regret, for the composition gave the general effect of the big orchards here surrounded by cypresses" (LT486). On 28 May he wrote of them as "failures," "one study too soft and the other too harsh...partly due to the changeable weather" (LT492). But by mid-June, he was "almost reconciled" to them both: "They may pass muster in the crowd" (LT504).

12. Orchard with Peach Blossom

Oil on canvas, 25⅝ × 31⅞ in. (65 × 81 cm.)
Unsigned
Private collection, New York

F551 H575 SG21 JH1396

Van Gogh never wrote of this painting alone, but always in tandem with *Orchard Bordered by Cypresses* (cat. 11). The two paintings were intended as the flanking horizontal wings of the third triptych of orchards he planned, representing "a very big orchard surrounded by cypresses" (LT477). Neither painting is described in the letters, and there is no clear indication when they were executed. But just as a *pochade* exists for *Orchard Bordered by Cypresses*, so a *pochade* exists for part of this composition (F399).

It is an experimental painting, where van Gogh regulates the touch and brushstroke in what he called the "stippling," or pointillism, of Georges Seurat and Paul Signac. But he applied the stippling more freely than they, and without the same scientific concern.

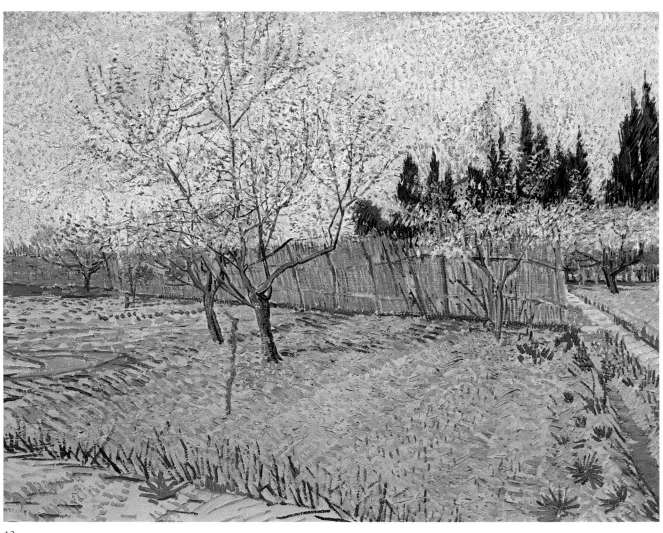

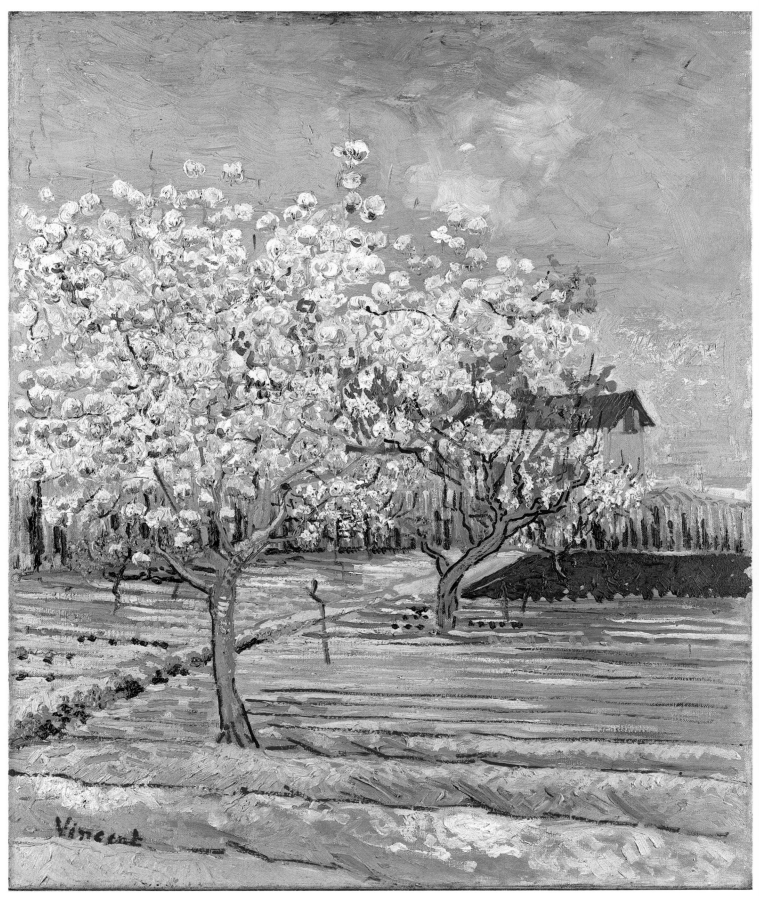

13. Orchard in Blossom

Oil on canvas, 28⅜ × 22⅞ in. (72 × 58 cm.)
Signed, lower left: Vincent
Private collection, Switzerland

F406 H440 SG23 JH1399

This was the last painting van Gogh made for the 1888 series of orchards. It was conceived specially for Theo's birthday: "Here is a sketch of an orchard [fig. 10] that I planned more particularly for you to celebrate May 1. It's absolutely clear, and done all at once. A frenzy of impastos of the faintest yellow and lilac on the original white mass" (LT478).

On the same day, probably about 21 April, he described and sketched it for Emile Bernard (fig. 11): "Here is another orchard, rather simple as a composition: a white tree, a small green tree, a square patch of green, lilac soil, an orange roof, a large blue sky" (B4).

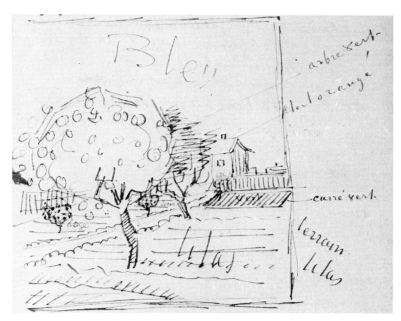

Fig. 10. Sketch of *Orchard in Blossom* (LT478). Rijksmuseum Vincent van Gogh, Amsterdam

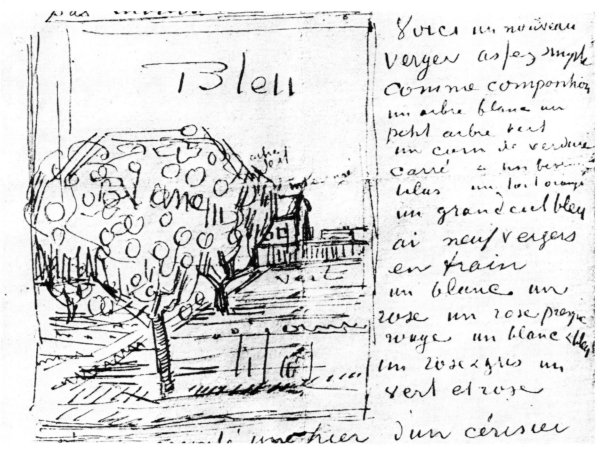

Fig. 11. Sketch of *Orchard in Blossom* (B4). Present location unknown

The First Drawings

If van Gogh used sketchbooks in Arles, nothing survives of them. Without them, his early drawing activity is difficult to chart, especially since it was seven weeks after his arrival before he even mentioned drawing. On 9 April, he wrote to Theo: "I must do a *tremendous* lot of drawing, because I want to make some drawings in the manner of Japanese prints.... If there should happen to be a month or a fortnight when you were hard pressed, let me know, and I will set to work on some drawings, which will cost us less" (LT474).

By 21 April, he had sent his brother two "large" drawings. He described their technique thus: "These drawings were made with a reed sharpened the way you would a goose quill; I intend to make a series of them, and hope to do better ones than the first two. It is a method that I already tried in Holland some time ago, but I hadn't such good reeds there as here" (LT478). A few days later, feeling threatened by the news of Theo's difficulties with his employers, Boussod & Valadon, over the sale of Impressionist paintings, he wrote: "As far as I'm concerned, I stopped painting at once, and went on with a series of pen drawings, of which you have had the first two, but in a smaller size.... Since I believe it's possible to produce a work of art at less cost than one must spend on a painting, I've begun the series of pen-and-ink drawings.... I'll send you pen drawings in a little while; I've done four already" (LT479).

He could write on 1 May: "I have just sent you a roll of small pen-and-ink drawings, a dozen I think. By which you will see that if I have stopped painting, I haven't stopped working" (LT480). And on about 7 May: "There has been a good deal of mistral here, so I did the dozen little drawings which I have sent you. Now the weather is splendid, I have already done two big drawings and five small ones" (LT483).

Four "large" and seventeen "small" drawings were completed in two weeks or so, when drawing became an exclusive activity. The dialectic between painting and drawing in Arles is far from simple. There were temporal distinctions, periods when he would do one and ignore the other. But a drawing was rarely done explicitly for a painting (see cat. 15). Certainly, there are no squared-up drawings. A shared motif usually represents separate sightings rather than a direct dependence of the painting on the drawing. Even the many drawings done *after* paintings were free translations, never painstaking copies.

In this first drawing campaign, van Gogh disregarded the grand monuments and picturesque corners of old Arles. When his art dealer uncle C. M. van Gogh commissioned views of The Hague in 1882, van Gogh chose unfashionable, workaday sites: the gasworks (F924), a factory (F925), a bakery (F914). Such wayward choice of motif recurred in 1888 (see cat. 14, 22, 23).

There are other tangible links with his Dutch past. He recalled using the reed pen in Holland: he had actually done so in Etten in 1881, when he was first setting out seriously to confront problems of landscape drawing (F845, F846). Reeds were so plentiful by the banks of the canal net-

work around Arles that he began to use them again. The versatility of the reed pen is demonstrated in these first drawings: it can operate like a brush (cat. 21); it can be delicately evocative (cat. 24); it can be brutal and dense yet supremely variable and inventive in its jabs, hatchings, and dots (cat. 27). Van Gogh rarely articulated the skies; and the dot retains a descriptive function, suggesting growth (an equivalent of nature) or spatial recession (a pictorial device).

Spatial recession implies perspective. In The Hague in 1882, van Gogh had made "an instrument for studying proportion and perspective, the description of which can be found in a book by Albrecht Dürer, and which the old Dutch masters also used. It makes it possible to compare the proportion of objects nearby with those on a more distant plane, in cases where construction according to the rules of perspective is not possible" (LT205). He illustrated its use by making sketches of it and of himself using it in letters of August 1882 (fig. 12, 13). This link with his Dutch period was maintained in several of these first drawings in Arles (cat. 15, 16, 17, 23, 26), where the distinctive inner rectangle drawn in pencil, sometimes with connecting diagonals, is apparent. It was not until he went to Saintes-Maries in late May that he finally discontinued using his perspective frame, both for his drawings and for his paintings.

Fig. 12. Sketch of a perspective frame (LT223). Rijksmuseum Vincent van Gogh, Amsterdam

Fig. 13. Sketch of van Gogh working with a perspective frame (LT222). Rijksmuseum Vincent van Gogh, Amsterdam

14

14. View of Roofs with the Tower of Saint-Julien

Pencil, reed pen and ink, 10 × 13⅝ in. (25.5 × 34.5 cm.)
Unsigned
Collection John R. Gaines, Lexington, Kentucky

F1480a JH1403

This view was taken from the Hôtel-Restaurant Carrel at 30 Rue Cavalerie during van Gogh's ten-week stay there. He never gave any clue as to where his room was situated; and this drawing is his only rooftop view. Looking toward the southwest, his arc of vision takes in, from the left, one of the towers of the arena, the spire of the Church of the Cordeliers, the distant cupola of the Homme de Bronze, the prominent tower of Saint-Julien, and, at the far right, near the Rhône, the Church of the Dominicans.

Van Gogh began with a fairly extensive pencil drawing; there are still pentiments visible, as well as much shading. The reed pen reinforces and restates. The acceptance of the thing seen can seldom have been more powerfully expressed than in this unusual closeup view. The vernacular tiles and the functional chimney stack dominate the distant monuments of Arles. Visual echoes occur: the large chimney and the Saint-Julien tower right of center, the smaller chimneys and the arena tower with spiky spire at left. These visual echoes become metaphors for van Gogh's concept of Arles, where monuments, whether classical or Christian, are usually seen as a distant skyline silhouette, their historical mystique ignored.

The hatched strokes in the receding roof tiles suggest the furrows of a ploughed field and are comparable to those in another early drawing from Arles, *Peasants Working* (F1090). Here, as there, the promise of burgeoning nature is conveyed: the spots of foliage at right indicate a late March or early April date.

15

15. Path Through a Field with Willows

Pencil, pen and brown ink on wove paper, 10 × 13⅝ in.
 (25.5 × 34.5 cm.)
Inscribed, lower center: Arles Mars '88
Rijksmuseum Vincent van Gogh, Amsterdam

F1499 JH1372

About 7 May, van Gogh wrote Theo that in the batch of paintings he was sending to Paris was "a little landscape with a hovel, white, red, and green, and a cypress beside it [fig. 14]; you have the drawing of it, and I did the whole painting of it in the house. This will show you that, if you like, I can make little pictures like the Japanese prints of all these drawings" (LT484).

The drawing is one of three in which relationships with paintings undoubtedly exist (see cat. 16, 17), but none is so close as this one. Further, there is no proof, as van Gogh's letter provides in this case, that the other two paintings were made directly from the drawings. This must be among the first drawings to be done in Arles, and it is the only one to have an inscribed date. The date is valuable as evidence that van Gogh had already begun to draw well before late April.

Much preparation with pencil, a rather tentative and deliberate technique, and in particular the use of the perspective frame link this drawing with three others

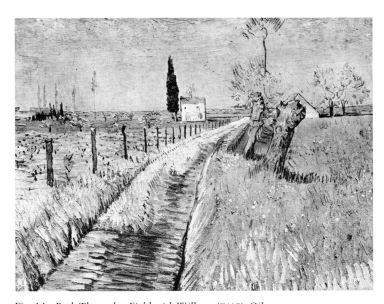

Fig. 14. *Path Through a Field with Willows* (F407). Oil on canvas, 12¼ × 15⅜ in. (31 × 38.5 cm.). Present location unknown

(cat. 16, 17, 23), which may well be the four drawings van Gogh, in LT479, reported having completed.

The motif shows the characteristic mixture of the Crau landscape: pollarded willows, cypresses, and a small *mas*, or farmhouse, which van Gogh called a *masure*, or hovel.

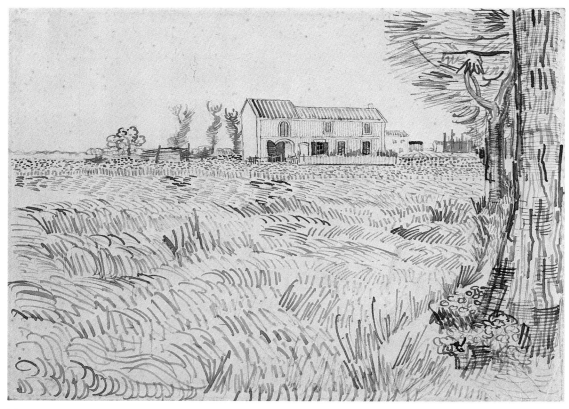

16

16. Farmhouse in the Wheat Field

Pencil, pen, reed pen and brown ink on wove paper,
 10 × 13⅝ in. (25.5 × 34.5 cm.)
Unsigned
Rijksmuseum Vincent van Gogh, Amsterdam

F1415 JH1408

"Just now I have done two new studies . . . you have a drawing of one of them already, a farm by the high road among cornfields," van Gogh wrote on 12 May (LT487). The relationship between drawing and painting (fig. 15) is different from that in *Path Through a Field with Willows* (cat. 15). The painting was done on the spot, not in the studio, and *after* the drawing had been sent to Theo. The two are separate sightings of the same motif; this is made clear in their different viewpoints, that of the painting being farther to the right.

The drawing shows signs of the use of the perspective frame, suggesting it was among the four drawings completed by the last week of April (LT479).

Van Gogh called the motif "farm by the high road among cornfields." Its precise location can be established. It was a half-mile from the Place Lamartine on the Avenue de Montmajour, which van Gogh called the "road to Tarascon." So quickly did countryside succeed town that this road, with its scattered farmhouses and surrounding fields, became one of his favorite and most repeated motifs.

In the 1950s, this area was largely countryside. Today the farmhouse still exists, but as a ruin—roofless, treeless, a gaunt survivor among the surrounding development. On its abandoned gateposts is inscribed "115 Mas Baudin."

Fig. 15. *Farmhouse in the Wheat Field* (F408). Oil on canvas, 17¾ × 19⅝ in. (45 × 50 cm.). Rijksmuseum Vincent van Gogh, Amsterdam

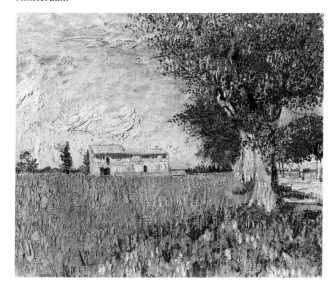

17. Meadow with Flowers

Pencil, pen, reed pen and brown ink on wove paper,
 10 × 13⅝ in. (25.5 × 34.5 cm.)
Unsigned
Rijksmuseum Vincent van Gogh, Amsterdam

F1474 JH1407

Closely related to *Farmhouse in the Wheat Field* (cat.
16) in both style and technique and in the use of the
perspective frame, this drawing also shares a familiar
motif, an area adjacent to the "road to Tarascon,"
slightly nearer the town; the fairly high horizon can
also be compared with that in the companion drawing.

By contrast, a painting of the motif (fig. 16) has a
much lower horizon, with the sky taking up half the
composition and with the viewpoint farther to the left.
This is another instance of a separate sighting of a virtu-
ally identical scene. The poppies in the field indicate
that it was done in May, after the drawing had been
sent to Theo (LT479).

The technique is interesting for the variety of stroke,
hatching, and dot—the last used quite extensively,
though as a representational element, and not yet in an
abstract or decorative manner.

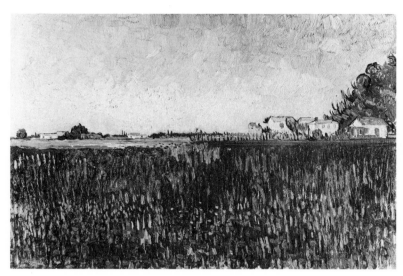

Fig. 16. *Meadow with Flowers* (F576). Oil on canvas, 9 × 13⅜ in.
(23 × 34 cm.). Rijksmuseum Vincent van Gogh, Amsterdam

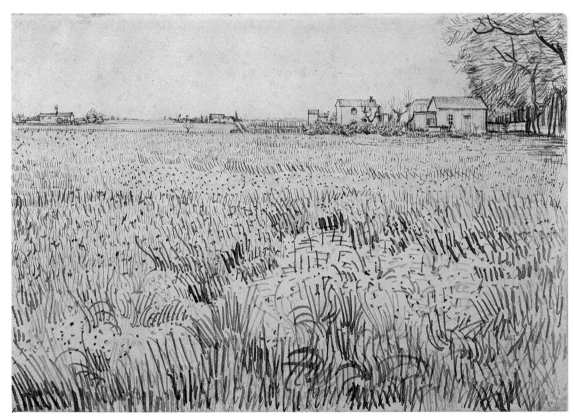

17

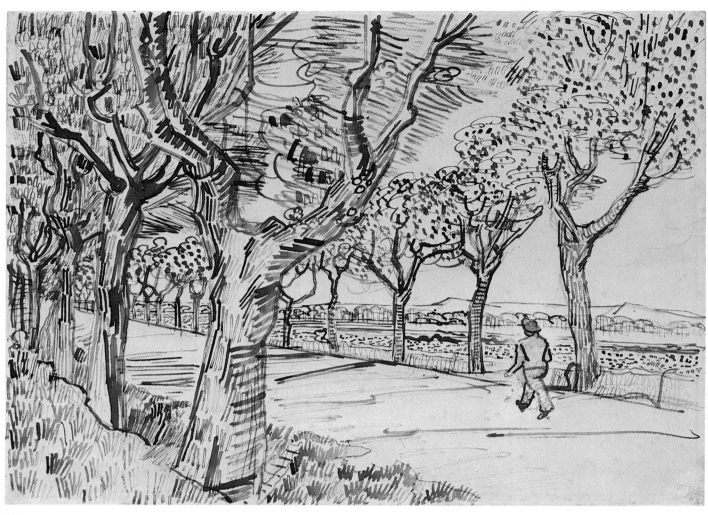

18

18. The Road to Tarascon with a Man Walking

Pencil, pen, reed pen and brown ink on wove paper,
 10⅛ × 13¾ in. (25.8 × 35 cm.)
Unsigned
Graphische Sammlung, Kunsthaus, Zurich

F1502 JH1492

There is no reference to this drawing in the letters, no comparable painting, and no evidence of the use of the perspective frame. But it shows the same "road to Tarascon" as cat. 16 and 17. This particular stretch of the road, farther out of town, also occurs in three other drawings (F1509, F1518, F1518a), as well as in a painting (F567). All were done in late April–early May.

The agitated touches and angular forms were probably conditioned in part by the mistral. The figure was added in the studio; an earlier attempt was scraped out before van Gogh achieved what must be his most reso-

lute and briskly walking figure. If it is a self-portrait, it contrasts vividly with the heavily laden artist in the destroyed canvas *The Painter on the Road to Tarascon* (cat. 78, fig. 40). The composition may also be contrasted with that of a Paris painting showing a figure, again possibly the artist, walking on the banks of the Seine (F299).

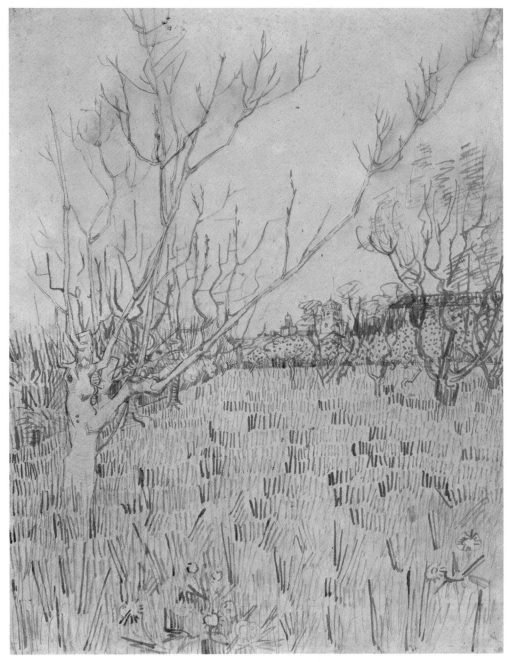

19

19. Orchard with Arles in the Background

Pencil, pen, reed pen and black and violet ink on buff-
 colored paper, 21 × 15½ in. (53.5 × 39.5 cm.)
Unsigned
The Hyde Collection, Glens Falls, New York

F1516 JH1376

This drawing has a threefold interest. First, it must be
the earliest representation of an Arles orchard, preced-
ing the first painting mentioned on 24 March (LT471),
since the spiky and leafless trees suggest an earlier March
date.

Second, among all the orchards of 1888, it is the
only one to give a glimpse of the town. The Saint-
Trophime tower and to its left the Homme de Bronze
establish that the orchard was to the south of Arles.

And third, it is related to the painting *Flowering
Orchard* (cat. 9). In one sense, it virtually reverses that
composition. But it is also possible that the viewpoint
differs in the painting, excluding the tree at left, chang-
ing the angle of vision, and therefore obscuring both
towers in the distance.

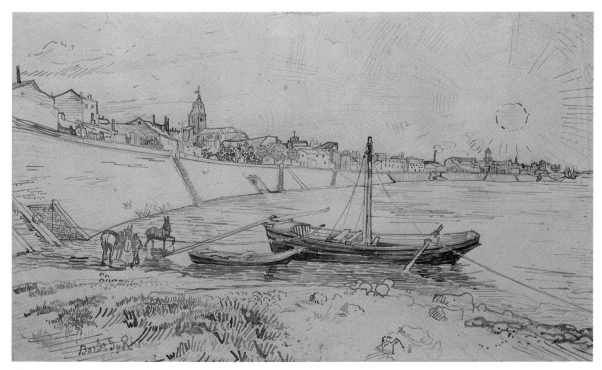

20

20. Bank of the Rhône

Pencil, pen, reed pen and violet ink, 15⅜ × 24 in.
 (39 × 61 cm.)
Watermark: in a sash, AL. PL Bas
Inscribed and signed, lower left: Bords du Rhône / Vincent
Museum Boymans-van Beuningen, Rotterdam

F1472a JH1497a

To obtain this view from riverbank level, van Gogh descended from the Place Lamartine. (When he painted the *Starry Night*, F474, in late September, he would remain in the Place, thus giving his view of the Rhône a much higher vantage point.) The drawing has an anecdotal quality rare in van Gogh's work in Arles, not only in the view taken at sunset (with the tower of Saint-Julien, also seen in cat. 14) but in the watering horses and the two boats. It can be compared with another

view done in September 1888 by the American illustrator and printmaker Joseph Pennell (1857–1926) and reproduced in *The Century Magazine* of July 1890 (fig. 17). This view would become a standard one for tourist postcards.

The ink, originally a bright violet, has discolored to brown from exposure to light. To preserve what remains of the original color, the edges of the drawing are kept covered, about one centimeter all the way around, by a mount; the drawing is exhibited in this way. Other drawings once had this violet color, especially a group done at Montmajour, and traces remain, similarly preserved under the edges of the mounts (see cat. 31, 32). Van Gogh used the same violet ink in several letters of this period.

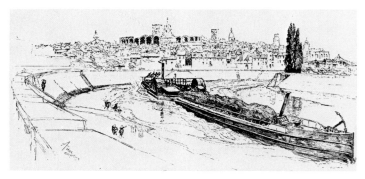

Fig. 17. Joseph Pennell. *Arles from the River.* September 1888.
Illustration for Harriet Waters Preston, "A Provençal Pilgrimage,"
The Century Magazine (July 1890). The New York Public Library

21. View of the Rhône

Reed pen and ink, 8⅞ × 13⅝ in. (22.5 × 34.5 cm.)
Unsigned
Staatliche Graphische Sammlung, Munich

F1472 JH1404

Viewed from riverbank level, like the Rotterdam drawing (cat. 20), this rapid pen sketch shows very little of the protective wall built after the disastrous flooding of 1856. It therefore gives, for the only time in van Gogh's work, a view of the immensity of the Rhône as it nears its estuary twenty-five miles away. Even the iron

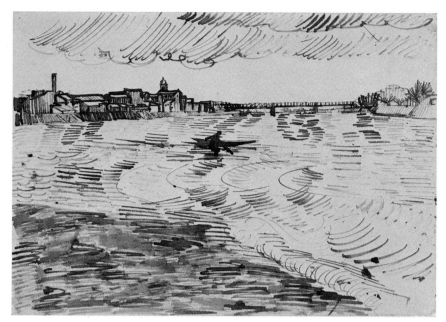

21

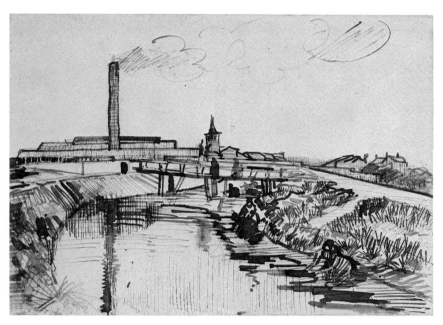

22

Trinquetaille Bridge, constructed in 1875, looks frail and diminutive.

To the force of water is added the power of wind, the presence of the mistral surely indicated both by the wave patterns and by the ominous clouds.

If the Rotterdam drawing reflects something of a tourist's or illustrator's view, this view of the Rhône has a summary Romantic evocation of the might of the natural elements and the puniness of man, symbolized by the lone figure in a boat. And to its belated Romantic imagery can be added stylistic affinities with some of Delacroix's drawings.

22. View of La Roubine du Roi with Washerwomen

Reed pen and ink, 8⅞ × 13⅝ in. (22.5 × 34.5 cm.)
Unsigned
Staatliche Graphische Sammlung, Munich

F1473 JH1405

Stylistically very close to the *View of the Rhône* (cat. 21), this drawing moves from the terrors of the Rhône and the mistral to a quiet, man-made canal, known as the Roubine du Roi (the King's Canal). It was here that

the women of Arles washed their clothes on a specially constructed wooden platform. Beyond it is a fragile, almost Oriental-style wooden footbridge. Van Gogh chose a view looking back toward the town. This unpicturesque, workaday aspect—it could be a suburb of Paris or The Hague—is closed off by the dominating chimney of the gasworks, dwarfing the tower and spire of the Convent of the Carmelites.

Van Gogh returned to the site in June, and in a painting that transforms the workaday into the spatially hallucinatory recorded an evening effect (cat. 50). In a letter to Theo, he recalled the earlier drawing: "Do you remember among the little drawings a wooden bridge with a washing place, and a view of the town in the distance? I have just painted that subject in a large size" (LT504). This, then, is a documented instance of separate sightings of the same motif, a process already referred to in cat. 16 and 17.

Compare also cat. 70.

23. Public Garden Opposite the Yellow House

Pen, reed pen and brown ink on wove paper, 10 × 13⅝ in.
 (25.5 × 34.5 cm.)
Unsigned
Rijksmuseum Vincent van Gogh, Amsterdam

F1421 JH1414

The view is of the garden that adjoined the remains of the fortified wall on the south side of the Place Lamartine. It was one of three gardens in the square. Curiously enough, the Roubine du Roi actually ran beneath it; and if van Gogh had shown the wall, beyond it

would have been the Convent of the Carmelites, visible in cat. 22.

While this drawing shares with cat. 15, 16, and 17 the use of the perspective frame, there is no pencil preparation whatsoever. It was done directly with the pen. Later, in the studio, van Gogh retouched it (the color of the ink changes slightly), and added the decoratively angular and rather stylized branch.

The feathery round bush, innocently placed in the small garden, was to attract van Gogh more than any other single natural form during his stay in Arles. It recurs in some ten paintings and drawings (including those done in letters). For some of these, see cat. 60, 72, 84, 104, and 107.

24. The Langlois Bridge

Pencil, reed pen and ink, 9½ × 12½ in. (24.1 × 31.7 cm.)
Unsigned
Los Angeles County Museum of Art. Mr. and Mrs. George
 Gard De Sylva Collection

F1471 JH1420

This rapid, on-the-spot, superbly economical sketch displays a pencil armature and demonstrates the versatility of the reed pen—as a surrogate brush to create effects that are liquid and silky and as an implement to produce bundles of sharp linear hatchings. This view of the Langlois Bridge is similar to that in a painting (cat. 28). But it announced the motif; it must date from late April, and would therefore have been sent to Theo before the painting was begun, about 10 May. It was later used, from memory, as one of the pages in van Gogh's projected album of his drawings, sketched in LT492 of 28 May (cat. 31, fig. 22).

25. The Langlois Bridge with Road

Pencil, pen, reed pen and ink, 12 × 18¾ in.
 (30.5 × 47.5 cm.)
Watermark: PL Bas
Unsigned
Graphische Sammlung, Staatsgalerie, Stuttgart

F1470 JH1377

Van Gogh's paintings and drawings of the Langlois Bridge tend to show a side-on, canal-bank view. This study is alone in facing the bridge virtually straight on, from the perspective of a walker about to cross it. The challenge of representing it in so foreshortened a view was met with meticulous pencil and ruler, especially in the four supporting uprights. Pencil was also used for laying in the main compositional elements. Nevertheless,

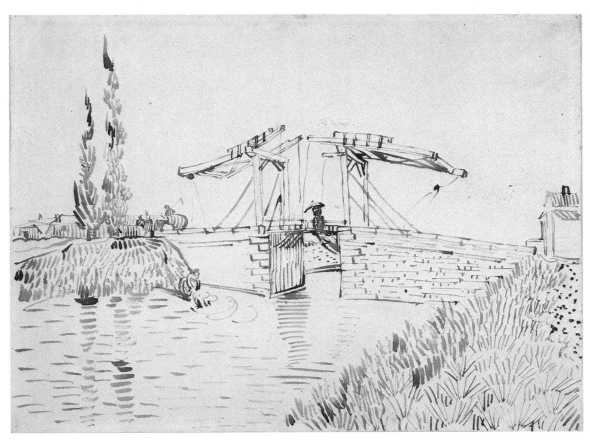

24

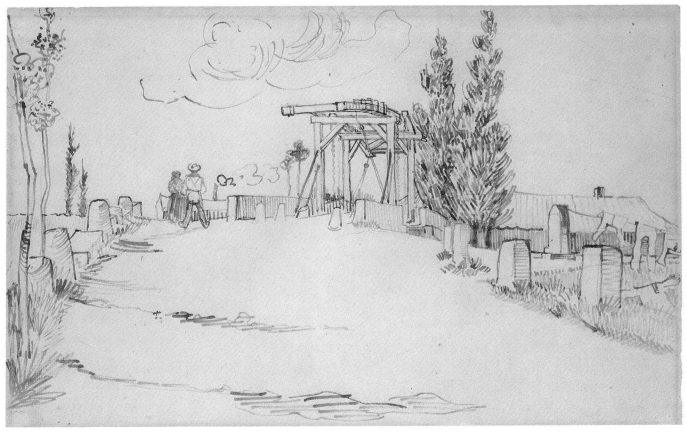

25

untouched paper predominates, especially in the wide, receding expanse of the road. Plotted and painstaking though the process may have been, the result is surprisingly free and improvisatory—in the shadows on the road, the puffs of smoke, the clouds (a late addition, with the two figures), and the wash hung out to dry at right, one garment on the grass.

26. View of Arles with Irises in the Foreground

Pen, reed pen and brown ink, 17⅛ × 21⅞ in.
 (43.5 × 55.5 cm.)
Inscribed and signed, lower left: Vue d'Arles / Vincent
Museum of Art, Rhode Island School of Design, Providence
 Gift of Mrs. Murray S. Danforth

F1416 JH1415

Van Gogh did not describe this drawing, or mention sending it to Theo. This is all the stranger since there is a closely related painting (cat. 27) that he described and sketched in a letter to Theo of 12 May, in which he wrote of having had "some difficulty getting the composition" (LT487).

For the drawing, van Gogh stood by a ditch with irises and took in a meadow of buttercups, a row of willows, fields, orchards, and, in the distance, the rooftops and towers of Arles. His compositional difficulties must' have been connected with the foreground field, which is rectangular, though its right-angle turn—after the third willow on the left—is scarcely indicated. Perhaps he was worried by this ambiguity, or by the thrust of the wedge of space toward the viewer, or by having to relate the intervals of middle ground to the town's silhouette.

Fig. 18. *Drawbridge at Arles* (F1416v). Graphite on paper, 17⅛ × 21⅞ in. (43.5 × 55.5 cm.). Museum of Art, Rhode Island School of Design, Providence. Gift of Mrs. Murray S. Danforth

Whatever the problems, he nevertheless carefully plotted the space through the perspective frame (the pencil grid is still visible on the drawing). The interplay between surface and depth is given an added dimension by the expressive variety of graphic means. In particular the dots, imitating buttercups and grass, begin to take on an abstract and rhythmic quality of their own.

The spring season seems slightly less advanced in the drawing; and the cutting of the meadow has not progressed so far as in the painting. The drawing, then, was produced first, as an independent study, and inscribed "Vue d'Arles."

On the verso of the sheet is a carefully executed drawing of a drawbridge (fig. 18).

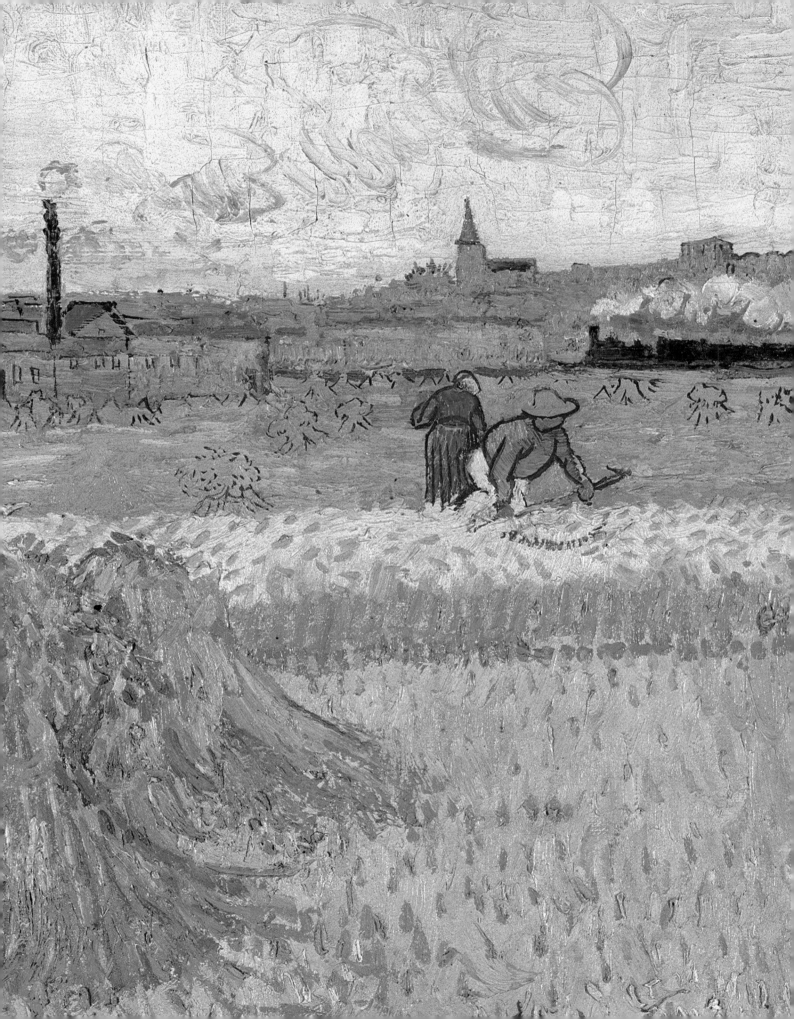

Tuesday 8 May
Pays bill at the Hôtel-Restaurant Carrel to regain possession of his belongings. Submits a complaint to the magistrate.

Buys two chairs and a table and "things for making a little coffee and soup at home."

Theo will visit Claude Monet (1840–1926) to look at his recent paintings of Antibes.

Thursday 10 May
Sends off a case of paintings by freight train to Theo.

Saturday 12 May
Goes with Carrel to the magistrate and gets 12 francs refunded.

Begins painting again after a break of over two weeks. Two landscape studies completed, *View of Arles with Irises in the Foreground* (cat. 27), and *Farmhouse in the Wheat Field* (cat. 16, fig. 15), probably begun 10 May.

Mid-May
Two more landscapes completed, *The Langlois Bridge* (cat. 28) and *Side of a High Road* (F567).

Health much improved, which he partly attributes to eating in a better restaurant, run by Madame Venissac at 28 Place Lamartine, close to the Café de la Gare at No. 30, where he has his lodgings.

Sunday 20 May
Finishes two still lifes (cat. 29; F600), the first one clearly celebrating his recent purchase of a coffeepot and crockery.

Reads a book on the Marquesas Islands, which he discusses at length in a letter to Bernard.

Receives a letter from Theo, whose health is causing concern: a Dr. Gruby has diagnosed heart trouble.

Theo suggests that he send some new drawings to the forthcoming exhibition of the Dutch Etching Society in Amsterdam.

Tuesday 22 May
Mourier-Petersen leaves Arles for Paris, taking two small pictures and two pen drawings to Theo. Van Gogh suggests that Mourier-Petersen might like to stay with his brother in Paris and also gives him an introduction to Russell.

Gauguin writes Theo a distraught letter from Pont-Aven.

Wednesday 23–Friday 25 May
Responding to Theo's suggestion, van Gogh produces some new pen drawings (cat. 30–32), his first at the Abbey of Montmajour, situated on a large rocky outcrop in the plain of the Crau, some three miles northeast of Arles. Completes five drawings, all views from Montmajour.

Saturday 26 May
Works again at Montmajour.

Sends two drawings of the abbey ruins (F1417; cat 56, fig. 32) to Theo with the other five. Encloses an order for paints. In the meantime, continues to draw.

Sunday 27 May
Arranges to have the Yellow House repainted, both inside and out; will have to pay 10 francs as his share.

Day of glorious sun and no wind. Probably does a large drawing of a view of Arles from Montmajour (cat. 33).

Monday 28 May
Day of gale and rain, which enables him to relax and write letters.

Important letter from Theo, with 100 francs enclosed: has received the case of paintings and the seven drawings of Montmajour; has visited Monet's studio and seen the Antibes paintings; and has invited two of their sisters, Lies (Elisabeth Huberta van Gogh, 1859–1936) and Wil, to come to Paris, since Koning will be leaving for Holland before the end of the week. More surprisingly, Boussod & Valadon has proposed to send Theo on a series of short journeys to New York, where a branch was opened in October 1887.

Already concerned about Theo's health, and therefore about the exhaustion these journeys might cause, van Gogh asks in his ten-page reply, "Would you like me to go to America with you?" He advises Theo to make albums of his drawings, like those made by Japanese artists; says his health, especially his digestion, has greatly improved in the past month; and hopes to visit Saintes-Maries-de-la-Mer and see the Mediterranean at last.

Later in the day he writes again, responding to Theo's wish to alleviate Gauguin's dire financial predicament. He also encloses a draft letter to Gauguin for Theo's approval, outlining the first proposal for Gauguin to come to Arles. Problems include cost of journey, payment of Gauguin's debts in Brittany, purchase of two beds, fixing of monthly allowance (van Gogh suggests 250 francs), with Gauguin providing Theo with one picture a month.

Finally, he writes to Gauguin: talks only about work and regrets that they are so far apart.

Tuesday 29 May
Sends Theo his large drawing *View of Arles from Montmajour* (cat. 33). Encloses a line of farewell to Koning. Writes to both Koning and Theo: "Early tomorrow I start for Saintes-Maries," adding to his brother, "I shall stay there until Saturday evening."

Wednesday 30 May
Leaves at 7 A.M. by diligence for Saintes-Maries, a five-hour journey across the Camargue.

Koning leaves Theo's apartment, where he has been staying since March, to return to Holland, taking van Gogh's letter of 29 May with him.

Wednesday 30 May–Sunday 3 June
Spends three days in Saintes-Maries before writing to Theo on Saturday 2 June. Decides to stay on an extra day to do more drawings, and leaves Sunday afternoon, having spent five days there. (When he reports his visit in letters to Russell, Bernard, and his sister Wil, he calls it "a week.")

Does three paintings—two seascapes and a view of the village—and eight drawings (see cat. 34–39).

Plans to return to Saintes-Maries as soon as possible.

Hopes to visit Tarascon the following week "to do two or three studies."

Monday 4 June
Letter from Theo, with 50 francs enclosed. (It may have arrived Sunday.)

Mourier-Petersen staying with Theo after Koning's departure.

Pays month's rent of 15 francs, and arranges to have the house painted this week.

Upon return, immediately begins the painting *Fishing Boats on the Beach* (cat. 37, fig. 24), based largely on the drawing done on the spot early on Sunday morning (cat. 37).

Sends Theo roll of Saintes-Maries drawings, but keeps three drawings of cottages for later paintings.

Tuesday 5 June
Works on two paintings of cottages in Saintes-Maries (cat. 41, 42) based on two drawings (cat. 38, 36).

Writes to Theo, enclosing a second letter for Gauguin.

Reading a book on the composer Richard Wagner.

Asks Theo to send money by Sunday 10 June: "If you send me your next letter Sunday *morning*, it is probable that I'll skip off again that day at 1 P.M. to Saintes-Maries to spend the week there."

Thursday 7–Friday 8 June
One-day visit to Tarascon. "Unfortunately, there was such a blazing sun and so much dust that I came back with an empty bag."

Letter from Gauguin, replying to his of 28 May.

Saturday 9 June
Replies to Gauguin's letter.

Working on some new drawings, two of them heightened with watercolor washes (F1425, F1483), and two or three painted studies (see cat. 44, 45).

Sunday 10 June
Expects 50 francs from Theo for a second trip to Saintes-Maries. In any case, payments for rent (15 francs), for the painting of the house (10 francs), and for other necessities make trip impossible. Instead, probably begins work on first size 30 canvas (28¾ × 36¼ in.), *The Harvest*, as he always called it, or *Blue Cart* (cat. 65, fig. 36).

Monday 11 June
Receives Theo's telegraph order for 50 francs. Buys fairly big stock of canvases.

Tuesday 12 June
Only 20 francs left from yesterday's order.

Theo, fully occupied with preparations for a Monet exhibition at his Paris gallery, has not written since 2 or 3 June. Van Gogh, also busy, has not written for a week.

Tells Theo of his exchange of letters with Gauguin, from which he learned that Theo had sent Gauguin 50 francs; and of MacKnight's visit to Marseilles, where he had seen two paintings by Monticelli.

Wednesday 13 June
Working on another harvest picture, "a farm and some ricks [cat. 75, fig. 39], which will probably be a pendant [to *The Harvest (Blue Cart)*, cat. 65, fig. 36]." "Everywhere now there is old gold, bronze, copper, one might say, and this with the green azure of the sky blanched with heat."

Friday 15 June
Theo writes after a fortnight's silence. His Monet exhibition of ten paintings of Antibes has opened. Visitors have included Tersteeg (who had not taken to Impressionism) and Maupassant (whose first book, *Des Vers*, 1880, van Gogh had just read). He encloses Gauguin's answer to the more definite proposal that the two brothers had concocted.

Sends Theo a third draft letter for Gauguin, and posts three drawings to Theo (F1425, F1483; cat. 43). Writes of his *Harvest (Blue Cart)* (cat. 65, fig. 36): "It kills everything else I have, except a still life, which I patiently worked out [cat. 29]. MacKnight and one of his friends who has also been in Africa saw it today, this study, and said it was the best I had done." MacKnight's friend is almost certainly the Belgian artist Eugène Boch (1855–1941); this is his first recorded meeting with van Gogh.

About this time, has his hair and beard shaved off.

Saturday 16 June
Gives Theo a remarkably synthetic and programmatic account of his "series paintings." First, the orchards (white and pink); then, the wheat fields (yellow); more seascapes (blue); and finally, the vineyards and autumn, which together "will give the whole scale of the lyre."

Probably paints *La Roubine du Roi with Washerwomen* (cat. 50), an evening view.

Reads Pierre Loti's *Madame Chrysanthème* (1887), "which contains interesting observations on Japan."

Sunday 17 June
Almost certainly writes a letter to Russell (cat. 151), with a sketch of *The Sower*

(cat. 49) and of *The Mudlark* (cat. 51), depicting a figure he had observed that afternoon when painting *The Trinquetaille Bridge* (cat. 71, fig. 38).

Monday 18 June
Probable date of letter to Bernard that includes sketches of *The Sower* (cat. 49) and *Summer Evening* (cat. 69, fig. 37), painted as a direct challenge to the raging mistral. Tells Bernard he is giving drawing lessons—with his perspective frame—to "a second lieutenant of the Zouaves here, called Milliet."

Wednesday 20 June
A sudden storm brings harvesting to an abrupt halt. The rain does not stop until Saturday; after more than a week of continual work in the wheat fields, is forced to remain in his studio. During the next three or four days, works on a drawing and two paintings of a Zouave (see cat. 52, 53).

Thursday 21 June
Thanks Theo for sending a copy of Gustave Geffroy's review in *La Justice*, 17 June, of the exhibition of Monet's Antibes landscapes.

Describes his week's "hard, close work among the cornfields in the full sun," particularly on *The Sower* (cat. 49); also tells of his sittings with the Zouave and of "the torrential rain of these last two days."

Friday 22 June
Rain—and the coldest day of the month. The Zouave sits for him in his studio.

Saturday 23 June
Still raining. Writes to Theo in the morning, and sends him a drawing of the Zouave (cat. 52).

Writes to Bernard in the evening, saying how "beat" he is "after drawing and painting from a model—a Zouave—for three or four days."

Sunday 24 June
Writes another letter to Bernard. Spends the morning in the fields; another harvest picture is completed, making seven studies of wheat fields.

Monday 25–Tuesday 26 June
Spends these two days completely reworking *The Sower* (cat. 49).

Friday 29 June
Overjoyed at news from Theo that Gauguin has agreed to their proposal to come to Arles. Writes a reply to Gauguin (but sends it to Theo). Also writes to Russell to urge him to make an exchange of paintings.

Has been retouching "all my canvases a bit before sending them to you"—probably over the past two or three days.

Hopes to spend two or three days in the Camargue to make some drawings.

Saturday 30 June
Does not go to the Camargue because the veterinary surgeon who was to have taken him let him down: "I don't much care, as I have only a moderate affection for wild bulls."

Probably continues retouching his canvases.

Sunday 1–Monday 2 July
Probably paints "a corner of a garden with clipped shrubs and a weeping tree" (cat. 60), his first picture of one of the three gardens in the Place Lamartine.

Wednesday 4 July
Watches a sunset from a stony heath, with Montmajour in the background, and brings back a study of it (cat. 59).

Reading Honoré de Balzac's *César Birotteau* (1837): "I think I shall read the whole of Balzac again."

Thursday 5 July
Probably begins a large painting of Christ in Gethsemane. Writes to Theo, somewhat dejected—by his failure to make friends, or interest art lovers, in Arles; by a sense of loneliness ("Often whole days pass without my speaking to anyone, except to ask for dinner or coffee"); and by the belief that even Marseilles, hitherto his artistic mecca, "may be nothing but an illusion."

Friday 6–Saturday 7 July
Again visits Montmajour and does two large pen drawings, with the intention of eventually producing six (see cat. 54–58). Probably about this time, scrapes off his painting of Christ in Gethsemane because he feels he must not depict such important figures without models.

Sunday 8 July
Letter from Theo, enclosing 50 francs, full of news from Paris: Père Tanguy claims that van Gogh owes him 80 francs for paints and canvas. (Van Gogh denies this: "The *only* money I really owe is to Bing [Samuel Bing, a dealer in Paris specializing in Japanese prints], in that I still have 90 francs' worth of Japanese stuff on commission.") The Impressionist painter Armand Guillaumin (1841–1927) has seen and liked van Gogh's recent paintings; the art dealer Georges Thomas has bought Louis Anquetin's (1861–1932) *The Peas-*

ant for 100 francs; Theo has asked whether he could be persuaded to do the same for van Gogh and Gauguin. Theo also sends the 7 July number of *Paris Illustré* with four illustrations by Toulouse-Lautrec.

Attempts to visit Boch and MacKnight at Fontvieille, but finds they have gone on a week's trip to Switzerland.

Monday 9 July
Spends the day at Montmajour with the Zouave Milliet: "We explored the old garden together, and stole some excellent figs." Makes a third large drawing (cat. 56), but not of the garden.

Writes to Russell (who has not replied to his letter of 29 June), again proposing an exchange of paintings. Also hopes to persuade Russell to buy a Gauguin painting.

Looking to Gauguin's arrival, employs "a charwoman now for 1 franc, who sweeps and scrubs the house for me twice a week."

Friday 13 July
Sends off by post a roll containing five large pen drawings of Montmajour (cat. 54–58). Hopes the Paris dealer Thomas will buy two of them at 100 francs each to help finance Gauguin's journey to Arles.

Despite being devoured by mosquitoes and having to struggle against "the nagging malice of the constant mistral," has spent "whole days outside with a little bread and milk, since it was too far to go back to the town."

Probably writes to Gauguin.

Sunday 15 July
Day of drawing in the studio and writing letters.

Letter from Theo enclosing 100 francs: says he will settle Bing's bill of 90 francs; van Gogh returns 50 francs to Theo.

Begins working on six drawings after his paintings to send to Bernard as an exchange (see cat. 62).

Writes to Bernard that Gauguin (who has been very ill) will probably spend next winter in Arles; sends the six drawings and promises more.

Writes to Theo again in the evening. Talks of Japanese prints, Bing, Bernard, General Georges Boulanger, and Victor Hugo's *L'Année terrible* (1872), which he has just read.

Tuesday 17 July
Sends Bernard nine more drawings after painted studies—"sketches of Provence," which may remind him of Paul Cézanne (1839–1906).

Thursday 19 July
Letter from Theo, with news of the failing health of their father's brother, Uncle Vincent (Vincent van Gogh, 1820–1888). In his reply, tells Theo he has taken some thirty paintings off their stretchers to be nailed up on the studio wall to dry thoroughly. Sends a "rather heavy" order for paints and canvas.

Completes a new pen drawing of a garden full of flowers (cat. 61, fig. 35), and two painted studies of the same garden (cat. 61; F429).

No reply from Russell, who has left Paris for Belle Ile, an island off the coast of Brittany, where he is building a house.

No letter recently from Gauguin.

MacKnight and Boch, having returned from Switzerland, visit: "Still a frosty silence about my work when they come."

Saturday 21 July
MacKnight "broke his silence a little by saying that he liked my last two studies (the garden of flowers) very much, and talked about them for a very long time [cat. 61; F429]."

Sunday 22 July
Letter from Theo, with 50 francs enclosed.

Probably visits Fontvieille and sees Boch's paintings for the first time. "The village where they are staying is *real Millet*, poor peasants and nothing else, absolutely *rustic* and homely."

Monday 23 July
Bernard sends ten drawings in exchange for the fifteen sent to him.

Tuesday 24 July
Letter from Russell, written from Belle Ile on 22 July, answering van Gogh's letters of 29 June and 9 July: he is unable to buy a painting by Gauguin.

Wednesday 25 July
Has painted *La Mousmé* (cat. 91, fig. 41): "a *mousmé* is a Japanese girl—Provençal in this case—twelve to fourteen years old"; it has taken him a whole week; has been ill, otherwise would have done some landscapes as well.

Thursday 26 July
Letter from Gauguin, replying to van Gogh's of about 13 July. "Fortunately he has recovered his health," writes van Gogh when he sends letter on to Theo.

Probably replies to Gauguin, enclosing a drawing done after his recently completed *Mousmé* (cat. 91, fig. 41), which Gauguin later pastes into his manuscript of *Noa Noa* (Musée du Louvre, Paris).

Saturday 28 July
Uncle Vincent dies at Prinsenhage, near Breda, in Holland. The former art dealer had directed van Gogh's early years as an apprentice at Goupil & Cie in The Hague, London, and Paris from 1869 to 1876. Long estranged from van Gogh, he became more interested in Theo and was likely to leave him a legacy.

First intimation that he has met Joseph Roulin (1841–1903), who handles mail at the railroad station. "A big bearded face, very like Socrates. A violent republican like Tanguy. A man more interesting than most."

Probably begins work on his first portrait of Roulin (cat. 87).

Monday 30 July
Works on portrait of Roulin.

MacKnight again visits the studio; likes *La Mousmé* (cat. 91, fig. 41), and says once more that he likes the *Flowering Garden* (cat. 61).

Tuesday 31 July
Birth of Roulin's daughter, Marcelle.

Letter from Wil announcing the death of Uncle Vincent.

Has completed eight of the twelve drawings planned for Russell.

Wednesday 1–Friday 3 August
Almost certainly finishes the four remaining drawings for Russell, and sends off the dozen to Belle Ile. Among these drawings after painted studies is a head of Roulin (cat. 89) taken after the life-size head he has just completed (cat. 88).

Probably writes to Koning.

Unable to pay rent because Roulin, who would not accept payment for posing, "cost[s] *more* eating and drinking." Gives Roulin a copy of Henri Rochefort's *La Lanterne* (1868).

Theo in Holland for Uncle Vincent's funeral.

Monday 6 August
Engaged in making drawings for Theo; intends to complete a dozen, with practically the same motifs as those just sent off to Russell.

Writes to Theo: "Today I am probably going to start on the interior of the café where I stay, by gas-lighting, in the evening."

Wednesday 8 August
Sends Theo three large drawings of gardens (cat. 61, fig. 35; cat. 85; F1456), and five small drawings after painted studies (see cat. 82–84; F1430b, F1431).

Recently made a "very interesting round of the farms with someone who knows the country."

MacKnight visiting regularly.

Reworks a portrait of the Zouave (cat. 52, fig. 31).

Thursday 9 August
Probably begins painting first portrait of Patience Escalier (F443), a peasant from the Camargue.

Saturday 11 August
Continues work on the *Portrait of Patience Escalier*. Sends a large drawing after it to Theo (F1460), together with another large drawing (cat. 92) after the *Portrait of Joseph Roulin* (cat. 87).

Monday 13 August
Letter from Theo, who has been left a legacy by Uncle Vincent.

Writes to Theo: has recently finished four small landscapes (F445–F447; and one now lost), and has given Milliet lessons in drawing.

Spends evening with Milliet, who will shortly take a roll of his canvases to Theo in Paris.

Tuesday 14 August
Works on the painting *Quay with Men Unloading Sand Barges* (F449). Also makes a drawing of the same motif (F1462).

Recently thinking of joining Gauguin in Pont-Aven if he will not come to Arles; must decide soon.

Wednesday 15 August
Telegram to Theo saying Milliet will arrive Friday morning with a roll of canvases.

Wil arrives in Paris to stay with Theo.

Friday 17 August
Milliet delivers thirty-six paintings to Theo.

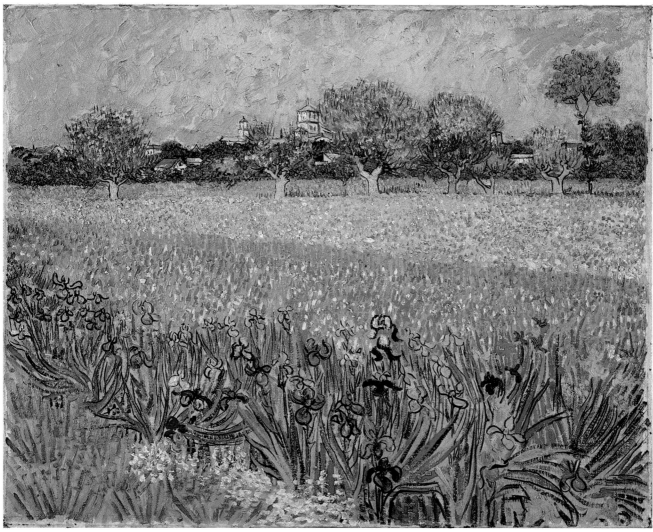

27

27. View of Arles with Irises in the Foreground

Oil on canvas, 21¼ × 25⅝ in. (54 × 65 cm.)
Unsigned
Rijksmuseum Vincent van Gogh, Amsterdam

F409 H442 SG28 JH1416

Van Gogh had done no painting since the last of the
orchards (cat. 13), which was probably completed by
20 April; his decision to do a series of drawings (see
cat. 14–26), his dispute with Carrel, his move to a new
hotel, his renting of the Yellow House, his attempts to
buy furniture, and the preparation of his first batch of
paintings to send to Theo in Paris left little time.

It was not until 12 May that he announced to Theo:
"Just now I have done two new studies like these: you
have a drawing of one of them already, a farm by the

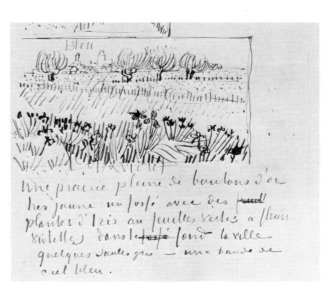

Fig. 19. Sketch of *View of Arles with Irises in the Foreground* (LT487).
Rijksmuseum Vincent van Gogh, Amsterdam

high road among cornfields. A meadow full of very yellow buttercups, a ditch with irises, green leaves and purple flowers, the town in the background, some gray willows, and a strip of blue sky. If the meadow does not get mowed, I'd like to do this study again, for the subject was very beautiful, and I had some difficulty getting the composition. A little town surrounded by fields all covered with yellow and purple flowers; exactly—can't you see it?—like a Japanese dream" (LT487).

And a few days later, he wrote to Emile Bernard of this "view of Arles. Of the town itself one sees only some red roofs and a tower, the rest is hidden by the green foliage of fig trees, far away in the background, and a narrow strip of blue sky above it. The town is surrounded by immense meadows all abloom with countless buttercups—a sea of yellow—in the foreground these meadows are divided by a ditch full of violet irises. They were mowing the grass while I was painting, so it is only a study and not the finished picture that I had intended to do. But what a subject, eh! That sea of yellow with a band of violet irises, and in the background that coquettish little town of the pretty women!" (B5).

This "view of Arles" is taken from south of the town, which is confirmed by the positions of the Homme de Bronze and the tower of Saint-Trophime. Van Gogh included a sketch of the painting in his letter to Theo (fig. 19), but he made no mention of the related draw-ing (cat. 26). It would seem to be another instance of two independent confrontations with the same motif. The painting has some yellow-violet complementary contrast, with a subsidiary orange-blue in the roofs and sky. The compositional difficulties van Gogh referred to in his letter to Theo may have been connected to his continued use of the perspective frame, and to the right-angled turn of the ditch and field in the center of the composition: the willows appear to be in alignment, but in fact they follow the turn in the field (after the third tree from the left).

As always, van Gogh made the vital distinction between a study and a finished picture.

28. The Langlois Bridge

Oil on canvas, 19½ × 25¼ in. (49.5 × 64 cm.)
Unsigned
Wallraf-Richartz-Museum, Cologne

F570 H588 SG31 JH1421

Van Gogh produced four landscapes in the period from 10 to 20 May. They were the first paintings he had produced in almost three weeks. He chose familiar motifs: two were to the north of Arles on the "road to Tarascon" (cat. 16, fig. 15; F567), and the other two were to the south and the southeast (cat. 27, and the

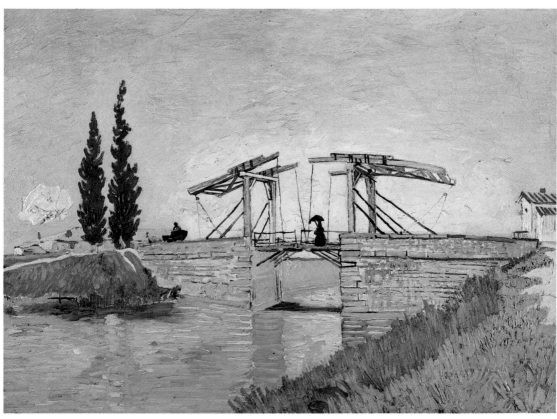

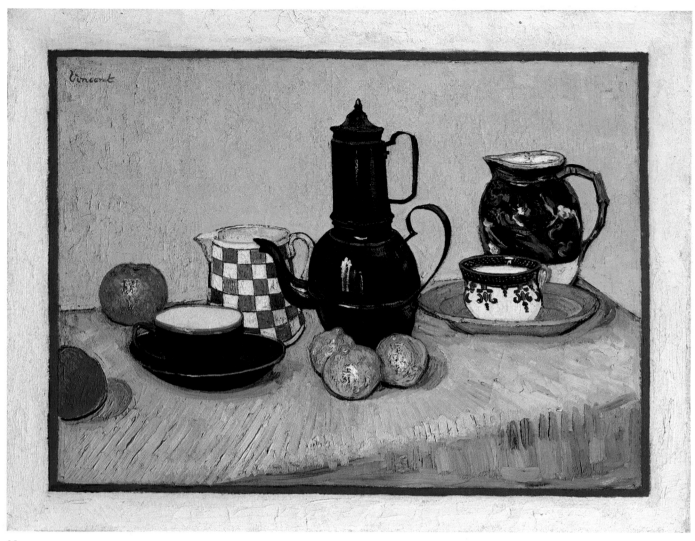

29

present canvas). Of the motifs, none was so familiar as the so-called Langlois Bridge, which he had already painted and drawn several times (see cat. 24, 25).

In early April, he described one of these drawbridge pictures as "an odd thing, not like what I generally do" (LT473). A curious statement, since it is always said that van Gogh painted these drawbridges because they reminded him of Holland.

In the present canvas, he added contrasting types: a washerwoman, an Arlésienne with a parasol, and a farmer in a carriage. The motif is extremely close to the drawing (cat. 24) but is not dependent upon it, since the drawing had already been sent to Theo. These were, as so often, separate sightings of the same motif.

Van Gogh called the bridge the Pont "Langlais," which has been corrected to the Pont Langlois, after the name of the keeper. Its real name, however, was the Pont de Réginelle (or Réginal). It was situated on the Arles–Bouc Canal, on the south side of the town.

29. Still Life with Coffeepot

Oil on canvas, 25⅝ × 31⅞ in. (65 × 81 cm.);
 inside brick-red frame, 20⅞ × 27⅛ in.
Signed, upper left: Vincent
Private collection, Lausanne

F410 HIX SG32 JH1426

About 20 May, van Gogh reported to Theo: "I have done two still lifes this week. A blue enamel coffeepot, a cup (on the left), royal blue and gold, a milk jug in squares of pale blue and white, a cup—on the right—of white with a blue and orange pattern, on an earthen tray of grayish yellow, a jug in earthenware or majolica, blue with a pattern in reds, greens and browns, and lastly two oranges and three lemons; the table is covered with a blue cloth, the background is greenish yellow, so that there are six different blues and four or five yellows and oranges. The other still life is the majolica pot with

Fig. 20. Sketch of *Still Life with Coffeepot* (LT489). Rijksmuseum Vincent van Gogh, Amsterdam

Fig. 21. Sketch of *Still Life with Coffeepot* (B6). Present location unknown

wildflowers [F600]" (LT489).

And to Bernard: "I have done a still life of a blue enameled iron coffeepot, a royal blue cup and saucer, a milk jug with pale cobalt and white checks, a cup with orange and blue patterns on a white ground, a blue majolica jug decorated with green, brown and pink flowers and leaves. The whole on a blue tablecloth, against a yellow background, and among this crockery two oranges and three lemons. So it is a variation of blues, livened up by a series of yellows that go as far as orange" (B5).

He included sketches in both of the letters (fig. 20, 21). What he did not illustrate in either of them is the 4¾ inch (12 cm.) expanse of white that surrounds the slim brick red enframement of the still-life motif. This is unique in his work, and clearly was planned with care. It is one of van Gogh's most considered canvases, one on which he worked for a week. Like many of the Paris flower pieces it is a color exercise, though no other is painted with such a degree of finish.

It is also a celebration of possession. For this coffeepot and these cups, saucers, and jugs were recent purchases, made for the Yellow House, affirmations of van Gogh's partial release from hotel owners. Here he rejoices in the simplicity of his kitchen table: the coffeepot and cups from *The Potato Eaters* (F82) have been transposed into a silent, unpeopled interior and become vessels of an almost religious, ritualistic presence.

In mid-July, when he was painting *The Harvest (Blue Cart)* (cat. 65, fig. 36), he told how that landscape "absolutely kills all the others; there is only one other that can hold its own next to it—a still life, with coffeepots and cups and plates in blue and yellow. It is something quite apart" (LT497).

Montmajour: The First Series of Drawings

"I have been for several walks in the country hereabouts but it is quite impossible to do anything in this wind," wrote van Gogh in early March. "The sky is a hard blue with a great bright sun which has melted almost all the snow, but the wind is cold and so dry that it gives you gooseflesh. But all the same I have seen lots of beautiful things—a ruined abbey on a hill covered with holly, pines, and gray olives. We'll have a try at that soon, I hope" (LT467).

Nothing more is said of the "ruined abbey on a hill" until the end of May. Then, on 26 May, he reported: "Today I again sent you some drawings, and I am adding another two. These are views taken from a rocky hill-slope, from which you see the country toward Crau (very good wine comes from there), the town of Arles and the country toward Fontvieille. The contrast between the wild and romantic foreground and the distant perspective, wide and still, with horizontal lines sloping into the chain of the Alpines...is very picturesque. The two belated drawings that I am adding now will give you an idea of the ruin that crowns the rocks" (LT490).

A long description; yet it still does not actually name the ruin. This was the Abbey of Montmajour, which rises dramatically from the plain of the Crau, some three miles northeast of Arles. Nor does it indicate how many drawings van Gogh sent. But a compact and stylistically cohesive corpus of seven drawings exists. Five of them are views looking out from the rock (cat. 30–32; F1448, F1493), and the other two are views of the ruin itself (F1417; cat. 56, fig. 32). All seven are on half-size paper (usually 11¾ × 18½ in., and watermarked AL. PL Bas), even when a vertical format is used. Six of the drawings are inscribed with a title ("Vue d'Arles" or "Vue de la Crau"), and the seventh is signed. All have a pencil underdrawing, which forms the armature, but which in several instances has been altered in the working over with the reed pen.

Van Gogh used a violet ink, though the color has faded through exposure to light. The only vestiges of color that remain are at the edges of those drawings that have been covered by mounts. Such vestiges are still very apparent on three sheets in the Rijksmuseum Vincent van Gogh, Amsterdam. Here the ink has faded, in parts to a ghostlike veil, where even the inscriptions are barely decipherable. The ruin on the hill has transferred its metaphor of a noble sense of decay, yet of contained power, to the drawings that van Gogh produced there.

This group of seven drawings of Montmajour was clearly meant as a series, but it was not self-generated, inspired solely by the scene itself. What really sparked them off was a letter from Theo inviting van Gogh to send some drawings to the second exhibition of the Dutch Etching Society, due to open in Amsterdam in mid-June. Van Gogh responded about 19 or 20 May: "Look here, I will do my best to send you some new drawings for Dordrecht" (LT489). (For some unaccountable reason, he always referred to the venue as Dordrecht.) A week later—on 26 May—when posting the drawings to Theo, he added, "But is it worth

the trouble to make frames for this Dordrecht exhibition? It seems idiotic to me, and I would rather not be in it" (LT490).

This, apparently, was sufficient to dissuade Theo from sending any of the drawings to the exhibition. This was a pity, since he had been invited to help select works by French artists, and eventually lent from his own collection a café-concert drawing by Georges Seurat, wood engravings by Lucien Pissarro, and etchings by Jean-Louis Forain and Jean-François Raffaëlli. In addition, his gallery, Boussod & Valadon, lent several works, including a drawing by Edgar Degas. Van Gogh would have been in good company. When, a little later, his sister Wil asked about the exhibition, he retorted: "You ask whether I sent something to the 'Arti' Exhibition—certainly not!" (W4). (The exhibition of the Dutch Etching Society was held on the premises of Arti et Amicitiae, a painters' association in Amsterdam.)

Nonetheless, van Gogh had begun these drawings enthusiastically, with the notion of doing them for Theo and the Amsterdam exhibition. He unified the series by choosing Montmajour as his focus, and apparently he selected a medieval ruin, a "wild," "romantic" foreground, and a "picturesque" panorama because he thought they would be motifs acceptable to a potential Dutch public.

Not everyone, however, was convinced by his logic. Christian Vilhelm Mourier-Petersen, for example, found the views boring and inartistic. Significantly, Mourier-Petersen left Arles on Tuesday 22 May, and the seven drawings were completed within the week of 20–26 May. It is clearly impossible to say how many days van Gogh spent at Montmajour, and difficult to propose a sequence for the drawings. What is certain is that the five views of the Crau preceded the two drawings of the abbey itself.

After van Gogh dispatched the seven drawings to Theo, he returned to Montmajour, sometime between 27 and 29 May. There he executed his first large drawing on full-size Whatman paper (cat. 33), which, in turn, he sent to Theo. It prefigures the second series of Montmajour drawings (cat. 54–58).

30

30. View of La Crau

Pencil, pen, reed pen and ink, 12½ × 18¾ in.
(30.9 × 47.7 cm.)
Inscribed, lower left: Vue de la Crau
Museum Folkwang, Essen

F1419 JH1430

This view of the Crau is taken from Montmajour, look-
ing east-southeast. It takes in the whole of the Mont
de Cordes; in the right distance is Barbegal, and at the
left the view is toward the village of Fontvieille, where
the American artist Dodge MacKnight stayed from April
to August 1888.

The Crau, flat, stony, and formerly covered with
marshland, was cultivated in the nineteenth century,
especially for the planting of vineyards. The contrast-
ing shapes and textures of the fields are conveyed
schematically, and without a prevalent use of the dot.

Part of the view overlaps that of the following draw-
ing (cat. 31), and the right half of the composition
reappears—seen from a different angle—in the large
drawing of the Crau made in July (cat. 57). There,
however, van Gogh reduced the obtrusive outcrop at
his feet by moving closer to its edge.

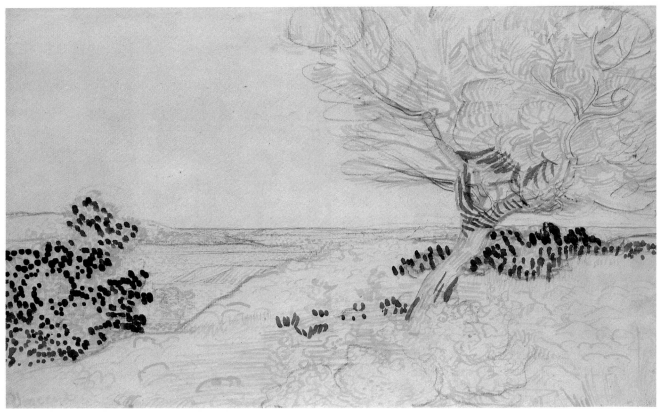

31

31. View of La Crau

Pencil, reed pen and ink, 12¼ × 18⅞ in. (31 × 48 cm.)
Watermark: AL
Signed, lower left: Vincent
Private collection, New York

F1418 JH1431

This view of the Crau is taken from Montmajour, look-ing southeast. It partly overlaps the view in the previous drawing (cat. 30): the Mont de Cordes is visible, as is Barbegal. In choosing his vantage point, van Gogh had to decide what relationship would be established be-tween the foreground outcrop and the distant panorama. In this instance, he kept the horizon low and intro-duced much sky, against which he silhouetted a large tree, as if it were the last of the flowering orchards.

The composition, with enlarged foreground and diminished middle distance and background, offers a dramatic contrast to the later drawing of the Crau (cat. 57). There van Gogh reduces much of the foreground impediment, dispenses with trees as *repoussoirs*, and in-creases the panoramic effect, not least by considerably heightening the horizon line, so that the sky, instead of occupying half the sheet as it does in the present draw-ing, takes up less than a quarter of it.

Two days after sending this drawing to Theo (with the six others of Montmajour), van Gogh wrote: "You know what you must do with these drawings—make sketchbooks with six or ten or twelve like those books of original Japanese drawings. *I very much want* to make such a book for Gauguin, and one for Bernard. For the drawings are going to be better than these" (LT492). He included with the letter a sketch of the projected album (fig. 22).

Fig. 22. Sketch of a projected album (LT492). Rijksmuseum Vincent van Gogh, Amsterdam

32. View of Arles

Pencil, reed pen and ink, 18½ × 12⅛ in.
 (47 × 30.7 cm.)
Watermark: AL
Inscribed, lower left: Vue d'Arles
Museum Boymans-van Beuningen, Rotterdam

F1475 JH1435

Had van Gogh agreed to let Theo send this drawing to the exhibition of the Etchers Society in Amsterdam, a Dutch audience, familiar with seventeenth-century Dutch landscape conventions, might well have approved of this distant prospect of Arles. However, it is unlikely that a Dutch seventeenth-century landscape artist would have allowed a sequence of rocky outcrops dotted with trees and bushes to occupy so much of the composition, leaving the prospect rather too distant.

This same view of Arles is clearer and more panoramic in a large drawing (cat. 33) that van Gogh made shortly after he had sent the present one to Theo.

33. View of Arles from Montmajour

Pencil, reed pen, quill pen and ink on Whatman paper,
 19⅛ × 23⅝ in. (48.6 × 60 cm.)
Watermark: J. Whatman Turkey Mill 1879
Signed, lower left: Vincent
Nasjonalgalleriet, Oslo

F1452 JH1437

In a letter of 29 May to the Dutch artist Arnold Hendrick Koning (1860–1944), who was staying with Theo in Paris, van Gogh described this drawing in some detail: "Tomorrow I am going to Saintes-Maries on the seacoast.... I have just finished a drawing, even larger than the first two [sent with LT478], of a cluster of straight pines on a rock, seen from the top of a hill. Behind this foreground a perspective of meadows, a road with poplars, and in the far distance the town. The trees very dark against the sunlit meadow;... I did them with very thick reeds on thin Whatman paper, and in the background I worked with a quill for the finer strokes. I can recommend this method to you, for the quill strokes are more in character than those of the reed" (LT498a). What he did not mention was that he began the drawing in pencil to establish the composition.

This drawing is the last van Gogh did in Arles before he left for Saintes-Maries on 30 May. He sent it to Theo on 29 May and wrote: "If the roll is not too big to be accepted by the post office, you will receive another big pen drawing, which I would very much like the Pissarros to see if they come on Sunday" (LT495). Hence, it was fresh in Theo's mind when on 2 June van Gogh described another large drawing (F1439) that he

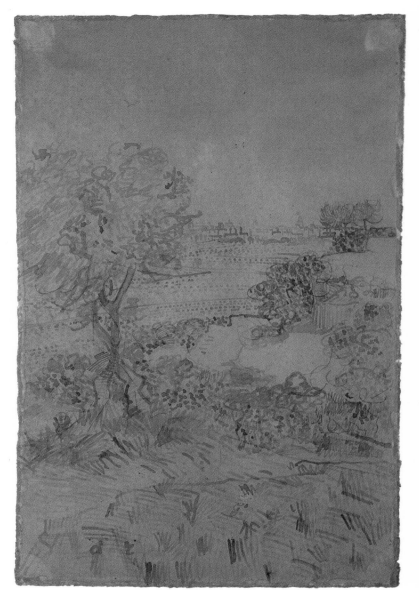

32

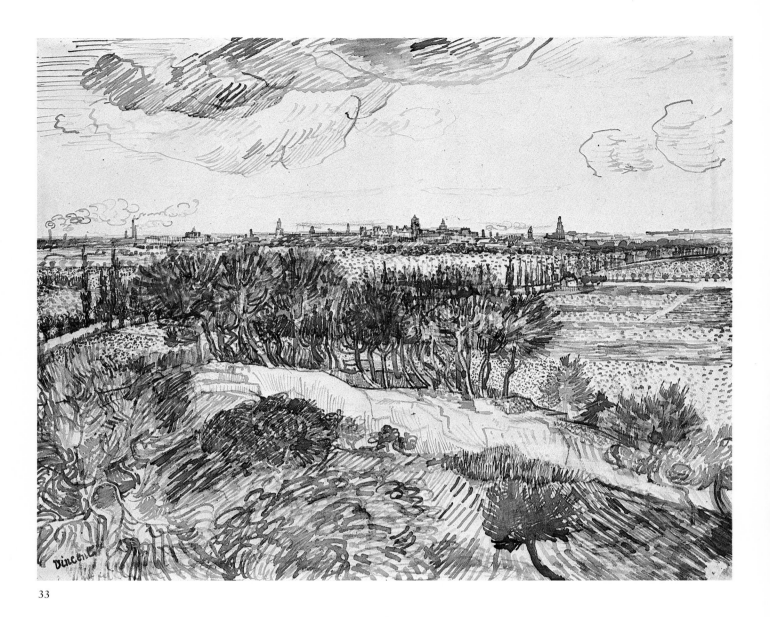

33

had done in Saintes-Maries as "the pendant of the last one" (LT499).

In fact, this large Montmajour drawing is the first of several done on full-size Whatman paper (usually 19 × 23⅝ in.). When van Gogh sent Theo a roll of five large pen drawings in July, he again referred back to the present drawing, just as he had done in Saintes-Maries: "You have a sixth of that series from Montmajour—a group of very dark pines and the town of Arles in the background" (LT509).

Topographically, it is the only work in any medium that shows such a wide view of Arles in the distance (sections of this view can be seen in cat. 6, 32, 48).

View of Arles from Montmajour was part of a large collection of van Gogh's work exhibited in 1893 in the Frie Udstilling, Copenhagen, where it appeared as catalogue number 193. It was acquired from that exhibition by the Nasjonalgalleriet, Oslo—the first drawing by van Gogh to enter a public collection.

Saintes-Maries-de-la-Mer

During van Gogh's first months in Arles, he occasionally talked of visiting the Mediterranean to do seascapes, at either Marseilles or Martigues. His urge to see the Mediterranean was partly the Northern European's archetypal wish, partly a reminder of his admiral-uncle's sea voyages there, and partly memories of another uncle who used to winter at Menton.

But he never mentioned the small Mediterranean fishing village of Saintes-Maries-de-la-Mer. Its very name, however, implies a significance beyond providing a locale for fishing. It was here, according to legend, that the three Marys—Mary Cléophas, sister of the Virgin; Mary Salomé, mother of the apostles James the Greater and John the Evangelist; and Mary Magdalene—landed in A.D. 45 with Martha, Lazarus, and Maximin and converted Provence to Christianity. Relics of the first two Marys, identified and exhumed by King René in the fifteenth century, have been preserved in a chapel over the apse of the church, and the remains of their servant, Sarah, in a crypt below. In particular, the relics of Saint Sarah are the object of gypsy pilgrimages that take place every year on 24–25 May.

The dates were significant for van Gogh because they focused his attention on the village. Special diligences, or horse-drawn carriages, were added to the daily run at reduced fares. Interestingly, only three days after this festival, he referred to Saintes-Maries for the first time in his letters: "I expect to make an excursion to Saintes-Maries, and see the Mediterranean at last" (LT492, 28 May). By Tuesday 29 May, he had decided: "Early tomorrow I start for Saintes-Maries on the Mediterranean. I shall stay there till Saturday evening. I am taking two canvases, but I'm rather afraid it will probably be too windy to paint. You go by diligence, it is fifty kilometers from here. You cross the Carmargue, grass plains where there are herds of fighting bulls and also herds of little white horses, half wild and very beautiful. I am taking especially whatever I need for drawing. I must draw a great deal, for the very reason you spoke of in your last letter. Things here have so much line. And I want to get my drawing more spontaneous, more exaggerated" (LT495).

Van Gogh left Arles by diligence at 7 A.M. Wednesday 30 May and arrived in Saintes-Maries at midday. He delayed writing to Theo for several days, eventually doing so on Saturday 2 June: "I am at last writing to you from Saintes-Maries on the shore of the Mediterranean. The Mediterranean has the colors of mackerel, changeable I mean. You don't always know if it is green or violet, you can't even say it's blue, because the next moment the changing light has taken on a tinge of pink or gray" (LT499).

He then decided to prolong his stay by one day to produce more drawings, and instead of leaving Saturday 2 June as he had intended, he left in the afternoon of Sunday 3 June.

He had taken three canvases to Saintes-Maries, and while there he painted two small seascapes (cat. 39, 40) and a view of the village (F416).

In addition he drew, taking back to Arles seven half-page drawings on the same type of paper he had used for his seven recent views of Montmajour (see cat. 30–32). He also produced one full-page view of the village (F1439), the equivalent—in size and paper—of the large drawing from Montmajour (cat. 33), which he had sent to Theo the day before he left Arles. On the last morning, he made a drawing of boats (cat. 37). In all, then, three paintings and nine drawings were produced during the five days.

Five of the drawings he sent to Theo on his return to Arles, to join those of Montmajour. Four others he kept back to serve as studies for paintings, three of which were executed in the studio of the Yellow House (cat. 37, fig. 24; cat. 41, 42).

In the visit to Saintes-Maries, van Gogh achieved his objective of, at long last, saluting the Mediterranean. But it was much more than a diversionary episode, or a short seaside vacation. It had a very positive and significant effect on his view of the South, and also on his artistic development.

The directly observable influence on his own painting and drawing was threefold. First, he wrote: "Now that I have seen the sea here, I am absolutely convinced of the importance of staying in the Midi and of positively piling it on, exaggerating the color." This he accomplished not so much in the paintings done on the spot, or in *Fishing Boats on the Beach* (cat. 37, fig. 24), painted in the studio on his return, as in the two small paintings of cottages done in the studio from drawings brought back from Saintes-Maries.

Second, he had gone there to allow his drawing to become "more spontaneous, more exaggerated." His report on his visit showed that freedom and spontaneity were achieved by the simple device of dispensing with his perspective frame. And this newfound facility was proved by doing the boats *in an hour*, "just by letting my pen go."

Third, he insisted that "after a while [here], one's sight changes: you see things with an eye more Japanese, you feel color differently. The Japanese draw quickly, very quickly, like a lightning flash, because their nerves are finer, their feeling simpler. I am convinced that I shall set my individuality free simply by staying on here" (LT500, 4 June).

Even during his short stay in Saintes-Maries, van Gogh talked of returning as soon as possible to make more studies. And once back in Arles, he wrote that if he received Theo's letter on Sunday morning 10 June, he would probably take himself off again to Saintes-Maries and spend a week there (LT494). But instead, he had to pay for the painting of the Yellow House and the purchase of a fairly big stock of canvases. The postman failed to deliver Theo's money order for 50 francs on time; but even had he done so, it is not certain that van Gogh would have made a second trip. Anxious though he was to paint more seascapes and to observe the open-air bathing there, he never returned to Saintes-Maries.

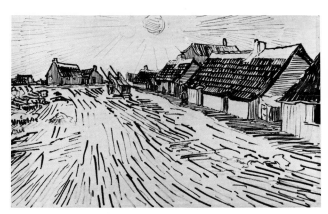

Fig. 23. *Cottages at Saintes-Maries-de-la-Mer* (F1437). Reed pen and ink on paper, 12¼ × 18½ in. (30.5 × 47 cm.). Rijksmuseum Vincent van Gogh, Amsterdam

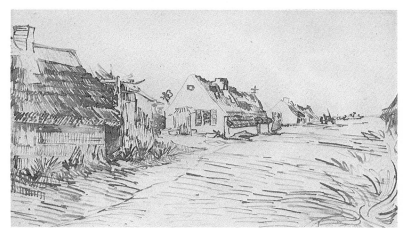

34

34. Cottages in Saintes-Maries-de-la-Mer

Pencil, reed pen and ink, 12 × 18½ in. (30.5 × 47 cm.)
Unsigned
Collection Henry P. McIlhenny, Philadelphia

F1436 JH1454

This is one of the seven half-page drawings done on the spot in Saintes-Maries. Of the small Mediterranean village van Gogh wrote, about 2 June: "I do not think there are a hundred houses. . . . The chief building, after the old church and an ancient fortress, is the barracks. And the houses—like the ones on our heaths and peat bogs in Drenthe; you will see some specimens of them in the drawings" (LT499).

These cottages—thatched, partly whitewashed, and each with its characteristic cross at one end of the roof ridge—reminded van Gogh of his stay from October to December 1883 in Drenthe, a desolate part of Holland (see the drawing in LT336). Over a summary pencil armature, the reed pen bites deeply, creating shadows and furiously modeling layers of thatch, but leaving the sky and patches of sunlight untouched. A companion view is in the Rijksmuseum Vincent van Gogh, Amsterdam (fig. 23). These must be the drawings that van Gogh described as "harsh" when he sent them to Theo on his return to Arles (LT500, c. 4 June).

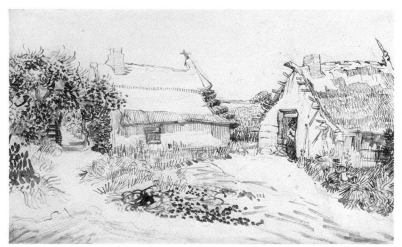

35

35. Two Cottages in Saintes-Maries-de-la-Mer

Pencil, pen, reed pen and ink, 11⅜ × 18½ in. (29 × 46 cm.)
Unsigned
Private collection

F1440 JH1451

This drawing and cat. 36 are contrasting interpretations of the same motif. The mood of this drawing, more soigné, more carefully drawn than its companion, is almost tender, with the relative profusion of vegetation, the woman standing in the doorway—a rare instance of human presence in the Saintes-Maries drawings—and the distant view of the Mediterranean.

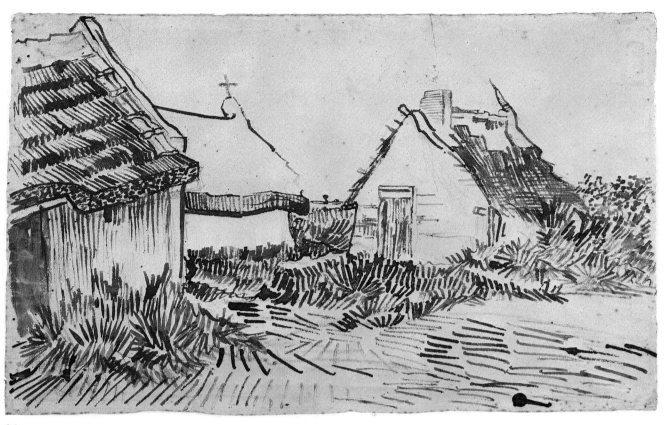

36

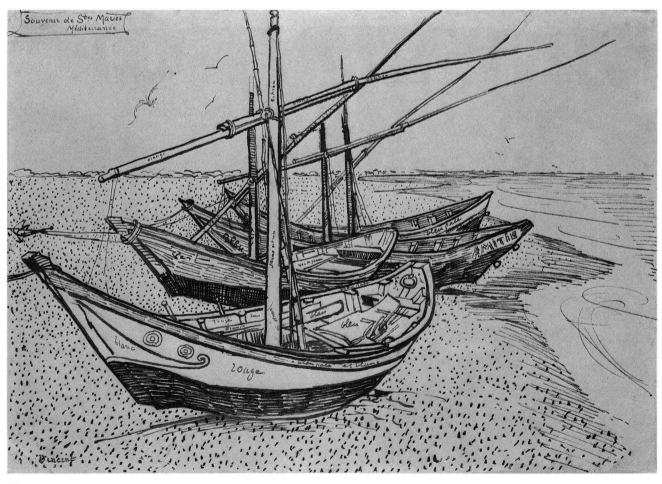

37

36. Three Cottages in Saintes-Maries-de-la-Mer

Pencil, reed pen and brown ink on Ingres paper, 1 1¾ × 18½ in.
 (30 × 47 cm.)
Watermark: AL
Unsigned
Rijksmuseum Vincent van Gogh, Amsterdam
F1438 JH1448

The motif is similar to that in cat. 35, but in this version the very abrupt and almost brutal drawing emphasizes the feeling of desolation. The contrast between the deeply bitten and the untouched white areas places it among the "harsh" group (see cat. 34). It was used as a working drawing for a painting (cat. 42) once van Gogh had returned to Arles from Saintes-Maries.

37. Fishing Boats on the Beach

Pencil, reed pen and ink, 15⅜ × 21 in.
 (39 × 53.3 cm.)
No visible watermark, but vertical laid lines
Inscribed, upper left, in cartouche: Souvenir de
 Stes Maries / Méditerranée
Signed, lower left: Vincent
Private collection
F1428 JH1458

Van Gogh made this study in Saintes-Maries very early on the last morning of his stay there, probably on Sunday 3 June. He described it in the first letter he sent to Theo after returning to Arles, probably Monday 4 June: "I am sending you by the same post some drawings of Saintes-Maries. I made the drawing of the boats very early on the morning I was due to leave, and I have the painting of it on the easel, a size 30 canvas, with more sea and sky at the right. It was before the boats cleared off. I had observed it all the other mornings, but as they leave very early [I] had not the time to do it." Later in the same letter he continued, "I have only been here a few months, but tell me this—could I, in Paris, have done the drawing of the boats *in an hour*? Even without the perspective frame, I do it now without measuring, just by letting my pen go" (LT500).

These are revealing passages. Clearly, this drawing was meant to be a demonstration piece. Van Gogh wanted to prove to his brother that without the crutch of the perspective frame he could quickly produce a large and intricate drawing. But it was also destined to serve as a working drawing. Each of the four boats carries detailed color notes. Indeed, no other Arles (or Saintes-Maries) study has so many annotations.

Immediately after his return to Arles, van Gogh began to work on the painting that is largely based on

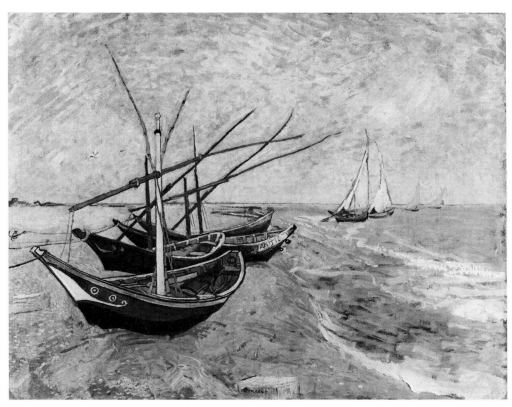

Fig. 24. *Fishing Boats on the Beach* (F413). Oil on canvas, 25⅝ × 31⅞ in.
(64.5 × 81 cm.). Rijksmuseum Vincent van Gogh, Amsterdam

this drawing (fig. 24). The boats are reproduced in precisely the same colors; he allowed himself no license. But in adding "more sea and sky at the right," he also added more boats, whose prototypes are to be found in the *Little Seascape* (cat. 40), which he had also brought back with him from Saintes-Maries.

The drawing itself, whatever its purpose, presages van Gogh's mature Arles style. Here is the first extensive use of the dot. It was no doubt meant to suggest sand, but it also conveys an antinaturalistic inner rhythm that creates dynamic tensions between surface and distance, reality and abstraction.

38. Street in Saintes-Maries-de-la-Mer

Pencil, reed pen and brown ink, 12 × 18½ in.
 (30.5 × 47 cm.)
Unsigned
Private collection, England

F1434 JH1449

This drawing is a powerful tour de force in which the reed pen, sweeping aside the trails of exploratory pencil, now emulates the brush, now aspires to imitate the quill. The diagonal view of five cottages is realized by a sequence of angular strokes fiercely present in the receding elements and contrasting with the untouched white of gable walls parallel to the picture plane (a contrast that is maintained even in the orthogonal-reducing wall at the end of the path). Shadows cast by the cottages are simply registered by horizontal hatchings, allowing shafts of light to spread between them.

On the right, van Gogh uses a less regular—or regulated—system: burgeoning summer growth, including poppies represented by virtual blots of ink. No human presence, no smoking chimneys, no large expanse of sky. In the painting executed on his return to Arles (cat. 41), he enlarged the sky and added smoke to the chimneys, giving an evening particularity to what had been a timeless evocation.

The compositional scheme of thatched cottages viewed on a diagonal recurs in a comparable view painted in 1890 at Auvers-sur-Oise (F780).

39. Seascape at Saintes-Maries-de-la-Mer

Oil on canvas, 20⅛ × 25¼ in. (51 × 64 cm.)
Signed, lower left: Vincent
Rijksmuseum Vincent van Gogh, Amsterdam

F415 H454 SG38 JH1452

This seascape was painted in Saintes-Maries between Wednesday 30 May and Sunday 3 June. According to a letter probably written on 2 June, van Gogh reported that he had "brought three canvases and...covered them—two marines, a view of the village" (LT499). The two "marines" are the present canvas and a smaller one that van Gogh himself called "la petite marine" (LT531), in the Pushkin State Museum of Fine Arts, Moscow (cat. 40); the "view of the village" is in the Rijksmuseum Kröller-Müller, Otterlo (F416).

These three paintings were evidently done on the spot, without preparatory drawings, and indeed the two seascapes have a self-sufficient spontaneity, with little

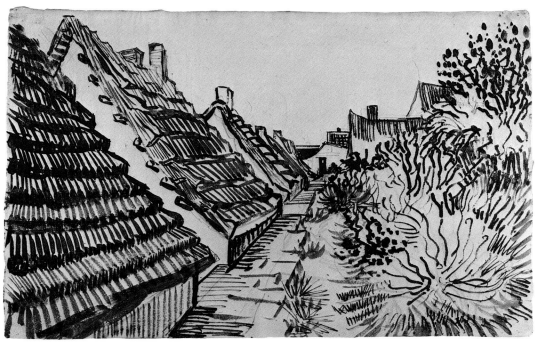

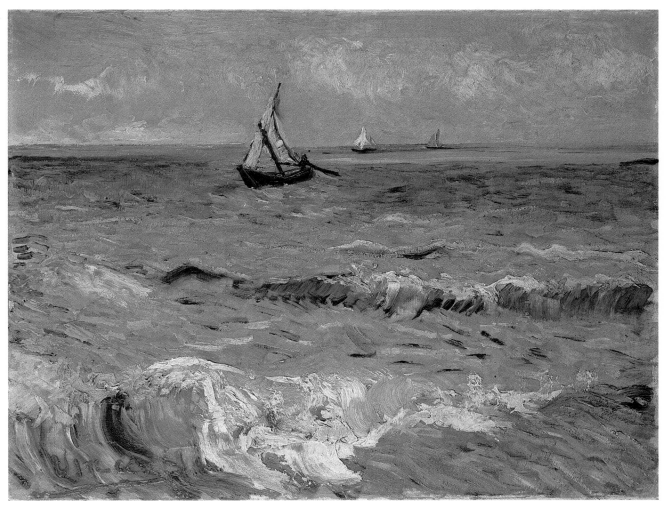

39

evidence of later retouching in the Arles studio. In the case of the view of the village an independent variant exists, a large horizontal drawing incorporating more of the village in its scan (F1439).

Immediately on his return to Arles, van Gogh wrote to his brother: "I'll send you a batch of paintings rolled up as soon as the marines are dry" (LT500). And a month later, speaking of the use of zinc white, he wrote: "I get on very well using it, but it has the disadvantage of drying very slowly, so that the studies made in Saintes-Maries, for instance, are not yet dry" (LT508). In late July, he took the painting off its stretcher and nailed it to the wall to dry (LT515). Before including it in the batch of thirty-six works destined for Theo in mid-August, he wrote: "I had begun to sign canvases, but I soon stopped, because it seemed too foolish. On one marine there is an excessively red signature, because I wanted a red note in the green" (LT524).

While the canvas was nailed up on the studio wall, van Gogh also made two drawn copies after it, one for John Russell (cat. 74), the other for Theo (F1431).

40. Little Seascape at Saintes-Maries-de-la-Mer

Oil on canvas, 17⅜ × 20⅞ in. (44 × 53 cm.)
Signed, lower right: Vincent
Pushkin State Museum of Fine Arts, Moscow

F417 H455 SG37 JH1453

NOT IN EXHIBITION

This seascape, like the Amsterdam picture (cat. 39), was painted on the spot in Saintes-Maries and described in a letter to Theo, written about 2 June (LT499). It is the smaller of the two, although it is the one the artist himself most admired. He expressed his satisfaction with the painting directly in a letter to Theo and indirectly by making several copies of it. He drew it first (fig. 25), with color notes, in an important letter to Emile Bernard (B6) written soon after his return from Saintes-Maries. The colors noted in the sea are remarkably varied—blue, violet-green, green and white, white, green and pink-white—and this is just the way he described

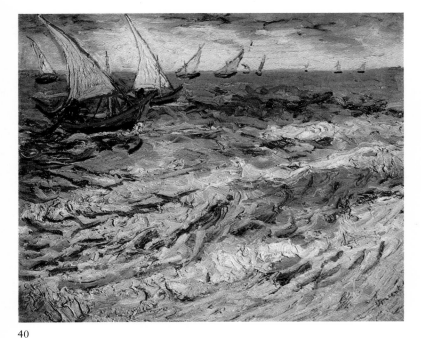

40

Fig. 25. Sketch of *Little Seascape at Saintes-Maries-de-la-Mer* (B6). Present location unknown

it to Theo: "The Mediterranean has the colors of mackerel, changeable I mean. You don't always know if it is green or violet, you can't even say it's blue, because the next moment the changing light has taken on a tinge of pink or gray" (LT499).

Then, while the canvas was pinned up on his studio wall in late July and early August, he made three drawn copies after it, one for Bernard (cat. 63), one for John Russell (cat. 73), and one for Theo (F1430b). He referred to Theo's drawing in his letter of 8 August: "The two marines [F1430b, F1431] are sketches after painted studies" (LT519). It was rare for van Gogh to make three drawings after the same painting; indeed the only other instance among the landscapes is *Arles: View from the Wheat Fields* (cat. 48).

Finally, he indicated his high regard for the Moscow painting in a letter to his brother written on 3 September, shortly after Milliet had delivered to Theo this picture and thirty-five others (see cat. 100). He told Theo to keep these paintings "as well aired as possible, because they are not yet thoroughly dry." He then picked out four—*La Mousmé* (cat. 91, fig. 41), *The Harvest (Blue Cart)* (cat. 65, fig. 36), *Garden with Weeping Tree* (cat. 60), and the present *Little Seascape*—and advised that they be put on stretchers. "I am rather keen on them. You will easily see from the drawing of the little seascape that it is the most thought-out piece." (LT531).

The picture was signed in red at the lower right just before it was dispatched to Theo in mid-August (LT524).

In the *Little Seascape*, van Gogh has depicted the distinctive fishing boats of Saintes-Maries that he had described to Bernard: "Little green, red, blue boats, so

pretty in shape and color that they make one think of flowers. A single man is their whole crew, for these boats hardly venture on the high seas. They are off when there is no wind, and make for the shore when there is too much of it" (B6). The composition, with its extremely high horizon (much higher than in the Amsterdam canvas, cat. 39) and vast empty foreground, can be compared to that of *The Sower* (cat. 49), which van Gogh painted soon after his return to Arles.

The *Little Seascape* was exhibited only once before it was acquired by the great Russian collector I. A. Morozov. That occasion was in van Gogh's one-man show at Bernheim-Jeune, Paris, in March 1901, where it appeared as number 28. It was later exhibited in Moscow, in 1926.

41. Street in Saintes-Maries-de-la-Mer

Oil on canvas, 15 × 18⅛ in. (38 × 46 cm.)
Unsigned
Private collection

F420 H446 SG42 JH1462

Van Gogh painted this picture in his studio at 2 Place Lamartine about 5 June, after he returned from Saintes-Maries. Just before, he had written Theo that he was sending by the same post some drawings of Saintes-Maries. He added, however, "I have three more drawings of cottages which I still need, and which will follow these" (LT500). He needed these drawings as cartoons for paintings he planned to do. In his next letter to Theo, probably written on 5 June, he said he had "two

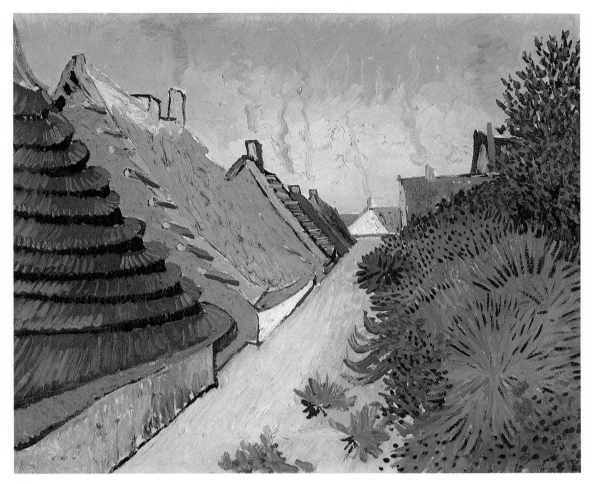

41

canvases on the easel" (LT494). These two canvases must be the present one and *Farmhouse in Provence* (cat. 44).

Both paintings are based directly on "drawings of cottages." The drawing for the present painting is cat. 38. However, there are modifications. The contour of the tiered thatch on the foreground cottage is much more rounded than in the drawing, where it is sharply angular. More sky is introduced, and the smoke from the chimneys now suggests evening.

A few days later, he wrote to Emile Bernard and included a sketch of the picture with color annotations (fig. 26). This studio painting is remarkable for the degree to which van Gogh has introduced the three pairs of complementary colors: blue and orange, yellow and violet, and red and green. The only significant departure from the drawing in the letter is the substitution of a vivid red in the background roof (annotated "orange" and "chrome 3"), which heightens the red-green contrast, previously sustained only by the red poppies.

"The mental labor of balancing the six essential colors, red—blue—yellow—orange—lilac—green," reminded van Gogh of the work of Monticelli (LT507). The present painting is the first full demonstration of

the balancing act, which became a frequently recurring theme in Arles.

Compare cat. 64, a drawing made after the finished painting and sent to Bernard in July.

Fig. 26. Sketch of *Street in Saintes-Maries-de-la-Mer* (B6). Present location unknown

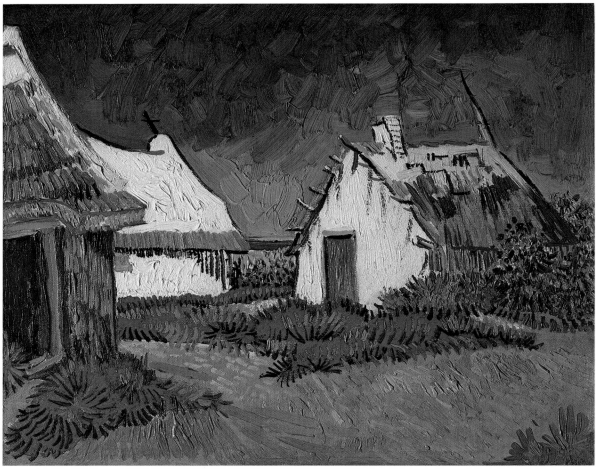

42

42. Three Cottages in Saintes-Maries-de-la-Mer

Oil on canvas, 13¼ × 16⅜ in. (33.5 × 41.5 cm.)
Unsigned
Loan at Kunsthaus, Zurich

F419 H445 SG41 JH1465

Van Gogh painted this picture in his studio at 2 Place Lamartine about 5 June, after his return from Saintes-Maries. The genesis of the painting is remarkably close to that of *Street in Saintes-Maries-de-la-Mer* (cat. 41). The drawing on which he based the present painting is cat. 36.

In a letter to Emile Bernard, he made a small drawing similar to one of these cottages (fig. 27) and asked him to "imagine in that landscape which is so naïve, and a good thing too, a cottage whitewashed all over (the roof too) standing in an orange field—certainly orange, for the southern sky and the blue Mediterranean provoke an orange tint that gets more intense as the scale of blue colors gets a more vigorous tone—then the black note of the door, the windows and the little cross on the ridge of the roof produce a simultaneous contrast of black and white just as pleasing to the eye as that of blue and orange" (B6).

This painting was included in the batch taken to Paris by Milliet (see cat. 100) in August. On 9 September, van Gogh wrote to his sister Wil, who was staying with Theo: "Did you think of taking a picture of mine for yourself? I hope so, and I am very curious to know which one you chose. I am inclined to think that you took the white cottages surrounded by green plants under a blue sky, which I made at Saintes-Maries on the coast of the Mediterranean" (W7). And he added, almost wistfully, "I ought to have gone back to Saintes-Maries again, as there are now people on the beach."

Fig. 27. Sketch of a cottage in Saintes-Maries-de-la-Mer (B6).
Present location unknown

The Harvest Series

Van Gogh made no preannouncement to Theo that he planned to do a series of paintings of the harvest. When he left for Saintes-Maries on 30 May, he talked of being "sunburned" and "orange," but did not mention the ripening, yellowing wheat (LT498a). On his return to Arles five days later, he continued to paint Saintes-Maries motifs for at least two days; and he planned to return there on 10 June.

It was not until 12 June, in what was his third letter to his brother following his return to Arles, and after he had decided not to go back to Saintes-Maries, that he mentioned finding a new subject: "I have two or three drawings, and two or three new painted studies too. . . . I am working on a new subject, fields green and yellow as far as the eye can reach. I have already drawn it twice, and I am starting it again as a painting; it is exactly like Salomon Koninck—you know, the pupil of Rembrandt who painted vast level plains" (LT496).

This was the famous *Harvest*, or *Blue Cart* (cat. 65, fig. 36), the picture that was for van Gogh undoubtedly the most important he would produce during the entire summer. It was his first size 30 canvas (28½ × 36¼ in.). "I think I have more chance of getting away with things, and of even bigger results, if I don't cramp myself by working on too small a scale. And for that very reason I think I am going to take a larger-sized canvas and launch out boldly into the 30 square. . . . Instinctively these days I keep remembering what I have seen of Cézanne's, because he has rendered so forcibly—as in the Harvest we saw at Portier's—the harsh side of Provence. It has become very different from what it was in the spring, and yet I have certainly no less love for the countryside, scorched as it begins to be from now on." And he continued: "The country near Aix where Cézanne works is just the same as this, it is still the Crau. If coming home with my canvas, I say to myself, 'Look! I've got the very tones of old Cézanne!' I only mean that Cézanne like Zola is so absolutely part of the countryside, and knows it so intimately, that you must make the same calculations in your head to arrive at the same tones. Of course, if you saw them side by side, mine would hold their own, but there would be no resemblance" (LT497). He planned a second size 30 canvas (cat. 75, fig. 39), "a farm and some ricks, which will probably be a pendant" (LT497).

However, before he launched into these large canvases, it seems more than probable that among the "two or three new painted studies" mentioned on 12 June are two smaller canvases: *Farmhouse in Provence* (cat. 44) and *Wheat Field* (cat. 45), both of which are related in motif to the two large paintings.

By about 13 June, then, van Gogh had four paintings, completed or in progress, that were connected with the harvest, and also a quartet of large drawings (cat. 43; F1425, F1483, F1484).

The pattern after 13 June can be fairly securely established. A local Arles newspaper announced that harvesting was brought to an abrupt

halt by a sudden storm on Wednesday 20 June at 2 P.M. The downpour continued virtually uninterrupted until Saturday 23 June: "We have had torrential rain these last two days, which has gone on all day, and will change the appearance of the fields," van Gogh wrote to Theo. "It came absolutely unexpectedly and suddenly, while everyone was harvesting. They brought in a great part of the wheat just as it was" (LT501).

In the same letter, which must have been written on the evening of Thursday 21 June, he wrote: "I have had a week's hard, close work among the cornfields in the full sun. The result is some studies of cornfields, landscapes, and—a sketch of a sower."

This activity was also reported to Emile Bernard in a letter written probably on 18 June, before the torrential rain began: "As for myself, I feel much better here than I did in the North. I work even in the middle of the day, in the full sunshine, without any shadow at all, in the wheat fields, and I enjoy it like a cicada." He quickly sketched in the letter his composition of a sower (cat. 49, fig. 28) and another of a summer evening with sunset, the wheat having "all the tones of old gold, copper, gold-green or gold-red, gold-yellow, bronze-yellow, green-red" (B7).

In a later letter to Bernard, written on Sunday 24 June, he confessed: "I am writing you now in a great hurry, greatly exhausted, and I am also unable to draw at the moment, my capacity to do so having been utterly exhausted by a morning in the fields. How tired you get in the sun here! In the same way I am wholly unable to judge my own work. I cannot see whether the studies are good or bad. I have seven studies of wheat fields, all of them landscapes unfortunately, very much against my will. The landscapes yellow—old gold—done quickly, quickly, quickly and in a hurry, just like the harvester who is silent under the blazing sun, intent only on his reaping" (B9).

It was a staggering achievement. The series, done for the most part between 13 and 20 June, with an additional painting completed on Sunday morning 24 June, consisted of no more than ten paintings. It included *The Harvest (Blue Cart)* (cat. 65, fig. 36), *Haystacks* (cat. 75, fig. 39), *Summer Evening* (cat. 69, fig. 37)—all size 30 canvas—and *The Sower* (cat. 49). That frenzy of work in the fields included the possibility of completing two paintings in one day, since he went out specially one evening to paint *Summer Evening*, which shows the effect of the mistral in the wheat fields.

It is hardly surprising that van Gogh talked of everyone's thinking that he worked too fast and of the pictures' being "criticized as hasty" (LT504). "Don't think that I would maintain a feverish condition artificially," he wrote to Theo on 29 June, "but understand that I am in the midst of a complicated calculation which results in a quick succession of canvases quickly executed but calculated long *beforehand*. So now, when anyone says that such and such is done too quickly, you can reply that they have looked at it too quickly. Apart from that I am now busy going over all my canvases a bit before sending them to you. But during the harvest my work was not any easier than what the peasants who were actually harvesting were doing.... It is just at these times in artistic life, even though it is not the real one, that I feel almost as happy as I could be in the ideal, in that real life" (LT507).

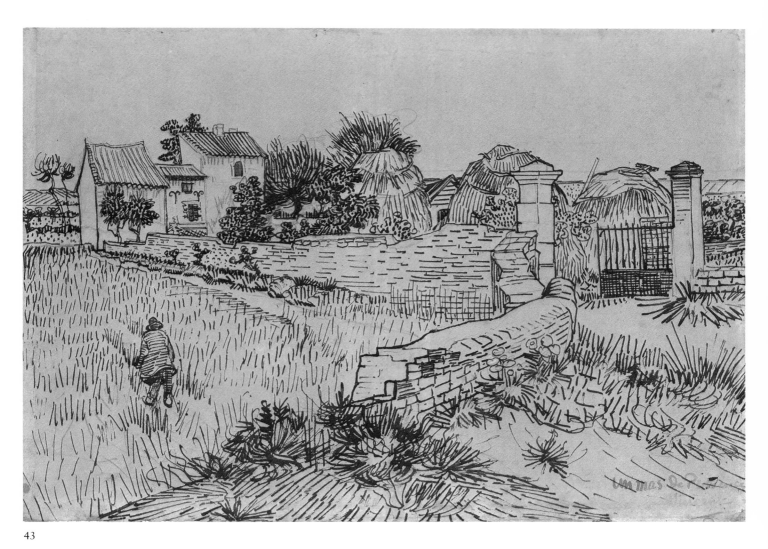

43

43. Farmhouse in Provence

Pencil, reed pen and brown ink on wove paper,
 15⅜ × 21⅛ in. (39 × 53.7 cm.)
Inscribed and signed, lower right: un mas de Provence /
 Vincent
Rijksprentenkabinet, Rijksmuseum, Amsterdam

F1478 JH1444

This inscribed drawing, showing a farmhouse in Provence, is not cited in van Gogh's letters. But comparisons with documented drawings (F1425, F1483, F1484) suggest a dating to about 8–12 June. Possibly it is one of the three drawings van Gogh sent to Theo about 15 June (LT498).

The existence of a painted counterpart to this drawing (cat. 44) again raises the question of the relationship between a drawing and painting of the same motif. In most instances, a separate confrontation is implied,

the drawing acting more as a means of familiarization with the motif than as a cartoon for the subsequent painting. Such appears to be the case not only with the present drawing in relation to the painting but also with the three other documented drawings mentioned above.

In the present drawing, van Gogh began with pencil, leaving parts of it visible (e.g., the chimney and the lower part of the right gatepost). The reed pen then took over. Late additions to the composition include the Bruegelesque figure and the tree behind the farmhouse.

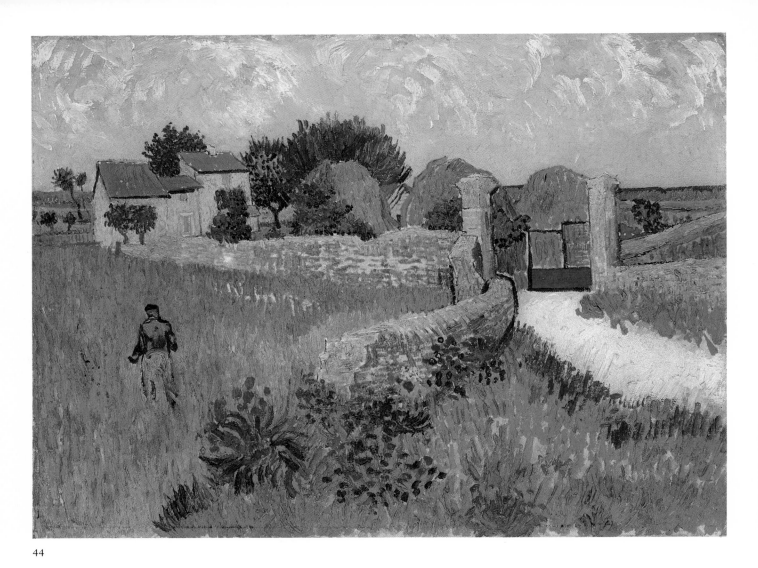

44

44. Farmhouse in Provence

Oil on canvas, 18⅛ × 24 in. (46.1 × 60.9 cm.)
Unsigned
National Gallery of Art, Washington, D.C. Ailsa Mellon
 Bruce Collection, 1970

F565 H542 SG170 JH1443

This painting and *Wheat Field* (cat. 45) are probably
among the "two or three new painted studies" van Gogh
reported as finished on 12 June (LT496).

 The motif is the same as in the drawing (cat. 43),
which was probably done first, but there are interest-
ing changes. The viewpoint is shifted slightly (compare
the position of the haystacks to the gateposts); there is
more foreground; and the composition is extended at
the right. Individual details also differ. There is no lad-
der against the right haystack in the painting, and the
haystacks lack their covers. The farmhouse, which has
a veranda and more trees around it, is squatter, and the

details of its façade do not correspond to those in the
drawing. The figure in the field is different as well.

 Cumulatively, then, all this suggests that the paint-
ing was not done from the drawing but represents a
separate, on-the-spot confrontation with the motif. The
same process occurs in the two harvest drawings (F1483,
F1484) and the harvest painting (cat. 65, fig. 36), and in
the wash drawing of the haystacks (F1426) and the re-
lated painting (cat. 75, fig. 39).

 In the present painting, van Gogh has introduced,
whenever possible, pairs of complementary colors: red
and green in the foreground (with a minor play of pink
and turquoise in the sky), blue and orange in the roofs,
and lilac and yellow. But the overall effect is of "old
gold, bronze, copper, one might say, and this with the
green azure of the sky blanched with heat: a delicious
color, extraordinarily harmonious, with the blended
tones of Delacroix" (LT497).

45. Wheat Field

Oil on canvas, 19⅝ × 24 in. (50 × 61 cm.)
Unsigned
Stichting Collectie P. en N. de Boer, Amsterdam

F564 H541 SG165 JH1475

This painting, like *Farmhouse in Provence* (cat. 44), is probably one of the two or three studies van Gogh mentioned to Theo in his letter of 12 June (LT496). The motif shows a stretch of the Crau, with the Alpilles in the background. It partly overlaps and extends the panoramic view of the plain shown in *The Harvest (Blue Cart)* (cat. 65, fig. 36), as indicated by the tall farmhouse. Since the *Harvest* was reported as begun on 12 June and the harvesting is more advanced in that painting, the present oil must have preceded it.

The sky is horizontally brushed with what became the dominant turquoise blue of many of the summer landscapes. The mixed strokes of yellows, oranges, and brick red in the standing wheat convey the sensation of heightened color and intense heat that van Gogh often described in his June letters. As in some of his other

harvest landscapes the trees, often in Prussian blue, were added last.

Part of this motif reappears in *La Crau with Peach Trees in Bloom* (F514) of April 1889, which van Gogh sketched in his letter to Paul Signac (cat. 152).

46. Wheat Field

Oil on canvas mounted on pasteboard, 21¼ × 25⅝ in. (54 × 65 cm.)
Unsigned
Rijksmuseum Vincent van Gogh, Amsterdam

F411 H444 SG167 JH1476

A small Provençal farmhouse at upper left, a truncated line of cypresses at upper right, the Alpilles in the background, and the heat-filled turquoise blue sky—all these take up only one-seventh of the picture surface: the canvas is dominated by the massive expanse of the wheat field.

The painting is about space and speed, exemplified in the deep and almost uncontrollably rapid thrust

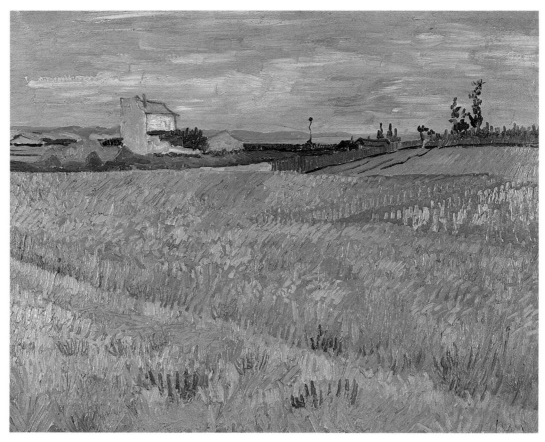

45

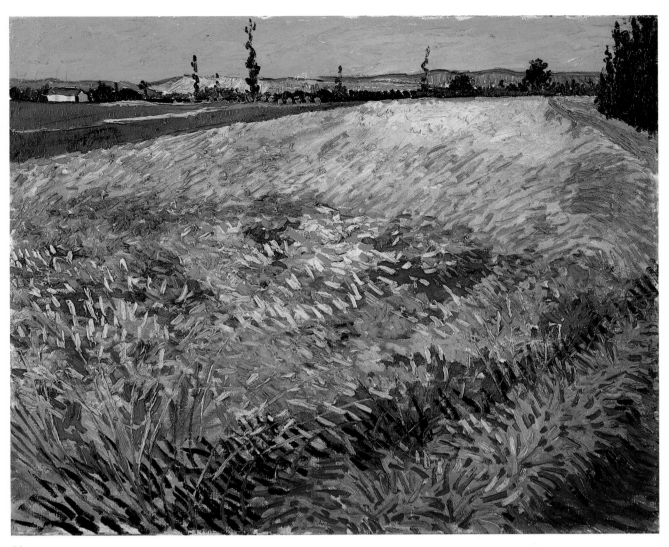

46

into space. Size diminution is also startling: a few long yellow lines signify stalks of wheat in the foreground; a row of orange dabs signify drying sheaves in the background. "Suppose . . . one is in a wheat field," van Gogh wrote to his sister Wil in mid-June. "Well, within a few hours one ought to be able to paint that wheat field, and the sky above it, in perspective, in the distance" (W4).

The surface is activated by short, stabbed brushstrokes comparable to hatchings with the reed pen. This dialogue between the two mediums is sustained in the drawing made after the painting in mid-July (cat. 66).

Van Gogh viewed the motif with his back to the Tarascon road (see cat. 16–18). The same stretch of field reappears in an October painting (F573).

47. Wheat Field with Sheaves

Oil on canvas, 21¾ × 26¼ in. (55.2 × 66.6 cm.)
Unsigned
Honolulu Academy of Arts. Gift of Mrs. Richard A. Cooke
 and family in memory of Richard A. Cooke, 1946

F561 H566 SG168 JH1480

In contrast to the deep drive into space of cat. 46, this composition is organized on a strictly planar base. Horizontal bands lead the eye from stubble to uncut wheat, to more sheaves of wheat and stubble, and finally to horizon and sky. The self-containment of each band is broken only by the sheaves in the foreground and the two horizon-line trees.

In this landscape without figures, the foreground sheaves almost become human presences. Substitute a sower, emphasize the standing wheat, retain the farmhouse and trees, and *The Sower* (cat. 49) results.

In the foreground, light clips the ears of wheat, throwing colored shadows to the right of the sheaves,

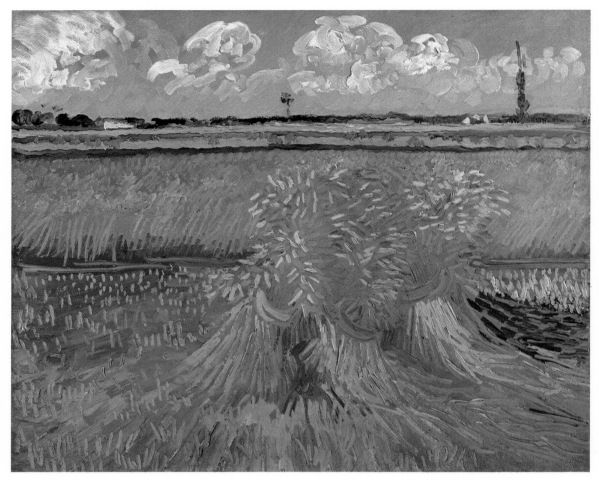

47

while yellow and violet set up a play of complementary contrasts (which will again be heightened in *The Sower*). The sky is here more blue than turquoise, with cursorily brushed-in fleecy clouds. The trees are added last. Brushstrokes comprising dots, dashes, and hatchings create a graphic effect, particularly in the lower half of the picture. The fascinating interchange of strokes between mediums can be observed by comparing the painting with the two drawn copies van Gogh made after it. One he sent to Emile Bernard in mid-July (cat. 67); the other he sent to John Russell in early August (cat. 76).

48. Arles: View from the Wheat Fields

Oil on canvas, 28¾ × 21¼ in. (73 × 54 cm.)
Unsigned
Musée Rodin, Paris

F545 H562 SG166 JH1477

Of the series of wheat fields painted between 10 and 24 June, all but two show views looking away from Arles: that is to say, the town is always at van Gogh's back.

The two exceptions, showing the silhouette of the town, are the present painting and *Summer Evening* (cat. 69, fig. 37).

This painting shows a remarkable mixture of the old and the new. In the background is the Roman town of Arles, its arena clearly visible, with four church towers and spires and, at right, the town hall. In the foreground, the traditional peasant labor of harvesting the wheat is exemplified by the reaper. This is the only instance in the wheat-field series where the reaper is so prominently shown.

Between the peasant reaping and the centuries-old town lie two symbols of nineteenth-century industrial development. At the extreme left are two chimneys—one of the large railroad workshops and the other of the gasworks; and at the far edge of the wheat field heavy clouds of smoke issue from a long black train.

The painting is unique in the series of wheat fields in its vertical format. It is the only harvest scene to have had three drawings made after it. One was sent to Emile Bernard in mid-July (F1491), another to John Russell about 3 August (F1490), and the third to Theo on 8 August (cat. 82).

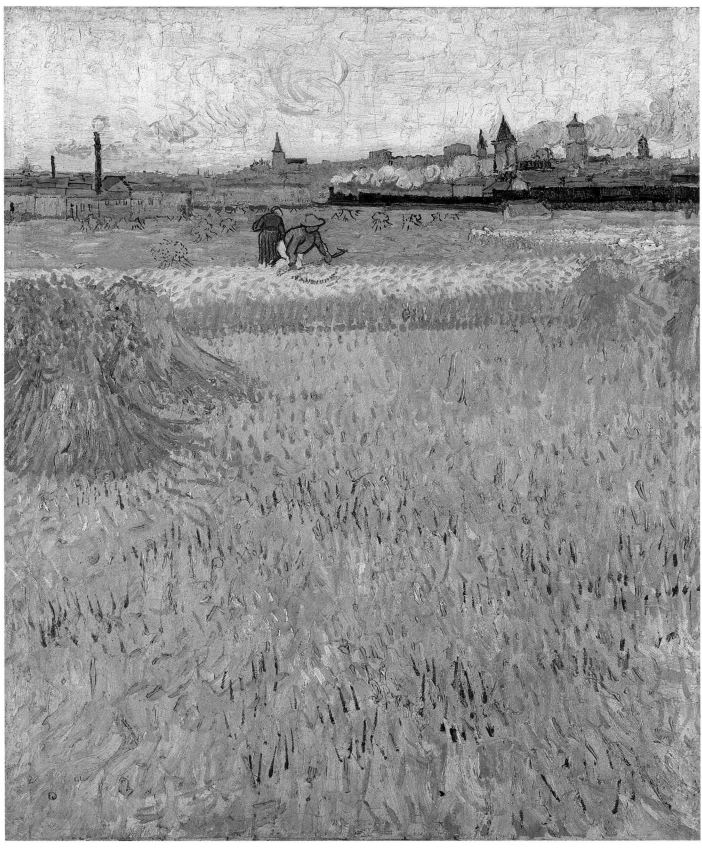

48

49. The Sower

Oil on canvas, 25¼ × 31¾ in. (64 × 80.5 cm.)
Signed, lower left: Vincent
Rijksmuseum Kröller-Müller, Otterlo

F422 H448 SG44 JH1470

Van Gogh wrote a great deal about the genesis and execution of *The Sower*, as well as the ideas, emotions, memories, and symbols that lay behind it. It is one of the seminal and most obsessive icons in his entire oeuvre.

It is also one of the most documented paintings from the Arles period. There are four different descriptions of it in the letters, two hasty sketches also in letters, and two drawings after the finished painting.

He first mentioned it to John Russell in a letter, with a sketch (cat. 151), probably dateable to 17 June: "Am working at a Sower: the great field *all violet* the sky & sun very yellow. it is a hard subject to treat."

He described it more fully to Emile Bernard, probably about 18 June: "Here is a sketch of a sower [fig. 28]: large ploughed field with clods of earth, for the most part frankly violet. A field of ripe wheat, yellow ocher in tone with a little carmine. The sky, chrome yellow, almost as bright as the sun itself, which is chrome yellow No. 1 with a little white, whereas the rest of the sky is chrome yellow Nos. 1 and 2 mixed. So very yellow. The sower's shirt is blue and his trousers white. Size 25 canvas, square. There are many hints of yellow in the soil, neutral tones resulting from mixing violet with yellow; but I have played hell somewhat with the truthfulness of the colors. I would much rather make naïve pictures out of old almanacs, those old 'farmer's almanacs' in which hail, snow, rain, fair weather are depicted in a wholly primitive manner, like the one Anquetin has hit upon so well in his 'Harvest' [fig. 29]. I won't hide from you that I don't dislike the country, as I have been brought up there—I am still charmed by

the magic of hosts of memories of the past, of a longing for the infinite, of which the sower, the sheaf are the symbols—just as much as before." And he added, "The white trousers allow the eye to rest and distract it at the moment when the excessive simultaneous contrast of yellow and violet would irritate it" (B7).

To Theo, on about 21 June, he described it with different emphasis: "It's a composition in which *color* plays a very important part. And the sketch, such as it is—a size 25 canvas—torments me, making me wonder if I shouldn't attack it seriously and make a tremendous picture of it. My Lord, I do want to. But I keep asking myself if I have vigor enough to carry it out. Such as it is, I am putting the sketch to one side, hardly daring to think about it. I have been longing to do a sower for such a long time, but the things I've wanted for a long time never come off. And so I am almost afraid of it. And yet, after Millet and Lhermitte, what still remains to be done is—a sower, in color and large-sized" (LT501).

The Sower was executed in the midst of van Gogh's work on the harvest pictures. Indeed, the composition is a simplification of that in *Wheat Field with Sheaves* (cat. 47). In its first state, it was finished about 18 June. Van Gogh considered it a sketch (*esquisse*), from which he might later make a large picture (*tableau*).

But he was unable to leave it in its first state. About 26 June, he told Theo: "Yesterday and today I worked on the sower, which is completely recast. The sky is yellow and green, the ground violet and orange" (LT503). These two days' reworking in the studio produced significant coloristic, compositional, and figural alterations. While keeping the line of the horizon much the same, he simplified the farmhouse and trees in the background and considerably reworked both sky and earth, enhancing the interplay of complementaries by adding green to the one and orange to the other, creat-

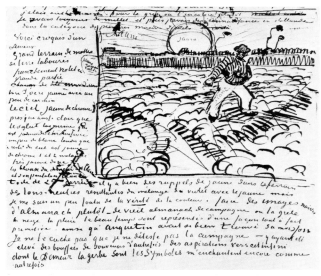

Fig. 28. Sketch of *The Sower* (B7). Present location unknown

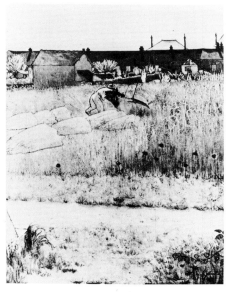

Fig. 29. Louis Anquetin. *The Mower at Noon: Summer.* 1887. Oil on canvas, 27¼ × 20⅞ in. (69.2 × 52.7 cm.). Collection Professor and Madame Léon Velluz, Paris

ing a heightened structural density. He radically altered the pose of the sower. In the sketches sent to Russell and Bernard, the sower is stiff-jointed, his action unconvincing as that of a moving figure. In the second state, van Gogh stressed the striding movement, reverting to a closer adaptation of Millet's *Sower*—and probably using the Zouave (see cat. 52, 53) as a model. He added the cast shadow of the sower, as well as the crows.

As the final gesture, van Gogh put a narrow painted frame around the edges of the canvas, contrasting violet in the upper part against the yellow sky, and yellow in the lower part against the violet earth. (Unfortunately, the existing picture frame obscures his intentions.) Recent X-ray examination has confirmed the existence of the first state beneath the present painting.

In its final form this is a studio painting, and one that deliberately exploits a language of color symbolism. Van Gogh explained the problem to Theo: "The 'Christ in the Boat' by Eugène Delacroix [Metropolitan Museum of Art, New York] and Millet's 'The Sower' are

absolutely different in execution. The 'Christ in the Boat'—I am speaking of the sketch in blue and green with touches of violet, red and a little citron yellow for the nimbus, the halo—speaks a symbolic language through color alone. Millet's 'Sower' is a colorless *gray*, like Israëls's pictures. Now, could you paint the sower in color, with a simultaneous contrast of, for instance, yellow and violet (like the Apollo ceiling of Delacroix's *which is just that, yellow and violet*), yes or no? Why, yes" (LT503).

Although van Gogh considered this *Sower* a failure (LT522), he nonetheless signed it and sent it to Theo in mid-August. "The idea of the *Sower* continues to haunt me all the time," he wrote on 10 September. "Exaggerated studies like the *Sower . . .* usually seem to me atrociously ugly and bad . . ." (LT535). He continued to wrestle with the subject, producing two major statements in October and November (cat. 114, 129).

For the two drawings van Gogh made after the present painting, see cat. 68 and 83.

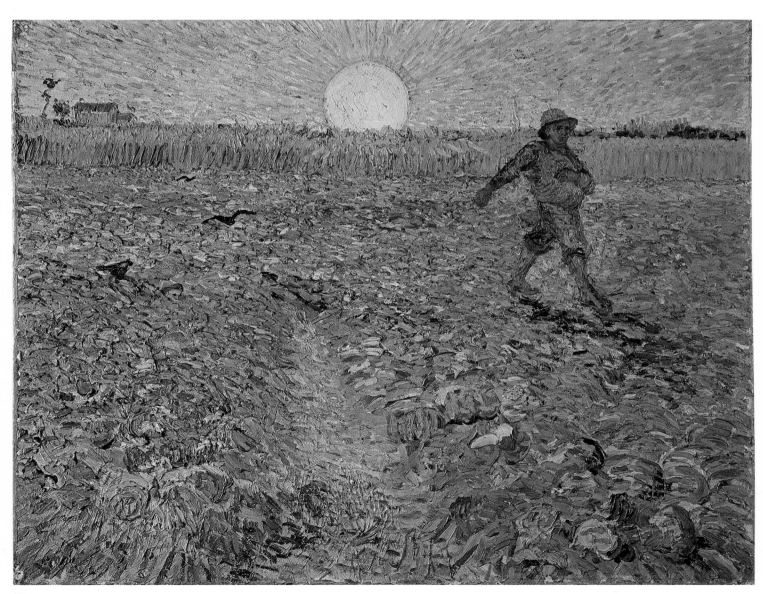

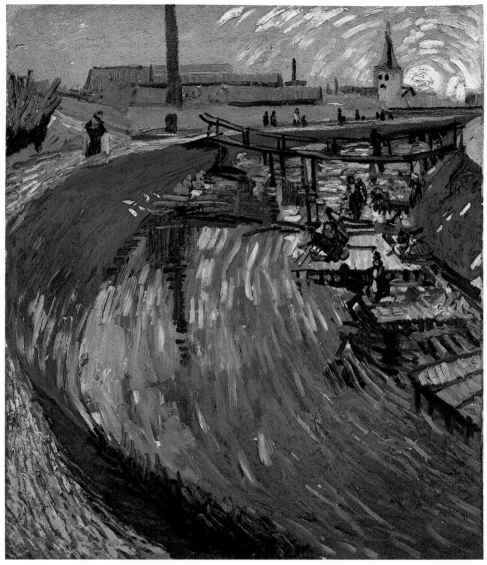

50

50. La Roubine du Roi with Washerwomen

Oil on canvas, 29⅛ × 23⅝ in. (74 × 60 cm.)
Unsigned
Private collection

F427 H453 SG50 JH1490

This painting van Gogh reported as completed in a letter to Theo of about 16 June: "Do you remember among the little drawings a wooden bridge with a washing place, and a view of the town in the distance? I have just painted that subject in a large size" (LT504).

The drawing van Gogh refers to (cat. 22), one of the early group of small sheets, shows the viewpoint very much at canal level. Here the viewpoint is much higher, appearing to be almost at bird's-eye level, an effect created by increasing the width of the narrow

waterway, exaggerating the wide curve of the canal bank at the left, pushing up the horizon line, and cutting the chimney of the gasworks at the top.

This is an evening view, a sunset observed on the spot, in contrast to an imagined sunset, as for example *Summer Evening* (cat. 69, fig. 37). The motif was quite near the Place Lamartine. Like *Summer Evening*, the painting was quickly executed, and no doubt it was undertaken after a day's painting in the wheat fields.

In the same letter quoted above, van Gogh continued: "I must warn you that everyone will think that I work too fast. Don't believe a word of it. Is it not emotion, the sincerity of one's feeling for nature, that draws us, and if the emotions are sometimes so strong that one works without knowing one works, when sometimes the strokes come with a continuity and a coherence like words in a speech or a letter, then one must

remember that it has not always been so, and that in time to come there will again be hard days, empty of inspiration."

Van Gogh made a drawing after the painting in mid-July (cat. 70), and included it in the batch of drawings he sent to Emile Bernard in Brittany.

51. Head of a Girl: The Mudlark

Pen and brown ink on wove paper (lozenge), 7⅛ × 7¾ in.
 (18 × 19.5 cm.)
Watermark: L-JD
Unsigned
The Solomon R. Guggenheim Museum, New York
 The Justin K. Thannhauser Collection

F1507a JH1466

51

Van Gogh enclosed this drawing in a letter to John Russell (cat. 151) of about 17 June: "Instead of continuing the letter I began to draw on the very paper the head of a dirty little girl I saw this afternoon whilst I was painting a view of the river with a greenish yellow sky. This dirty 'mudlark' I thought yet had a vague Florentine sort of figure like the heads in the Monticelli pictures, and reasoning and drawing this wise I worked on the letter I was writing to you. I enclose the slip of scribbling that you may judge of my abstractions, and forgive my not writing before as such."

The painting referred to is *The Trinquetaille Bridge* (cat. 71, fig. 38), where the foreground figure can be identified as the young girl van Gogh calls the "mudlark." The same model also appears in a small oil, the *Girl with Ruffled Hair* (F535); there the costume is simplified, excluding all the decorative pattern in the drawing. The painting could be a memory sketch, done in June, but it is also possible that van Gogh persuaded the girl to sit for him in late August, when, paid in advance for subsequent sittings, she did not come again. If that is the case, she may well be the model referred to as "the woman with yellow hair and a sunburned brick red face" (B15). She may also be the blonde girl with hat seen in profile in *The Dance Hall* (cat. 138).

On the verso of this small sketch, parts of a first draft of the above-quoted letter to Russell can still be deciphered (fig. 30): "Have you been working in the country lately and is the house you are building getting on. It appears that Claude Monet has done fine things my brother writes to say that he has at present an exhibition of 10 new pictures. One representing pine trees at the seaside with a red sunset casting a red glow over some branches foliage and the ground. It is a marvel I hear. Bernard is doing good things I believe he is taking a lot of trouble. Gauguin is still at Pont-Aven and suffering of his liver complaint [bu]t working nevertheless."

Fig. 30. Verso of *Head of a Girl: The Mudlark*

52

52. The Seated Zouave

Pencil, reed pen and brown ink, heightened with white, on
 Whatman paper, 19¼ × 24 in. (49 × 61 cm.)
Watermark: J. Whatman Turkey Mill 1879
Signed, lower left: Vincent
Rijksmuseum Vincent van Gogh, Amsterdam

F1443 JH1485

This drawing was made in the studio of the Yellow
House during the four days' heavy rain that fell from
20 to 23 June. During this period van Gogh also painted
two portraits of the same model (see cat. 53). The draw-
ing was in no way used as a preparatory study for the
paintings. Indeed, it is possible that it was done later.
On 21 June, van Gogh described only the paintings to
Theo (LT501). But two days later he wrote that he would
send a drawing of the Zouave that same day (LT502).

Its independent status is similar to that of many of
van Gogh's landscape drawings. In any case, the sitter's
trousers differ from the pantaloons he wears in the full-
length painting (fig. 31), and he sits on a chair, not a
bench. The red tiles of the studio floor are indicated,
and other summary shapes suffice for the setting. The
directly frontal confrontation, hands clasping thighs,
does not make for elegant presentation. Over the rapid
pencil markings, the reed pen elaborates the decora-
tively exotic uniform. And there is promise of further
elaboration beyond the four touches of Chinese white
—rare additions to the drawings in Arles. Nonetheless,
perhaps because of his physical exhaustion and the tired
state of his eyes, van Gogh was happy to sign it and send
it off to Theo. It was, after all, proof that he had made
his first figure drawing after four months in the South.

53. The Zouave

Oil on canvas, 25⅝ × 21¼ in. (65 × 54 cm.)
Unsigned
Rijksmuseum Vincent van Gogh, Amsterdam

F423 H449 SG45 JH1486

Painted in the studio of the Yellow House during the
four days of heavy rain, 20 to 23 June, this is one of
three portraits van Gogh did of the same model. The
other two are a drawing (cat. 52) and a full-length paint-
ing (cat. 53, fig. 31). He described the model and the
progress of the two paintings both to Theo and to Emile
Bernard.

On 21 June, he wrote to Theo: "I have a model at
last—a Zouave—a boy with a small face, a bull neck,
and the eye of a tiger, and I began with one portrait,
and began again with another; the half-length I did of
him was horribly harsh, in a blue uniform, the blue of
enamel saucepans, with braids of a faded reddish orange,
and two citron yellow stars on his breast, an ordinary
blue, and very hard to do. That bronzed, feline head of
his with the reddish cap, against a green door and the
orange bricks of a wall. So it's a savage combination of
incongruous tones, not easy to manage. The study I
made of it seems to me very harsh, but all the same I'd
like always to be working on vulgar, even loud por-
traits like this. It teaches me something, and above all
that is what I want of my work. The second portrait
will be full length, seated against a white wall" (LT501).

And again to his brother on 23 June: "I am very
dissatisfied with what I have been doing lately, because
it is very ugly. But all the same, figure is interesting me
more than landscape" (LT502).

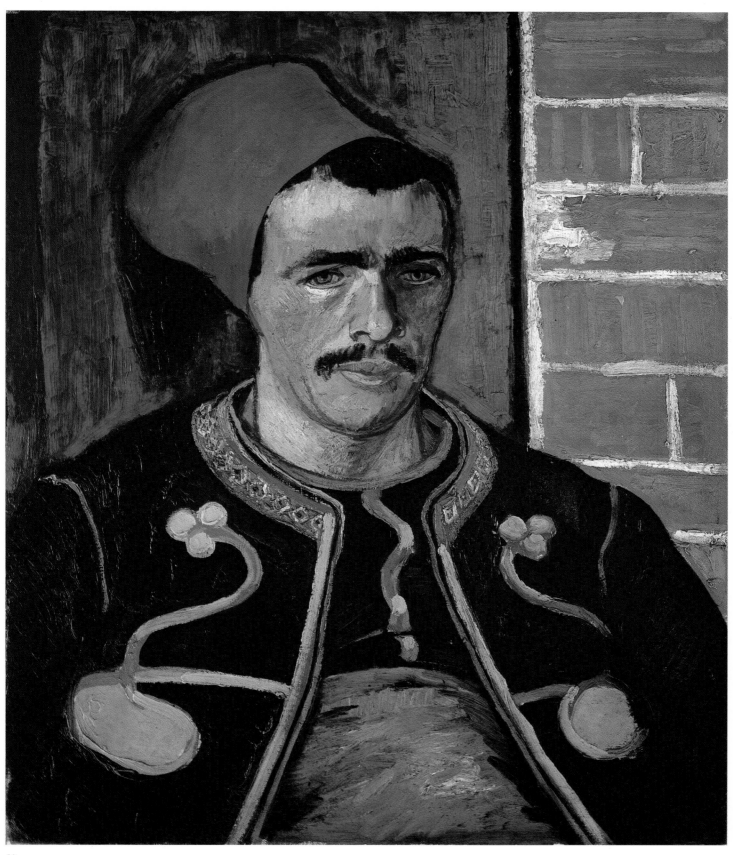

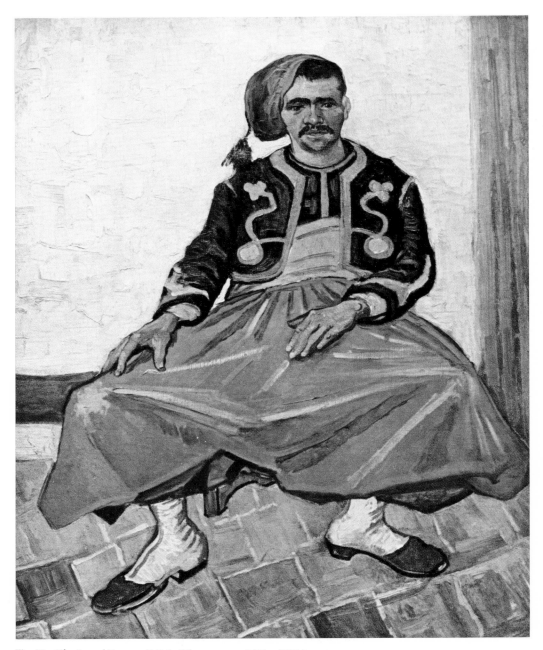

Fig. 31. *The Seated Zouave* (F424). Oil on canvas, 31⅞ × 25⅝ in.
(81 × 65 cm.). Private collection, Argentina

That same evening he told Emile Bernard he was exhausted "after drawing and painting from a model—a Zouave—for three or four days. . . . What I have dashed off is very ugly: a drawing of a seated Zouave, a painted sketch of the Zouave against a completely white wall, and finally his portrait against a green door and some orange bricks of a wall. It is hard and utterly ugly and badly done. All the same, since it means attacking a real difficulty, it may pave the way for me in the future" (B8).

And the following day—Sunday 24 June—he again wrote to Bernard: "I will set apart the head of the Zouave which I have painted for an exchange with you if you like. . . . If we two did a picture of a brothel, I feel sure that we would take my study of the Zouave for character" (B9).

On 31 July, he provided a more particularized inventory for his sister Wil: "A portrait bust of a Zouave, in a blue uniform with red and yellow trimmings, with a sky blue sash, a blood red cap with a blue tassel, the face sunburned—black hair cropped short—eyes leering like a cat's—orange and green—a small head on a bull's neck. In this one the background is a harshly green door and some orange bricks of the wall and the white stucco" (W5).

Montmajour: The Second Series of Drawings

Van Gogh had not worked at Montmajour since late May (see cat. 30–33). Saintes-Maries, the harvest, and the Zouave had kept him busy throughout June. At the end of the month he had planned to spend a weekend in the Camargue doing some drawings, but the veterinary surgeon who was to have taken him let him down at the last moment. Far more important news, however, had reached him on Friday 29 June. Theo wrote that Gauguin had at last agreed to go to Arles. The problem was how to raise the money to pay Gauguin's debts in Brittany and his railroad ticket south. Spurred on by his own need to contribute to Gauguin's visit, van Gogh prepared for his second, full-scale assault on Montmajour.

On Sunday 8 July, he reported: "I have two new big [drawings]. When there are six of them I will send them." And later in the same letter, "If the four other drawings that I have in mind are like the first two I have done, then you will have an epitome of a very beautiful corner of Provence" (LT505).

Two days later, in one of his most richly evocative passages, van Gogh described, for the first and only time, the ruin of Montmajour and its environs. And he found a literary parallel in Zola's fictional garden, Le Paradou, in the novel *La Faute de l'abbé Mouret* (1875). "I have come back from a day in Montmajour, and my friend the second lieutenant [Milliet; see cat. 100] was with me. We explored the old garden together, and stole some excellent figs. If it had been bigger, it would have made me think of Zola's Paradou, high reeds, and vines, ivy, fig trees, olives, pomegranates with lusty flowers of the brightest orange, hundred-year-old cypresses, ash trees, and willows, rock oaks, half-broken flights of steps, ogive windows in ruins, blocks of white rock covered with lichen, and scattered fragments of crumbling walls here and there among the green. I brought back another big drawing, but not of the garden. That makes three drawings. When I have half a dozen I shall send them along" (LT506).

By the end of that week, he had completed two more drawings, "two views of the Crau and of the country on the banks of the Rhône" (cat. 57, 58). He then sent off to Theo a roll of five large pen drawings, hoping that "after the celebrations of 14 July you may be pleased to refresh your eyes with the wide-open spaces of the Crau" (LT509).

Completed in just over a week, these five large drawings were conceived of as substitute paintings. Not only were they cheaper to do than paintings (van Gogh wanted to have paints and canvas in reserve for when Gauguin arrived) but they could also be more controlled in handling. Often van Gogh had to battle with the mistral's constant shaking of the easel, which caused a "haggard" look in his paintings; this was not a problem when he drew. His letters show that he was prepared to spend whole days working on his drawings, despite the discomfort of mosquitoes, the mistral, and little but bread and milk to sustain him. They also indicate that he sometimes completed only one drawing in a day.

In making the drawings, van Gogh usually followed a three-step procedure: beginning with a quick pencil underlay, he continued with pen and for the most part brown ink, and finished up with some final touches in pen and black ink for textural emphases and added staffage. Most of the work was probably done in situ, but some studio retouchings must have taken place, in particular those in black ink.

Without sketchbooks, notebook jottings, or alternative full-size tryouts, there is no way of knowing how quickly van Gogh decided on a program of six views. Interestingly, several of the views chosen in the May series recur: for example, two views of the Crau (cat. 30, 31) reappear in cat. 57, and another view (F1448) in cat. 58.

The order in which they were done can only be deduced. The likeliest sequence would seem to be the two tree and rock drawings (cat. 54, 55), reported as finished by 8 July; the view of the ruin (cat. 56), finished by 10 July; and the pair of panoramic views (cat. 57, 58), finished between 10 and 13 July.

The news that Gauguin had agreed to come to Arles acted as a catalyst. The drawings represented van Gogh's contribution to the cause. To this end, they were dispatched to Theo in the hope that he would persuade the Paris art dealer Georges Thomas to buy two of them at 100 francs each (in which case, van Gogh was prepared to give him the other three). In any event, Thomas refused to buy them. And van Gogh never completed the projected sixth drawing, which was to have been a view of the whole of the ruins, equivalent to the "hurried scratch of it [F1417] among the small drawings" sent in May (LT509).

There were, as he wrote to Theo, other reasons for doing them. He had been "fully fifty times to Montmajour to look at this flat landscape." Fascinated by the huge plains—where he experienced an infinity that was "*inhabited*" and where memories of the Dutch seventeenth-century landscapes of Jacob van Ruisdael were keenly revived—he produced the pair of panoramic vistas, "the best things I have done in pen and ink." These were summaries of innumerable viewings; not the result of sudden, impulsive inspiration, they were planned and calculated: "There is no attempt at effect. At first sight it is like a map, a strategic plan as far as the *execution* goes." Yet he could also say that these two drawings "*do not look Japanese*, but . . . really are, perhaps more so than some others" (LT509). Van Gogh derived his sense of "Japanese"—bareness and simplicity of decor—from Pierre Loti's *Madame Chrysanthème* (1887), which he had recently read. He hoped the two drawings—perhaps put in "a reed frame, like a thin stick"—would give Theo "a *true idea* of the simplicity of nature here." So succinctly had he conveyed that simplicity that he never again felt it necessary to return to Montmajour— at least not to draw or paint there.

54. Rocks with Trees: Montmajour

Pencil, pen, reed pen, brown and black ink on Whatman
paper, 19¼ × 23⅝ in. (49 × 60 cm.)
Watermark: J. Whatman Turkey Mill 1879
Signed, lower right: Vincent
Rijksmuseum Vincent van Gogh, Amsterdam

F1447 JH1503

This is most likely one of the first two drawings of the
second Montmajour series, reported as finished on Sun-
day 8 July (LT505). The other is probably *Olive Trees:
Montmajour* (cat. 55). Its composition resolves any
conflict between outcrop and panorama that occasion-
ally bedeviled some of the May drawings of Montmajour
(see cat. 30–32). Rocks, trees, and path dominate, mak-
ing the glimpse of fields and the distant town of Arles
incidental.

The natural rise of the ground tends to flatten the
picture space; and despite the play of conflicting diag-
onals, the drawing is ultimately about surface and
pattern. Abrupt and heterogeneous marks swap roles
in their reading as texture of stone, plant, or tree trunk.
Here are sickle-shaped hatchings, bunches of linear
hatchings, bands of crosshatching, and interpenetrat-
ing dots; outlines of forms are never overinsistent.

55. Olive Trees: Montmajour

Pencil, reed pen, brown and black ink on Whatman paper,
18⅞ × 23⅝ in. (48 × 60 cm.)
Watermark: J. Whatman Turkey Mill 1879
Signed, lower left: Vincent
Musée des Beaux-Arts, Tournai

Not previously catalogued

This study of olive trees shows three layers of working.
Pencil was used to lay in the composition; pen and brown
ink was then applied to give a more definite articulation;
and finally, pen and black ink was added for emphases,
especially in the trees at left and in the foreground, but
leaving the central rock untouched. It has a similar, if
gentler and more discreet, system of signs to that of the
previous drawing (cat. 54), though it lacks crosshatching,
which creates such strong textural contrasts in that
drawing. The treatment of the trees, however, especially
their loose, ragged edges, is almost identical in the two
drawings, and as in all these Montmajour drawings,
the sky is left untouched, apart from the few cursorily
suggested birds.

Together with six other drawings, this one was
exhibited—as *Provence, Verger d'Oliviers*—at the eighth
exhibition of Les XX in Brussels in 1891. It was the
enterprising secretary, Octave Maus, who accepted the
suggestion of Johanna van Gogh-Bonger, Theo's widow,

that van Gogh's drawings as well as his paintings be
included in what constituted a small memorial exhibi-
tion. The drawing was bought from the exhibition, by
the famous Belgian collector Henri-Emile van Cutsem,
and must therefore be among the first drawings by van
Gogh to be sold.

The van Cutsem collection included works by
Edouard Manet, Claude Monet, Georges Seurat, and
Henri de Toulouse-Lautrec, as well as many examples
by contemporary Belgian artists. After the owner's death,
the collection was bequeathed to the city of Tournai. In
1912, the Belgian Art Nouveau architect Victor Horta
was commissioned to design a new museum to house
the collection. It finally opened in 1928.

Inexplicably this drawing, signed "Vincent," lay
unrecognized and uncatalogued among some 1,300
drawings. It was first exhibited as by van Gogh in April
1957 as number 96 in the exhibition "Dessins et Gra-
vures Inédits de la Collection van Cutsem," where it
was called simply *Les Oliviers*. It was not until 1971
that it was illustrated in an updated catalogue of the
collection by Louis Pion (pl. 27), where it was titled
Oliviers à Montmajour.

Executed in the same mediums as the other four
Montmajour drawings and on the same full-size What-
man paper with the Turkey Mill watermark, it shares
their stylistic mannerisms, even though their expression
is more subdued. The rehabilitation of this drawing·
—uncatalogued in the van Gogh literature and hitherto
unmentioned in any publication on the artist—removes
speculation about the identity of the "lost" fifth draw-
ing from the second Montmajour series. It is exhibited
here for the first time since 1891 among van Gogh's
own works.

Fig. 32. *A Ruin, Montmajour* (F1423). Graphite, reed pen and ink
on paper, 18⅞ × 12¼ in. (47.5 × 31 cm.). Rijksmuseum Vincent
van Gogh, Amsterdam

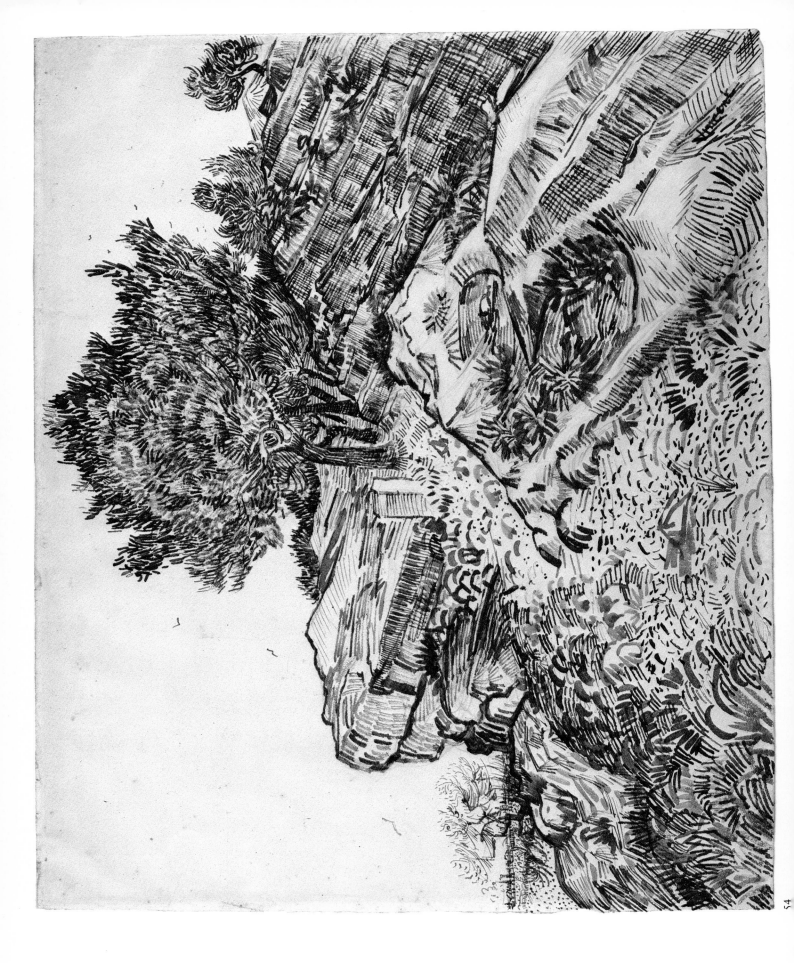

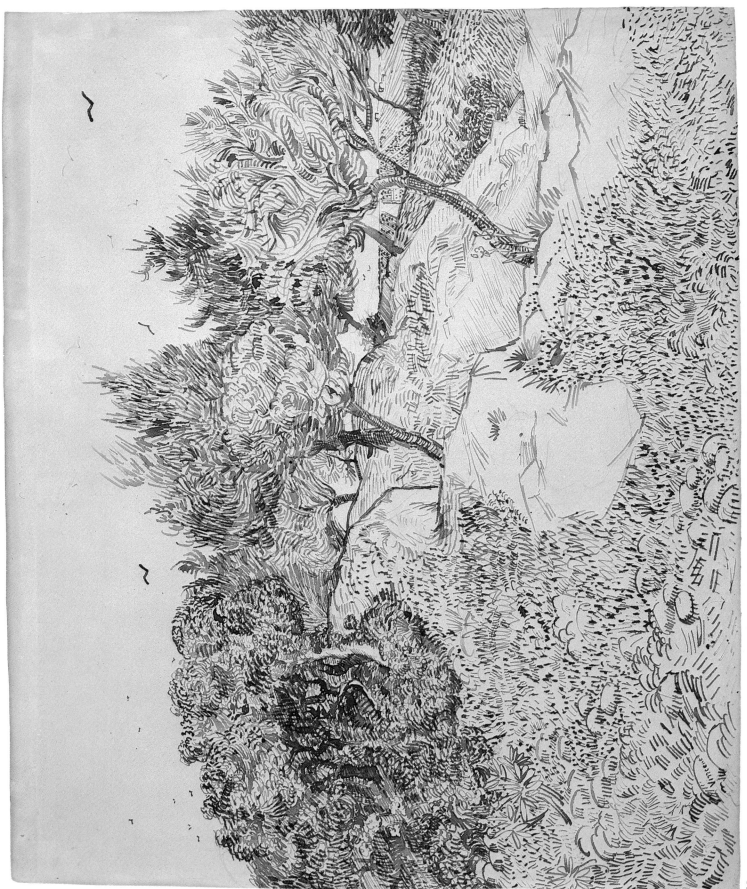

56. Montmajour

Pencil, reed pen, brown and black ink on Whatman paper,
 18⅞ × 23⅝ in. (48 × 60 cm.)
Watermark: J. Whatman Turkey Mill 1879
Signed, lower right: Vincent
Rijksprentenkabinet, Rijksmuseum, Amsterdam

F1446 JH1504

This is the only drawing of the second series that shows a view of the ruin of the Abbey of Montmajour itself. (An intended sixth drawing, showing the whole ruin from a vantage point similar to that of F1417 from the May series, was never executed.) It shows part of the terrace on the southeastern side, which culminates in the fortified tower. The same terrace and tower are seen in one of the views of the ruin from the May series (fig. 32; see page 111). Here in the July drawing, van Gogh has taken a longer view, introducing the large rock and, below, the receding fields, with the edge of the Mont de Cordes. As a piquant contrast, two minute black silhouettes materialize as Arlésiennes with parasols.

57. La Crau Seen from Montmajour

Pencil, reed pen, quill pen, brown and black ink on
 Whatman paper, 19¼ × 24 in. (49 × 61 cm.)
Watermark: J. Whatman Turkey Mill 1879
Signed and inscribed, lower left: Vincent / La Crau / Vue
 prise à Mont Major
Rijksmuseum Vincent van Gogh, Amsterdam

F1420 JH1501

Van Gogh took this view with his back to the main buildings of the abbey, looking southeast across the plain of the Crau and taking in part of the Mont de Cordes and, in the distance, the plateau of the Crau. It combines elements from two of the May drawings (cat. 30, 31). However, in reducing the foreground intrusion and widening his field of vision, he allowed the panorama the fullest possible play.

In representing "the flat countryside covered with vines and stubble fields" (LT509) seen from above, van Gogh applied a remarkably controlled system of graphic signs: small bunches of linear hatchings and large stabbed dots for the rocky foreground, curved and interlaced strokes for the foreground trees, dots consistently used for the stubble fields, and intermeshed strokes of brown and black ink for the vines (the latter giving a heightened textural effect). The sky was left untouched, and some middle-ground trees and the two walking figures were added last—perhaps in the studio—in black ink. The clarity of distant forms, holding their colors, never ceased to delight his northerner's eye, and here he depicts them sharply, with the quill pen.

Linked to this controlled system of strokes—the opposite of haphazard and impulsive—may well be a carefully contrived layout. Three near-horizontal divisions, the lower two equal in size, can be detected. The composition is essentially angular, with strong geometric and gridlike elements. Or, as van Gogh himself described it: "There is no attempt at effect. At first sight it is like a map, a strategic plan as far as the *execution* goes" (LT509). This much more conceptual approach distinguishes the drawing from the May series.

Van Gogh always paired this drawing with the *Landscape of Montmajour with Train* (cat. 58). Both were probably executed between 10 and 13 July, and he considered them the best things he had done in pen and ink.

58. Landscape of Montmajour with Train

Pencil, reed pen, quill pen, brown ink on Whatman paper,
 19¼ × 24 in. (49 × 61 cm.)
Watermark: J. Whatman Turkey Mill 1879
Signed, lower left: Vincent
Inscribed, lower right, in cartouche: La campagne du côté
 des bords / du Rhône vue de / Mon Majour
Trustees of the British Museum, London

F1424 JH1502

The vantage point for this panoramic vista is west of the Abbey of Montmajour looking northwest toward the banks of the Rhône, with the range of the Alpilles at right. The small railroad runs toward Fontvieille. Part of the composition, seen from a different viewpoint, appears in one of the May drawings (F1448).

Van Gogh completed this drawing sometime between 10 and 13 July; he always considered it a companion drawing to *La Crau Seen from Montmajour* (cat. 57). Although a similarly controlled system of graphic signs is applied here, maintained even to the finest touches of the quill pen in the far distance, the angular and gridlike formality of the companion sheet is broken by the dominating curve of the receding road, in turn echoed in the slower curve of the foreground descent from the hill of Montmajour.

The presence of the railroad projects the viewer into the nineteenth century, diminishing the timeless quality of the companion drawing. The maplike, space-plotting composition is further humanized by three late (studio?) additions: the horse and carriage at left, the ploughman at center right, and the two walking figures on the road. There are here more late additions in the trees than are found in the companion sheet.

In these vast plains, van Gogh felt infinity and rediscovered his native Dutch landscape tradition, the tradition of Rembrandt, Salomon Koninck, and Jacob van Ruisdael.

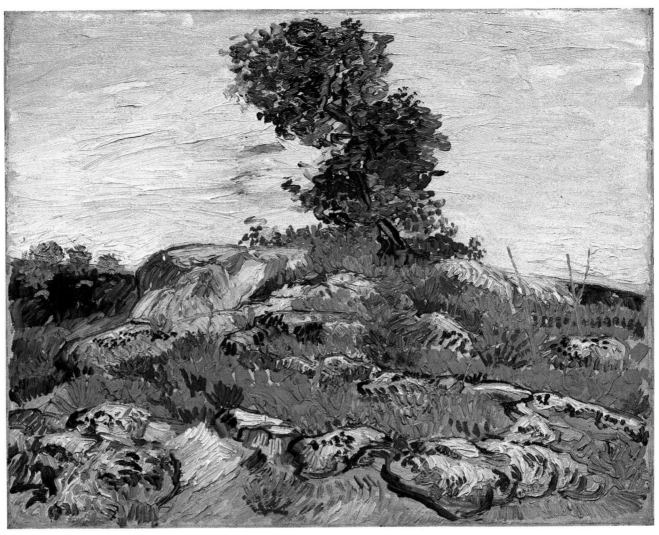

59

59. Rocks with Oak Tree

Oil on canvas, 21¼ × 25⅝ in. (54 × 65 cm.)
Unsigned
Museum of Fine Arts, Houston. John A. and Audrey Jones
 Beck Collection

F466 H494 SG85 JH1489

This is almost certainly the painting referred to in van Gogh's letter to Theo of about 5 July: "Yesterday at sunset I was on a stony heath where some very small and twisted oaks grow; in the background, a ruin on the hill, and wheat in the valley. It was romantic, you can't escape it, like Monticelli; the sun was pouring bright yellow rays on the bushes and the ground, a perfect shower of gold. And all the lines were lovely, the whole thing nobly beautiful. You would not have been a bit surprised to see knights and ladies suddenly appear, coming back from hunting or hawking, or to have heard the voice of some old Provençal troubadour. The fields

looked violet, the distances blue. I brought back a study, but it is very far below what I tried to do" (LT508).

The "stony heath" was in the area of Montmajour. Van Gogh was never able to paint the abbey as he planned—neither a view of the ruins nor a panorama of the plains below. He managed to produce two panoramic drawings (cat. 57, 58), and he "began a painting as well, but there [was] no way of doing it with the mistral blowing" (LT509).

Rocks with Oak Tree remains his only painting of the immediate environs of Montmajour. That he thought highly of it is indicated by the fact that he made a drawing after it in mid-July (F1554) which he sent to Emile Bernard. And Theo, to whom he sent the painting in mid-August, chose to frame it, along with *The Sower* (cat. 49). On about 12 September, van Gogh wrote: "I have a study of an old mill [cat. 103] painted in broken tones like the oak tree on the rock, that study you were saying you had had framed" (LT535).

Theo shared van Gogh's admiration for Monti-

celli. And it was their joint viewing in Paris of a painting by this artist that was recalled in a letter from Saint-Rémy of about 8–10 October 1889: "You remember that fine landscape by Monticelli which we saw at Delarebeyrette's of a tree on some rocks against a sunset?" (LT610).

60. Garden with Weeping Tree

Oil on canvas, 23⅞ × 19 in. (60.5 × 73.5 cm.)
Unsigned
Private collection, Zurich

F428 H457 SG52 JH1499

"Here is a new subject," van Gogh wrote to Theo about 5 July. "A corner of a garden with clipped shrubs and a weeping tree, and in the background some clumps of oleanders. And the lawn just cut with long trails of hay drying in the sun, and a little corner of blue-green sky

at the top" (LT508; fig. 33). And on 31 July, he described the picture in more detail to his sister Wil: "I have also got a garden without flowers, that is to say a lawn, newly mown, bright green with the gray hay spread in long streaks. A weeping ash and a number of cedars and cypresses, the cedars yellowish and spherical in form, the cypresses rising high into the air, blue-green. At the back, oleander and a patch of green-blue sky. The blue shadows of the shrubs on the grass" (W5).

The motif was taken from one of the public gardens in the Place Lamartine, which van Gogh could see from the Yellow House. He would walk through the garden en route to the brothels, and he made drawings of the site (see cat. 23). But he delayed painting it, allowing his observations to accumulate for more than two months. With the harvest over, he needed a new subject. Perhaps he was seduced by the flowering of the oleanders.

In this first painting of the garden, he is observing, composing, thinking of color questions, and not looking for associative or symbolic overtones. He talked

Fig. 33. Sketch of *Garden with Weeping Tree* (LT508). Rijksmuseum Vincent van Gogh, Amsterdam

of gardens painted by Manet and Renoir. And broadly speaking, this is an Impressionist painting, searching for equivalent brushstrokes, observing color in shadows, and recording a specific time of day. In composition, with empty foreground and center, and everything pushed to the edges, it can be compared with a dance rehearsal scene by Degas.

It seems probable that a second, upright version of the same motif—at a different time of day—was also painted. The existence of that version, now lost and not mentioned in the letters, can be predicated on a drawing sent to John Russell (cat. 79).

Two drawings after the present painting were sent to Emile Bernard and to Theo (cat. 72, 84). And once the painting had been delivered, rolled, to Theo in mid-August, it was singled out by van Gogh as one of the four canvases that should be put on stretchers: "I am rather keen on them" (LT531, 3 September).

For other views of the same garden, see cat. 104 and 107.

61

61. Flowering Garden

Oil on canvas, 36¼ × 28¾ in. (92 × 73 cm.)
Unsigned
Private collection

F430 H459 SG53 JH1510

About 19 July, van Gogh wrote to Theo: "I have a new drawing of a garden full of flowers, and two painted studies as well.... You will see from this sketch [fig. 34] the subject of the new studies. There is one vertical and another horizontal of the same subject, size 30 canvases. There really is a subject for a picture in it, as in other studies that I have. And I truly can't tell if I shall ever paint pictures that are peaceful and quietly worked out, for it seems to me it will always be headlong" (LT512).

On 31 July, he wrote to his sister Wil: "I have a study of a garden one meter wide, poppies and other red flowers surrounded by green in the foreground, and a square of blue blowballs. Then a bed of orange and yellow Africans, then white and yellow flowers, and at last, in the background, pink and lilac, and also dark violet scabiosas, and red geraniums, and sunflowers, and a fig tree and an oleander and a vine. And in the far distance black cypresses against low white houses with orange roofs—and a delicate green-blue streak of sky" (W5).

Wil's inventory is balanced by Theo's schematic color sketch, and surely it describes this upright version and not the horizontal one (F429; see fig. 35). The painting is a joyous celebration of a Provençal flower garden rather than a doctrinaire demonstration of color theory. Schematic and audacious in design, with a sustained tension between surface and depth, it is still broadly Impressionist. Yet it is also remarkable for the system of dots, stabs, hatchings, and superbly inventive painterly neologisms (e.g., the vine leaves at the lower right), which seem borrowed from his drawing techniques.

He described his approach to Wil: "Oh, I know very well that not a single flower is drawn completely, that they are mere dabs of color, red, yellow, orange, green, blue, violet, but the impression of all these colors in their juxtaposition is there all right, in the painting as in nature. But I suppose you would be disappointed, and think it unbeautiful, if you saw it. But you see that the subject is rather summery" (W5).

Someone who hitherto had maintained "a frosty silence" whenever he saw van Gogh's paintings on his visits to the Yellow House was now won over. On 21 July, the American artist Dodge MacKnight "broke his silence a little by saying that he liked my last two studies (the garden of flowers) very much, and talked about them for a very long time" (LT513). And nine days later, on another visit to the studio, MacKnight repeated that "he liked my Garden" (LT516).

See also the drawing sent to John Russell (cat. 80).

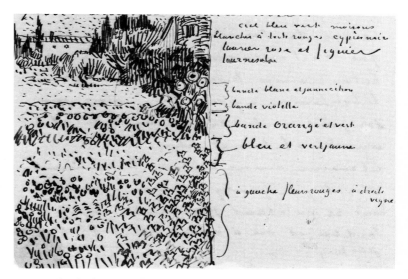

Fig. 34. Sketch of *Flowering Garden* (LT512). Rijksmuseum Vincent van Gogh, Amsterdam

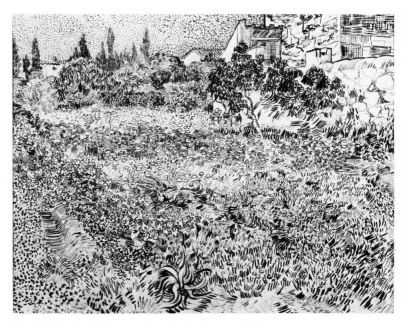

Fig. 35. *Garden in Provence* (F1455). Reed pen and ink on paper, 19½ × 24 in. (49.5 × 61 cm.). Oskar Reinhart Collection, "Am Römerholz," Winterthur

Drawings After Paintings

In mid-July, van Gogh arranged a one-man show of the work he had produced since 10 May—that is, since he sent his first batch of paintings to Theo. This two-month retrospective occurred when he took some thirty canvases from their stretchers and nailed them to his studio walls to speed up their drying. He intended to send them, rolled, to Theo fairly soon, but, in the event, they remained in his studio until mid-August.

He was able to take stock of his painting, retouching some canvases, signing others. He could also think of exchanges of work with other artists, and of ways of helping Gauguin and Emile Bernard.

It was Bernard who first came to mind. Van Gogh had not written since 24 June, and Bernard's reply had remained unanswered. On Sunday 15 July, van Gogh at last wrote: "Perhaps you will be inclined to forgive me for not replying to your letter immediately, when you see that I am sending you a little batch of sketches along with this letter.... Let me know whether you will consent to make sketches after your Breton studies for me. I have a batch [of paintings] ready to be forwarded [to Theo in Paris], but before it goes off I want to do at least half a dozen new subjects for you, pen-and-ink sketches" (B10). And he confirmed to Theo: "Today I sent six drawings after painted studies to Bernard. I have promised him six more, and I have asked for some sketches after his painted studies in exchange" (LT511).

Van Gogh's purpose was not just to exchange drawings so that each artist might see what the other was doing. He also intended to send Bernard's drawings on to Theo, in the hope that his brother would then be persuaded to buy a Bernard painting to add to their growing collection.

Two days later, on Tuesday 17 July, van Gogh again wrote to Bernard: "I have just sent you—today—nine more sketches after painted studies. In this way you will see subjects taken from the sort of scenery that inspires 'father' Cézanne, for the Crau near Aix is pretty similar to the country surrounding Tarascon or the Crau here.... As I know how much you like Cézanne, I thought these sketches of Provence might please you; not that there is much resemblance between a drawing of mine and one by Cézanne" (B11).

Promised a dozen drawings, Bernard eventually received fifteen, chosen from the thirty canvases drying on the studio walls. In making his choice, van Gogh excluded paintings done in May before he went to Saintes-Maries. From Saintes-Maries itself, he ignored two of his now most popular pictures—*Fishing Boats on the Beach* (F413) and *View of Saintes-Maries-de-la-Mer* (F416)—sending instead drawings after a small seascape (cat. 63) and a street scene (cat. 64). The seascape (cat. 40) van Gogh always considered one of his best paintings, while he had previously consulted Bernard about the painting of the street scene (cat. 41).

Van Gogh's major concentration was on the harvest series—some seven drawings, including the *Sower*—which showed Bernard the Crau

and suggested Cézanne. *Rocks with Oak Tree* (cat. 59; F1554) also conveyed something of the Crau, while the *Garden with Weeping Tree* (cat. 72) gave a more poetic view of Provence. The two urban scenes of the canal (cat. 70) and the river (cat. 71) were meant to remind Bernard of the northern suburbs of Paris at Asnières and Clichy, where he and van Gogh had painted in 1887. The one figure drawing, *The Zouave* (cat. 62), van Gogh had thought of as his contribution to a brothel picture that he and Bernard might collaborate on.

These fifteen drawings were executed immediately after van Gogh had finished his five large drawings of Montmajour (cat. 54–58). In one sense, they are a relaxation after his admitted exhaustion from a week's tireless work at Montmajour. All these drawings were done on the same wove paper, of identical size (one quarter that of the Montmajour sheets). They were never laborious copies, like reproductive engravings, but fresh, improvisatory translations, at most half the size of the original painting and often in a different format. Compositions are sometimes added to, sometimes truncated, and, within, relationships and proportions are changed. A rapid pencil underdrawing establishes the idea, then the reed pen takes over. Strokes may appear multidirectional and uncontrolled, but there is a certain logic and resolved stability—even a clear system of division regarding the representational function of hatching (very rarely crosshatching), whorls, and dots.

Van Gogh was aware of Bernard's personal enmity toward Signac and of his ideological dissociation from Pointillism. He therefore used dots with discretion—never, for example, do they appear in the skies. Nonetheless, they articulate systematically and consistently all horizontal surfaces: roads, streets, and river and canal embankment paths. Van Gogh's most extensively dotted drawing is *Street in Saintes-Maries-de-la-Mer* (cat. 64), where the gable ends of the cottages are given this additional decorative rhythm.

Bernard sent in exchange ten drawings, which van Gogh received on 23 July (B12). Although expressly forbidden by Bernard to send them on to his brother, van Gogh in fact did so. But since they were not done after paintings, Theo was unable to use them as a guide to choosing a picture by Bernard for the brothers' collection. For his part, Bernard made an album of van Gogh's drawings, which he showed to Gauguin soon after moving to Pont-Aven in mid-August.

Unknowingly, Gauguin was very much the cause of a further bout of drawing after the nailed-up paintings. Van Gogh had for some weeks been hoping that his friend John Russell (see cat. 150) would buy a Martinique canvas by Gauguin from Theo. Such a purchase would help pay Gauguin's debts in Pont-Aven and facilitate his journey to Arles. Van Gogh was therefore greatly disappointed when Russell wrote on 22 July (LT501b) refusing to commit himself to the Gauguin purchase. Russell's letter probably reached van Gogh on 24 July. Two days later, news arrived from Gauguin, the most optimistic to date: he had recovered his health; he was painting well; and, above all, he talked of coming south.

This cheering news caused van Gogh to rethink the Russell problem. He described his plan to Theo on 31 July: "I am working hard for Russell, I thought that I would do him a series of drawings after my

painted studies; I believe that he will look upon them kindly, and that, at least I hope so, will bring him to make a deal.... If we prod Russell, perhaps he will take the Gauguin that you bought.... When I write him, sending the drawings, it will of course be to urge him to make up his mind.... I have eight [drawings] and shall do twelve" (LT516).

By 3 August, he told Theo: "I have sent Russell twelve drawings after painted studies, and so I had an opportunity to speak to him about it again [the purchase of a Gauguin painting]" (LT517).

The motives, then, were different from those that prompted the drawings for Bernard. And so were some of the motifs. In the first place, additional paintings completed since mid-July provided van Gogh with new ideas. He chose three of them for Russell: the horizontal garden (cat. 80), the head of the *mousmé* (cat. 81), and the head of Joseph Roulin (cat. 89). In the second place, he was not deliberately slanting his selection toward "sketches of Provence" à la Cézanne. Russell received only four harvest drawings, without a sower, as against seven for Bernard. The two canal and river views (cat. 70, 71), significant for Bernard, were excluded. But unique inclusions for Russell were two drawings showing motifs after paintings that no longer exist (cat. 78, 79).

Motivation and motifs differ, and also morphology. The twelve Russell drawings have a coherent stylistic unity, distinct from the Bernard set. They are more stylized and generally more finished. The major difference is the use of the dot. It invades and occupies every sky (a small exception being cat. 78); it takes over the background of *La Mousmé* and partly models the face; it constructs totally the Zouave's head.

Unfortunately, the letter to Russell accompanying the drawings is lost. And van Gogh had to wait over a month for Russell's answer, which again proved negative in regard to the purchase of a Gauguin painting (LT536). After that, the correspondence with Russell—at least from Arles—ceased.

When van Gogh told his brother in his letter of 31 July of his plan to make twelve drawings for Russell, he added: "I hope to do these sketches after the studies for you as well. You will see that they have something of a Japanese air" (LT516).

And by 6 August, he asked: "Did I tell you that I had sent the drawings to friend Russell? At the moment I am doing practically the same ones over again for you, there will likewise be twelve. You will then see better what there is in the painted studies in the way of drawing. I have already told you that I always have to fight against the mistral, which makes it absolutely impossible to be master of your stroke. That accounts for the 'haggard' look of the studies" (LT518).

Finally, by 8 August, he sent only five drawings to Theo, and commented: "Now the harvest, the Garden, the Sower, and the two marines are sketches after painted studies. I think all these ideas are good, but the painted studies lack clearness of touch. That is another reason why I felt it necessary to draw them" (LT519). Though he added that he hoped to do more, he never in fact completed the intended dozen for Theo.

Of the five he did send, three are in the present exhibition (cat. 82–84); absent are the two Saintes-Maries seascapes (F1430b, F1431).

These five drawings might be taken to reflect van Gogh's most considered favorites among his paintings. He deliberately avoided doing motifs that could have been affected by the mistral. Two of them certainly were among the pictures he singled out as special and worth putting on stretchers when they finally arrived in Paris: *Garden with Weeping Tree* (cat. 60) and *Little Seascape at Saintes-Maries-de-la-Mer* (cat. 40).

The process of increased stylization and refinement, already noted in the Russell set, is here carried further. As well as improving his painted studies in clarity of touch and consistency of finish, van Gogh improved them in placement and proportion of parts. This is especially apparent in *The Sower* (cat. 83), where the conception is made grander, even monumental, by the enlargement of sun, wheat, and the sower himself.

Within the three weeks from mid-July, van Gogh made some thirty-two drawings after his own paintings for very specific reasons. They were exchanges (with Bernard), gifts (to Russell), progress reports (to Theo). They were also political counters in a wider context. The selections van Gogh made were to some degree conditioned by the tastes and proclivities of the intended recipient. Each group coheres stylistically, with its own recognizable traits and idiosyncracies.

62

62. The Zouave

Pencil, reed pen and brown ink, wax crayon, watercolor,
12⅜ × 9¼ in. (31.5 × 23.6 cm.)
Inscribed and signed, upper right: à mon cher copain / Emile
 Bernard / vincent
The Metropolitan Museum of Art, New York. Gift of
 Emanie Philips, 1962

F1482 JH1487

Soon after painting *The Zouave* (cat. 53), van Gogh wrote to Emile Bernard: "I will set apart the head of the Zouave which I have painted for an exchange with you if you like. Only I won't speak of it unless I can let you sell something at the same time. It would be in response to your sketch of a brothel. If we two did a picture of a brothel, I feel sure that we would take my

study of the Zouave for character. . . . I am writing you now in a great hurry, greatly exhausted, and I am also unable to draw at the moment, my capacity to do so having been utterly exhausted by a morning in the fields" (B9, 24 June).

The painted portrait was never exchanged with Bernard. But the present drawing was inscribed to him and almost certainly included among the first six drawings van Gogh sent him three weeks later on 15 July.

The use of several mediums—in particular the unique use in Arles of wax crayon—enhanced the drawing's importance, dedicated as it was to his "copain" Bernard. In copying the painted portrait, van Gogh simplified the background of green door and orange brick wall to a single sharp green, and there are hints that he introduced the play of the three pairs of com-

63

plementaries, red-green and blue-orange more emphatically than yellow-violet. There is an immediacy and freshness, not least because the face and neck are untouched by watercolor or crayon. The overall effect is less harsh than in the oil.

Compare the drawing sent to John Russell (cat. 77).

63. Fishing Boats at Sea

Pencil, reed pen and ink on wove paper, 9½ × 12⅝ in.
 (24 × 32 cm.)
Unsigned
Staatliche Museen, Berlin (German Democratic Republic)

F1430 JH1505

Drawn after the *Little Seascape at Saintes-Maries-de-la-Mer* (cat. 40) and sent to Emile Bernard between 15 and 17 July.

Van Gogh had already sent Bernard a sketch, with

color notes, in a letter of early June (cat. 40, fig. 25), soon after the painting was completed. There he was anxious to show how he had distilled the colors of the Mediterranean (which he had found so changeable, like "the colors of mackerel") in oil paint.

His second copy for Bernard posed different problems. He did not use wash or watercolor, and he did not add color notes. Compositionally, he lowered the horizon slightly, enlarged two of the middle-distance boats, and suggested cast shadows from their sails.

Most astonishing, however, and clearly his most challenging problem was how to represent the waves of the sea, how to register the painted distillation with only pen and ink. He resorted to a mixture of thinnish curvilinear combings and thicker, more incipiently three-dimensional strokes.

Van Gogh made two more drawn copies after the painting, one for John Russell (cat. 73) and one for Theo (F1430b).

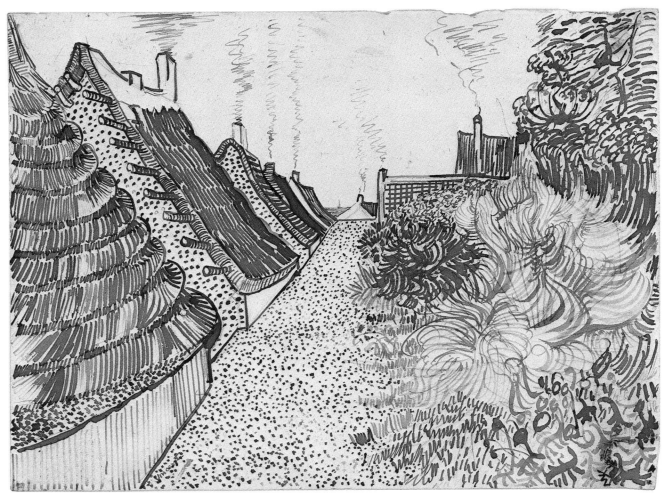

64

64. Street in Saintes-Maries-de-la-Mer

Pencil, reed pen and brown ink on wove paper,
 9⅝ × 12½ in. (24.5 × 31.8 cm.)
Signed, lower left: Vincent
The Museum of Modern Art, New York. Abby Aldrich
 Rockefeller Bequest

F1435 JH1506

Drawn after the painting *Street in Saintes-Maries-de-la-Mer* (cat. 41) and sent to Emile Bernard between 15 and 17 July.

Van Gogh followed an elaborate work sequence here, which involved four separate stages. First he made a drawing on the spot in Saintes-Maries (cat. 38), about 1 June. Back in the studio in Arles, about 5 June, he executed a painting based on the drawing (cat. 41). He then sketched the painting in a letter to Bernard, annotated with color notes (cat. 41, fig. 26), about 8 June. Stage four was reached when he made the present draw-ing from the painting, as it hung to dry in his studio in mid-July.

In this last drawing, he made major compositional readjustments. He pulled the cottages farther to the left and introduced a dominant orthogonal at their base; and he widened the small street, made it look much steeper, and cleared it of obtruding plant growth.

Such significant changes in proportion and placement do not occur to this degree in other copies done for Bernard. Nor do those sketches have such large areas of concentrated dotting. Here the dots have a triple function: they describe the street, the cottage gables, and the lowest part of the thatching on the first cottage.

The other half of the composition challenged van Gogh's capacity to reproduce a profusion of natural growth. He responded by concocting strokes that balance the descriptive and the natural against the stylized and the abstract.

To this version alone he added, as a distant speck, a sailboat on the Mediterranean.

65. Harvest in Provence

Reed pen and brown ink on wove paper, 9½ × 12⅝ in.
 (24 × 32 cm.)
Unsigned
Staatliche Museen, Berlin (German Democratic Republic)

F1485 JH1540

Drawn after *The Harvest (Blue Cart)* (fig. 36) and sent
to Emile Bernard between 15 and 17 July.

The view is across the flat plain of the Crau, with
the distant Abbey of Montmajour on its rocky hill at
far left, and the Mont de Cordes at center, its outline
confused with the faraway line of the Alpilles. Previous
to the painting, van Gogh had made two large draw-
ings of the motif, each slightly different in vantage point
(F1483, F1484). The painting in turn differs from them.
Each was an independent confrontation with the motif.

Van Gogh always considered the *Harvest* his most
important painting of the summer: "It kills everything
else I have, except a still life [cat. 29] which I patiently
worked out," he wrote in mid-June (LT498).

Oddly enough, he had never mentioned the paint-

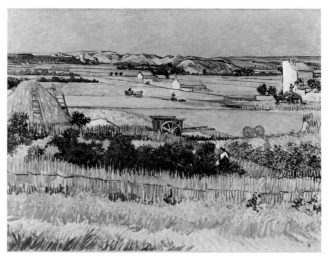

Fig. 36. *The Harvest (Blue Cart)* (F412). Oil on canvas, 28¾ ×
36¼ in. (72 × 92 cm.). Rijksmuseum Vincent van Gogh, Amsterdam

ing to Bernard, for whom he transcribed the composi-
tion in the present drawing; it, too, deviates in several
respects from the painting.

A second copy after the painting was sent to John
Russell (F1486).

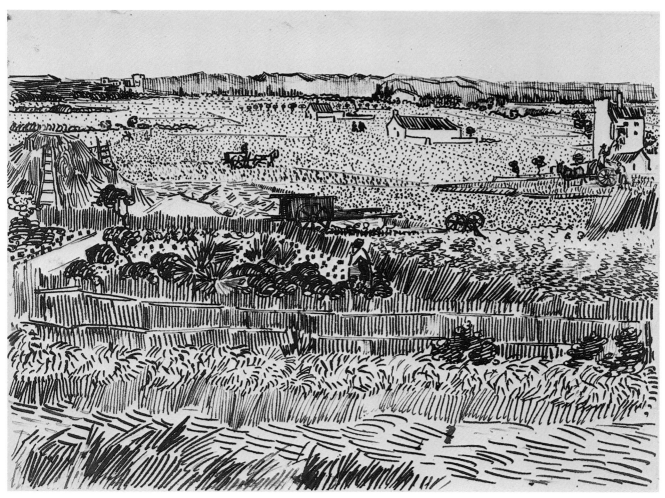

65

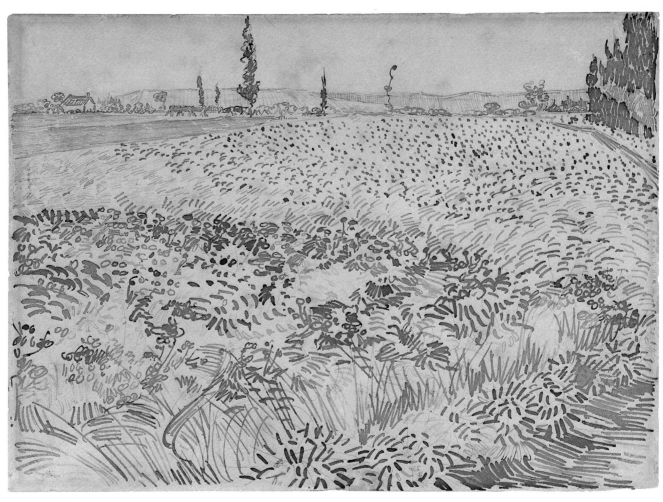

66

66. Wheat Field

Pencil, pen, reed pen and brown ink on wove paper,
 9½ × 12½ in. (24.1 × 31.7 cm.)
Unsigned
The Metropolitan Museum of Art, New York. Gift of
 Mrs. Max J. H. Rossback, 1964

F1481 JH1515

Drawn after the *Wheat Field* (cat. 46) and sent to Emile
Bernard between 15 and 17 July.

 Quickly establishing the composition in pencil, van
Gogh nonetheless made changes as he worked the draw-
ing up in pen—altering, for example, the line of the
hills. As so often happened, omissions were made in
the transcription, so that the hill behind the farmhouse
at the upper left is excluded in the drawing. Otherwise,
the daring *mise en page* and the many subtle variations
in texture and substance are superbly conveyed.

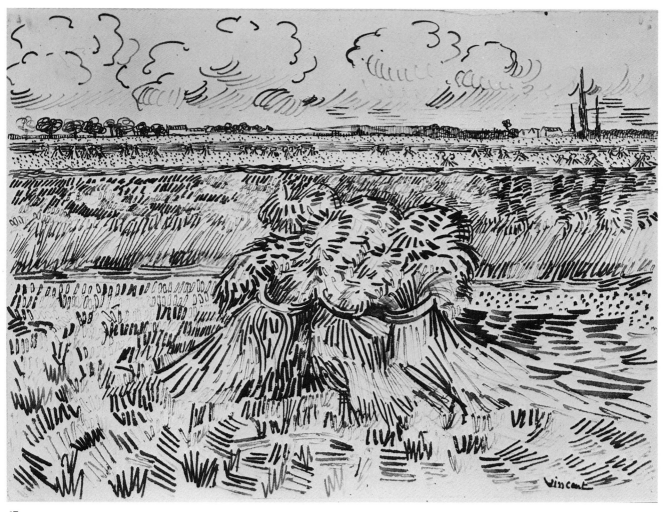

67

67. Wheat Field with Sheaves

Pencil, reed pen and brown ink on wove paper,
 9⅝ × 12⅝ in. (24.5 × 32 cm.)
Signed, lower right: Vincent
Staatliche Museen, Berlin (German Democratic Republic)

F1488 JH1517

Drawn after *Wheat Field with Sheaves* (cat. 47) and sent to Emile Bernard between 15 and 17 July.

A fortnight or so later, van Gogh also made a drawing after the same painting for John Russell (cat. 76). Comparison of the two drawings highlights the compositional differences that could arise in separate copies of the same painting. Russell's drawing is closer to the painting. In Bernard's, the foreground sheaves are shifted to a central position and the horizon is lower. Skies tend to be left untouched in Bernard's set of drawings; here a few squiggles suggest the fleecy clouds of the painting. As in the two panoramic views from Montmajour (cat. 57, 58), the dots signify stubble.

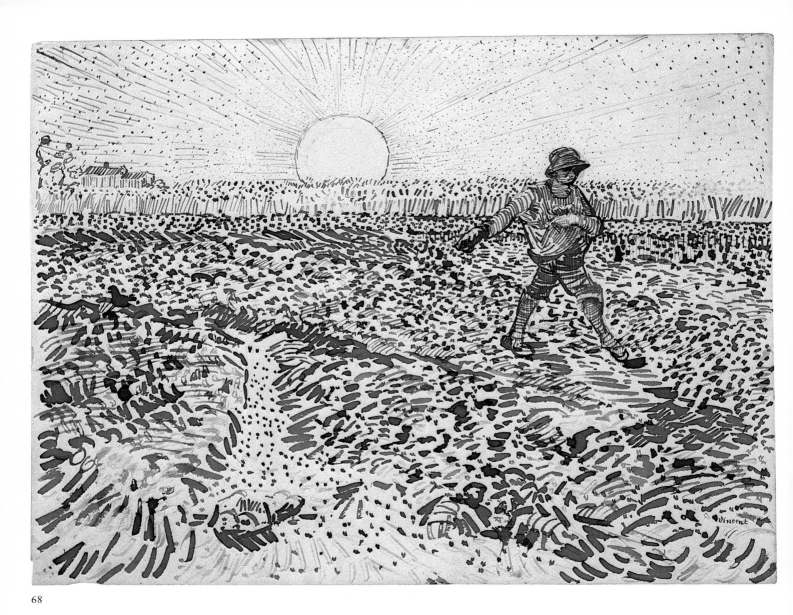

68

68. The Sower

Pencil, reed pen and brown ink on wove paper,
 9⅝ × 12½ in. (24.5 × 31.7 cm.)
Signed, lower right: Vincent
Private collection, New York

F1442 JH1508

Drawn after *The Sower* (cat. 49) and sent to Emile Bernard between 15 and 17 July.

 Bernard had received a letter of about 18 June with a page showing a rapid sketch, with color notes, of a recently completed painting of a sower (see cat. 49). A week later, about 25–26 June, van Gogh considerably reworked the painting, redefining above all the pose of the sower. The present drawing was made after this second and final state, which it follows quite closely. The seemingly schematic band of dots immediately in front of the uncut wheat represents stubble, as distinct from the rest of the field, which has been ploughed.

 Van Gogh did not send a drawing after *The Sower* to John Russell, who had already received a sketch in a letter of the first state of the painting (see cat. 151). But in early August he did send Theo, who had not previously seen a sketch of the work in any state, a second drawing (cat. 83) after the final painting.

69. Summer Evening

Pencil, pen, reed pen and brown ink on wove paper,
 9½ × 12½ in. (24.2 × 31.6 cm.)
Unsigned
Kunstmuseum, Winterthur

F1514 JH1546

Drawn after the painting *Summer Evening* (fig. 37) and sent to Emile Bernard between 15 and 17 July.

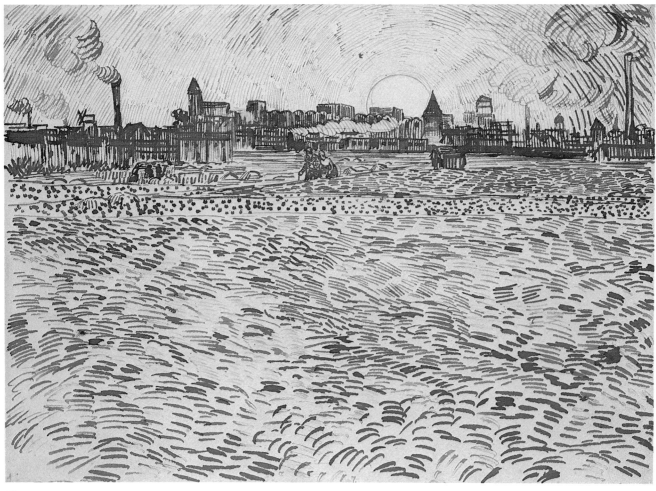

69

Hitherto, this drawing has been assumed to be one of the "small" set sent to Theo on 8 August. But it lacks the controlled and harmonious touch of the five drawings Theo is known to have received (see cat. 82–84). Far more hastily done, it fits much more comfortably into the Bernard set. Compare, for example, the treatment of buildings and sky with that in *La Roubine du Roi with Washerwomen* (cat. 70) and *Arles: View from the Wheat Field* (F1491), and the treatment of the windswept wheat with that in *Wheat Field* (cat. 66).

There are significant differences between drawing and painting. The drawing shows the painting in its first state in mid-July, a month or so after it was finished. In September, the painting was extensively reworked in the silhouette of the town—especially in the addition of more chimneys—and in color changes. In early October, after the reworking, van Gogh sent it to Bernard at Pont-Aven as one of the seven paintings for the proposed exchange of works.

By then, Bernard would have had a fairly complete dossier on this composition: the sketch in a letter (B7) sent to him soon after the picture was painted in June; the present drawing, sent to him in mid-July, showing the picture in its first state; and finally the picture itself, as it had been recently reworked.

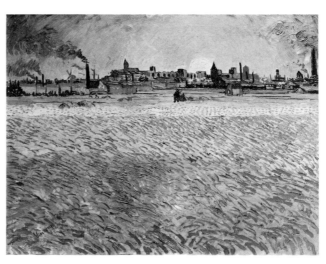

Fig. 37. *Summer Evening* (F465). Oil on canvas, 29⅛ × 35⅞ in. (74 × 91 cm.). Kunstmuseum, Winterthur

135

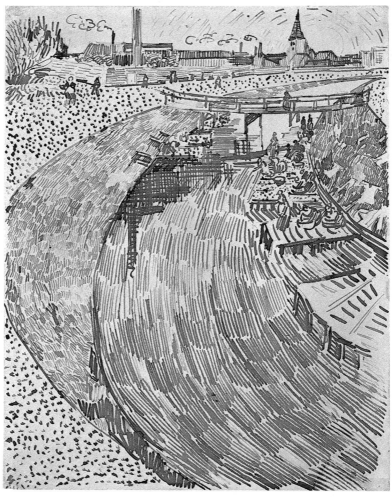

70

70. La Roubine du Roi with Washerwomen

Reed pen and ink on wove paper, 12⅜ × 9½ in.
 (31.5 × 24 cm.)
Unsigned
Rijksmuseum Kröller-Müller, Otterlo

F1444 JH1507

Drawn after the painting *La Roubine du Roi with Washerwomen* (cat. 50) and sent to Emile Bernard between 15 and 17 July.

The drawing is executed entirely in pen, with no preparatory pencil work. (The small pencil additions at top left and lower right are by a later hand, making up lost or damaged areas.) The graphic system is logically applied, each specific area or physical element having its own system of emblematic signs: bunched parallel lines for the water, smaller and denser striations for the sides of the canal, crosshatchings in the water for the shadows thrown by the setting sun, dots for the paths on either side of the canal, and simple horizontal and vertical hatchings for the gasworks.

Interestingly, among the "sketches of Provence"

made for Bernard, van Gogh included two townscapes (the present drawing and cat. 71), each of which could almost represent a suburb of Paris. And as if to underline the point, he sent no such drawings either to John Russell or to Theo.

Compare the treatment of the same motif in the first batch of drawings done in Arles (see cat. 22).

71. The Trinquetaille Bridge

Pencil, reed pen and ink on wove paper, 9⅝ × 12½ in.
 (24.3 × 31.6 cm.)
Unsigned
Private collection

F1507 JH1469

Drawn after the painting *The Trinquetaille Bridge* (fig. 38) and sent to Emile Bernard between 15 and 17 July.

This view shows the Rhône from the Arles side, with the suburb of Trinquetaille across the river, connected by the iron bridge that opened in 1875. The drawing deviates considerably from the painting. The

bridge is more diagonalized and its three visible supports are differently placed, setting up new relationships with middle-ground elements. In addition, the exaggeratedly large walking figure is radically altered. (Was this simply a new invention specially done for the drawing, or would X-ray examination reveal that van Gogh reworked the figure before sending the painting to Theo a month later?)

Like *La Roubine du Roi with Washerwomen* (cat. 70), this drawing is a rare choice of townscape among the "sketches of Provence" intended to remind Bernard of Cézanne. This one clearly served a different function: it must have reminded Bernard of the quays, bridges, and yachts of the Seine at Asnières and Clichy, where he and van Gogh had spent time together in 1887.

A distant view of the same bridge appears in one of the early group of small drawings (cat. 21); a closeup view, with its pedestrian approach by stone steps, is the subject of an October painting (cat. 110).

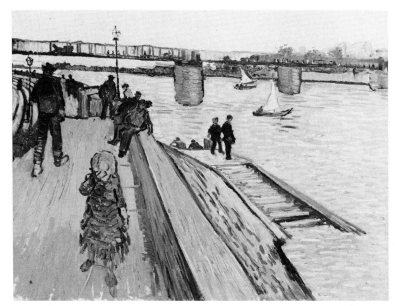

Fig. 38. *The Trinquetaille Bridge* (F426). Oil on canvas, 25⅝ × 31⅞ in. (65 × 81 cm.). Private collection

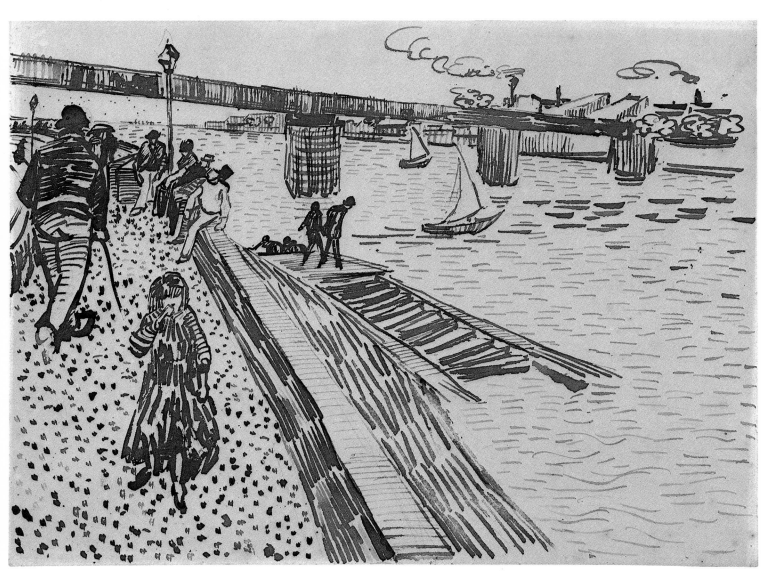

72. Garden with Weeping Tree

Pencil, reed pen and brown ink on wove paper,
 9½ × 12½ in. (24.2 × 31.6 cm.)
Signed, lower left: Vincent
Private collection, New York

F1450 JH1509

Drawn after the painting *Garden with Weeping Tree* (cat. 60) and sent to Emile Bernard on Sunday 15 July.

 This is the only one of the set of fifteen drawings destined for Bernard that is actually referred to in the letters. Responding to some verses by Bernard, van Gogh wrote: "In the sketch 'The Garden' maybe there is something like 'Des tapis velus / De fleurs et verdures tissus' [Shaggy carpets woven of flowers and greenery], by Crivelli or Virelli, it doesn't matter much which" (B10).

 After he completed a second painting of this motif in mid-September (cat. 104), which by then he had come to call the Poet's Garden, he reminded Bernard that "among the sketches you have there is the first conception of it, done after a smaller study that is already at my brother's" (B18, 3 October).

 The daring economy and loose sketchiness of this drawing can be compared with the more deliberately finished and ultimately more stylized drawing of the same motif made for Theo in early August (cat. 84).

73. Fishing Boats at Saintes-Maries-de-la-Mer

Pencil, reed pen and brown ink on wove paper,
 9⅝ × 12⅝ in. (24.3 × 31.9 cm.)
Unsigned
The Solomon R. Guggenheim Museum, New York
 The Justin K. Thannhauser Collection

F1430a JH1526

Drawn after the painting *Little Seascape at Saintes-Maries-de-la-Mer* (cat. 40) between 31 July and 3 August and sent to John Russell in Belle Ile, Brittany.

 In both this drawing and the drawing after the same painting sent to Emile Bernard in mid-July (cat. 63), van Gogh followed the composition fairly closely. In Russell's version, however, he accentuated the curves of the sails, though not in the unduly stylized manner that characterizes the drawing he sent to Theo (F1430b). As with all but one of the landscape drawings for Russell (cat. 79), he filled the sky with dots.

74. Fishing Boats at Saintes-Maries-de-la-Mer

Pencil, reed pen and brown ink on wove paper,
 9⅝ × 12½ in. (24.3 × 31.9 cm.)
Unsigned
Private collection

F1433 JH1528

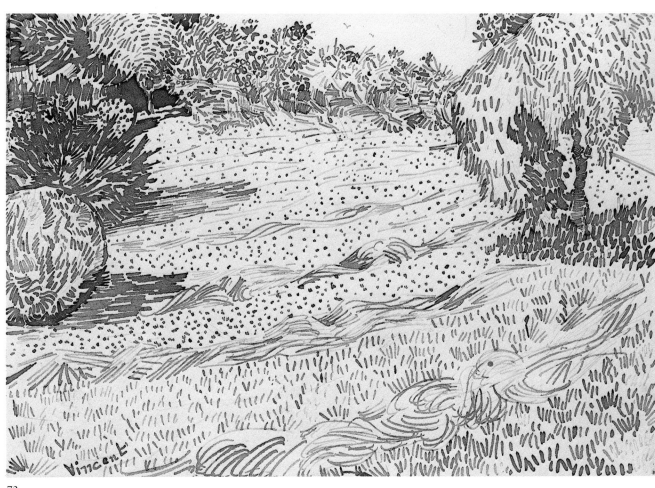

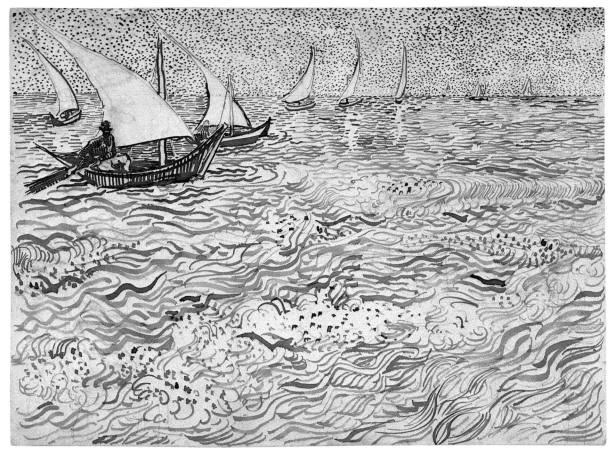

73

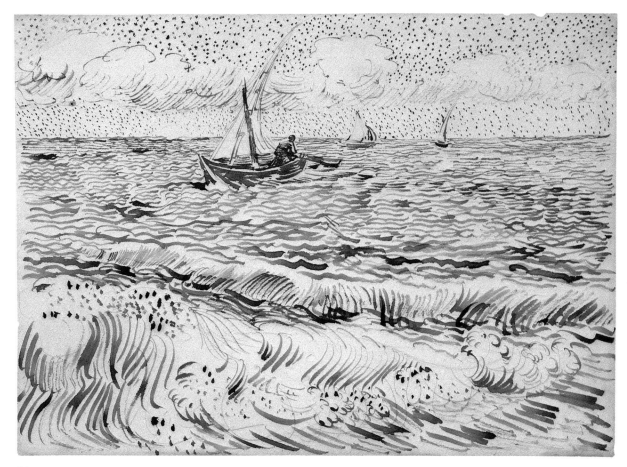

74

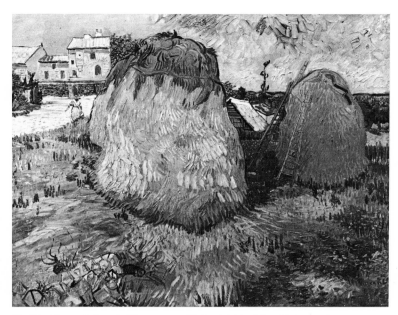

Fig. 39. *Haystacks* (F425). Oil on canvas, 28¾ × 36⅝ in. (73 × 92.5 cm.).
Rijksmuseum Kröller-Müller, Otterlo

Drawn after the painting *Seascape at Saintes-Maries-de-la-Mer* (cat. 39) between 31 July and 3 August and sent to John Russell in Belle Ile, Brittany.

This drawing follows the painting fairly closely, although the pose of the fisherman in the nearest boat has been changed and the mast is more upright. The cloudy sky is conveyed by a rhythmic dispersal of dots. The waves are more sparingly indicated than in *Fishing Boats at Saintes-Maries-de-la-Mer* (cat. 73). Indeed, here the touch is lighter and the surface less worked, as they are also in comparison with the drawing after the same painting sent to Theo on 8 August (F1431).

75. Haystacks

Reed pen and brown ink on wove paper, 9½ × 12¼ in.
 (24 × 31 cm.)
Signed, lower left: Vincent
Philadelphia Museum of Art. The Samuel S. White III
 and Vera White Collection

F1427 JH1525

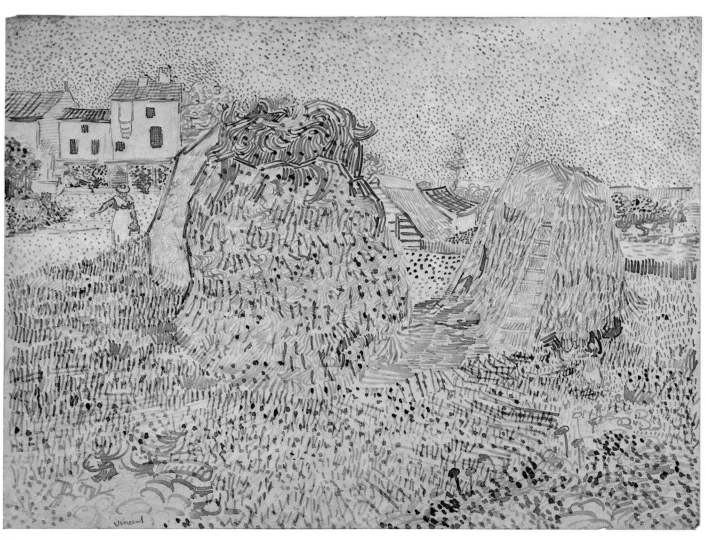

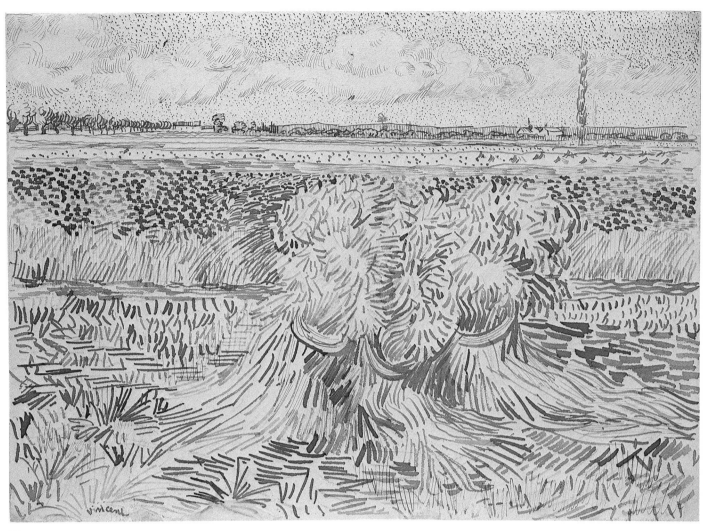

76

Drawn after the painting *Haystacks* (fig. 39) between 31 July and 3 August and sent to John Russell in Belle Ile, Brittany.

There are no radical departures from the painting in overall layout or individual elements, but the composition reads more as surface pattern. The uniformly dotted sky and the combination of variously sized stabs and short linear strokes (as if aspiring to be musical notation) assist this flattening process. There are, moreover, no strong contrasts in the ink. In all these ways, the drawing differs strongly from the one sent earlier to Emile Bernard (F1426), where the vibrant strokes and rhythmic whorls in the haystacks presage elements of the Saint-Rémy style.

76. Wheat Field with Sheaves

Pencil, pen, reed pen and black ink on wove paper,
 9½ × 12½ in. (24.2 × 31.7 cm.)
Signed, lower left: Vincent
Private collection, Switzerland

F1489 JH1530

Drawn after the painting *Wheat Field with Sheaves* (cat. 47) between 31 July and 3 August and sent to John Russell in Belle Ile, Brittany.

A comparison with the drawing after the same painting sent to Emile Bernard in mid-July (cat. 67) shows how these transcriptions could vary, not only in morphology of stroke but also in compositional elements. There is a slight shift in the proportion of landscape to sky; and in Bernard's version the foreground sheaves are more centrally placed.

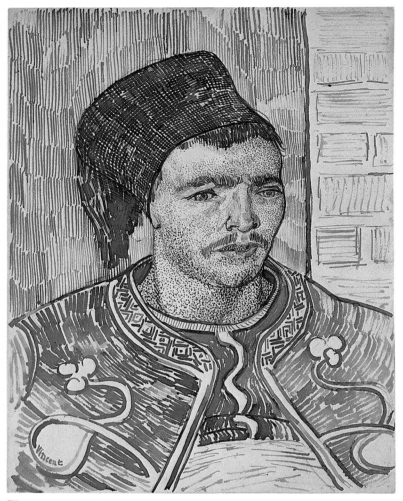

77

"a boy with a small face, a bull neck, and the eye of a tiger" (LT501, c. 21 June). Face and neck, left untouched in Bernard's version, are here modeled with dots, varied in density, creating light and shadow. The function of the dot is rigorously defined in this drawing, whereas in *La Mousmé* (cat. 81), also sent to Russell, it is allowed to suggest the background as well. Bunches of vertical hatchings simulate the green door of the painting, and a close-meshed crosshatching renders the reddish cap.

78. The Road to Tarascon

Pencil, reed pen and brown ink on wove paper,
 9⅛ × 12½ in. (23.2 × 31.9 cm.)
Signed, lower right: Vincent
The Solomon R. Guggenheim Museum, New York
 The Justin K. Thannhauser Collection

F1502a JH1531

Drawn between 31 July and 3 August and sent to John Russell in Belle Ile, Brittany.

This drawing is usually said to have been made after the destroyed painting *The Painter on the Road to Tarascon* (fig. 40). But there is a radical change in format, and many differences in composition. In the painting there is less sky, no sun, and no band of cypresses at right; there is more road, the foreground

77. The Zouave

Pencil, reed pen, quill pen and brown ink on wove paper,
 12½ × 9⅝ in. (31.9 × 24.3 cm.)
Signed, lower left: Vincent
The Solomon R. Guggenheim Museum, New York
 The Justin K. Thannhauser Collection

F1482a JH1535

Drawn after the painting *The Zouave* (cat. 53) between 31 July and 3 August and sent to John Russell in Belle Ile, Brittany.

In the version sent to Emile Bernard in mid-July (cat. 62), van Gogh extends the display of uniform compared with that in the June painting, working it up in color and enhancing the Zouave's picturesque appearance. In Russell's version he does the opposite, reducing the spread of the uniform on three sides, increasing concentration on the Zouave's squat and powerful head, and conveying to the full his description of the model,

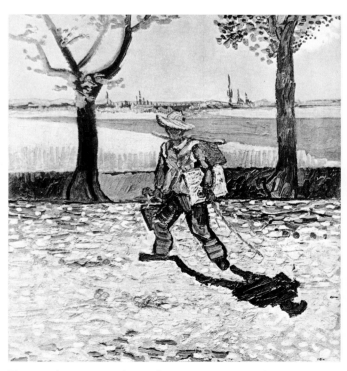

Fig. 40. *The Painter on the Road to Tarascon* (F448). Oil on canvas, 18⅞ × 17⅜ in. (48 × 44 cm.). Destroyed; formerly Kaiser Friedrich Museum, Magdeburg

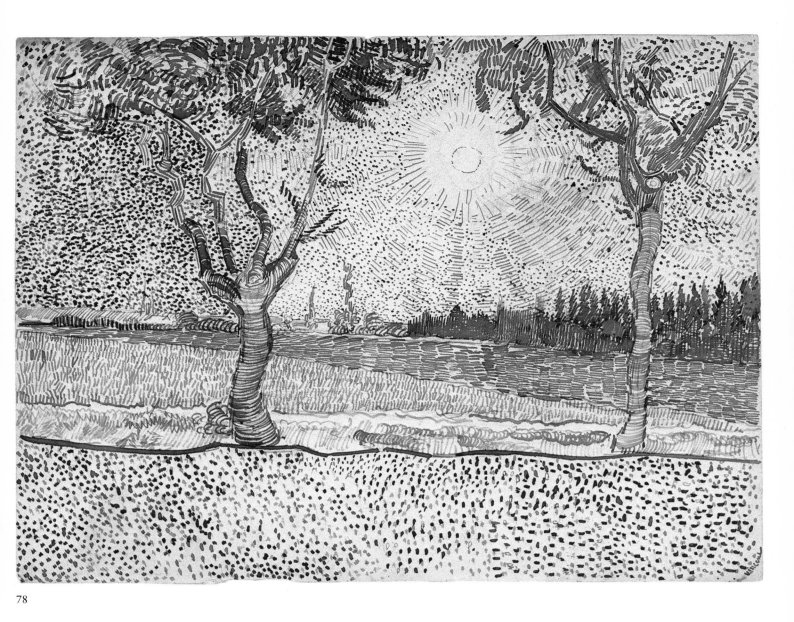

78

trees are more columnar, and of course there is a figure. The motifs are comparable in general layout, but then the road to Tarascon was characterized for a two-mile stretch by trees and flat fields.

Given the horizontal format of the drawing, it would seem more likely that it was made after another landscape painting, now lost and not mentioned in the letters.

The drawing repeats certain of van Gogh's graphic conventions. The dot, for example, is consistently used for path or road in the drawings for both Bernard and Russell. Additionally, dots are used extensively in the drawings to Russell to signify sky. Here they also help signify the northerner's joyous celebration of sunrise. And there is something northern in the Gothic sway

and twist and ringlike modeling of the tree trunk at left, as if a tree from the vicarage garden at Nuenen (F1128) had been transplanted to Arles—a remarkable piece of idiosyncratic northern intrusion into the Provençal landscape.

Different stretches of the same Tarascon road appear in some of the early drawings and paintings (see cat. 16–18; F567). The same landscape recurs in a painting of October (F573) and also in the last of the 1888 series of sowers (cat. 128, 129).

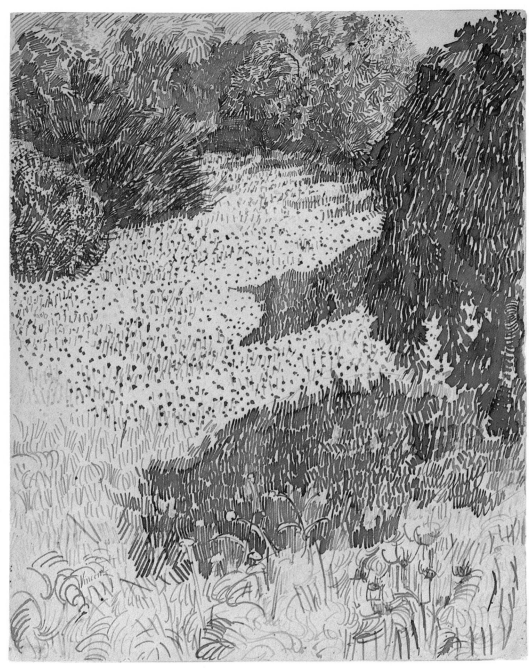

79

79. Garden with Weeping Tree

Pencil, reed pen and brown ink on wove paper,
 12⅜ × 9⅝ in. (31.5 × 24.5 cm.)
Signed, lower left: Vincent
Private collection

F1449 JH1534

Drawn between 31 July and 3 August and sent to John
Russell in Belle Ile, Brittany.

While the motif is immediately recognizable as the weeping tree in the Place Lamartine garden (see cat. 60, 72), the upright format and the fall of shadows, implying a quite different time of day, suggest that the drawing was made after a lost painting. As with *The Road to Tarascon* (cat. 78), there is no mention of such a picture in the letters. The existence of two paintings of the same motif in both vertical and horizontal versions is by no means unknown: compare, for example, the two versions of the *Flowering Garden* (cat. 61, 80).

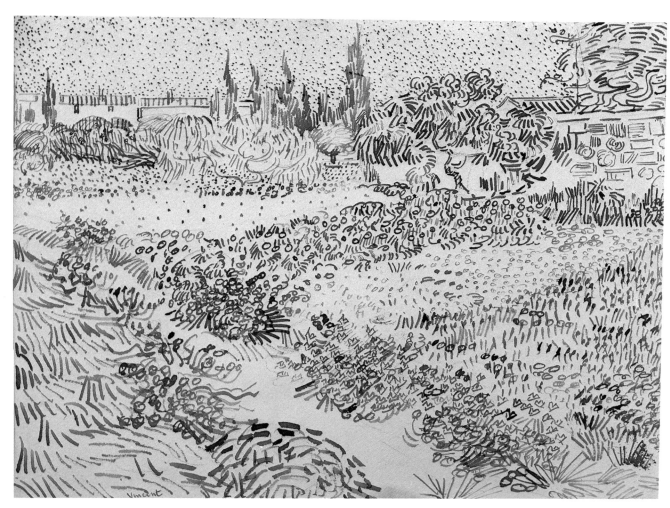

80

80. A Flowering Garden

Pencil, reed pen and brown ink on wove paper,
 9½ × 12⅜ in. (24.1 × 31.4 cm.)
Signed, lower left: Vincent
Private collection, U.S.A.

F1454 JH1532

Drawn after the painting *A Flowering Garden* (F429) between 31 July and 3 August and sent to John Russell in Belle Ile, Brittany.

 About 19 July, van Gogh wrote to Theo: "I have a new drawing of a garden full of flowers, and two painted studies as well" (LT512); and he sketched in the same letter the upright version (cat. 61, fig. 34). Russell alone received a drawing, the present one, after the horizontal version, while Theo was sent the large independent drawing (cat. 61, fig. 35).

 The spare and laconic style, with much untouched paper, is unusual among the drawings destined for Russell.

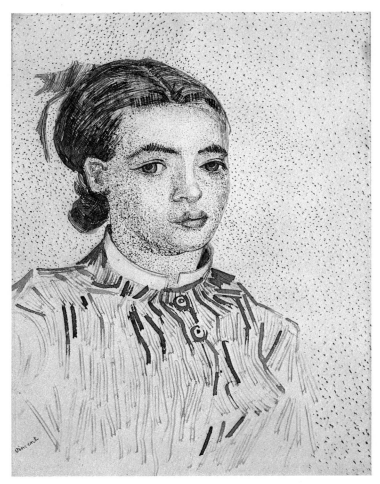

81

81. La Mousmé

Pen, reed pen and brown ink on wove paper, 12⅜ × 9½ in.
 (31.5 × 24 cm.)
Signed, lower left: Vincent
Thomas Gibson Fine Art, Ltd., London

F1503 JH1533

Drawn after the painting *La Mousmé* (cat. 91, fig. 41)
between 31 July and 3 August and sent to John Russell
in Belle Ile, Brittany.

The portrait of the *mousmé*, "a Japanese girl—
Provençal in this case—twelve to fourteen years old,"
was painted in a week, probably between 18 and 25
July (LT514). Shortly afterward, van Gogh began work
on his twelve drawings for Russell. This drawing, then,
almost comes into the category of a sketch after a re-
cently completed work.

However, instead of copying the entire figure seated
in the cane chair, van Gogh concentrated on the head
and shoulders, accentuating the Oriental look by mak-
ing the eyes larger and more almond-shaped. In realiz-
ing his drawn equivalent, he allowed both the deliberate
and the accidental to play their roles. The dot, for
example, is used systematically to model the face and
to activate the background, while the "tramways" left
by the reed pen beautifully suggest the sitter's striped
bodice.

Compare also the drawing after the same painting
sent to Emile Bernard in August (cat. 91).

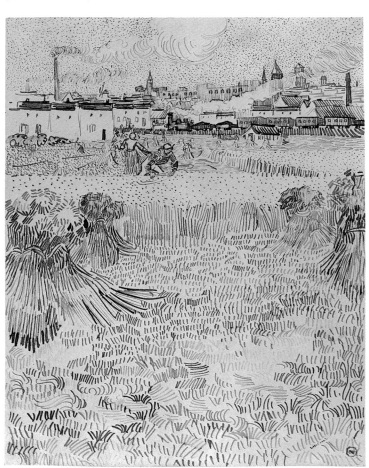

82

82. Arles: View from the Wheat Fields

Reed pen and brown ink on wove paper, 12¼ × 9½ in.
 (31.2 × 24.2 cm.)
Signed, lower right: Vincent
Private collection

F1492 JH1544

Drawn after the painting *Arles: View from the Wheat
Fields* (cat. 48) during the first week of August and sent
to Theo in Paris on 8 August.

This is one of three drawings made after the same
harvest painting. The other two are F1491, sent to
Emile Bernard, and F1490, sent to John Russell. A
comparison of the three underscores the fact that van
Gogh was not attempting to make perfectly accurate
copies, like reproductive engravings. Each drawing has
a quite separate identity showing variations from the
parent painting; and each differs from the other two in
handling as well as compositional format. Bernard's is
looser and more summary; Russell's is worked all over
its surface, and the town is pushed farther away; Theo's
is an attempt to demonstrate the clearness of touch that
van Gogh felt was sometimes lacking in his paintings.

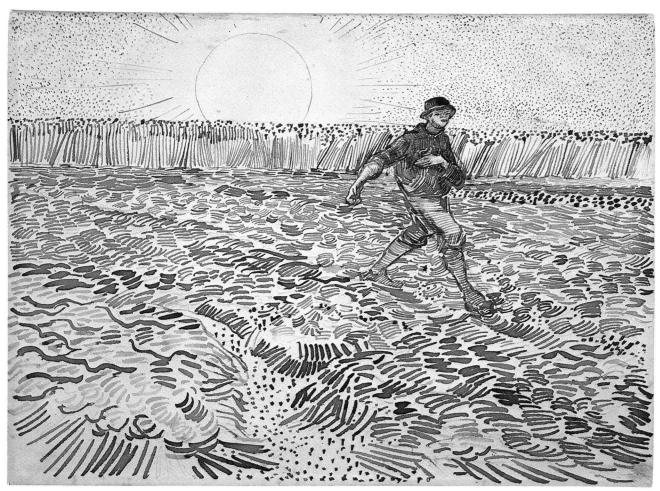

83

83. The Sower

Pencil, reed pen, brown and black ink on wove paper,
 9⅝ × 12½ in. (24.3 × 31.9 cm.)
Unsigned
Rijksmuseum Vincent van Gogh, Amsterdam

F1441 JH1543

Drawn after the painting *The Sower* (cat. 49) during
the first week of August and sent to Theo in Paris on 8
August.

 Van Gogh used pencil rapidly to establish the layout
of both figure and landscape. In working up the compo-
sition with pen, however, he changed his initial inten-
tions, so that the sower's stride is made wider and more
purposeful than in the painting itself, or in the copy for
Emile Bernard (cat. 68).

 Bernard's copy is much closer to the painting than
Theo's. For his brother, van Gogh eliminated the house
and tree at left, increased the height of the uncut wheat,
and considerably enlarged the sun. The composition
becomes simpler, grander, more elemental.

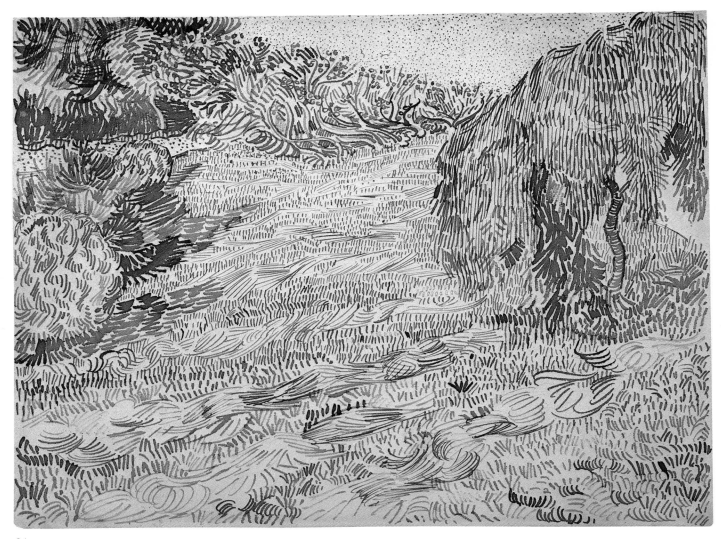

84

84. Garden with Weeping Tree

Reed pen and black ink on wove paper,
 9½ × 12⅜ in. (24.1 × 31.5 cm.)
Unsigned
Collection Mrs. John de Menil

F1451 JH1545

Drawn after the painting *Garden with Weeping Tree* (cat. 60) during the first week of August and sent to Theo in Paris on 8 August.

Van Gogh had already drawn his favorite garden in the Place Lamartine for Emile Bernard, in a looser and more improvised style (cat. 72). He chose not to send John Russell a drawing after the painting, but instead selected an alternative view (cat. 79), evidently after a lost painting. In this drawing for Theo, he was anxious to clarify the painted composition: for example, he makes clear that a path exists in the upper left, conveyed, as in all the drawings, by a system of dots.

Typical of the small group of drawings sent to Theo is the creation of contrasting stylized rhythms: the thin vertical lines in the weeping tree, the interlaced skeins of the cut grass, and the curvilinear patterning of the oleander bushes.

85. Garden with Sunflowers

Pencil, reed pen and brown ink on Whatman paper,
 23⅞ × 19⅛ in. (60.5 × 48.7 cm.)
Watermark: J. Whatman Turkey Mill 1879
Signed, lower right: Vincent
Rijksmuseum Vincent van Gogh, Amsterdam

F1457 JH1539

On 8 August van Gogh told Theo: "I have just sent off three big drawings. . . . The one with the sunflowers is a little garden of a bathing establishment. . . . Under the

blue sky the orange, yellow, red splashes of the flowers take on an amazing brilliance, and in the limpid air there is something or other happier, more lovely than in the North. It vibrates like the bouquet by Monticelli which you have. I reproach myself for not painting flowers here" (LT519).

Not quite true: he had painted a still life of wild-flowers in a jug in mid-May (F600). But the *Garden with Sunflowers* suggests a monumental outdoor still life, with its decorative calligraphy of potted plants and sunflowers segregated on their table-island. (A fortnight later, sunflowers would be taken indoors to inspire his most famous series of flower still lifes.)

The now statutory dotted sky (first announced in *Garden in Provence*, cat. 61, fig. 35) reappears here. The presence of a cat is unique in the Arles work. And van Gogh has wittily added his signature on the bucket.

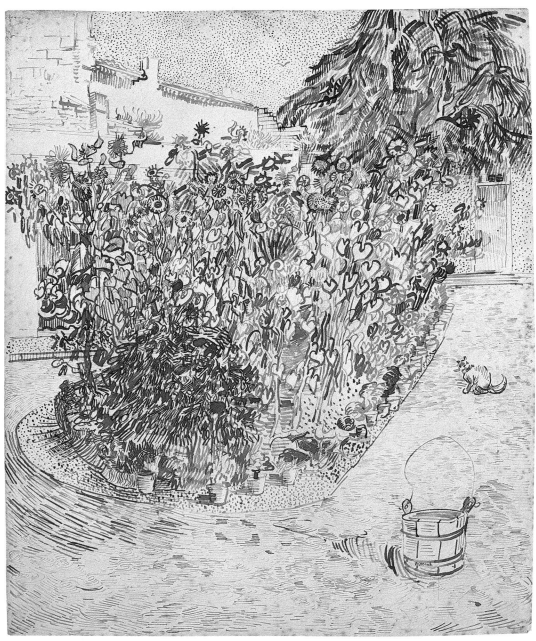

85

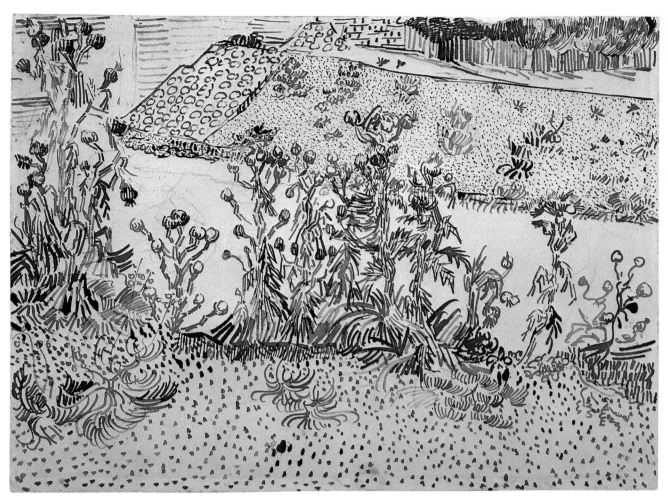

86

86. Thistles Along the Roadside

Pencil, reed pen and brown ink on wove paper,
 9⅝ × 12⅝ in. (24.3 × 32 cm.)
Unsigned
Rijksmuseum Vincent van Gogh, Amsterdam

F1466 JH1552

About 13 August, van Gogh wrote to Theo: "As to
[painted] studies, I have two studies of thistles in a vague
field, thistles white with the fine dust of the road"
(LT522). Only one of these paintings survives (F447).
The motif of the lost painting may well be reproduced
in the present drawing, although almost certainly as an
independent confrontation.

 This drawing is a lexicon of van Gogh's incessantly
inventive graphic expression. By excluding the sky and
forcing one to examine the selected fragment of roadside,
he created a composition with a subtle interplay be-
tween a heightened naturalistic observation and a will
to stylization. The compressed closeup causes spatial
ambiguities, rapid changes of scale, leaving the precise
identity of certain areas difficult to decipher. But the
entire sheet is infused with a vital, organic energy.

Joseph-Etienne Roulin

For a friend who loomed so large in van Gogh's life and art in Arles, the "postman" Roulin came relatively late on the scene. There is not a hint of his existence before late July, whereas Eugène Boch and the Zouave Milliet (see cat. 98, 100) were often described to Theo long before their portraits were painted. If his entrance was unheralded, it was nonetheless greeted with a fine descriptive flourish.

In two letters of Tuesday 31 July, van Gogh announced, first to his sister Wil: "I am now engaged on a portrait of a postman in his dark blue uniform with yellow. A head somewhat like Socrates, hardly any nose at all, a high forehead, bald crown, little gray eyes, bright red chubby cheeks, a big pepper-and-salt beard, large ears. This man is an ardent republican and socialist, reasons quite well, and knows a lot of things. His wife was delivered of a child today, and he is consequently feeling as proud as a peacock, and is all aglow with satisfaction" (W5).

And then to Theo: "I am now at work with another model, a postman in a blue uniform trimmed with gold, a big bearded face, very like Socrates. A violent republican like Tanguy. A man more interesting than most" (LT516).

Roulin was not, technically speaking, a postman, whom van Gogh would have seen daily delivering letters; rather, he was an *entreposeur des postes* who handled the mail at the railroad station. He lived just to the north of van Gogh at 10 Rue de la Mont de Cordes, between the Yellow House and the station, and he frequented the nearby Café de la Gare, run by Joseph Ginoux and his wife Marie, where van Gogh had a room from early May to mid-September. Van Gogh was attracted to him by his easygoing, colorful character and striking appearance, his political opinions, and his drinking. In early April 1889, he would write: "Roulin, though he is not quite old enough to be like a father to me, nevertheless has a salient gravity and a tenderness for me such as an old soldier might have for a young one. All the time—but without a word—a something which seems to say, We do not know what will happen to us tomorrow, but whatever it may be, think of me. And it does one good when it comes from a man who is neither embittered, nor sad, nor perfect, nor happy, nor always irreproachably just. But such a good soul and so wise and so full of feeling and so trustful" (LT583).

Joseph-Etienne Roulin was forty-seven when he first sat for van Gogh. In November 1888, not only Roulin but his entire family—his wife, two sons, and baby daughter—were painted by the artist (see cat. 132–136).

87. Portrait of Joseph Roulin

Oil on canvas, 32 × 25¾ in. (81.2 × 65.3 cm.)
Unsigned
Museum of Fine Arts, Boston. Gift of Robert Treat Paine II

F432 H461 SG56 JH1522

This is the first and largest portrait that van Gogh did of Joseph Roulin. Sittings began toward the end of July. Certainly it was under way by 31 July (LT516), said to be still in progress on 3 August (LT517), and reported as finished by Monday 6 August (LT518).

In letters to Theo and to his sister Wil, van Gogh talked of the man, his appearance, his character, his opinions, never actually describing the painting, apart from the sitter's dark blue and yellow uniform. It was only in writing to Emile Bernard, almost certainly on Saturday 4 August, that he said more about the color: "A Socratic type, none the less Socratic for being somewhat addicted to liquor and having a high color as a result. . . . A blue, nearly white background on the white canvas, all the broken tones in the face—yellows, greens, violets, pinks, reds. The uniform Prussian blue with yellow adornments" (B14).

"He is a terrible republican, like old Tanguy," he wrote to Bernard, as he had to Theo, adding: "God damn it! what a motif to paint in the manner of Daumier, eh!" Images of Daumier permeated life in Arles for van Gogh: he found them in his studio, in the adjacent square, in figures seen in the street. He equated Daumier socially with drink, politically with the republican left, and artistically with the ability to capture the essence of a model quickly, in a few bold strokes. He saw these aspects potentially brought together in his portrait of Roulin. But, he complained, Roulin posed stiffly: "I do not know if I can paint the postman *as I feel him*. . . . I once watched him sing the 'Marseillaise,' and I thought I was watching '89, not next year, but the one ninety-nine years ago. It was a Delacroix, a Daumier, straight from the old Dutchmen" (LT520). Van Gogh was here thinking of Frans Hals and Rembrandt, two artists whose virtues he was extolling at the time in letters to Bernard.

The portrait was done after *La Mousmé* (cat. 91, fig. 41). There is no evidence of any intervening paintings between the completion of the girl's portrait and the beginning of Roulin's, although during the days Roulin posed for him, van Gogh was also busy with the dozen drawings for Russell (see cat. 73–81). He posed Roulin in the same cane chair as the *mousmé*. But he changed the background color from a greenish white to a bluish white, shifted the axis of the chair, and pulled Roulin's torso parallel to the picture plane. Whereas the *mousmé* occupies the chair with great aplomb, as if she were organically united to it, Roulin appears rather ungainly and ill at ease.

Yet was it all the fault of Roulin? His awkward pose could have something to do with the compositional scheme. First, the table is introduced not so much as an armrest (to ease the model's tenseness) as to imply its use as a repository for a glass of beer, to suggest the notion of Roulin as Drinker. Second, it creates a complex pattern by its assertive diagonal placement, echoed in the longer, but interrupted, diagonal on the floor. The floor is that of van Gogh's studio, whose distinctive red tiles so dominate *The Seated Zouave* (cat. 52, fig. 31), *A Pair of Shoes* (cat. 94), and *Van Gogh's Chair* (cat. 141); here, however, van Gogh has grayed them, thereby reducing their impact. The bluish white wall, receding in space, also creates a diagonal, which is contradicted by the flat parallel-to-the-picture-plane basket-weave strokes, so prominent to the right of Roulin's head.

What appears so simple in its awkwardness turns out to be awkward in its apparent simplicity.

88. Portrait of Joseph Roulin

Oil on canvas, 25¼ × 18⅞ in. (64 × 48 cm.)
Unsigned
Collection Mr. and Mrs. Walter B. Ford II

F433 H466 JH1524

Because Roulin posed so stiffly for his first portrait (cat. 87), van Gogh painted a second one, "a life-size head," in a single sitting. This gentler portrait was probably painted on 1 or 2 August. It cannot be later, because one of the twelve drawings sent to John Russell by 3 August (cat. 89) was done after this picture.

By excluding the chair and painting Roulin in an uncomplicated frontal pose, without arms or hands showing, van Gogh concentrated attention on the head; Roulin's "high color," his "little gray eyes [and] bright red chubby cheeks" were made the object of painterly investigation.

The light comes from the right, but the conventional vertical division of the head into light and shadow is expressed through color. Compared with the half-length portrait, the glance is softer. There are also slight

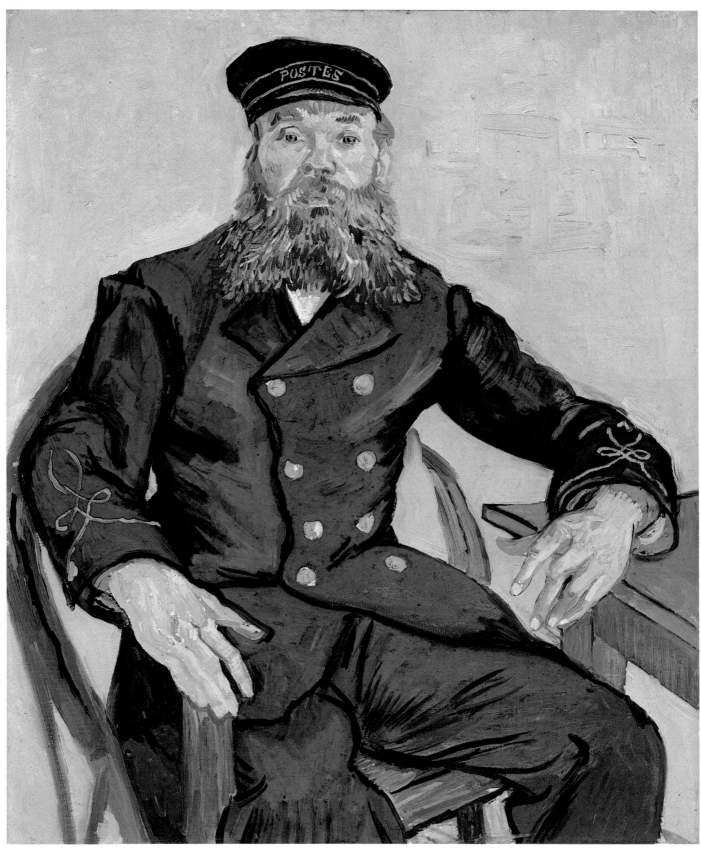

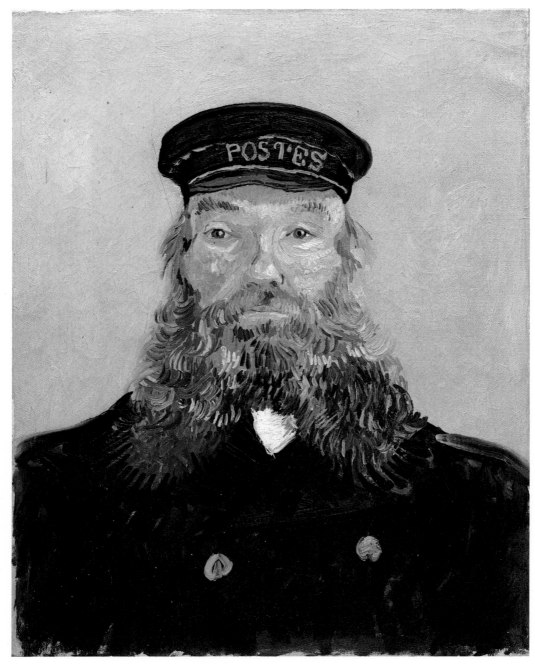

88

changes in cap, beard, hair, and ear. The palette scarcely alters (van Gogh used Tasset's paints for both portraits).

A fortnight after it was painted, in mid-August, Milliet took it to Paris along with thirty-five other rolled canvases (see cat. 100). Van Gogh wrote to Theo: "I have kept the big portrait of the postman, and the head which I included was done at a *single sitting*. But that's what I'm good at, doing a fellow roughly in one sitting. If I wanted to show off, my boy, I'd always do it, drink with the first comer, paint him, and that not in water-colors but in oils, on the spot, in the manner of Daumier" (LT525).

89. Portrait of Joseph Roulin

Reed pen, quill pen and ink, 12½ × 9⅝ in.
 (31.8 × 24.3 cm.)
Unsigned
Private collection, Switzerland

F1458 JH1536

This powerful drawing must have been done the same day van Gogh finished the "life-size head" of Roulin (cat. 88), on either 1 or 2 August: the cap (position, visor, and lettering), the spread of the beard, the scarcely visible ear, and the light coming from the right are all

closer to that portrait than to the "half-length with hands" (cat. 87), the earlier of the two. It celebrated van Gogh's completion of the second portrait, and was immediately dispatched to John Russell as one of the dozen drawings done after painted studies (see cat. 73–81).

Using the reed pen, van Gogh produced forceful crosshatching in the coat, layers of striated strokes in the cap, and a contrast of spiky and rounded hatchings in the beard. The fine web of quill strokes is similar to that in *The Zouave* (cat. 77), where it suggests a brick wall; and the basket-weave effect is seen in both the painted studies, although it is more apparent in the "half-length with hands." In "copying," van Gogh allowed himself to improvise and transform, so that such details as the buttons—one as opposed to two—and the styling of the lapels differ from those in the painted model.

90. Portrait of Joseph Roulin

Pen and ink, 12⅝ × 9½ in. (32 × 24 cm.)
Annotated, in bottom margin: uniforme gros bleu & jaune
 fond/blanc fortement teinté de cobalt
Private collection, New York

FSD1723 JH1523

This drawing is clearly related to *La Mousmé* (cat. 91). Each was done after a painting, van Gogh rapidly and cursively reproducing the figure, leaving the background blank, and providing the recipient with a margin filled with color notes.

The recipient was Emile Bernard. The two drawings were sent to him in Brittany some three weeks after he had received the group of fifteen sketches (see cat. 62–72).

At the end of his letter to Bernard describing the two portraits of Roulin, van Gogh had written: "[I] am overburdened with work, and haven't found time yet for figure sketches" (B14). That was about 4 August. In his next letter to Bernard, written two weeks later, he began: "I want to do figures, figures and more figures. I cannot resist that series of bipeds from the baby to Socrates, and from the woman with black hair and white skin to the woman with yellow hair and a sunburned brick-red face" (B15). In decoding this cryptic message —the baby was Marcelle Roulin, Socrates Roulin himself, and the two women the *mousmé* and, most probably, the mudlark (see cat. 51)—Bernard would have been helped by having already received the two drawings, since it was within the fortnight separating the two letters that van Gogh did them and sent them to Bernard. It seems likely that Bernard received them in Saint-Briac, and then took them in mid-August to Pont-Aven, where he showed Gauguin the album he had made of van Gogh's drawings.

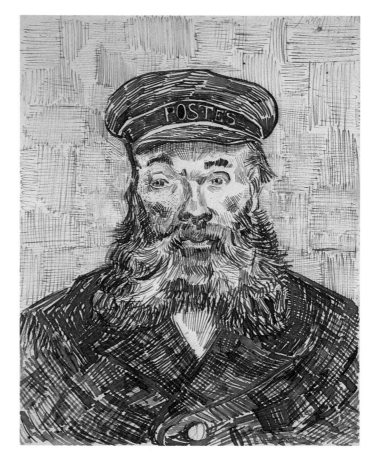

89

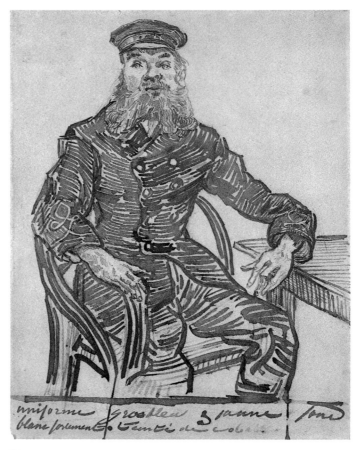

90

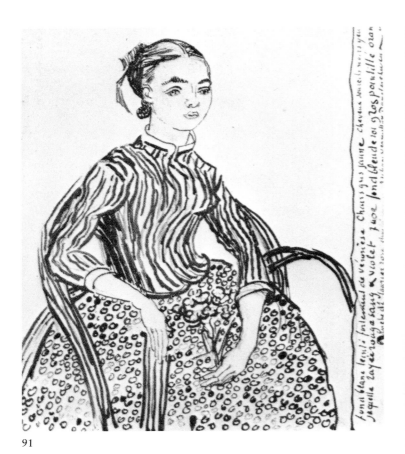

91

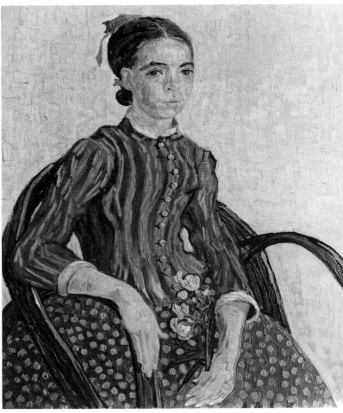

Fig. 41. *La Mousmé* (F431). Oil on canvas, 28⅞ × 23¾ in. (73.3 × 60.3 cm.). National Gallery of Art, Washington, D.C. Chester Dale Collection

91. La Mousmé

Pencil, reed pen and ink, 12¾ × 9⅝ in. (32.5 × 24.5 cm.)
Annotated, in margin at right: fond blanc teinté fortement de véronèse Chairs gris jaune Cheveux sourcils noirs yeux bruns/jaquette rayée rouge sang & violet jupe fond bleu de roi gros pointillé orangé jaune/branche de laurier rose dans la main ruban vermillon dans les cheveux
Pushkin State Museum of Fine Arts, Moscow

F1504 JH1520

NOT IN EXHIBITION

When van Gogh sent the group of fifteen drawings to Emile Bernard about 15–17 July, he had not yet begun to paint *La Mousmé* (fig. 41). He wrote to Theo about 25 July that he had spent the week painting a *mousmé*, "a Japanese girl—Provençal in this case—twelve to fourteen years old" (LT514). This drawing after the painting van Gogh sent to Bernard in Brittany, together with the drawing of Roulin (cat. 90). It is more of a free variation than a reproductive copy. More of the model's skirt is shown, the position of the left arm is changed, and the space between arm and waist is increased. The background has been extended at the top (because of the paper's format), and a margin of comprehensive color notes added at the right.

92. Portrait of Joseph Roulin

Pencil, reed pen and ink on Whatman paper,
23¼ × 17½ in. (59 × 44.4 cm.)
Unsigned
Los Angeles County Museum of Art. Mr. and Mrs. George
Gard De Sylva Collection

F1459 JH1547

On 11 August, van Gogh sent Theo a drawing (F1460) after his recently completed *Portrait of Patience Escalier* (F443), "as well as the drawing of the portrait of the postman Rollin [*sic*]" (LT520). Both are on Whatman paper of almost identical size, and both have drawn inner frames giving them an additional finish as surrogate paintings.

The relationship of this drawing to the "half-length with hands" (cat. 87) is far from clear. The implication in van Gogh's letter is that it was done as a copy after the painting. Yet in the drawing, the image has been extended on all four sides. Much more of the chair and table is shown, but the complicating diagonal of the wall is eliminated. There are innumerable minor variations: the zigzag of coat and sleeve and its effect on the buttons, the smallness of the right hand, and the

cap's being worn at a slightly different angle. Roulin looks squatter, more vulnerable, and older.

Above all, the glass on the table makes a more explicit reference to Roulin's drinking. As van Gogh was to tell his brother later, on 10 October: "My friend the postman . . . lives a great deal in cafés, and is certainly more or less of a drinker, and has been so all his life. But he is so much the reverse of a sot, his exaltation is so natural, so intelligent, and he argues with such sweep, in the style of Garibaldi" (LT550).

The drawing seems to be an alternative and elaborated version for Theo. Having complained of Roulin's stiffness when posing, van Gogh has now introduced the drinking glass to render the portrait more natural, an effect accentuated by the sitter's crumpled angularities and the less arbitrary cut of the chair.

The image of a lone drinker in a café was prevalent in the illustrated periodicals of the 1870s and 1880s. It is also found quite frequently in the work of Manet (his *Bon Bock* of 1873, in the Philadelphia Museum of Art, could have been known to van Gogh), Degas, Forain, and Toulouse-Lautrec. An especially apt comparison is Raffaëlli's *The Absinthe Drinker* (fig. 42).

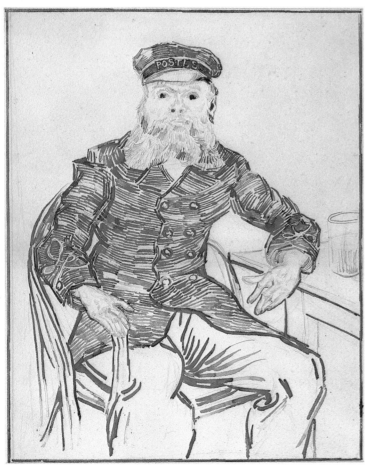

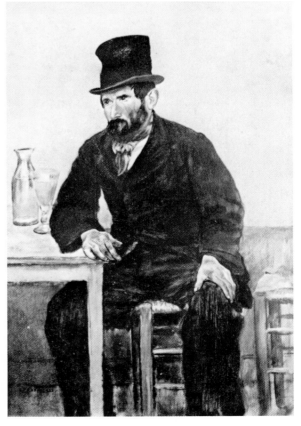

Fig. 42. Jean-François Raffaëlli. *The Absinthe Drinker.* c. 1885. Oil on canvas, 19⅝ × 12⅝ in. (50 × 32 cm.). Musée des Beaux-Arts, Liège

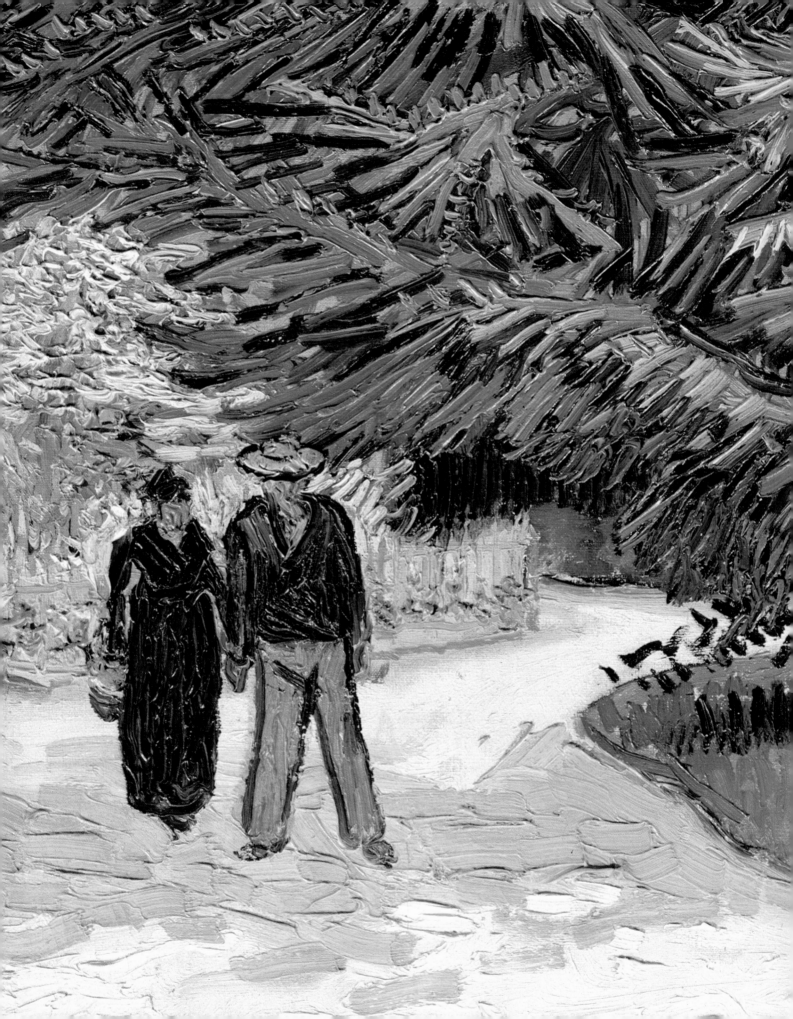

Friday 17–Saturday 18 August
Letter from Theo, enclosing 100 francs: promises the necessary financial support to enable Gauguin to join van Gogh in Arles.

In his reply, van Gogh suggests that Theo lend him 300 francs in one lump sum—to be repaid in the future by his sending 200 francs a month instead of the present 250. He could then buy two beds and furniture for the Yellow House.

Buys a black velvet jacket of fairly good quality, for 20 francs, and a new hat.

Decides definitely not to go to Pont-Aven.

No letter from Gauguin "for almost a month."

Letter from Bernard, who has recently joined Gauguin in Pont-Aven.

Tells Bernard that he plans to decorate his studio with six pictures of sunflowers, "a decoration in which the raw or broken chrome yellows will blaze forth on various backgrounds. . . . Effects like those of stained-glass windows in a Gothic church."

Tuesday 21–Wednesday 22 August
Writes to Theo: has three paintings of sunflowers on the easel (F453, F456, F459), destined for his studio decoration—probably a dozen panels. Works on them every morning from sunrise.

Letter from Koning, who is going to live in The Hague.

Letter from Gauguin—the first in almost a month: he hopes to come south "as soon as the opportunity arises"; Bernard has made an album of van Gogh's drawings.

Friday 24 August
Engaged on a fourth painting of sunflowers (F454).

Saturday 25 August
MacKnight leaves Fontvieille and returns to Paris.

Sunday 26 August
Spends the evening with Boch.

Monday 27 August
Letter from Theo, with 50 francs enclosed.

Plans second portrait of the "old peasant," Patience Escalier (cat. 96).

Wednesday 29 August
Two or three perfect days, very hot and windless; the grapes are ripening.

Finishes the second *Portrait of Patience Escalier*.

Probably engaged on two still lifes, *Oleanders* (cat. 93) and *A Pair of Shoes* (cat. 94).

Still no reply from Russell about the twelve drawings.

Saturday 1 September
Depressed: Gauguin might find Arles too isolated; models are difficult to get; constant grief that his work does not sell, and he therefore cannot repay Theo; his life is "disturbed and restless"; it is a terrible handicap not to speak the Provençal patois; often hesitates before planning a picture because of the cost of colors; but is regaining physical strength and his stomach is stronger.

Reading Daudet's *L'Immortel* (1888). Sends Theo three volumes of Balzac.

Sunday 2 September
Spends day with Boch: weather not fine, but they take a walk and also go to a bullfight. Boch sits for a sketch, the "Poet" (cat. 98).

Monday 3 September
Finishes Daudet's *L'Immortel*.

Having two oak frames made for the *Portrait of Patience Escalier* (cat. 96) and the *Portrait of Eugène Boch* (cat. 98) as part of the decoration for the Yellow House.

Tuesday 4 September
Writes Theo a long letter early in the morning as he waits to say farewell to Boch, who is leaving Arles for Paris and then the Borinage.

No paints left; will make drawings in the meantime.

Concerned about whether Gauguin will come to Arles. Writes to him and to Bernard.

Begins painting *The Night Café* (cat. 101, fig. 45). Works through the night.

Wednesday 5–Thursday 6 September
Continues working on *The Night Café*, painting at night and sleeping during the day.

Saturday 8 September
Letter from Theo, with 300 francs enclosed. At last able to begin furnishing the Yellow House. Buys two beds, twelve rustic chairs, one white deal table, one mirror, and "some small necessities."

Camille Pissarro (1830–1903) has seen his second batch of paintings, and likes *La Mousmé* (cat. 91, fig. 41).

Letter from Milliet: on leave in northern France; will call on Theo in Paris on his return journey to Arles.

Making a watercolor copy of *The Night Café* (cat. 101) to send to Theo.

Sunday 9 September
Sends off watercolor copy of *The Night Café*.

Writes long letter to Theo from the same night café he has just painted. Describes his new purchases and his immediate intentions for the decoration and furnishing of the Yellow House.

Plans an autumn series of paintings.

Monday 10 September
Probably receives a letter from Russell: repeats that he is not able to buy a Gauguin painting, but invites van Gogh to Belle Ile. (It is unlikely that van Gogh replied. This was their last exchange of letters in Arles. Their correspondence was not renewed until January 1890 in Saint-Rémy.)

Tuesday 11 September
Letters from Bernard and Gauguin. Gauguin more unsure about coming to Arles as his debts increase.

Wednesday 12 September
Replies to Gauguin, suggesting an exchange. "If they are willing," he tells Theo, "I would very much like to have here the portrait of Bernard by Gauguin and that of Gauguin by Bernard."

Has painted a study of an old mill (cat. 103).

Thursday 13–Sunday 16 September
Continues to furnish his house and buys a mattress for 30 francs.

Detail, cat. 109

Has painted the outside of a café at night (F467); a *Self-Portrait* (cat. 99), with the help of the mirror he has recently bought; and the first of his autumn gardens (cat. 104), whose motifs are selected from the gardens in the Place Lamartine.

Takes "a splendid walk by myself today among the vineyards."

Sleeps in the Yellow House for the first time.

Monday 17 September
Letter from Theo, enclosing 50 francs and a copy of *Le Courrier Français* with a drawing by Charles Maurin (1856–1914) and a story by Charles Morice, "La Truie bleue."

Gauguin has written to Theo, suggesting his prices be lowered to attract purchasers.

Letter from Bernard: he might come to Arles this winter.

Overjoyed to be in the Yellow House at last; weather magnificent.

Works on another garden in the square opposite, "a walk under plane trees, with the green turf, and the black clumps of pines [cat. 105]." Finishes picture, then begins a second canvas of the same garden (cat. 106, fig. 48), and with his last tubes of paint produces green by mixing Prussian blue and chrome yellow.

Writes Theo a second letter in the evening: touches on Dante, Petrarch, and Boccaccio; some of his autumn gardens he will call the Poet's Garden (cat. 104, 107, 109).

Spends a full and celebratory first day in his house and in the adjoining square. But paints, canvas, and purse "all completely exhausted."

Will make drawings until paints arrive.

Wednesday 19–Thursday 20 September
Letter from Theo, enclosing 100 francs.

Milliet returns, bringing for van Gogh Japanese prints; lithographs by Delacroix, Géricault, and Daumier; a copy of the periodical *Le Japon Artistique*; a photograph of his mother—all from Theo.

Has scraped off—for the second time—a painting of Christ in Gethsemane.

Monday 24 September
Day of storm and rain. Remains indoors. Writes Theo a long letter discussing Leo Tolstoy's *What I Believe* (1882–1884), the hanging of the Japanese prints and French lithographs in his studio, Monticelli, the women of Arles, Japanese art, Bing's book, and an article on Wagner. Not a single reference to his own paintings, only to his wish to draw this winter figures in a few strokes and in the right proportion.

"While I have been writing this letter I have drawn about a dozen."

Wednesday 26 September
Paints *Ploughed Field* (F574), and includes a sketch of it in a letter to Theo.

Has begun the *Portrait of Milliet* (cat. 100).

Thursday 27 September
From 7 A.M. to 6 P.M. works on yet another painting of an autumn garden (now lost). Encloses a small sketch (cat. 107) of it in a letter to Theo. "I have a lucidity or a lover's blindness for work just now."

Saturday 29 September
Letter from Gauguin: describes his *Vision After the Sermon: Jacob Wrestling with the Angel* (WC245), of which he includes a drawing, and "seems very unhappy and says that as soon as he has sold something, he will certainly come." Sends the letter on to Theo, with his reply.

Letter from Theo, enclosing 50 francs. Tells him by return that he has finished the *Portrait of Milliet* (cat. 100); encloses two small sketches of the *Starry Night* (F474) and *The Yellow House* (cat. 102, fig. 47), which he has just painted.

Tuesday 2 October
Letter from Boch, now in the Borinage. Replies immediately, with a report on his recent paintings, two rapid sketches, and the news that "your portrait is in my bedroom along with that of Milliet, the Zouave, which I have just finished."

Spends the day painting a vineyard near Montmajour—"all purple and yellow-green under the blue sky" (F475).

Wednesday 3 October
"A very, very remarkable letter from Gauguin," describing his *Self-Portrait: "Les Misérables"* (cat. 99, fig. 44), immediately sent on to Theo.

Letter also from Bernard, proposing an exchange of work between van Gogh and himself and three other artists at Pont-Aven.

Finishes *The Green Vineyard* (F475), "again for the decoration of the house."

Answers Gauguin and Bernard in the afternoon: tells Gauguin of his own *Self-Portrait* (cat. 99) and *The Green Vineyard*; of his conception of Gauguin as the head of a studio and the new poet of the South; of the decoration of the Poet's Garden for the studio; of the possible exchange of paintings with Pont-Aven artists. Pursues the question of an exchange with Bernard, listing several paintings and suggesting that if tomorrow, when exposed to the sun, it is dry enough to be rolled, he will add *Quay with Men Unloading Sand Barges* (F449).

Paints a sunset.

Thursday 4 October
Receives package from Pont-Aven with self-portraits by Gauguin and Bernard and Bernard's "Au Bordel," a poem with ten drawings.

Writes to Bernard, telling him the self-portraits have arrived and that his own exchange paintings are being dispatched to Pont-Aven.

Letter from Theo, who has sold several of Gauguin's ceramics for 300 francs. Van Gogh's reply is not posted.

Friday 5–Monday 8 October
Money ran out Thursday, largely because he had ordered too many frames and stretchers. Had asked Theo to send money by Friday. Yet during these four days, he sends no news to Theo, has only two meals, lives on twenty-three cups of coffee and bread—all not paid for.

A merciless mistral from Saturday on prevents his painting outdoors. No evidence that he draws, or even reads—a "lost" four days.

Tuesday 9–Wednesday 10 October
Painting a brothel study for Bernard.

Letter from Gauguin, who has been ill: dreading the journey to Arles, but will come "before the end of the month."

Buys a chest of drawers for 14 francs.

Finishes another painting of the public garden (cat. 108).

Thursday 11 October
Writes to Gauguin.

Saturday 13 October
Theo sends money order for 50 francs.

Writes Theo of four recently completed paintings; makes sketches of all of them in his letter (see cat. 109–112).

Complains of very tired eyes.

Has finished fifteen size 30 canvases (28¾ × 36¼ in.) since mid-August.

Sunday 14 October
Letter from Gauguin: has sent Theo some pictures and studies.

Letter from Bernard: the seven exchange canvases have arrived in Pont-Aven. He will send "another study in exchange."

Complains of being nearly half-dead from

the past week's work: "I have just slept sixteen hours at a stretch, and it has restored me considerably. And tomorrow I shall have recovered from this queer turn."

A very violent mistral.

Tuesday 16 October
Eyes still tired, but has begun a painting of his bedroom (cat. 113). Sketch enclosed in letter to Theo.

Wednesday 17 October
Letter from Gauguin: has sent off his trunk and will come to Arles "as early as the twentieth." In reply, tells Gauguin of the *Bedroom* and encloses sketch of it.

Has gas-lighting installed in the studio for 25 francs—to give "good light in winter."

Finishes painting the *Bedroom* in the afternoon.

Reads Jean Richepin's *Césarine* (1888).

Sunday 21 October
Letter from Theo, enclosing 50 francs.

Has finished his fourth Poet's Garden (F485), for the scheme of decoration for Gauguin's room.

"I am not ill, but without the slightest doubt I'd get ill if I did not eat plenty of food and if I did not stop painting for a few days."

Desperately in need of another 50 francs.

Monday 22 October
Repeats request for 50 francs.

Finishes another size 30 canvas, *An Autumn Garden* (F472), even though he has sworn not to work.

Autumn effects have begun: trees turning yellow, and leaves beginning to fall.

Awaits Gauguin's arrival "from one day to the next."

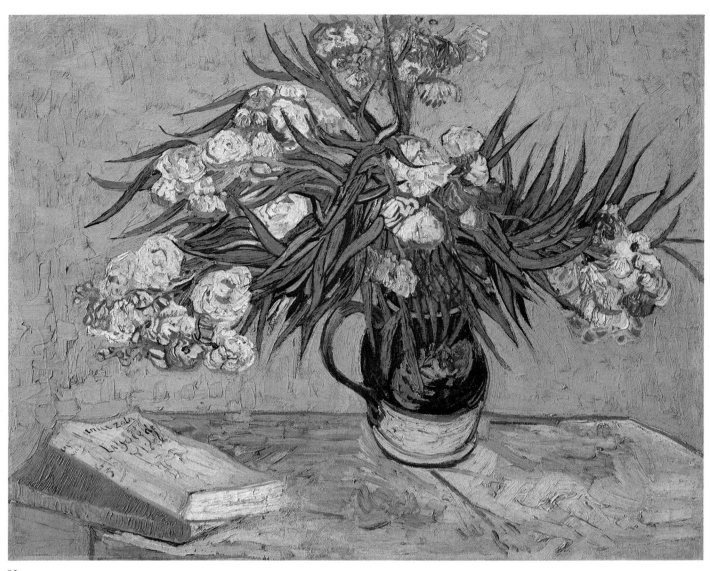

93

93. Oleanders

Oil on canvas, 23¾ × 29 in. (60.3 × 73.6 cm.)
Inscribed, lower left, on book: EMILE ZOLA/LA joie
 de/VIVRE; on spine: La joie de/vivre/Emile/Zola
The Metropolitan Museum of Art, New York. Gift of
 Mr. and Mrs. John L. Loeb, 1962

F593 H594 SG80 JH1566

"I reproach myself for not painting flowers here," van Gogh had written to Theo on 8 August (LT519). The reproach was justified. He had painted and drawn flowering gardens (cat. 61, 85), but he had certainly neglected flowers as a still-life subject. All he had done was a few wildflowers in a majolica jug (F600), painted in May at the same time as the *Still Life with Coffeepot* (cat. 29). By mid-August, however, he was thinking of possibilities—"One of these days I hope to make a study of oleanders" (LT524)—but he was deflected by a week's painting of four of his famous still lifes of sunflowers

for the decoration of the Yellow House.

Van Gogh never actually described a still life of oleanders; and it can only be assumed that this is the "bunch of flowers" he referred to in late August (LT529). He took the same majolica jug from his May still life, stood it on a table, filled it with oleanders, and added two yellow novels at left. One of the novels was Zola's *La Joie de vivre* (1884), which he had also used in a Nuenen still life of 1885 in opposition to the open family Bible.

Perhaps van Gogh painted the oleanders as a release from the sunflower decorations. Instead of upright canvases, he used a horizontal format to allow for the possessive spread of stalks; instead of repeated roundels, he created a brazen spikiness; instead of yellow on yellow (or blue-green), a medley of greens and pink-reds, with the sunflowers' yellows absorbed in the two books; instead of consoling sunflowers, vitalistic, joyous, life-affirming oleanders. He also produced a small upright picture of oleanders (F594), less thrustfully

ambitious, the flowers more contained in their majolica pot.

"The oleander—ah! that speaks of love and is beautiful like the Lesbos of Puvis de Chavannes" (LT587); he even talked of planting two oleanders in tubs outside the door of the Yellow House (LT540).

The present painting has an added interest. It once belonged to Joseph Roulin, no doubt a gift from the artist.

Are they perhaps boots that belonged to the peasant Patience Escalier? The late August reference coincides with the second version of his portrait (cat. 96). However that may be, the floor with its red tiles is clearly that of the Yellow House. It lies, as it were, between the tiled floor depicted in *The Seated Zouave* (cat. 52, fig. 31) and that seen in *Van Gogh's Chair* (cat. 141). In all three pictures, the floor rises almost vertically, creating a spatially ambiguous pattern.

94. A Pair of Shoes

Oil on canvas, 17⅜ × 20⅞ in. (44 × 53 cm.)
Unsigned
Private collection, U.S.A.

F461 H488 SG81 JH1569

Still lifes of boots or shoes figure prominently in van Gogh's Paris period (see cat. 2). In Arles, he apparently painted this one pair, which is usually identified as the "still life of an old pair of shoes" mentioned in a letter to Theo of late August (LT529). This painting may be one of the seven possible exchange pictures offered to Emile Bernard in a letter of 3 October, and there described as "a still life of a peasant's old boots" (B18).

95. Coal Barges

Oil on canvas, 28 × 37⅜ in. (71 × 95 cm.)
Unsigned
Private collection

F437 H483 SG59 JH1570

On 31 July, van Gogh wrote to Theo: "I saw a magnificent and strange effect this evening. A very big boat loaded with coal on the Rhône, moored to the quay. Seen from above it was all shining and wet with a shower; the water was yellowish white and clouded pearl gray; the sky, lilac, with an orange streak in the west; the town, violet. On the boat some poor workmen in dirty blue and white came and went carrying the cargo

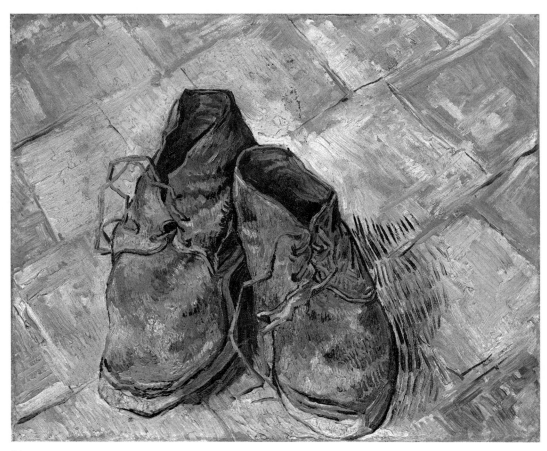

94

163

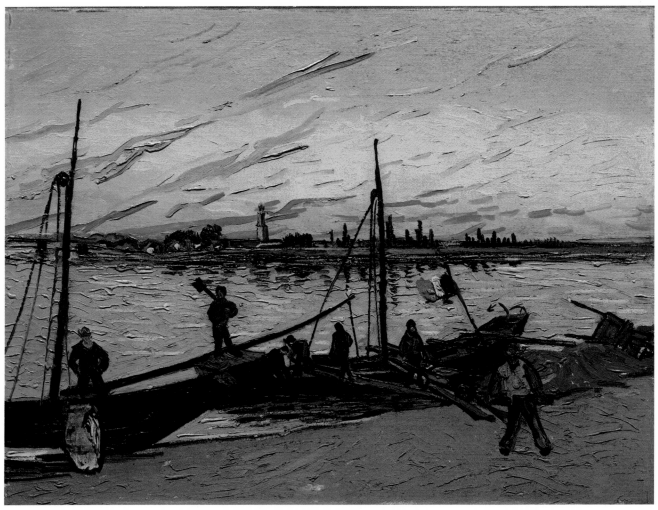

95

on shore. It was pure Hokusai. It was too late to do it, but one day when that coal boat comes back, I must give it a try" (LT516).

In fact, he first painted and drew workmen unloading sand from boats on the Rhône in mid-August (F449, F1462), which he recalled in a letter of about 21 August: "I saw again today the same coal boat with the workmen unloading it that I told you about before, at the same place as the boats loaded with sand which I sent you the drawing of. It would be a splendid subject" (LT526).

Van Gogh does not refer to the subject of the coal barge again in his letters. But he painted two versions of it, probably before the end of August. The smaller one (F438) is simpler in composition, with fewer boats and fewer figures than the present picture. Van Gogh descended to riverbank level rather than taking his vantage point from above, as he had done in *Quay with Men Unloading Sand Barges* (F449). The suburb of Trinquetaille is seen across the river, with the bridge just visible at left.

This is very much an Impressionist motif: Monet painted such a subject on the Seine at Asnières in the mid-1870s. Handling and color, however, project van Gogh's painting into early twentieth-century Fauvism and Expressionism.

96. Portrait of Patience Escalier

Oil on canvas, 27⅛ × 22 in. (69 × 56 cm.)
Unsigned
Private collection

F444 H479 SG61 JH1563

After one of his visits to Fontvieille to see the artists Dodge MacKnight and Eugène Boch (see cat. 98), van Gogh wrote: "The village where they are staying is *real Millet*, pure peasants and nothing else, absolutely *rustic* and homely." And he added, in the same letter, "The natives [of Fontvieille] are like Zola's poor peasants, innocent and gentle beings, as we know" (LT514, c. 25 July).

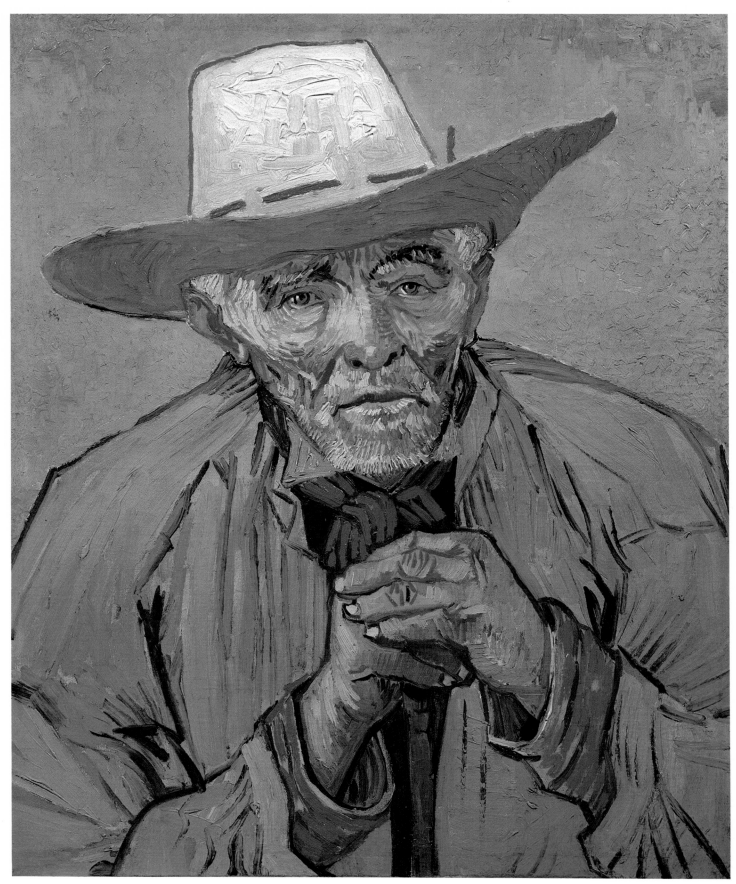

Peasants are seldom mentioned in letters from Arles before July, just as peasants rarely appear in van Gogh's paintings, certainly not with any prominence. But once he touched on the peasant theme in late July, he continued to pursue it. By 8 August, he was literally pursuing one peasant: "I wanted to paint a poor old peasant, whose features bear a very strong resemblance to Father, only he is coarser, bordering on a caricature. Nevertheless, I should have been very keen to do him exactly like the poor peasant that he is. He promised to come, and then he said that he wanted to have the picture for himself, so that I should have had to do two the same, one for him and one for myself. I said No. Perhaps he will come back someday" (LT519).

He returned to the familiar comparison: "Millet gave the synthesis of the peasant, and now, yet, there is [Léon-Augustin] Lhermitte, certainly there are a few others, [Constantin Emile] *Meunier*... Then have we in general learned to see the peasant now? *No*, hardly anyone knows how to pull one off. Doesn't the fault really lie a little with Paris and the Parisians, changeable and faithless as the sea?" And he added a further practical illustration: "I must tell you that I made a very interesting round of the farms with someone who knows the country. But you know in the real Provence there is more poor peasantry à la Millet than anything else" (LT519). Then, triumphantly, he announced on 11 August: "You are shortly to make the acquaintance of Master Patience Escalier, a sort of 'man with a hoe,' formerly cowherd of the Camargue, now gardener at a house in the Crau. The coloring of this peasant portrait is not so black as in the 'Potato Eaters' of Nuenen [F82]" but, instead, "terrible in the furnace of the height of harvesttime, as surrounded by the whole Midi. Hence the orange colors flashing like lightning, vivid as red-hot iron, and hence the luminous tones of old gold in the shadows" (LT520).

Theo was sent the drawing (F1460) after this first painting of Patience Escalier (F443). And the familiar refrain returned: "We've read *La Terre* and *Germinal* [by Zola], and if we are painting a peasant, we want to show that in the end what we have read has come very near to being part of us" (LT520).

This was van Gogh's first real portrait of a peasant since the magnificent series of heads he had produced at Nuenen in 1885. He also recalled the Nuenen *Potato Eaters* to Emile Bernard: "I have another figure ... which is an absolute continuation of certain studies of heads I did in Holland. I showed them to you one day along with a picture from that period, 'The Potato Eaters'; I wish I could show you this one. It is still a study, in which color plays a part such as the black and white of a drawing could not possibly reproduce. I wanted to send you a very large and very careful drawing. Very well! It turned out quite different, though it is correct.

For this time again the color suggests the blazing air of harvesttime right at midday, in the middle of the dog days, and without that it's another picture. I dare believe that Gauguin and you would understand it; but how ugly people will think it! *You* know what a peasant is, how strongly he reminds one of a wild beast, when you have found one of the true race" (B15).

Patience Escalier was not seen for some days. But toward the end of August, van Gogh reported: "I am doing [the old peasant] this time against a background of vivid orange which, although it does not pretend to be the image of a red sunset, may nevertheless give a suggestion of one" (LT529).

This second portrait of Patience Escalier, then, was painted a fortnight after the first one. Between the two portraits came the four canvases of the sunflowers, the *Oleanders* (cat. 93), and the "still life of an old pair of shoes [cat. 94]," which could well have been those worn by Patience Escalier. For this "new peasant's head" he ordered an oak frame, to hang the picture in the Yellow House (LT531).

In the second version, van Gogh changed the hat and introduced the stick, on which rest those "man with a hoe" hands. He substituted for the symbol of harvest in the full sun at midday the image of a red sunset—"to express ... the eagerness of a soul by a sunset radiance" (LT531). Or, as he had said when he painted the first version: "What I learned in Paris is leaving me, and I am returning to the ideas I had in the country before I knew the impressionists. And I should not be surprised if the impressionists soon find fault with my way of working, for it has been fertilized by Delacroix's ideas rather than by theirs. Because instead of trying to reproduce exactly what I have before my eyes, I use color more arbitrarily, in order to express myself forcibly" (LT520).

97

97. Portrait of Patience Escalier

Pen and brown ink, 5⅜ × 5⅛ in. (13.5 × 13 cm.)
Unsigned
Private collection, Switzerland

F1461 JH1564

This rapid pen drawing, done on an unevenly torn piece of plain paper (with, nevertheless, clear indications of an inner frame), was sent as an accompaniment to a letter; it is a "letter drawing." It relates to the second painted portrait of Patience Escalier (cat. 96); yet there are differences, most obviously in the upward "swing piece" of the hat. The problem is, which letter?

Van Gogh wrote Emile Bernard about 20 August that he wanted to send him a "very large and very careful drawing" after the first painted version of the peasant, but "it turned out quite different, though it is correct" (B15). No such drawing has survived.

There is, however, a lost letter to Bernard, written about 5 September, in which van Gogh reported, among other things, on the painting of *The Night Café* (cat. 101, fig. 45). The second version of the *Portrait of Patience Escalier* was completed during the last days of August (LT529). It seems highly likely that the present drawing was done after that painting and enclosed in the lost letter to Bernard. It has all the characteristics of a Bernard-intended drawing: no dots, for example, in the background, and a fluent yet abrupt manner of drawing.

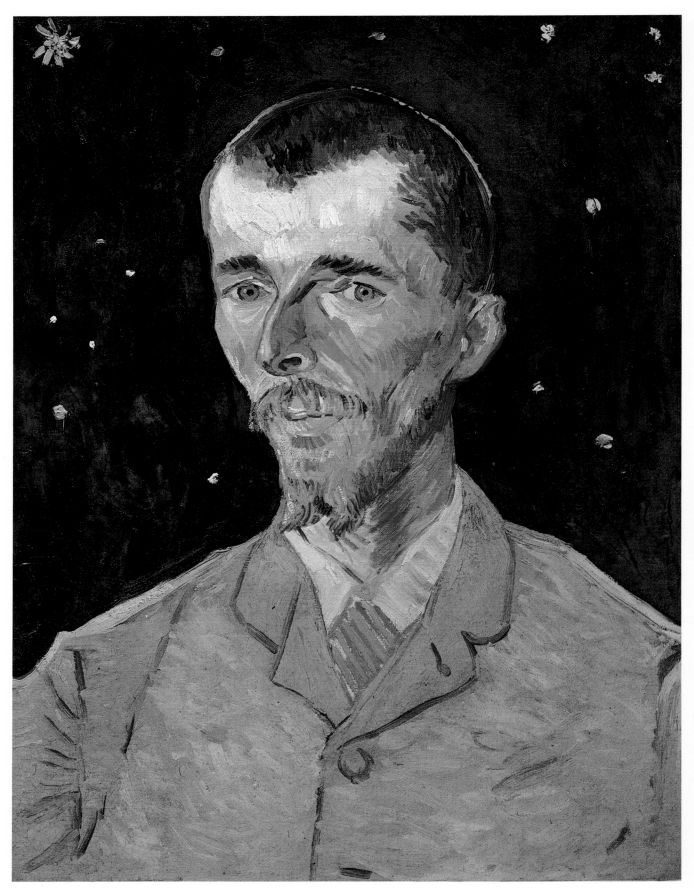

98. Portrait of Eugène Boch

Oil on canvas, 23⅝ × 17¾ in. (60 × 45 cm.)
Unsigned
Musée d'Orsay (Galerie du Jeu de Paume), Paris
F462 H490 SG63 JH1574

Van Gogh met the Belgian artist Eugène-Guillaume Boch (1855–1941; fig. 43) in mid-June 1888, when he was painting *The Harvest (Blue Cart)* (cat. 65, fig. 36). Boch was a friend of the American artist Dodge MacKnight (1860–1950), and the two of them lived in the nearby village of Fontvieille from mid-June until late August. They would often visit van Gogh at the Yellow House, and he in turn would visit them at Fontvieille. He never described MacKnight; but Boch's appearance clearly intrigued him.

"He is a young man whose appearance I like very much," he wrote to Theo about 8 July. "A face like a razor blade, green eyes, and a touch of distinction. MacKnight looks very common beside him" (LT505). And on 9 July: "This Bock [*sic*] has a head rather like a Flemish gentleman of the time of the Compromise of the Nobles, William the Silent's time and Marnix's. I shouldn't wonder if he's a decent fellow" (LT506).

By 11 August, he had a clear conception in mind: "I should like to paint the portrait of an artist friend, a man who dreams great dreams, who works as the nightingale sings, because it is his nature. He'll be a blond man. I want to put my appreciation, the love I have for him, into the picture. So I paint him as he is, as faithfully as I can, to begin with. But the picture is not yet finished. To finish it I am now going to be the arbitrary colorist. I exaggerate the fairness of the hair, I even get to orange tones, chromes and pale citron yellow. Behind the head, instead of painting the ordinary wall of the mean room, I paint infinity, a plain background of the richest, intensest blue that I can contrive, and by this simple combination of the bright head against the rich blue background, I get a mysterious effect, like a star in the depths of an azure sky" (LT520).

It was only after MacKnight left Fontvieille, on about 25 August (LT528), that van Gogh found it possible to realize his intention. On 2 September, he and Boch spent an entire Sunday together in Arles, walking and visiting the arena for the bullfight. But most important, "this young man [he was thirty-three] with the look of Dante" sat for van Gogh. "Well, thanks to him I at last have a first sketch of that picture which I have dreamed of for so long—the poet. He posed for me. His fine head with that keen gaze stands out in my portrait against a starry sky of deep ultramarine; for clothes, a short yellow coat, a collar of unbleached linen, and a striped tie. He gave me two sittings in one day" (LT531).

Fig. 43. Photograph of Eugène Boch. c. 1888. Reproduced courtesy of John Rewald

It was only a study. Boch left Arles two days later, and van Gogh tried to produce a picture from the study without the model. "I have mercilessly destroyed one important canvas—a 'Christ with the Angel in Gethsemane'—and another one representing the 'Poet against a Starry Sky'—in spite of the fact that the color was right—because the form had not been studied beforehand from the model, which is necessary in such cases" (B19).

The study for the "Poet," however, was framed in oak, together with the *Portrait of Patience Escalier* (cat. 96). When it was framed, van Gogh hung it in his bedroom, with the *Portrait of Milliet* (cat. 100), as he told Boch in a letter of 2 October (LT553b). In the painting *Van Gogh's Bedroom* (cat. 113), the two portraits hang on the wall by the bed.

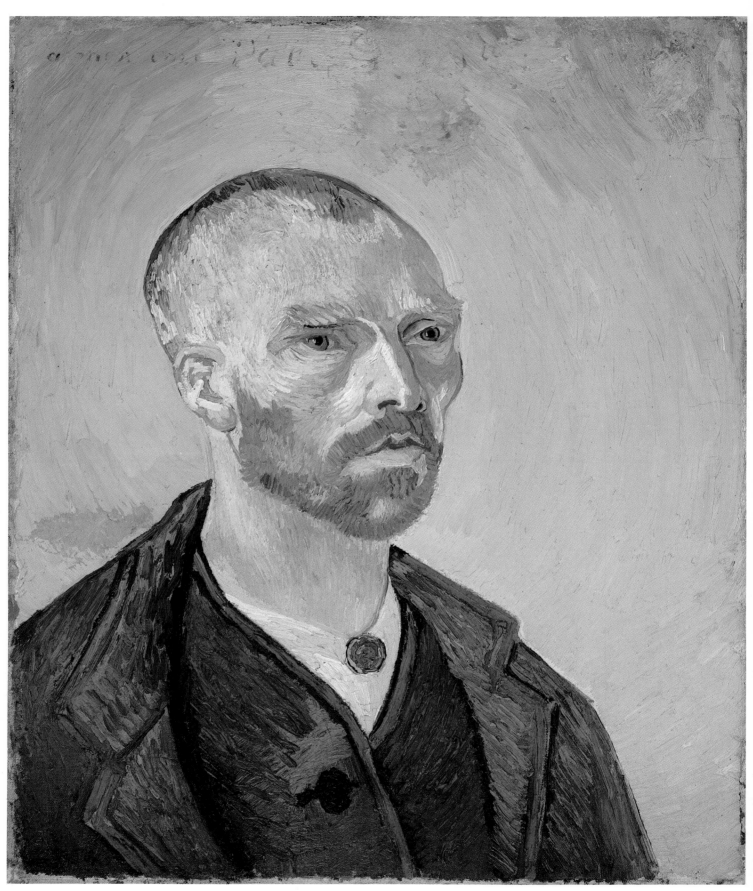

99

99. Self-Portrait

Oil on canvas, 23⅝ × 19⅝ in. (60 × 49.9 cm.)
Signed and inscribed, lower right: Vincent / Arles
Inscribed, upper left: à mon ami Paul G[auguin]
Fogg Art Museum, Harvard University, Cambridge, Massachusetts. Bequest—Collection of Maurice Wertheim, Class of 1906

F476 H505 SG90 JH1581

This is the second self-portrait van Gogh painted in Arles. The first was the unusual *Painter on the Road to Tarascon* (cat. 78, fig. 40), now destroyed, probably painted in June. It seems fairly certain that he kept his head and beard shaved throughout the summer. In mid-June he told his sister Wil: "I am wearing neither hair nor beard, the same having been shaved off clean" (W4); and about 25 July he wrote to Theo: "Not only my pictures but I myself have become haggard of late, almost like Hugo van der Goes in the picture of Emile Wauters. Only, having got my whole beard carefully shaved off, I think that I am as much like the very placid priest in the same picture as like the mad painter so intelligently portrayed therein" (LT514).

The timing of the Fogg self-portrait is interesting. It would seem that in mid-September, after the high summer heat, van Gogh was allowing his hair and beard to grow again. He bought a mirror for the express purpose of working on the portrait, and the painting was completed in the week before he finally moved to the Yellow House, as if he wanted the consolation of his own identity to accompany him there. He hoped that having managed to paint the "coloring of his own head," he would then be able to persuade other models to sit for him.

Completed by 16 September, the self-portrait was considered a study, and was therefore not signed. (It was virtually the same size as the *Portrait of Eugène Boch*, cat. 98, also an unsigned study for an eventual picture.) But it was not hastily done. He told Theo about six days later of the "terrific amount of trouble" he had taken "to get the combination of ashen and gray-pink tones" (LT504).

His first descriptions of it to Theo (LT537, LT539, LT540) concentrate on questions of color, "my own ashen coloring" against "a background of pale malachite." Only to his sister Wil did he introduce an additional element: "I also made a new portrait of myself, as a study, in which I look like a Japanese" (W7, 16 September).

The Japanese notion was repeated when, on 3 October, he received a letter from Gauguin, in which Gauguin described his own self-portrait, *"Les Misérables"* (fig. 44), in symbolic terms. Van Gogh responded: "I have a portrait of myself, all ash-colored. The ashen gray color that is the result of mixing malachite green with an orange hue, on pale malachite ground, all in harmony with the reddish brown clothes. But as I also exaggerate my personality, I have in the first place aimed at the character of a simple bonze worshiping the Eternal Buddha. It has cost me a lot of trouble, yet I shall have to do it all over again if I want to succeed in expressing what I mean. It will even be necessary for me to recover somewhat more from the stultifying influence of our so-called state of civilization in order to have a better model for a better picture" (LT544a).

The reference to the bonze he picked up from his reading of Pierre Loti's *Madame Chrysanthème* (1887). The following day, 4 October, Gauguin's self-portrait, which had been painted for van Gogh, arrived. "So now at last I have a chance to compare my painting with what the comrades are doing," he wrote to Theo. "My portrait, which I am sending to Gauguin in exchange, holds its own, I am sure of that. I have written to Gauguin in reply to his letter that if I might be allowed to stress my own personality in a portrait, I had done so in trying to convey in my portrait not only myself but an impressionist in general, had conceived it as the portrait of a bonze, a simple worshiper of the eternal Buddha" (LT545). On the same day, van Gogh dispatched his self-portrait to Gauguin in Pont-Aven. Before doing so, however, he inscribed it and signed it. The paint could hardly have been dry.

The picture returned to Arles with Gauguin on 23 October. He took it with him to Paris in late December and told van Gogh in a letter of 9 January 1889 (GAC34) that it was hanging in his studio. At some point, both the name and the signature were partially erased; there have been retouchings.

A close scientific analysis of the painting has recently been undertaken at the Fogg Art Museum. Its findings were not yet published as this catalogue went to press.

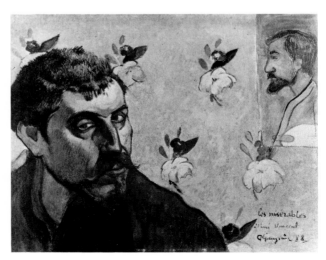

Fig. 44. Paul Gauguin. *Self-Portrait: "Les Misérables"* (WC239). Oil on canvas, 17⅜ × 21⅝ in. (44 × 55 cm.). Rijksmuseum Vincent van Gogh, Amsterdam

100. Portrait of Milliet

Oil on canvas, 23⅝ × 19¼ in. (60 × 49 cm.)
Unsigned
Rijksmuseum Kröller-Müller, Otterlo

F473 H499 SG98 JH1588

Paul-Eugène Milliet was a second lieutenant in the third regiment of the Zouaves, a body of light infantry in the French army composed originally of Algerians. Van Gogh certainly knew him by mid-June. "There is someone here who has been to Tonkin" (LT496, c. 12 June) is a clear reference to Milliet, whose regiment returned from French Indochina to the Zouave barracks in Arles in February 1888. Van Gogh wrote to Emile Bernard about 18 June: "I am acquainted with a second lieutenant of the Zouaves here, called Milliet. I give him drawing lessons—with my perspective frame—and he is beginning to make drawings; by God, I've seen worse! He is zealously intent upon learning" (B7).

Such was van Gogh's enthusiasm for teaching Milliet to draw that on 23 June he asked Theo to send him A. Cassagne's *ABCD du dessin* (LT502). He had asked for it a fortnight earlier in an Arles bookshop: clearly, then, he was already instructing Milliet by 9 June.

Shortly after this, from 20 to 23 June, van Gogh was working on three portraits of a Zouave whose identity has often been confused with that of Milliet (see cat. 52, 53). Doubtless he was a friend of Milliet's who served in the same regiment, and who agreed to sit for van Gogh because of Milliet's friendship with the artist.

In early July, Milliet and van Gogh spent the day together at Montmajour (LT506). By mid-August, however, "this valiant warrior has given up the art of drawing, into the mysteries of which I endeavored to initiate him, but it was for a plausible reason, namely that he had unexpectedly to take an examination, for which I am afraid he was anything but prepared. Always supposing the aforesaid young Frenchman always speaks the truth, he astonished his examiners by the confidence of his answers, a confidence he had reinforced by spending the eve of the examination in a brothel" (LT522).

Nevertheless, Milliet, who was going on leave for some weeks to the north of France, agreed to take to Paris the thirty-six rolled canvases that formed van Gogh's second batch of paintings for Theo. He delivered them on 17 August. On his way back to Arles, Milliet called again on Theo in Paris and picked up some Japanese prints, nineteenth-century lithographs, and illustrated periodicals for van Gogh. Milliet arrived in Arles about 20 September (LT540). Yet even before he arrived, van Gogh told Emile Bernard: "One of these days I am going to do the portrait of the second lieuten-

ant of the Zouaves whom I told you about, and who is on the point of leaving for Africa" (B16).

The progress of the portrait was then reported to Theo about 26 September: "I am . . . working on a portrait of Milliet, but he poses badly, or I may be at fault myself, which, however, I do not believe, as I am sorely in want of some studies of him, for he is a good-looking boy, very unconcerned and easy-going in his behavior, and he would suit me damned well for the picture of a lover. I have already promised him a study for his trouble, but, you know, he cannot keep still" (LT541a). And the following day he wrote: "I hope to work with Milliet tomorrow" (LT541). When he wrote to Theo two days later (LT543, 29 September), he enclosed a drawing of his recently completed painting of the Yellow House (cat. 102, fig. 47); on the back of this small sketch he wrote: "I now have [finished] his portrait with red cap on emerald green ground, and in the background the arms of his regiment, the crescent and a five-pointed star." And on 2 October, he reported it finished to Eugène Boch (LT553b). With Boch's portrait (cat. 98), it was framed in oak and hung in van Gogh's bedroom.

The portrait follows the head-and-shoulders formula established in the "life-size head" of Roulin (cat. 88) and continued in the first version of *Patience Escalier* (see cat. 96), in the portrait of Boch, and in the *Self-Portrait* (cat. 99). But here there is no concerted attempt at symbolic overtones. The star and crescent moon are simply the coat of arms of the regiment; the background color is not therefore to be read as sky; and Milliet's decoration is the commemoration medal of the expedition to Tonkin.

Nor does van Gogh exaggerate the decorative elements in the uniform. The bounding contours are not insistent: the face is almost free of them, and the red hat has only its two lateral sides loosely bordered with Prussian blue lines. Van Gogh left the portrait unsigned. And while he clearly considered it a study, he never spoke of doing a more finished picture.

When Milliet left Arles for service in Algeria about 1 November, van Gogh gave him a study "for troubling to take the canvases to Paris" (LT561). The identity and fate of that study are unknown. An interesting letter written by Milliet to van Gogh from Algeria survives (LT590c, 11 December 1888, not printed in the English edition of the letters). Milliet died during the Second World War.

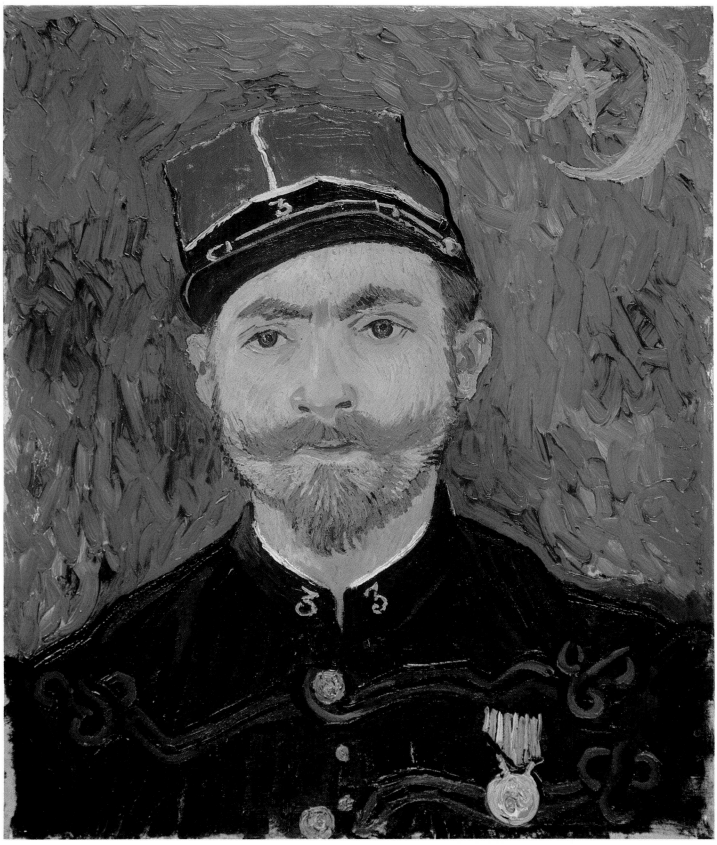

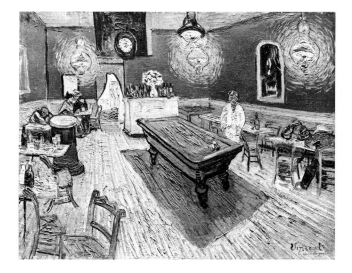

101

101. The Night Café

Pencil, watercolor, and gouache, 17½ × 24⅞ in.
(44.4 × 63.2 cm.)
Unsigned
Private collection, Switzerland

F1463 JH1576

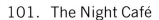

Van Gogh moved to the Café de la Gare, run by Joseph Ginoux and his wife Marie, in early May, and had a room there until mid-September, when he finally moved into the Yellow House. The Café de la Gare was situated at 30 Place Lamartine.

On 6 August, he announced to Theo: "Today I am probably going to start on the interior of the café where I stay, by gas-lighting, in the evening. It is what they call here a 'café de nuit' (they are fairly common here), staying open all night. Night prowlers can take refuge there when they have no money to pay for a lodging or are too tight to be taken in" (LT518).

But it was not until 8 September that he was able to report that he had stayed up for three nights running, sleeping only during the day, to paint *The Night Café* (fig. 45): "I have tried to express the terrible passions of humanity by means of the red and green. The room is blood red and dark yellow with a green billiard table in the middle; there are four citron yellow lamps with a glow of orange and green. Everywhere there is a clash and contrast of the most disparate reds and greens in

Fig. 45. *The Night Café* (F463). Oil on canvas, 28½ × 36¼ in. (72.4 × 92.1 cm.). Yale University Art Gallery, New Haven. Bequest of Stephen Carlton Clark

the figures of little sleeping hooligans, in the empty, dreary room, in violet and blue. The blood red and the yellow-green of the billiard table, for instance, contrast with the soft tender Louis XV green of the counter, on which there is a pink nosegay. The white coat of the landlord, awake in a corner of that furnace, turns citron yellow, or pale luminous green. I am making a drawing of it with the tones in watercolor to send to you tomorrow to give you some idea of it" (LT533).

The following day, his letter began: "I have just mailed the sketch of the new picture, the 'Night Café'" (LT534).

102. The Yellow House

Watercolor, 10⅛ × 12½ in. (25.7 × 31.7 cm.)
Watermark: Glaslam
Unsigned
Rijksmuseum Vincent van Gogh, Amsterdam

F1413 JH1591

Van Gogh rented the Yellow House at 2 Place Lamartine, unfurnished, in early May, but did not sleep there until mid-September. He had it painted inside and out after his return from Saintes-Maries in early June, and he used it as a studio for posing his models and as a "gallery" to hang his paintings, certainly those he took off stretchers and nailed to the wall in mid-July. In a letter to Theo of 1 May (LT480), he drew the exterior very rapidly, and inaccurately, from memory, and at the same time he sent his brother three drawings of the garden opposite, in one of which especially the Yellow House can be seen in the background (F1513).

He bought a few necessary kitchen utensils in early May (see cat. 29), but was only able to begin furnishing the house in earnest once Theo had sent him 300 francs —part of their Uncle Vincent's legacy to Theo—on 8 September.

The renting of this little house had enormous emotional significance for van Gogh: it was a symbol of possession, of security, and of freedom from hotel-keepers. It was also a house and a studio to be shared, and to be shared, above all, with Gauguin, who he hoped would soon join him and become the head of a studio in the South.

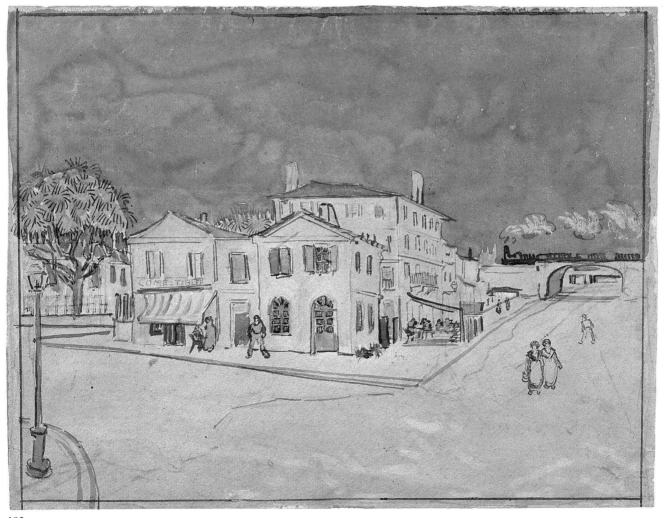

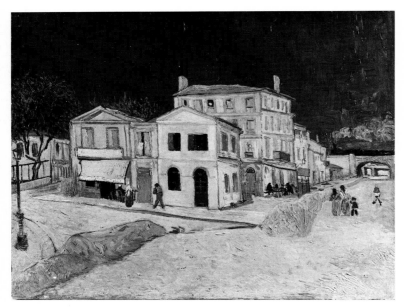

Fig. 46. *The Yellow House* (F464). Oil on canvas, 29⅞ × 37 in. (79 × 94 cm.). Rijksmuseum Vincent van Gogh, Amsterdam

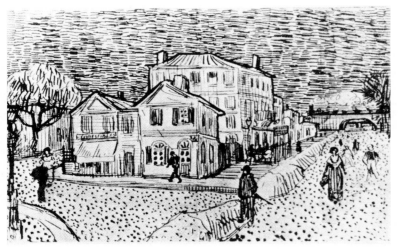

Fig. 47. *The Yellow House* (F1453). Pen and ink on paper, 5⅛ × 8¼ in. (13 × 20.5 cm.). Present location unknown

By 29 September, he reported on his recently finished paintings, one of which was "a size 30 canvas representing the house and its surroundings in sulphur-colored sunshine, under a sky of pure cobalt [fig. 46]. The subject is frightfully difficult, but that is just why I want to conquer it. It's terrific, these houses, yellow in the sun, and the incomparable freshness of the blue. And everywhere the ground is yellow too. I shall send you a better drawing than this rough improvised sketch out of my head [fig. 47] later on.

"The house on the left is pink with green shutters, I mean the one in the shadow of the tree. That is the restaurant where I go for dinner every day. My friend the postman lives at the end of the street on the left, between the two railroad bridges. The night café I painted is not in the picture, it is to the left of the restaurant.

"Milliet thinks this horrible, but I need not tell you that when he says he cannot understand anyone amusing himself doing such a dull grocer's shop, and such stark, stiff houses with no grace whatever, remember that Zola did a certain boulevard at the beginning of *L'Assommoir*, and Flaubert a corner of the Quai de la Villette in the midst of the dog days at the beginning of *Bouvard et Pécuchet*, and neither of them is moldy yet" (LT543).

Van Gogh excluded the Place Lamartine gardens from his view in order to concentrate on the house —the right wing of the foreground complex, with the prominent green shutters. There is yet an unreality about this painted image. The house is raised on its island, as it were, defended by mounds of earth (or cut grass?), seen from a slightly high viewpoint, with the cobalt blue so intense as to suggest a night sky.

In a letter of about 9 October, van Gogh asked Theo: "Did you see that drawing of mine which I put in with Bernard's drawings, representing the house? You can get some idea of the color. I have a size 30 canvas of that drawing" (LT548). Like the watercolor of *The Night Café* (cat. 101), the present watercolor gave Theo some indication of the colors of the oil painting, as well as of the composition. But, as so often happened, van Gogh provided a translation rather than a copy. The watercolor medium lightens the colors, so that the blue is much less intense, the greens sharper. In the slightly squarer format, there are compositional shifts and variations, especially in the lamppost at lower left and in the walking figures. And less obvious (though their outlines were originally drawn in pencil) are those mysterious mounds.

The house and the grocer's shop in the other wing later became a café-bar. Allied bombing in June 1944 caused considerable damage. Although capable of being restored, the house was pulled down.

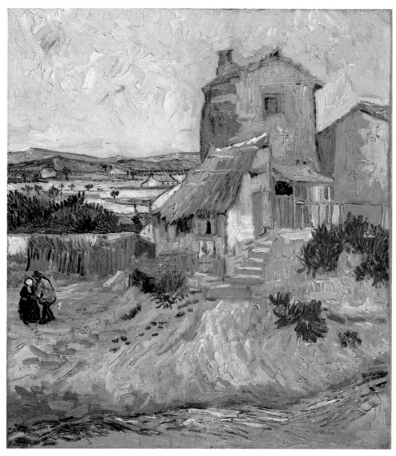

103

103. The Old Mill

Oil on canvas, 25⅝ × 21¼ in. (65 × 54 cm.)
Signed, lower right: Vincent
Albright-Knox Art Gallery, Buffalo, New York
 Bequest of A. Conger Goodyear, 1966

F550 H561 SG86 JH1577

"I have a study of an old mill painted in broken tones like the oak tree on the rock [see cat. 59], that study you were saying you had had framed along with the 'Sower' [cat. 49]," van Gogh wrote to Theo on about 12 September (LT535). He was referring to the present painting, which, apart from a brief citing in a letter to Emile Bernard (B19), is not actually described in the letters.

The landscape shows part of the Crau, which van Gogh had first really explored in his June paintings and drawings of the harvest. The same distant farmhouses, the Mont de Cordes, and the Alpilles recur here (see cat. 45; cat. 65, fig. 36; F558).

The mill was one of several that still existed in the nineteenth century. (Another, with its sails intact, can be seen in *Arles: View from the Wheat Fields*, cat. 82, but no longer stands.) Already, however, in 1888, it had lost its sails and was probably functioning simply as a farmhouse. A building, much altered today, in the Rue Mireille seems to be the same as that in the present picture.

The facture is more vigorous and impetuous, and the paint surface more worked and substantial, than in the June canvases. Strokes cascade down from the mill; greens in the sky are echoed in the earth, blues in the man's coat in the distant Alpilles; whites, in the wheat fields of June, reappear in and around the mill buildings. The increased impasto, the cascading strokes, and the surface echoes of color among seemingly disparate elements characterize some of van Gogh's October paintings (see cat. 109–112); on this smaller scale—a *pochade* executed no doubt in one session—they enhance the notion that this is essentially a painter's painting. Appropriately, it was one of seven canvases sent to Pont-Aven on 4 October (B19, LT545) as exchanges of work with Paul Gauguin, Emile Bernard, Charles Laval, and others; hence, it is signed. One of these artists was the French painter and sculptor Ernest-Henri de Chamaillard (c. 1865–1930). It seems probable that Chamaillard chose *The Old Mill*, and that van Gogh received in exchange a watercolor now in the Rijksmuseum Vincent van Gogh, Amsterdam.

104. Public Garden with Weeping Tree: Poet's Garden I

Oil on canvas, 28¾ × 36¼ in. (73 × 92 cm.)
Unsigned
The Art Institute of Chicago. Mr. and Mrs. Lewis Larned
 Coburn Memorial Collection

F468 H497 SG88 JH1578

In a letter of about 16 September, van Gogh reported that he had finished "a corner of a garden with a weeping tree, grass, round clipped cedar shrubs and an oleander bush. The same corner of the garden, that is, which you have already had a study of in the last batch [cat. 60]. But as this one is bigger, there is a citron sky over everything, and also the colors have the richness and intensity of autumn. And besides it is in even heavier paint than the other one, plain and thick" (LT537).

He spoke of the same painting the following day in a letter in which he recalled Petrarch's presence at Avignon. He marveled that he was seeing the same cypresses and oleanders, and wrote that he was trying "to put something of that into one of the pictures painted in a very thick impasto, citron yellow and lime green" (LT539).

This painting eventually became the first of four canvases that make up the Poet's Garden, a decoration destined for Gauguin's room in the Yellow House. The others are the *Public Garden with Round Bush* (cat. 107), the *Public Garden with Couple and Blue Fir Tree* (cat. 109), and *The Lovers* (F485).

This first Poet's Garden is a variation on a painting done in July of a corner of the public garden in the Place Lamartine (see cat. 60). The present view is given additional interest because of the summarily suggested tower in the left background—unmistakably that of Saint-Trophime. The angle at which it is seen clearly confirms the position of this garden in the Place Lamartine in the southeast corner, near the Rue du Pont d'Arles, which van Gogh called "the street of the kind girls" (LT539).

For a variation of this view seen from a totally different angle, without the tower of Saint-Trophime and conceived by van Gogh as a pendant to this painting, see the *Public Garden with Round Bush* (cat. 107).

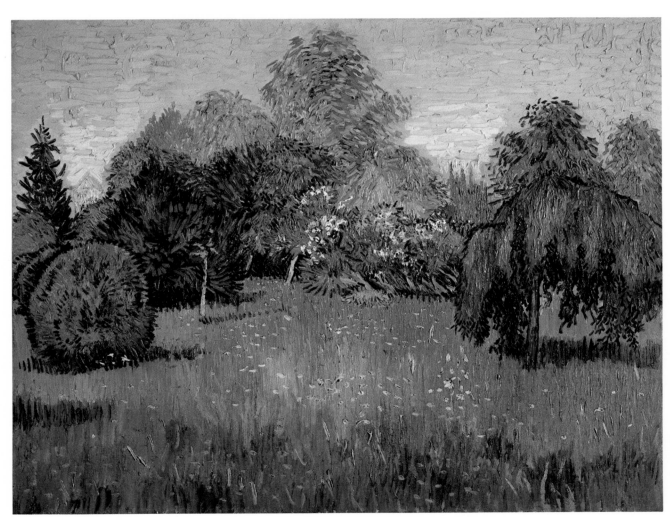

105. A Lane in the Public Garden

Oil on canvas, 28¾ × 36¼ in. (73 × 92 cm.)
Unsigned
Rijksmuseum Kröller-Müller, Otterlo

F470 H498 SG95 JH1582

On about 17 September 1888, van Gogh wrote to Theo telling him that he had slept in the Yellow House for the first time the previous night. He referred to the "glimpses of an intense blue sky and greenery through the windows." It was appropriate that he should have spent his first full day as occupant of the Yellow House painting in one of the gardens in the Place Lamartine. He went on to tell his brother: "At the moment I am working on another square size 30 canvas, another garden or rather a walk under plane trees, with the green turf, and black clumps of pines" (LT538).

In a second letter, written the same evening, he began: "I wrote to you already, early this morning, then I went away to go on with a picture of a garden in the sunshine. Then I brought it back and went out again with a blank canvas, and that also is finished [F471].

And now I want to write to you again. Because I have never had such a chance, nature here being so *extraordinarily* beautiful. Everywhere and all over the vault of heaven is a marvelous blue, and the sun sheds a radiance of pure sulphur, and it is soft and as lovely as the combination of heavenly blues and yellows in a Van der Meer of Delft. I cannot paint it as beautifully as that, but it absorbs me so much that I let myself go, never thinking of a single rule" (LT539).

This garden was situated on the Rhône side of the Place Lamartine. Instead of oleander bushes, so prominent in the *Public Garden with Weeping Tree: Poet's Garden I* (cat. 104), it contained "ordinary plane trees, pines in stiff clumps, a weeping tree, and the green grass." Compared with that of the first picture of the Poet's Garden, the paint is less thickly applied, apart from the substantial basket-weave strokes in the sky; it is, rather, an accumulation of dense, multidirectional hatchings. The impact of the sky's intense blue is lessened by the *sous-bois* effect. A touch of *la vie moderne* is introduced in the promenading figures, including the fashionable Arlésiennes with their parasols.

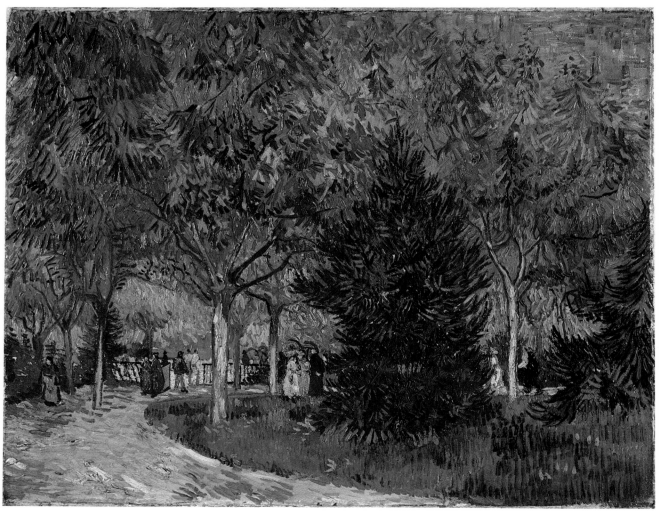

105

106

106. Public Garden with Fence

Pencil, reed pen, brown and black ink on wove paper,
 12⅝ × 9⅝ in. (32 × 24.3 cm.)
Unsigned
Rijksmuseum Vincent van Gogh, Amsterdam

F1477 JH1411

About mid-August, drawing ceased to be such a compulsive activity for van Gogh. There would never again be in Arles a series of drawings such as those of Montmajour (see cat. 30–33, 54–58) or Saintes-Maries (see cat. 34–42). But he did of course continue to draw, especially when he had no paints. "I find that I have now used up my entire stock of paints.... While I am without them I must draw," he wrote on 4 September (LT532). And again, only a fortnight later, on about 17 September: "My paint, my canvas and my purse are all completely exhausted.... Tomorrow I am going to draw until the paints come" (LT539). He had used his last tubes of blue and yellow to finish a smaller canvas of the same garden depicted in *A Lane in the Public Garden* (cat. 105). This smaller canvas (fig. 48) shows a view of the garden from the inside, looking toward the fenced exit to the road running through the Place Lamartine. In contrast, the present drawing shows a view into the garden from the road, with the small sidewalk in the foreground, then the fence, and the same trees differently disposed. Just visible at the left are windows of a building in the Place Lamartine.

The style continues to exhibit the system of signs van Gogh had evolved by July and August. But rarely have their directional, textural, shape, and surface variations been so remarkably inventive.

107. Public Garden with Round Bush: Poet's Garden II

Pen and ink, 5⅜ × 6¾ in. (13.5 × 17 cm.)
Unsigned
Private collection

F1465 JH1583

"Since seven o'clock this morning," wrote van Gogh to Theo about 27 September, "I have been sitting in front of something which after all is no great matter, a clipped round bush of cedar or cypress growing amid grass. You already know this clipped bush, because you have had a study of the garden. Enclosed also a sketch of my canvas, again a square size 30. The bush is green, touched a little with bronze and various other tints. The grass is bright, bright green, malachite touched with citron, and the sky is bright, bright blue. The row of

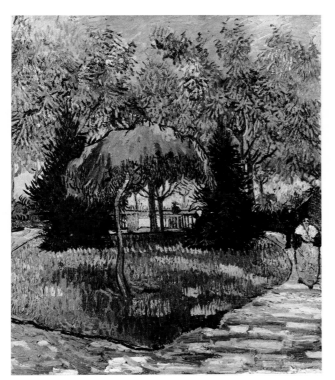

Fig. 48. *The Park with the Entrance Seen Through the Trees* (F471). Oil on canvas, 29¼ × 24½ in. (74 × 62 cm.). Destroyed; formerly Collection Eduard Arnhold, Berlin

bushes in the background is all oleanders, raving mad; the blasted things are flowering so riotously they may well catch locomotor ataxia. They are loaded with fresh flowers, and quantities of faded flowers as well, and their green is continually renewing itself in fresh, strong shoots, apparently inexhaustibly. A funereal cypress is standing over them, and some small figures are sauntering along a pink path. This makes a pendant to another size 30 canvas of the same spot, only from a totally different angle, in which the whole garden is in quite different greens, under a sky of pale citron" (LT541).

This small drawing van Gogh enclosed in the letter. Sadly, it is our only record of a lost painting, one he valued highly and had framed in walnut to hang in Gauguin's room as the second of the Poet's Garden series of decoration (see cat. 104). He continued to Theo: "It is true that I have left out some trees, but what I have kept in the composition is really there just as you see it. Only it has been overcrowded with some shrubs

which are not in character. And to get at that character, the fundamental truth of it: that's three times now that I've painted the same spot. It happens to be the garden just in front of my house. But this corner of the garden is a good example of what I was telling you, that to get at the real character of things here, you must look at them and paint them for a long time. Perhaps you will see nothing from the sketch except that the line is now very simple. This picture is again painted very thickly, like its pendant with the yellow sky" (LT541).

In his letter of 2 October to Eugène Boch (LT553b), he also made a sketch of the same painting.

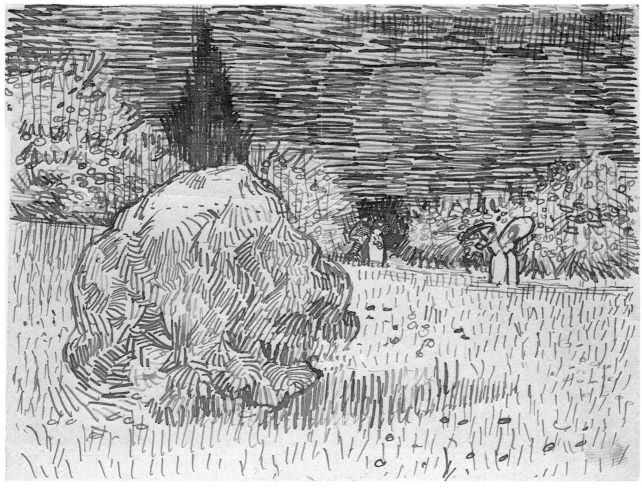

107

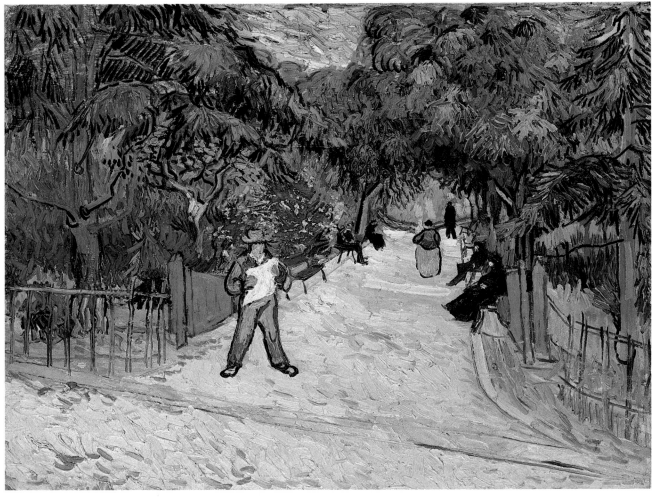

108

108. Entrance to the Public Garden

Oil on canvas, 28½ × 35⅞ in. (72.5 × 91 cm.)
Unsigned
The Phillips Collection, Washington, D.C.

F566 H553 SG91 JH1585

Although this painting was not specifically described by van Gogh, its context can be fairly securely established. In a letter to Theo of about 10 October, he said he had done "a new size 30 canvas . . . another garden" (LT549). But nothing more. Two considerations help identify this painting as the one referred to. The first involves a change in the published letters. If LT551, which describes another garden picture (F472), is placed after LT556 (and thus becomes the last letter sent to Theo before Gauguin's arrival in Arles), it is possible to accommodate the present painting in the "count" of garden pictures. This "count" is the second confirming factor. In a list of size 30 canvases appended to LT552, van Gogh cited "3 canvases of the poet's garden" (cat. 104, 107, 109) and "2 canvases of the other garden." The paintings of "the other garden" are *A Lane in the Public Garden* (cat. 105), completed in mid-September, and the present picture: there is no other candidate once LT551 (with F472) has been placed after LT556.

This also establishes the location of the *Entrance to the Public Garden*. It has been repeatedly claimed to show part of the more fashionable public garden in the Boulevard des Lices on the south side of the town (which still exists today). It must, however, be a different part of the "other" garden on the Rhône side of the Place Lamartine from that shown in *A Lane in the Public Garden*. The surrounding fence is reminiscent of the one shown in a drawing and in a lost oil (see cat. 106).

Compared with the Poet's Garden, this "other" garden is always presented without symbolic overtones or poetic accretions. It is commonplace and everyday,

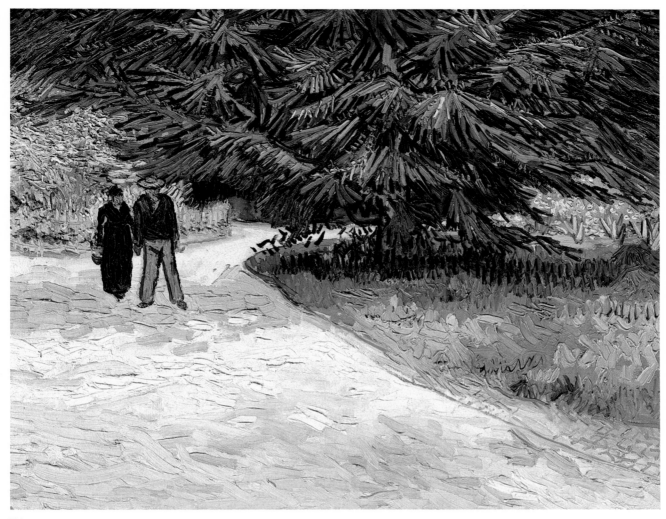

109

often with park benches and seated figures and a stronger flavor of *la vie moderne*. Writing to Gauguin on 3 October, van Gogh noted, "Very often the figures here are absolutely Daumier" (LT544a). (Daumier lithographs, recently sent by Theo, were hanging in his studio.) Some of the figures in the present painting can be seen as translations of Daumier: the man reading the newspaper, for example, and the strolling woman seen from behind, who is surely carrying a baby swaddled in white and may be based on Madame Roulin with her daughter, Marcelle.

Van Gogh confirmed the Daumier connection even more forcibly three days after completing the present painting: "Autumn still continues to be so beautiful! It's a queer place, this native land of Tartarin's! Yes, I am content with my lot, it isn't a superb, sublime country, this; it is only a Daumier come to life" (LT552).

109. Public Garden with Couple and Blue Fir Tree: Poet's Garden III

Oil on canvas, 28¾ × 36¼ in. (73 × 92 cm.)
Unsigned
Private collection

F479 H504 SG111 JH1601

In his letter to Theo of 13 October, van Gogh included both a quick sketch (fig. 49) and a descriptive inventory of a recently completed painting: "Imagine an immense pine tree of greenish blue, spreading its branches horizontally over a bright green lawn, and gravel splashed with light and shade. Two figures of lovers in the shade of the great tree: size 30 canvas. This very simple patch of garden is brightened by beds of geraniums, orange in the distance under the black branches" (LT552).

He makes no reference to its status—whether it is one of the Poet's Gardens or one of the "other" gardens

—but in a list of size 30 canvases at the end of the same letter, it becomes clear that it belongs to the series the Poet's Garden, conceived as a decoration for Gauguin's room in the Yellow House. It is number three in the sequence.

But now oleanders, small round bushes, and weeping tree are replaced by a large pine tree and geraniums. The design is simpler, grander. And two figures of lovers heighten the poetic concept and allude to an image associated in van Gogh's mind with Adolphe Monticelli —as if Boccaccio and Monticelli were brought together. In his famous letter of thanks to the art critic Albert Aurier for the article about him that was published in the *Mercure de France* in January 1890, he wrote: "It seems to me that Monticelli's personal artistic temperament is exactly the same as that of the author of the *Decameron*—Boccaccio—a melancholic, somewhat resigned, unhappy man who saw the wedding party of the world pass by, painting and analyzing the lovers of his time—he, the one who had been left out of things" (LT626a).

The painting was among those dispatched to Theo in Paris in May 1889 (LT589).

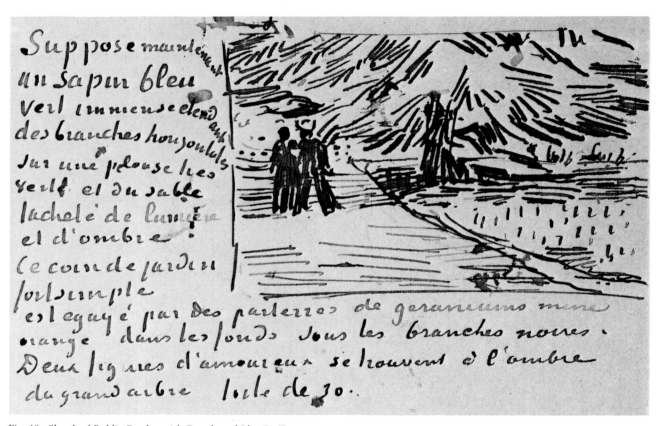

Fig. 49. Sketch of *Public Garden with Couple and Blue Fir Tree: Poet's Garden III* (LT552). Rijksmuseum Vincent van Gogh, Amsterdam

184

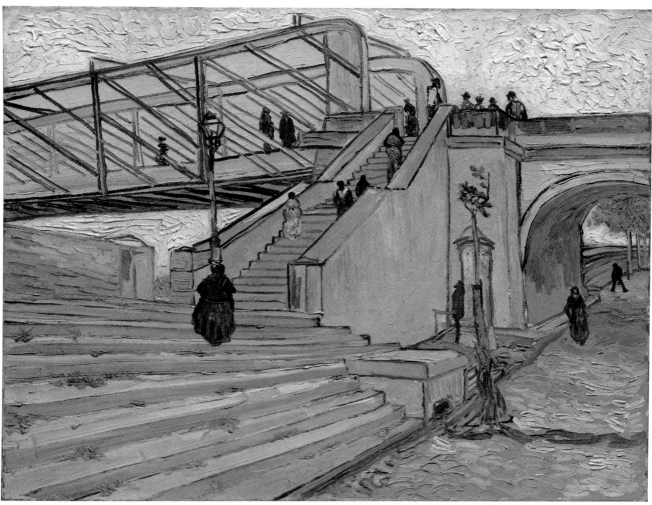

110

110. The Trinquetaille Bridge

Oil on canvas, 28¾ × 36¼ in. (73 × 92 cm.)
Unsigned
Private collection, U.S.A.

F481 H506 SG107 JH1604

When reporting this painting as finished by 13 October,
van Gogh also included a sketch of it for Theo (fig. 50).
"This canvas is a little like a Bosboom in color. The
Trinquetaille Bridge with all these steps is a canvas done
on a gray morning, the stones, the asphalt, the pave-
ments are gray; the sky pale blue; the figures colored;
and there is a sickly tree with yellow foliage" (LT552).
It was, he concluded, done in "gray and blended" tones.
The reference to Johannes Bosboom (1817–1891) is to
the Dutch artist's essentially subdued coloring.

Van Gogh here viewed the Trinquetaille Bridge, a
road bridge spanning the Rhône (fig. 51), farther down-
stream and in the reverse direction from the view he
took of it in his June canvas (cat. 71, fig. 38). The image

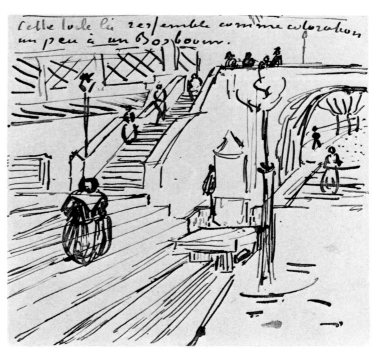

Fig. 50. Sketch of *The Trinquetaille Bridge* (LT552). Rijksmuseum
Vincent van Gogh, Amsterdam

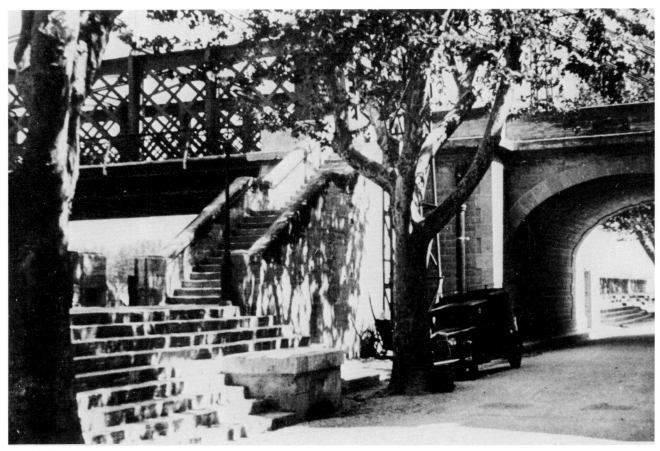

Fig. 51. The Trinquetaille Bridge. c. 1935. Photograph by John Rewald

conveys the very opposite of a sun-drenched southern landscape. It is almost a memory of the North, a gray Dutch morning combined with elements of modern urban life culled from the working-class suburbs of Paris. Such was van Gogh's concentration on stone, asphalt, and iron that he excluded any sight of the Rhône itself. It is as if he were painting a footbridge over a railroad rather than this open, massive boxlike structure—a triumph of modern engineering skills erected in 1875.

The relatively closeup view of the approaches to the bridge produced arbitrary croppings. Spatially disparate diagonals compete for attention but are counteracted by the strategic placing of the figures, especially the woman seen from behind climbing the steps.

It seems almost certain that the picture was painted in a single morning session. The heavy impasto of sky and road, the rapid linear constructions of the brush in bridge and steps, and the laconically created figures attest to this.

The painting has recently been cleaned, and the subtlety of the "gray and blended" tones has been beautifully revealed.

111. The Railroad Bridge

Oil on canvas, 28¾ × 36¼ in. (73 × 92 cm.)
Unsigned
Loan at Kunsthaus, Zurich

F480 H507 SG108 JH1603

This painting was briefly reported as completed by 13 October—"another bridge, where the railroad passes over the road"—and sketched in the same letter (LT552; fig. 52).

Taken from the Avenue de Montmajour looking south toward the Place Lamartine (with its gardens visible in the distance), the view is through two railroad bridges. The first and dominating one is that of the main PLM line from Arles to Marseilles; the second served a minor local line. The bridges are seen from the opposite direction—looking from the Place Lamartine —in *The Yellow House* (cat. 102).

The complex multidirectional axes make this one of van Gogh's most arresting images. The dominating focus is under and through the main bridge, with its

receding side walls, set-back central wall, iron underside, and sidewalk all competing to project the onlooker into fast-receding space. The recession is slowed down by the astute placing of figures, especially the woman seen from the back at right, who covers two converging orthogonals, and by the play of sunlight between the two bridges. There is also the counterthrust, from right to left, of the bridge itself, so rapid, however, that it tends to evaporate at left.

Color, by contrast, has no strong role. But the very tactile presence of the paint itself creates an insistent surface interest, which also reduces the spatial pyrotechnics: for example, the swirling, interpenetrating strokes in the sky; the areas of impasto (such as the slab of white for the woman's face); and the various greens that subtly change and react and repeat in the distant gardens, in the right inner wall, and in the odd touches of vegetation.

In its exploration of deep space, this painting comes between *The Night Cafe* (cat. 101, fig. 45) and *Van Gogh's Bedroom* (cat. 113).

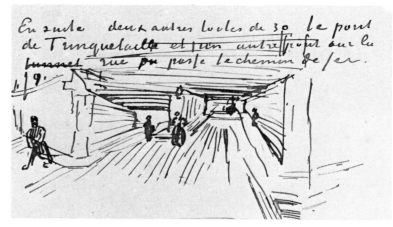

Fig. 52. Sketch of *The Railroad Bridge* (LT552). Rijksmuseum Vincent van Gogh, Amsterdam

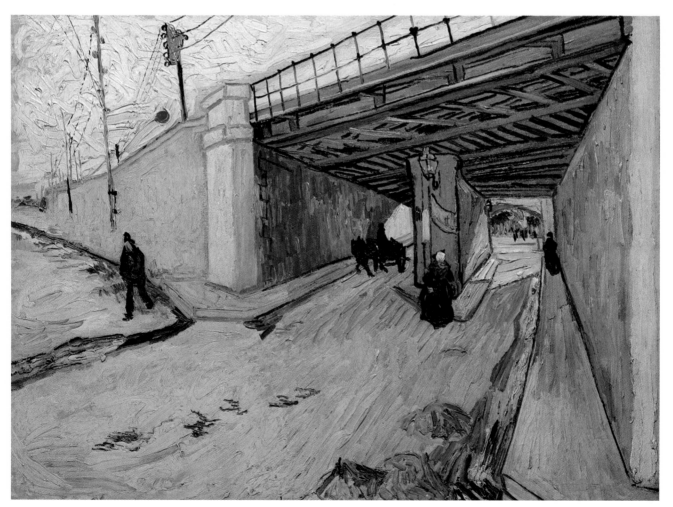

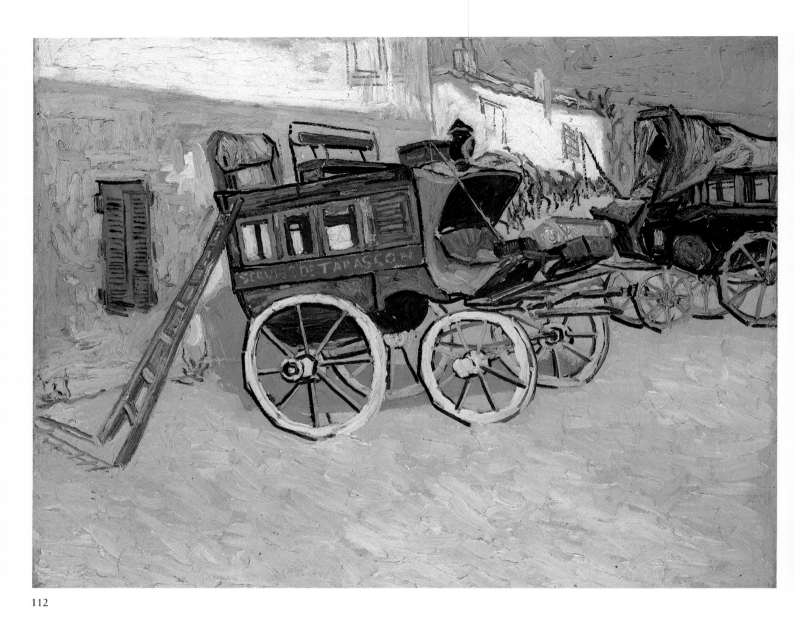

112

112. Tarascon Diligence

Oil on canvas, 28⅜ × 36¼ in. (72 × 92 cm.)
Unsigned
The Henry and Rose Pearlman Foundation, Inc.

F478a H811 JH1605

Van Gogh had just finished painting the *Tarascon Diligence* when he wrote to Theo on 13 October and asked: "Have you reread *Tartarin* yet? Be sure not to forget. Do you remember that wonderful page in *Tartarin*, the complaint of the old Tarascon diligence? Well, I have just painted that red and green vehicle in the courtyard of the inn. You will see it. This hasty sketch [fig. 53] gives you the composition, a simple foreground of gray gravel, a very, very simple background too, pink and yellow walls, with windows with green shutters, and a patch of blue sky. The two carriages very brightly colored, green and red, the wheels—yellow, black, blue, and orange. Again a size 30 canvas. The carriages are painted like a Monticelli with spots of thickly laid-on paint. You used to have a very fine Claude Monet showing four colored boats on a beach. Well, here they are

carriages, but the composition is in the same style"
(LT552).

The references are to the episode in Alphonse
Daudet's novel *Tartarin de Tarascon* (1872) where the
diligence—or horse-drawn carriage—complains of being
exiled in North Africa, and to a painting by Monet of
boats on the beach at Etretat that had passed through
Theo's hands at Boussod & Valadon (probably the pic-
ture now in the Art Institute of Chicago).

Later in the same letter, van Gogh confessed he
was completely exhausted after painting "this Tarascon
diligence." It seems likely that he finished it in one
session: there is little evidence of studio retouching. It
brought to an end a remarkably productive week that
included two garden pictures (cat. 108, 109) and two
pictures of bridges (cat. 110, 111). All five were of motifs
within easy walking distance of his house. Three of them
are about modes and means of transport, of arrival and
departure, as if the pressing thoughts of Gauguin's im-
minent coming made him especially conscious of the
contrast between an old-fashioned diligence, a modern
iron road bridge, and the railroad bridges and viaduct.

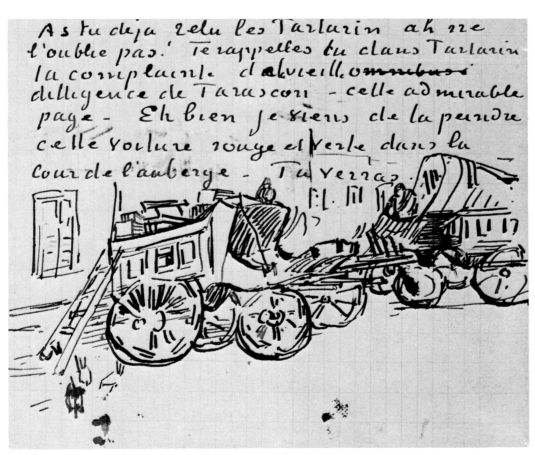

Fig. 53. Sketch of *Tarascon Diligence* (LT552). Rijksmuseum
Vincent van Gogh, Amsterdam

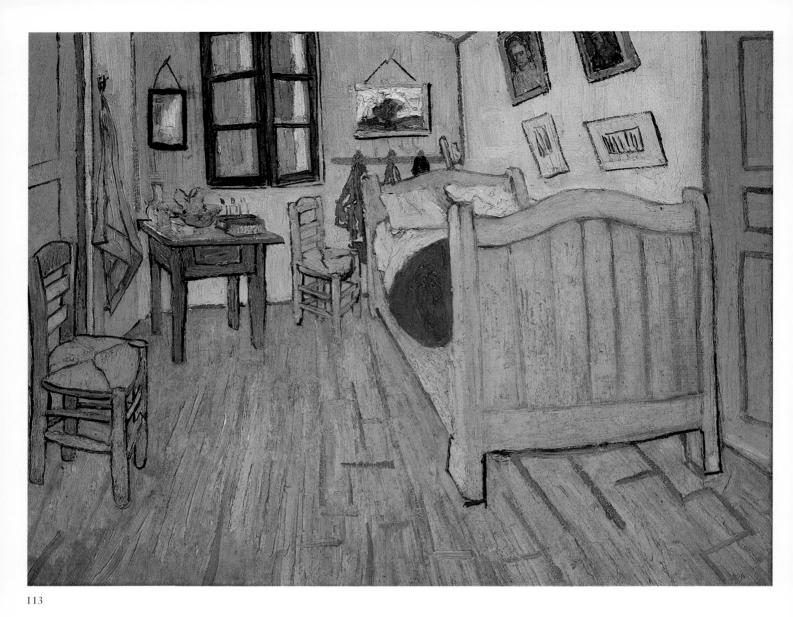

113

113. Van Gogh's Bedroom

Oil on canvas, 28⅜ × 35⅜ in. (72 × 90 cm.)
Unsigned
Rijksmuseum Vincent van Gogh, Amsterdam

F482 H627 SG26 (Saint-Rémy) JH1608

"I have been and still am nearly half-dead from the past week's work," van Gogh wrote to Theo on 14 October, exhausted from having painted five size 30 canvases in a week (cat. 108–112). "I cannot do any more yet, and besides, there is a very violent mistral that raises clouds of dust which whiten the trees on the plain from top to bottom. So I am forced to be quiet. I have just slept sixteen hours at a stretch, and it has restored me considerably" (LT553).

Two days later he could write: "Today I am all

right again. My eyes are still tired, but then I had a new idea in my head and here is the sketch of it [fig. 54]. Another size 30 canvas. This time it's just simply my bedroom, only here color is to do everything, and giving by its simplification a grander style to things, is to be suggestive here of *rest* or of sleep in general. In a word, looking at the picture ought to rest the brain, or rather the imagination. The walls are pale violet. The floor is of red tiles. The wood of the bed and chairs is the yellow of fresh butter, the sheets and pillows very light greenish citron. The coverlet scarlet. The window green. The toilet table orange, the basin blue. The doors lilac. And that is all—there is nothing in this room with its closed shutters. The broad lines of the furniture again must express inviolable rest. Portraits on the walls, and a mirror and a towel and some clothes. The frame—as there is no white in the picture—will be white. . . . I shall work on it again all day, but you see how simple the

conception is. The shadows and the cast shadows are suppressed; it is painted in free flat tints like the Japanese prints. It is going to be a contrast to, for instance, the Tarascon diligence [cat. 112] and the night café [cat. 101, fig. 45]" (LT554).

And the next day, 17 October: "This afternoon I finished the canvas representing the bedroom...the workmanship is...virile and simple. No stippling, no hatching, nothing, only flat colors in harmony" (LT555). The same day he wrote to Gauguin, enclosing a sketch of the painting (fig. 55): "Listen, the other day I wrote you that my eyesight was strangely tired. All right, I rested for two and a half days, and then I set to work again, but without daring to go out into the open air yet. I have done, still for my decoration, a size 30 canvas of my bedroom with the white deal furniture that you know. Well, I enormously enjoyed doing this interior of nothing at all, of a Seurat-like simplicity; with flat tints, but brushed on roughly, with a thick impasto, the wall pale lilac, the ground a faded broken red, the chairs and the bed chrome yellow, the pillows and the sheet a very pale green-citron, the counterpane blood red, the washstand orange, the washbasin blue, the window green. By means of all these very diverse tones I have wanted to express an *absolute restfulness*, you see, and there is no white in it at all except the little note produced by the mirror with its black frame (in order to get the fourth pair of complementaries into it)" (B22).

"An absolute restfulness," van Gogh had written. Yet the picture has often been interpreted as evidence of psychological disturbance, especially in the apparent distortions of pictorial space. Such interpretations, however, have been based on the assumption that van Gogh's bedroom was a simple rectangular space. In fact, it was shaped thus:

window

door door

Van Gogh's Bedroom

which meant that the right-hand wall thrust more deeply into space. The distortions, therefore, were already part of the room's unusual shape; van Gogh, on the whole, accepted it without "correction."

After his first period in the hospital, van Gogh wrote Theo about 22 January 1889: "When I saw my canvases again after my illness, the one that seemed the best to me was the bedroom" (LT573). It was eventually one of the batch of paintings sent off to Theo in May 1889 (LT589). But once it arrived in Paris, Theo reported that it had been damaged (LT594, 9 June 1889).

"I shall send you back the bedroom," wrote Theo on 16 June, "but you must not think of retouching this canvas if you can repair the damage. Copy it, and then send back this one so that I can have it recanvased" (T10).

Van Gogh reported in early September 1889 that he had made a copy of the picture (F484), and in late September that he had made a smaller version for his mother and his sister Wil (F483).

There are differences between the three versions, not least in the pictures hanging on the walls. In the present version, an unidentified landscape framed in walnut hangs over the bed, replacing a portrait of van Gogh's mother, which was shown in the first sketch (fig. 54), while the portraits of Eugène Boch and the Zouave Milliet (cat. 98, 100) hang on the side wall in their recently acquired oak frames. Beneath them are probably Japanese prints.

Fig. 54. Sketch of *Van Gogh's Bedroom* (LT554). Rijksmuseum Vincent van Gogh, Amsterdam

Fig. 55. Sketch of *Van Gogh's Bedroom* (B22). Present location unknown

191

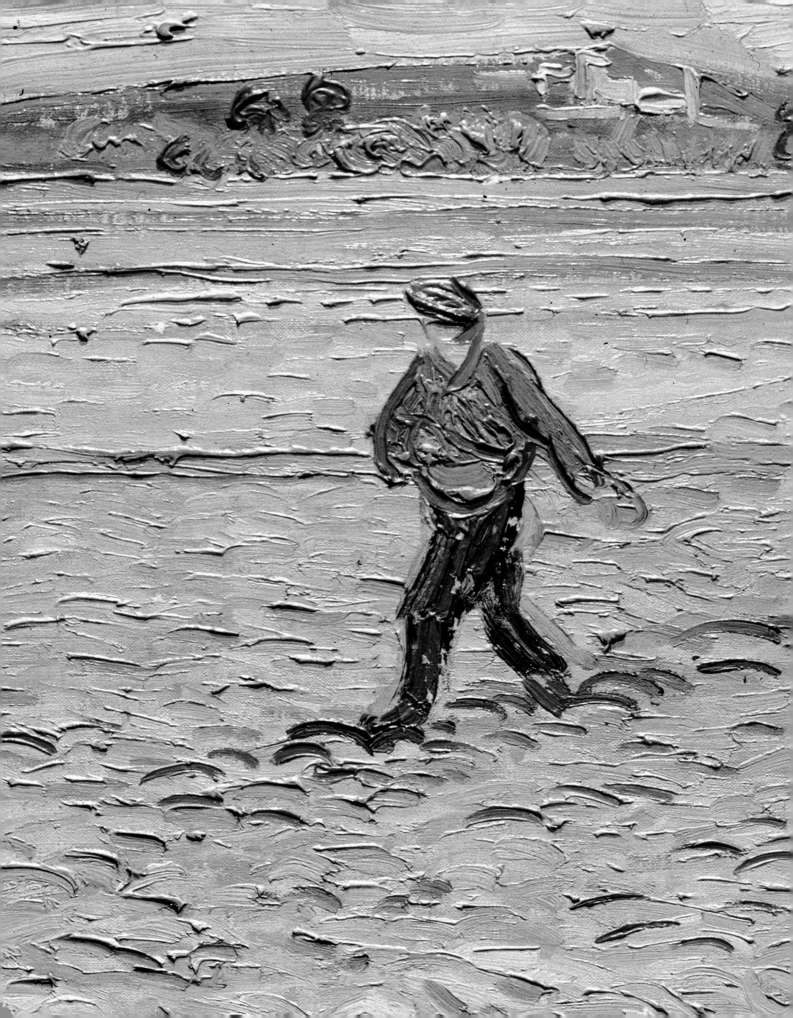

Tuesday 23 October
Gauguin arrives in Arles before daybreak after leaving Pont-Aven on Sunday 21 October. He goes to the Café de la Gare, where Ginoux recognizes him from his self-portrait, *"Les Misérables"* (cat. 99, fig. 44). A letter from Theo of 22 October, sending Gauguin 500 francs for the sale of his painting *Four Breton Women* (WC201), arrived in Pont-Aven after Gauguin had left.

Theo leaves Paris for Brussels on a business trip, staying until Friday or Saturday. Van Gogh's telegram, announcing Gauguin's arrival, reaches Paris after Theo's departure.

Wednesday 24 October
Letter from Theo, enclosing 50 francs. In reply, van Gogh writes of Gauguin: "He is very interesting as a man, and I have every confidence that we shall do loads of things with him. He will probably produce a great deal here, and I hope perhaps I shall too"; made acutely aware of his own failure to sell by Gauguin's recent sale; hopes his pictures will one day be worth more than the price of the paint; agonized that there is no demand for them, and feels he must produce "even to the extent of being mentally crushed and physically drained by it. . . . For a while I had a feeling that I was going to be ill, but Gauguin's arrival has so taken my mind off it that I'm sure it will pass. I must not neglect my food for a time, and that is all, absolutely all there is to it."

They intend to bypass the art supplier Tasset by using cheaper colors and preparing their own canvas.

"Gauguin brought a magnificent canvas which he has exchanged with Bernard, Breton women in a green field, white, black, green, and a note of red, and the dull flesh tints" (see cat. 125).

Thursday 25 October
Gauguin writes to the artist Emile Schuffenecker (1851–1934) of his arrival in Arles and of the sale, through Theo, of his *Four Breton Women.*

Saturday 27 October
Theo returns to Paris from Brussels to find van Gogh's telegram and letters of 22 and 24 October. Sends money order for 50 francs, and writes that Tasset will send paints and canvas shortly and that Gauguin's Brittany canvases have not yet arrived.

Sunday 28 October
Letter from Theo to van Gogh, with 50 francs, and the one to Gauguin of 22 October, with 500 francs, sent on from Pont-Aven. Gauguin writes acknowledging both letters: hopes that his Brittany canvases will please Theo when they arrive and that Theo's journey to Brussels has been "good for the cause." He says nothing of his work in Arles.

Van Gogh writes to Theo: he is surprised to learn that Gauguin has been a sailor. "This gives me an awful respect for him and a still more absolute confidence in his personality"; Gauguin is busy with paintings of a black woman and a large landscape; van Gogh has painted two studies —a sower (cat. 114) and "a ploughed field with the stump of an old yew tree[F573]," both sketched in his letter; "My brain is still feeling tired and dried up, but this week I am feeling better than during the previous fortnight."

Most likely, Gauguin also writes to Bernard this same day. Having just received 500 francs, he is anxious to pay his debts in Pont-Aven, and sends 280 francs to pay the pension Gloanec, adding 5 francs so that Bernard can send a few more of his paintings to Theo in Paris. He observes: "It is strange, Vincent is inspired here to paint like Daumier, while I on the contrary find a combination of a colorful Puvis [Pierre Puvis de Chavannes, 1824–1898] and Japanese art."

The Dutch artist Jacob Meyer de Haan (1852–1895) comes to stay with Theo.

Monday 29 October
During this week, Gauguin spends almost 100 francs buying a chest of drawers, various household utensils, and 20 meters of very strong canvas. Using this canvas, van Gogh paints two views of the Alyscamps with falling leaves (cat. 116, 117).

Thursday 1 November
Milliet leaves Arles for Africa. Van Gogh writes to Theo: "He got a study of mine for troubling to take the canvases to Paris, and Gauguin gave him a small drawing in exchange for an illustrated edition of [Pierre Loti's] *Madame Chrysanthème."*

Friday 2 November
Wind and rain probably keep van Gogh and Gauguin indoors.

Most likely they write a joint letter to Bernard—van Gogh's first news to Bernard since Gauguin's arrival. Van Gogh reports that he has read Zola's *Le Rêve* (1888); he thinks the future of painting is in the tropics; Gauguin is working "on a canvas of the same night café I painted too, but with figures seen in the brothels [cat. 123]"; he and Gauguin have made some excursions to the brothels; Milliet has gone to Africa and would like Bernard to write to him; he himself has done "two studies of the fall of leaves in an avenue of poplars, and a third study of the whole avenue, entirely yellow [cat. 115–117]." Gauguin adds in a postscript: "Two studies of falling leaves are in my room; you would like them very much. They are on very heavy but good burlap."

Sunday 4 November
During an evening walk they see "a red vineyard, all red like red wine. In the distance it turned to yellow, and then a green sky with the sun, the earth after the rain violet, sparkling yellow here and there where it caught the reflection of the setting sun."

Monday 5 November
Van Gogh probably works on *The Red Vineyard* (cat. 119), Gauguin on "some women in a vineyard, completely from memory [cat. 118]," both based on their Sunday evening walk.

Tuesday 6 November
Letter from Theo, enclosing 100 francs: confirms that he has now received Gauguin's Brittany paintings, which he and others have liked. Van Gogh replies that Gauguin is working on his women in a vineyard and "a picture of the same night café that I painted [cat.123]." He himself is working on *The Red Vineyard* (cat. 119); also announces triumphantly: "I have an Arlésienne at last, a figure (size 30 canvas) slashed on in an hour [see cat. 120, 121]."

"Gauguin and I are going to have our dinner at home today, and we feel as sure that it will turn out well as that it will prove to be better or cheaper."

Wednesday 7–Monday 12 November
They continue working on their various canvases.

Van Gogh finishes *The Red Vineyard*. Writes to Theo: "I think that you will be able to put this canvas beside some of Monticelli's landscapes"; has done "a rough sketch of the brothel," with the intention of doing a brothel picture.

Gauguin finishes his "women grape gatherers" (cat. 118); and has almost finished his *Night Café* (cat. 123).

Van Gogh refuses art critic Edouard Dujardin's invitation to exhibit at the offices of *La Revue Indépendante*.

Gauguin "knows how to cook *perfectly*; I think I shall learn from him, it is very convenient. We find it very easy to make frames with plain strips of wood nailed on the stretcher and painted, and I have begun doing this."

"We are having wind and rain here [especially on Friday 9], and I am very glad not to be alone. I work from memory on bad days, and that would not do if I were alone."

Tuesday 13 November
Theo has arranged a small exhibition of Gauguin's Brittany paintings at Boussod & Valadon, 19 Boulevard Montmartre. He writes to Gauguin: the pictures are a great success; he has framed them in "a very fine white frame of unpainted wood"; Degas is enthusiastic and intends to buy a spring landscape; two other landscapes have been sold for 375 and 225 francs respectively; a third, *Breton Children* (WC 251), can also be sold if Gauguin will retouch part of it: "It seems to me that this will not be difficult for you, and so I am sending you the canvas."

Wednesday 14–Thursday 15 November
Gauguin replies by return mail to Theo's letter: delighted with the sales, and with Degas's praise; he will retouch the canvas; the housekeeping is going very well; he and van Gogh do their own cooking and eat at home; but terrible, rainy weather has prevented work outdoors; instead, they devote themselves to "la peinture de chic," painting from memory; it is in this way that van Gogh is doing "a good Dutch garden that you [Theo] know with the family [cat. 126]," and Gauguin himself "a poor girl bewitched in a field full of red vines [cat. 118]"; he hopes in a year's time his health will be so improved that he will be able to return to the tropics.

Gauguin also writes to Bernard about his success in Paris, and encloses an order for paints from Tanguy.

Friday 16–Saturday 17 November
Van Gogh replies to a letter enclosing 100 francs from Theo.

Also writes to his sister Wil: has received the exchanges of canvases from Pont-Aven, a seascape by Bernard and a self-portrait by Charles Laval (1862–1894); has had a letter from Jet Mauve about the painting of the orchard dedicated to Anton Mauve (F394); Gauguin is working on *Woman in the Hay* (WC301); he himself has been working on two canvases, *Memory of the Garden at Etten* (cat. 126) and *The Novel Reader* (F497), each described at length; Gauguin gives him "the courage to imagine things, and certainly things from the imagination take on a more mysterious character."

Monday 19–Friday 23 November
Gauguin's canvas *Breton Children* arrives from Paris; van Gogh reports to Theo that "he has altered it very well," and that Gauguin is going to send Theo *Grape Gathering: Human Misery* (cat. 118) and *Woman in the Hay* (WC301). "His last two canvases, which you will soon be seeing, are very firm in the impasto, there is even some work with the palette knife. And they will throw his Breton canvases a little in the shade—not all, but some."

"Gauguin, in spite of himself and in spite of me, has more or less proved to me that it is time I was varying my work a little. I am beginning to compose from memory, and all my studies will still be useful for that sort of work, recalling to me things I have seen."

"Gauguin was telling me the other day that he had seen a picture by Claude Monet of sunflowers in a large Japanese vase, very fine, but—he likes mine better. I don't agree—only don't think I am weakening."

Van Gogh working on two size 30 canvases: "a wooden rush-bottomed chair all yellow on red tiles against a wall (daytime) [cat. 141]. Then Gauguin's armchair, red and green night effect, walls and floor red and green again, on the seat two novels and a candle, on thick canvas with a thick impasto [cat. 141, fig. 69]."

Friday 23 November
Gauguin writes to Schuffenecker: has been invited to exhibit at the office of *La Revue Indépendante*; as soon as he receives money from Theo, he will send some to his wife in Copenhagen.

Sunday 25 November
Letter from Theo, enclosing 100 francs. In reply, van Gogh writes: he is very pleased with Gauguin's continued success with the

sale of his paintings; "Here the weather is cold, notwithstanding which one sees very fine things. For instance yesterday evening an extraordinarily beautiful sunset of mysterious, sickly citron color—Prussian blue cypresses against trees with dead leaves in all sorts of broken tones without any speckling with bright greens"; at work on a canvas of a sower (cat. 129), whose colors partly respond to the described sunset; discusses Rembrandt and light in connection with two photographs of drawings by Meyer de Haan sent to him by Theo; "Gauguin is working on a very beautiful picture of women washing [see cat. 130, 131], and also on a large still life of an orange-colored pumpkin and apples and white linen on a yellow background and foreground [now lost]."

Tuesday 4 December
Letter from Theo, enclosing 100 francs.

Both artists are "working all the time, in the evening we are dead beat and go off to the café, and after that, early to bed! Such is our life. Of course it's winter here with us too, though it's still very fine from time to time. But I do not dislike trying to work from imagination, since that allows me to stay in. It does not worry me to work in the heat of a stove, but cold does not suit me, as you know. Only I have spoiled that thing that I did of the garden in Nuenen, and I think that you also need practice to work from the imagination. But I have made portraits *of a whole family*...the man, his wife, the baby, the little boy, and the son of sixteen [*sic*]." This must have occupied him for the previous ten days. The family in question is Roulin's (see cat. 132–136).

Theo's letter had clearly said complimentary things about the new *Sower* (cat. 129). Van Gogh replies: "From time to time there's a canvas which will make a picture, such as the 'Sower' in question, which I myself think better than the first"; will send Theo a batch of pictures, "say *within a month*," but wants them to be thoroughly dry; "Gauguin works a lot. I very much like a still life, background and foreground yellow [now lost]; he is working on a portrait of me which I do not count among his useless undertakings [cat 142, fig. 70]; just now he is doing some landscapes; and lastly, he has a good canvas of women washing, even very good I think [see cat. 130, 131]"; Gauguin has been invited to contribute to the exhibition of Les XX in Brussels.

It is probably on this same day that Gauguin sends five rolled canvases to Theo in Paris: the altered *Breton Children* (WC251), a *Night Café* (cat. 123), a landscape of

"three graces at the temple of Venus" (cat. 115, fig. 57), "the pigs" (WC301), and "Wine Harvest, or the Poor Woman" (cat. 118).

Saturday 8 December
Gauguin's canvases have arrived in Paris. Schuffenecker sees them at Boussod & Valadon. Gauguin replies to Theo's letter acknowledging their safe arrival: very touched by Degas's praise; has received an invitation to exhibit at the offices of *La Revue Indépendante*, and encloses his letter of refusal; has accepted the invitation from Les XX in Brussels.

Tuesday 11 December
Schuffenecker writes enthusiastic letter to Gauguin, full of admiration for his recent paintings.

c. Wednesday 12 December
Gauguin encloses Schuffenecker's letter with his own letter to his wife, Mette, in Copenhagen, in which he tells her of his invitation to Les XX in Brussels, and sends her 200 francs.

c. Friday 14–Saturday 15 December
Gauguin writes Theo that he feels obliged to return to Paris: van Gogh and he "could not live together without trouble because of our temperamental incompatibility."

Gauguin also writes to Schuffenecker, asking to be put up in Paris.

c. Sunday 16–Monday 17 December
Writes to Theo: thanks him for his letter enclosing 100 francs, and also for money order of 50 francs; Gauguin, he thinks, was "a little out of sorts with the good town of Arles, the little yellow house where we work, and especially with me"; hopes Gauguin will reconsider: "I am waiting for him to make a decision with absolute serenity."

c. Monday 17–Tuesday 18 December
Gauguin and van Gogh make a day visit to Montpellier to see the Alfred Bruyas collection in the Musée Fabre, with its many works by Eugène Delacroix (1798–1863) and Gustave Courbet (1819–1877).

c. Tuesday 18–Wednesday 19 December
Gauguin writes to Theo: tells him to consider his journey to Paris an imaginary thing, and his recent letter a bad dream; he is happy with Theo's success in recent sales; would like Theo to accept his portrait of van Gogh painting sunflowers (cat. 142, fig. 70); he and van Gogh have visited Montpellier.

Van Gogh also writes to Theo of the previous day's visit to Montpellier, and especially of the Bruyas collection. "Gauguin and I talked a lot about Delacroix, Rembrandt, etc. Our arguments are terribly *electric*, sometimes we come out of them with our heads as exhausted as a used electric battery. . . . Gauguin was saying to me this morning when I asked him how he felt that 'he felt his old self coming back,' which gave me enormous pleasure. When I came here myself last winter, tired out and almost dazed in mind, before being able to begin to recover, I had some inner suffering too."

Sunday 23 December
Van Gogh working on *La Berceuse* (see cat. 146).

Theo sends 100 francs.

After a violent quarrel with Gauguin (who had decided to spend the night in a hotel), van Gogh appeared at 11:30 P.M. "at the *maison de tolérance*, No. 1, asked for a girl called Rachel, and handed her his ear with these words: 'Keep this object carefully.' Then he disappeared" (*Le Forum Républicain*, 30 December 1888; in fact, van Gogh did not cut off the whole of his ear, but only the lower part). After presenting it to Rachel, he returned to his house and went to bed.

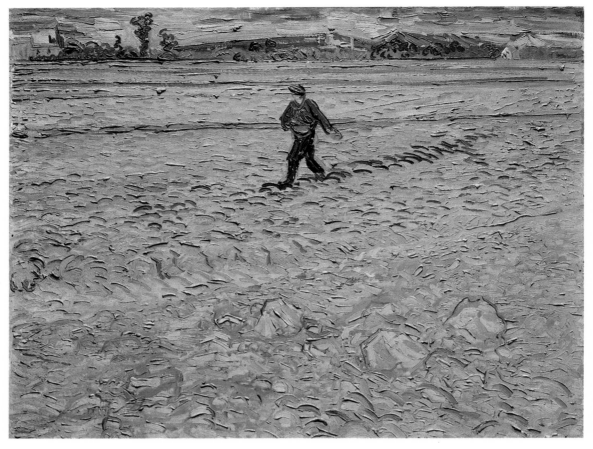

114

114. The Sower

Oil on canvas, 28¾ × 36¼ in. (73 × 92 cm.)
Unsigned
Private collection, Switzerland

F494 H511 SG43 JH1617

Painted between Wednesday 24 and Sunday 28 October, this is one of two landscapes van Gogh completed during Gauguin's first week in Arles. Writing to Theo on 24 October, van Gogh announced that he "must go out and set to work on another size 30 canvas" (LT557). It is not certain whether he is referring to this *Sower* or to the *Trunk of an Old Yew Tree* (F573). However, by 28 October, he had finished these two landscapes, and sketched them both in his letter of that day (LT558b; fig. 56).

The motifs for both pictures were taken from the fields adjoining the "road to Tarascon," which figures so often in van Gogh's first series of drawings (see cat. 18). In *The Sower*, the Abbey of Montmajour can be seen in the center background, the Mont de Cordes at right, with the Alpilles in the distance.

Simply described as "a new study of a sower, the landscape quite flat, the figure small and vague," it was van Gogh's first attempt at redoing the subject since his struggle with the much-worked June version (cat. 49).

Fig. 56. Sketch of *The Sower* (LT558b). Rijksmuseum Vincent van Gogh, Amsterdam

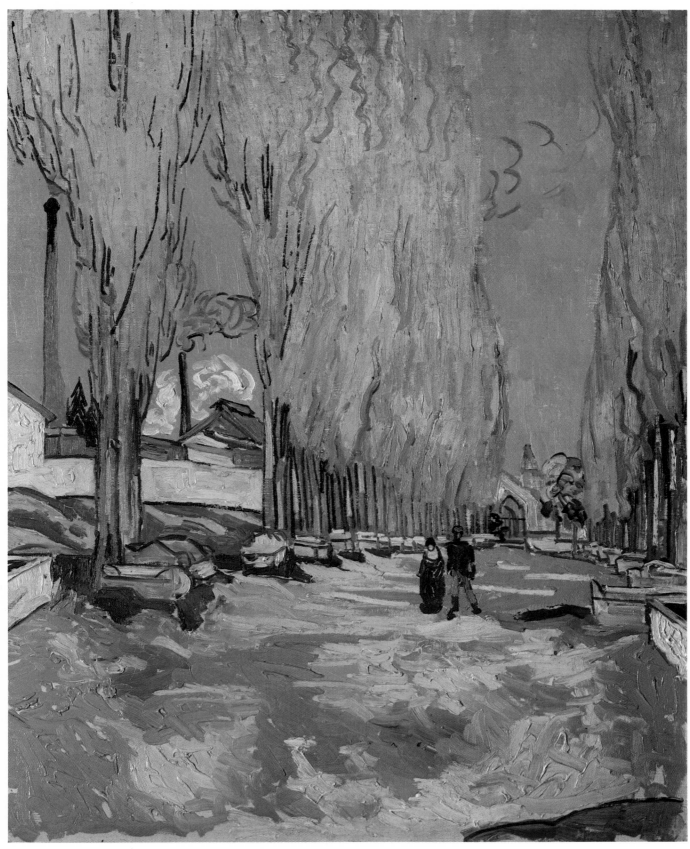

That picture, which Theo had had framed when he received it in August, van Gogh had called "ugly" and "a failure." Now, perhaps, he was intent on producing a less challenging and more agreeable image, without, for example, the harsh, competing complementaries of yellow and violet. Instead, the dominating aspect is the varied yellow notes of autumn; the recording of the landscape itself is also a major concern. Van Gogh achieved the recession by deploying an amazing range of graphic shapes that register the stony base of the Crau.

The planar arrangement and high horizon repeat a compositional formula that van Gogh first used in his February snowscape (cat. 6), and which reappeared at intervals, most notably in one of the June harvest pictures (cat. 47).

In the 1880s in the Arles region, the sowing of the wheat was usually done about mid-October, with the harvest being gathered in June.

115. Les Alyscamps

Oil on canvas, 36⅝ × 28⅜ in. (93 × 72 cm.)
Unsigned
Private collection, Lausanne

F568 H551 SG124 JH1622

In describing three paintings of the Alyscamps in a letter to Emile Bernard, probably of 2 November, van Gogh referred to "a third study of this whole avenue, entirely yellow" (B19a).

This picture seems, nevertheless, to have preceded the two horizontal versions (cat. 116, 117). It is painted on a fairly fine canvas, not on the thick, rough canvas bought by Gauguin and used by van Gogh for the other two. It is much more rapidly done, with contrasts of impasto (the walls) and very thin areas (the trees), and parts of the canvas left untouched at the bottom. It seems likely, then, that van Gogh painted the picture in

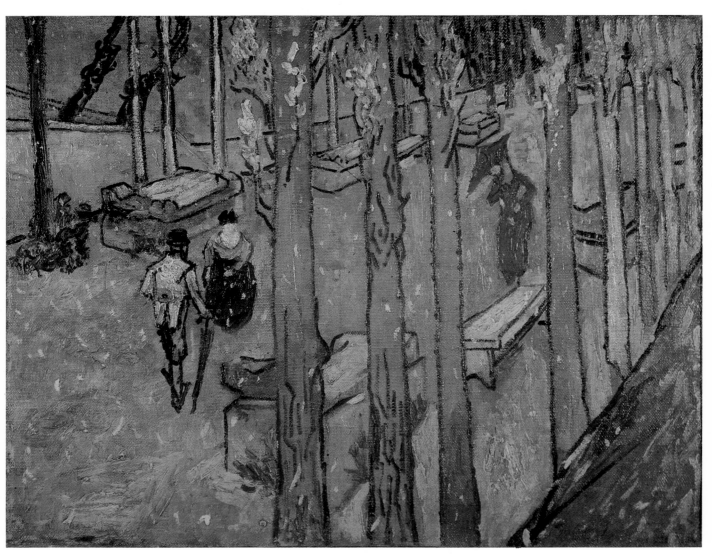

the last days of October, probably immediately after he had completed *The Sower* (cat. 114) and the *Trunk of an Old Yew Tree* (F573), continuing his studies of autumn effects.

It is probable that at this time as well, Gauguin painted his own upright picture of the Alyscamps (fig. 57; see page 200). It, too, is on regular canvas. Gauguin, however, took his view outside the avenue of poplars, on the bank that adjoins the Canal de Craponne. Van Gogh stood in the avenue itself, and while he included the tombs and the distant view of Saint-Honorat, he did not hesitate to show one of the factory chimneys of the adjoining workshops of the PLM railroad. A similarly "honest" look occurs in a postcard view of the Alyscamps of about 1905 (fig. 58).

A second, undocumented, vertical version exists (F569), where both viewpoint and figures differ from those in the present work.

116. Les Alyscamps

Oil on canvas, 28¾ × 36¼ in. (73 × 92 cm.)
Unsigned
Rijksmuseum Kröller-Müller, Otterlo

F486 H513 SG116 JH1620

117. Les Alyscamps

Oil on canvas, 28⅜ × 35⅞ in. (72 × 91 cm.)
Unsigned
Private collection

F487 H514 SG115 JH1621

Gauguin received 500 francs from Theo on Sunday 28 October for the sale of the painting *Four Breton Women* (WC201). It must have been quite soon after this that he bought twenty meters of very strong canvas. It was this

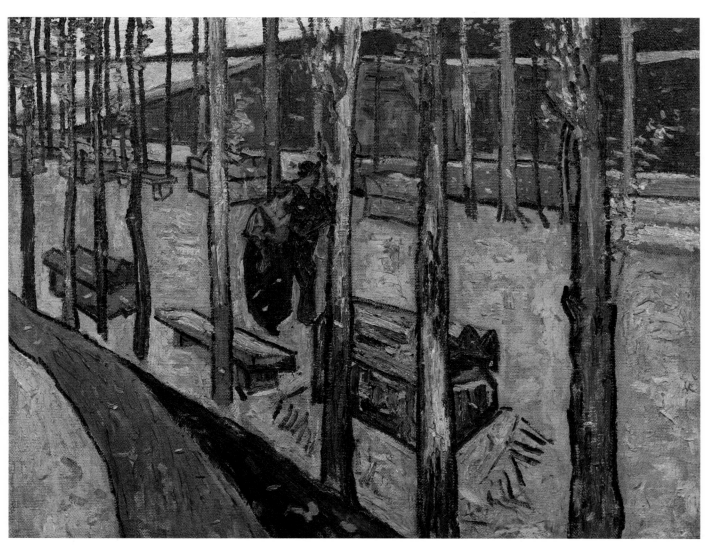

Fig. 57. Paul Gauguin. *Les Alyscamps* (WC307). Oil on canvas, 36¼ × 28¾ in. (92 × 73 cm.). Musée d'Orsay (Galerie du Jeu de Paume), Paris

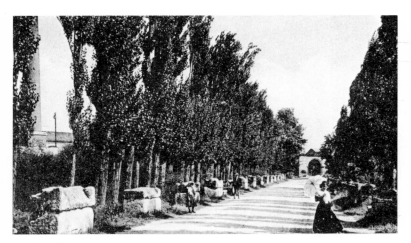

Fig. 58. The Alyscamps. Postcard. c. 1905

canvas that van Gogh used for these two horizontal paintings of the Alyscamps.

He reported to Emile Bernard, probably on 2 November: "I...have done two studies of the fall of leaves in an avenue of poplars" (B19a). And Gauguin added in a postscript that the "two studies of falling leaves are in my room; you would like them very much. They are on very heavy but good burlap."

The two landscapes were described more fully in a letter to Theo some four days later: "I think you will like the falling leaves that I have done. It is some poplar trunks in lilac cut by the frame where the leaves begin. These tree trunks are lined like pillars along an avenue where there are rows of old Roman tombs of a blue lilac right and left. And then the soil is covered with a thick carpet of yellow and orange fallen leaves. And they are still falling like flakes of snow. And in the avenue, little black figures of lovers. The upper part of the picture is a bright green meadow, and no sky, or almost none. The second canvas is the same avenue but with an old fellow and a woman as fat and round as a ball" (LT559).

The high viewpoint was not a deliberately concocted studio device. It was caused by van Gogh's placing his easel on the seven-foot-high bank that separated the Alyscamps from the adjoining Canal de Craponne. Parts of path and bank are visible in both paintings. The oblique views and tilted space resulted.

In the one, van Gogh looked toward the exit from the avenue; in the other, he looked toward Saint-Honorat, as he did in the first painting of the Alyscamps (cat. 115). It was from very near the vantage point of this latter view that Gauguin painted his view of the Alyscamps (cat. 115, fig. 57). He too, therefore, actually stood outside the line of the avenue itself.

The figures in van Gogh's two paintings are suggestive of Daumier, an artist he talked about increasingly at this period. One of them, indeed, has the transferred flavor of a Ratapoil in motion.

These views of the Alyscamps were not meant as associative evocations of the historic site. They are the culmination of the series of autumn effects, the fall of the leaves. And they enabled van Gogh to pursue his study of contrasting colors—in the one blue and orange, and in the other violet and yellow with a subsidiary blue and orange.

Gauguin in Arles

The fateful partnership between Paul Gauguin and Vincent van Gogh in Arles was much briefer than either protagonist remembered. Van Gogh twice referred to the "months" during which they worked together in letters of 1890 to the art critic Albert Aurier (LT626a) and to Gauguin himself (LT643). While Gauguin, writing his autobiographical *Avant et après* in 1903, confessed: "How long did we remain together? I couldn't say, I have entirely forgotten. In spite of the swiftness with which the catastrophe approached, in spite of the fever of work that had seized me, the time seemed to me a century." Gauguin, in fact, spent nine weeks in the Yellow House, arriving on 23 October and leaving probably on 26 December 1888.

The preamble can be quickly sketched. Van Gogh and Gauguin first met in Paris in November 1887. They exchanged paintings (see cat. 3). Shortly afterward, Gauguin met Theo, who, on 4 January 1888, bought for his own collection a large painting, *Aux Mangos* (WC224). Theo also began to take Gauguin's paintings at his gallery, Boussod & Valadon, and to include them in the small exhibitions he arranged there. Some ten days before van Gogh left Paris for Arles, Gauguin returned to Pont-Aven in Brittany, where he had already worked in 1886. A triangular relationship between Paris, Pont-Aven, and Arles was set in motion. From early May, when he rented the Yellow House, van Gogh became increasingly obsessed with the idea of inviting Gauguin to share it with him.

Negotiations between Gauguin and van Gogh and Theo produced an agreement by the end of June. Gauguin was to receive 150 francs a month from Theo; he would have a room and share the studio in the Yellow House; in return, he would give Theo one painting a month. There were, however, two obstacles: Gauguin's debts in Pont-Aven and the cost of his rail fare to Arles. (Van Gogh also feared that the arrival in Pont-Aven of Charles Laval in late July and of Emile Bernard in mid-August would anchor Gauguin in Pont-Aven, and for a time he himself thought of joining them there.) A solution was found early in October, when Theo sold several pieces of Gauguin's pottery for 300 francs: the journey to Arles became possible.

By then, van Gogh had had gas-lighting installed and had furnished the Yellow House, hired a charwoman, and finished his series of sunflower and Poet's Garden pictures, specially painted as decorations for Gauguin's bedroom.

Gauguin came to Arles to restore his health; he had been dogged by dysentery and other ailments in Brittany. Van Gogh certainly felt that the southern climate would help cure him. With Theo acting as his dealer in Paris, Gauguin also hoped that sales of his paintings would enable him to return to the tropics—at this stage he was thinking of Martinique. To

van Gogh's way of thinking, Gauguin was coming to head a studio of the South, where, he thought, Laval and Bernard might join them in February 1889. Van Gogh planned to make that studio a permanent base for an artists' colony, as well as a stopping place en route to the tropics, where he felt the future of painting lay. He condoned Gauguin's plan to return to Martinique, worrying only that Gauguin would go too soon with insufficient funds. He feared the lure of Paris more than he did that of the tropics.

Yet how long he expected Gauguin to stay in Arles is hard to determine. A year, the van Gogh brothers seemed to assume. Six months, Gauguin had told his wife in July; and until May 1889, he wrote to Emile Schuffenecker in December 1888. Gauguin's nine-week stay has become the most controversial period of van Gogh's sojourn in Arles —not least because relatively little is known about it. It is difficult to reconstruct the sequence of events as they unfolded during those weeks, and also to observe the work pattern of each artist. Van Gogh's letters became much less frequent—only thirteen exist, whereas he wrote that number in the fortnight before Gauguin's arrival. They are all undated, and their order is by no means firmly established. Some of Gauguin's letters are published only in fragments, others are unreliably transcribed and often incorrectly dated. The chronology that is proposed for the period 23 October to 23 December is based on a substantially revised order and a modified dating of many of the letters (see Appendix I).

From this working hypothesis, a pattern of three distinct phases of roughly three weeks each can be deduced; phases one and two are relatively well documented (see Chronology). Phase one (23 October–13 November) was characterized by comparative harmony: the two artists shared walks, landscape motifs, the same model (Madame Ginoux), and the coarse canvas purchased by Gauguin. Van Gogh did the shopping, Gauguin the cooking. There were some reservations on Gauguin's part and disagreements about the artists they each admired.

Phase two (13 November–4 December) was marked by changes in their working habits. Van Gogh ceased to paint landscapes; he and Gauguin no longer shared a model; their motifs had little in common— the closest are Gauguin's *Garden at Arles* (cat. 127) and van Gogh's *Memory of the Garden at Etten* (cat. 126). Gauguin now began to urge van Gogh to work from "imagination," or "memory"—what van Gogh later called "abstractions." Gauguin never referred to this in *Avant et après,* but for later commentators, it has become the crucial issue of artistic contention and a major cause of van Gogh's breakdown. Yet van Gogh had previously tried to work without the model (for example, the painting of Christ in Gethsemane), and Gauguin continued to paint portraits and landscapes in Arles. Nonetheless, this phase closed with van Gogh's working directly from the model—producing a series of portraits of the Roulin family (see cat. 132–136)—and Gauguin's painting a still life (WC312) and two compositions of washerwomen (cat. 130, 131).

The problem is the third phase, the following three weeks in December. In the working hypothesis, there are only two letters from van Gogh after 4 December, with a gap from that date until mid-

December. He does not describe any of his paintings. Gauguin's letters are more numerous in December (four to Theo, for example), but they too do not describe any of his current paintings. All that can be gathered retrospectively from van Gogh's letters of January 1889 is that Gauguin painted a self-portrait (cat. 142) and that van Gogh was working on *La Berceuse* (cat. 146) on 23 December. The work pattern, then, has to be deduced. Van Gogh's *The Dance Hall* (cat. 138) and *Spectators in the Arena* (cat. 139) may belong to this December phase. Each painting includes members of the Roulin family, whose presence seems to imply that the two paintings from the imagination followed the portraits of the Roulin family (cat. 132–136). The second portrait of Madame Roulin with the baby (cat. 136, fig. 66) may also belong here.

As for Gauguin, he may well have continued to work on some landscapes that van Gogh had mentioned in early December (see cat. 140), as well as to give the finishing touches to his portrait of van Gogh painting sunflowers (cat. 142, fig. 70). In this December phase, however, there are no paintings done explicitly from the imagination.

What of their life together in December? Writing in *Avant et après* in 1903, Gauguin placed all the drama in the last two days—that is, 22 and 23 December. By so doing, he heightened the tragic impact and exaggerated the sudden flare-up of the "catastrophe." Gauguin's account, however, does contain elements of credible fact. And if the events are spaced out over ten days or so rather than compressed into two, the following sequence can be suggested.

About 14 December, Gauguin completed his portrait of van Gogh painting sunflowers. Van Gogh allegedly said to Gauguin, "It is certainly I, but it's I gone mad." That evening in the café, van Gogh threw a glass of absinthe at Gauguin's head. Gauguin ducked it, and took his friend back to the Yellow House. Van Gogh apologized the following morning, but Gauguin said he had to return to Paris and therefore wrote to Theo (the letter, GAC11, survives). Van Gogh followed it with his own letter a day or so later (LT565). Gauguin proposed a day visit to Montpellier, which took place about 17 or 18 December. The following day, they both wrote to Theo, van Gogh describing the pictures at Montpellier (LT564) and Gauguin saying that he would not now return to Paris and offering Theo his portrait of van Gogh as a conciliatory gesture (GAC12).

Harmony seems to have been restored. But there is then a gap, with apparently no letters, from 19 to 23 December. A letter from Theo, enclosing 100 francs, arrived on 23 December. Gauguin described the events of 23 December fifteen years later. The day was spent uneasily. In the evening, after dinner, he took a walk among the oleanders in the garden of the Place Lamartine. He heard footsteps, recognized them as van Gogh's, and turned to find himself threatened with a razor. (The account Gauguin gave to Emile Bernard on 30 December 1888 contains no mention of a razor.) His stare transfixed van Gogh, who went back to the Yellow House. Gauguin chose to spend the night in a hotel. When he returned to the Yellow House the following morning, he found that van Gogh had mutilated his left ear.

Of the many explanations of the tragic denouement, one possible

factor was not mentioned by Gauguin, and has not been discussed by later commentators. During that "dark" period from 19 to 23 December, it rained day and night. Ten times the average rainfall fell that month, most of it from 19 to 24 December and again from 28 to 31 December. The already fragile relationship between the two men must surely have worsened in the enforced confinement of the Yellow House. A contributory factor in the collapse of van Gogh's dream of a studio in the South could well have been this incessant rain.

118. Paul Gauguin
Grape Gathering: Human Misery

Oil on canvas, 28¾ × 36¼ in. (73 × 92 cm.)
Signed and dated, lower right: P. Gauguin 88
The Ordrupgaard Collection, Copenhagen

WC304

This painting was reported in progress by van Gogh on about 6 November: "Just now [Gauguin] is doing some women in a vineyard, completely from memory, but if he does not spoil it or leave it unfinished, it will be very fine and very unusual" (LT559).

He told Theo about 12 November: "What will please you is that Gauguin has finished his canvas of the 'Women Grape Gatherers'" (LT561).

For his part Gauguin described it, with an accompanying sketch (fig. 59), in what may be a fragment of a letter to Emile Bernard, probably of about 10 November: "Purple vines forming triangles against the upper part, which is chrome yellow. On the left a Breton woman of Le Pouldu in black with gray apron. Two

Breton women bending down in blue and light green dresses with black bodice: in the foreground pink soil and a poor woman with orange-colored hair, white blouse and skirt (*terre verte* with white added). All this done with bold outlines enclosing tones which are almost similar and laid on thickly with a knife on coarse sack-cloth. It is a view of a vineyard which I have seen at Arles. I have put Breton women into it—accuracy doesn't matter. It's my best canvas this year and as soon as it is dry I will send it to Paris" (Lord 23).

Gauguin then mentioned the picture to Theo, about 15 November: "I have done also from memory [*chic*] a poor woman totally bewitched in an open field of red vines" (GAC8).

And when he sent it with four other canvases to Theo, about 4 December, he called it "Grape Harvest, or the Poor Woman" (GAC9).

Shortly thereafter, he gave a final interpretation in a letter to the artist Emile Schuffenecker: "Do you notice in the *Vintage* a poor disconsolate being? It is not a nature deprived of intelligence, of grace and of all the gifts of nature. It is a woman. Her two hands under her

118

chin she thinks of few things, but feels the consolation of the earth (nothing but the earth) which the sun spreads with its red triangle. And a woman dressed in black goes by, looking at her like a sister." And he added: "In French, happiness and unhappiness are words which express a state: black is the color of mourning" (Dorra, p. 12).

The "poor woman" is related, in her slanting eyes and head-in-hands pose, to a figure in a still life of fruits dedicated to Charles Laval and probably painted in Pont-Aven toward the end of the summer (WC288). There she appears to symbolize suppressed gluttony. In *Grape Gathering*, Gauguin's interpretations shift in emphasis, but he may have wanted an image of death, or the notion of perpetual labor or of sexual indiscretion. The figure reappears in reverse in a lithograph, *Human Misery* (Guérin 5), of January 1889, accompanied by a young boy whose features and pose seem close to those of the figure at the lower left in the *Washerwomen* (cat. 130).

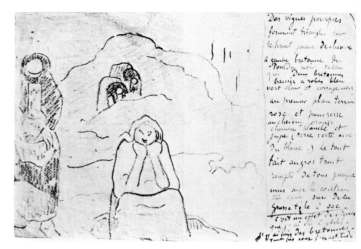

Fig. 59. Paul Gauguin. Sketch of *Grape Gathering: Human Misery* (Lord 23). Present location unknown

119. The Red Vineyard

Oil on canvas, 29½ × 36⅝ in. (75 × 93 cm.)
Unsigned
Pushkin State Museum of Fine Arts, Moscow

F495 H512 SG119 JH1626

NOT IN EXHIBITION

Van Gogh described to Theo a sunset effect that he and Gauguin had observed during a walk on Sunday 4 November: "A red vineyard, all red like red wine. In the distance it turned to yellow, and then a green sky with the sun, the earth after the rain violet, sparkling yellow here and there where it caught the reflection of the setting sun" (LT559, c. 6 November).

In the same letter, he wrote: "I'm working now on a vineyard all purple and yellow." That evening walk had clearly provided the necessary stimulus. By about 12 November he could write: "I . . . have finished a canvas of a vineyard all purple and yellow, with small blue and violet figures and a yellow sun. I think that you will be able to put this canvas beside some of Monticelli's landscapes" (LT561).

Van Gogh had already painted this vineyard in early October—the *Green Vineyard* (F475)—the first of a series of vineyards projected as early as mid-June (LT504). In fact, he did only the two paintings. Compositionally the two are comparable, but in the later *Red Vineyard*, the line of the horizon is higher. From where van Gogh was standing, Montmajour was at his back, the silhouette of the town of Arles being visible in the distance. The figure at the right appears to be based on Madame Ginoux, who also posed for *L'Arlésienne* (cat. 120, 121).

The Red Vineyard has often been thought the only painting van Gogh sold during his lifetime, and the painting bought from the exhibition of Les XX in Brussels in February 1890 by Eugène Boch's sister, Anna, herself an artist. It now seems more likely, however, that Anna Boch bought another picture from the exhibition, and acquired *The Red Vineyard* after van Gogh's death.

120. L'Arlésienne: Madame Ginoux

Oil on canvas, 36⅝ × 29⅛ in. (93 × 74 cm.)
Unsigned
Musée d'Orsay (Galerie du Jeu de Paume), Paris

F489 HXI JH1625

121. L'Arlésienne: Madame Ginoux

Oil on canvas, 36 × 29 in. (91.4 × 73.7 cm.)
Unsigned
The Metropolitan Museum of Art, New York
 Bequest of Sam A. Lewisohn, 1951

F488 H515 SG118 JH1624

"I have an Arlésienne at last," wrote van Gogh to Theo about 6 November 1888, "a figure (size 30 canvas) slashed on in an hour, background pale citron, the face

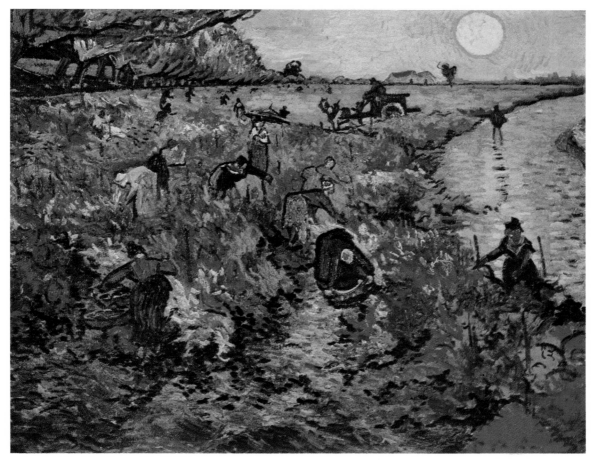

119

gray, the clothes black, black, black, with perfectly raw Prussian blue. She is leaning on a green table and seated in an armchair of orange wood" (LT559).

In a later letter, of about 22 January 1889, he asked: "During your hasty visit [to Arles] did you see the portrait of Madame Ginoux in black and yellow? That portrait was painted in three-quarters of an hour" (LT573).

The portrait was included in the batch sent to Theo in May 1889. On 16 June, Theo reported: "I am . . . very fond of that figure of a woman seen from a height. I had a visit from a certain Polack, who knows Spain and the pictures there well. He said it was as fine as one of the great Spaniards" (T10).

To which van Gogh responded two days later: "I am also glad to hear that someone else has turned up who actually saw something in the woman's figure in black and yellow. That does not surprise me, though I think that the merit is in the model and not in my painting" (LT595).

From these excerpts, it would appear that van Gogh is referring to the same painting. Yet there are two ver-

sions of *L'Arlésienne*; both are close in the black-yellow contrast, in pose, and in the presence of the green table and orange armchair. But in the one, parasol and gloves lie on the table; and in the other, two books. Which came first? Which was "slashed on" in forty-five to sixty minutes? The Paris version is thinner, more summary, more rapidly painted than the New York version. Moreover, it is on the thicker canvas that Gauguin bought soon after Sunday 28 October, and which van Gogh used for the two horizontal versions of *Les Alyscamps* (cat. 116, 117). This would suggest that the Paris version was completed in early November, and is probably the one referred to in the letters.

The New York portrait is on thinner canvas and it is more worked, especially in the background. Yet it also conveys the impression of being based on a painted prototype in the ease with which forms and brushstrokes cohere. It could well be possible that van Gogh painted it specially for Madame Ginoux just before he left Arles in May 1889. The presence of the two books and the image of the interrupted reader can be compared with the painted copies after Gauguin's drawing *L'Arlésienne*

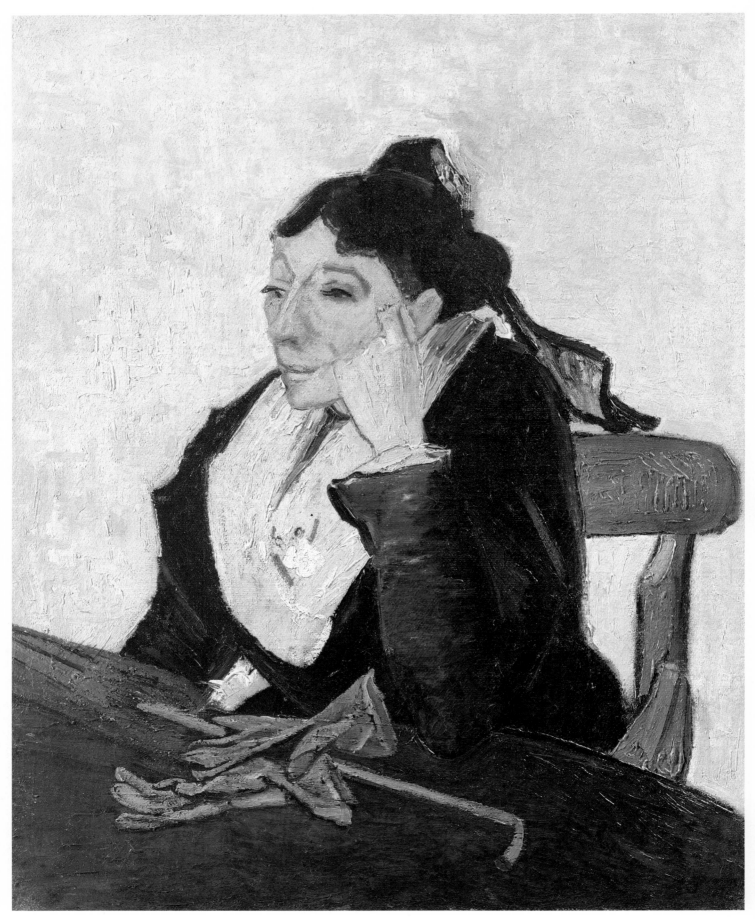

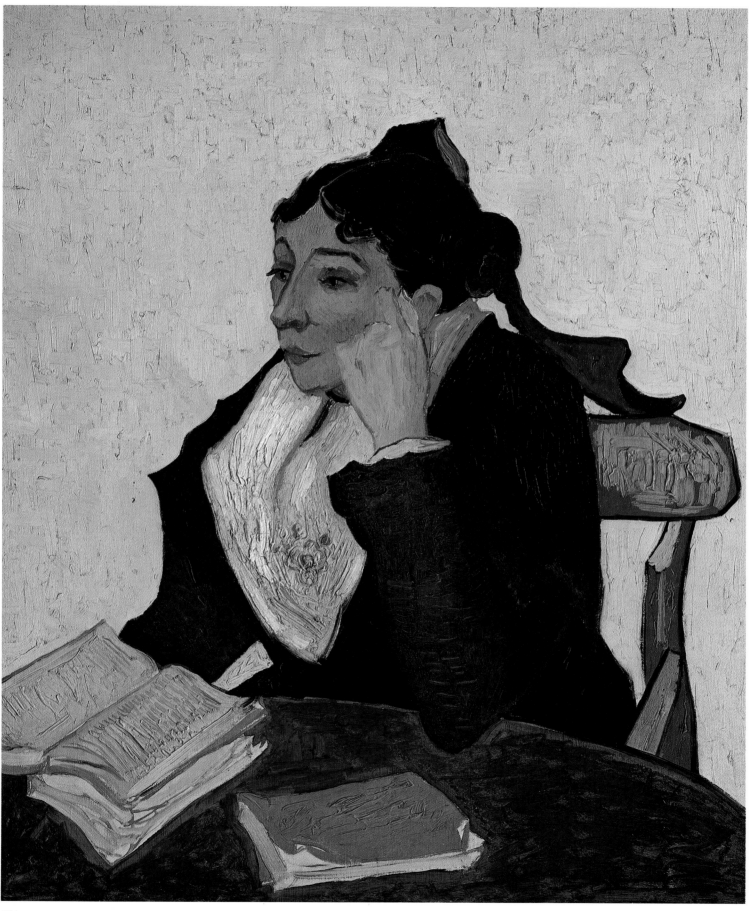

121

(cat. 122), one of which is also likely to have been completed before May 1889 (see F540–F543).

The model was Madame Marie Ginoux. She was born Marie Julien on 8 June 1848 in Arles. She married Joseph-Michel Ginoux (1836–1902), twelve years her senior, on 2 February 1866. Together they ran the Café de la Gare at 30 Place Lamartine, where van Gogh had a room from early May to mid-September 1888. Madame Ginoux died on 2 August 1911.

122. Paul Gauguin
L'Arlésienne: Madame Ginoux

Charcoal under black conté crayon, red crayon heightened with white chalk on tan wove paper, 22⅛ × 19⅜ in. (56.1 × 49.2 cm.)
Annotated, upper right: L'oeil moins à côté du / nez / Arête vive / à la narine
The Fine Arts Museums of San Francisco, Achenbach Foundation for Graphic Arts. Dr. T. Edward and Tullah Hanley Collection

It seems most probable that Gauguin made this drawing of Madame Ginoux at the same time that van Gogh "slashed on" his painted portrait of the same model in an hour or less (see cat. 120, 121). It must therefore date from early November 1888. Such a dating is also confirmed by the fact that it served as a preliminary study for the figure of Madame Ginoux in the painting *The Night Café* (cat. 123), which van Gogh reported in progress on about 2 November (B19a) and again on about 6 November (LT559). The annotation on the relationship between eye and nose establishes the drawing's function as a study for the painting, whose slow, deliberate rhythms echo the pace of the drawing, which was carefully built up in a sequence of various graphic mediums.

Apart from the few studies that exist in Gauguin's notebook, this is the only drawing to survive from his two-month stay in Arles. Left behind by Gauguin, it was later used by van Gogh for at least four paintings of Madame Ginoux, in which he added on the table in front of her books by Charles Dickens and Harriet Beecher Stowe (F540–F543).

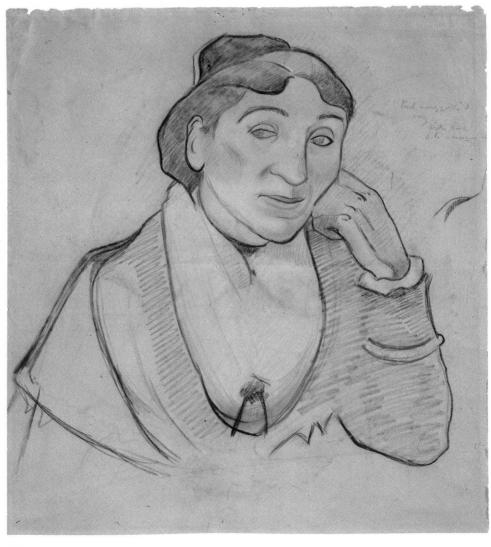

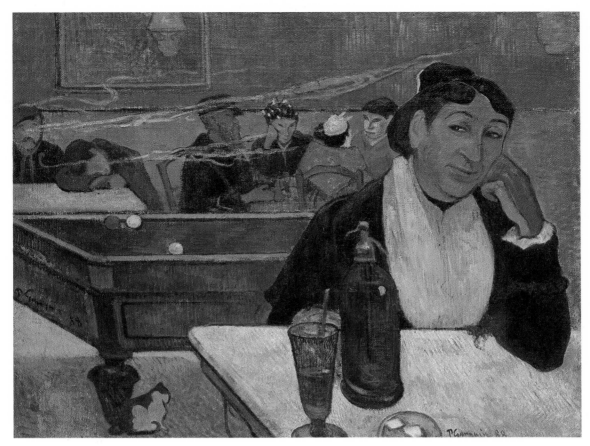

123

123. Paul Gauguin
The Night Café

Oil on canvas, 28¾ × 36¼ in. (73 × 92 cm.)
Signed and dated, lower right: P. Gauguin 88; and at left,
 on the billiard table: P. Gauguin 88
Pushkin State Museum of Fine Arts, Moscow

WC305

NOT IN EXHIBITION

This is one of Gauguin's most documented paintings from his Arles period. Not only does the preliminary study for the figure of Madame Ginoux survive (cat. 122) but the painting is frequently mentioned in letters both by Gauguin and by van Gogh.

About 2 November, van Gogh wrote to Emile Bernard: "At the moment Gauguin is working on a canvas of the same night café I painted too [cat. 101, fig. 45], but with figures seen in the brothels. It promises to turn out beautiful" (B19a). He then wrote to Theo about 6 November: "Just now he is doing . . . a picture of the same night café that I painted" (LT559).

Gauguin too described it, with an accompanying sketch (fig. 60), in what may be a fragment of a letter to Bernard, probably of about 10 November: "I have also done [a painting of] a café which Vincent likes a lot and myself less. Actually it's not my subject and the vulgar local colors don't suit me. I like it in the work of others but myself I am always afraid. It's a matter of education and one cannot start all over again. At the back red wallpaper and three prostitutes: one bristling with curl-papers, the second seen from behind wearing a green shawl. The third in a scarlet shawl: on the left a man asleep. A billiard table—in the foreground a rather carefully executed figure of an Arlésienne with a black shawl and a white tulle front. Marble table. Across the picture runs a streak of blue smoke but the figure in the foreground is much too orthodox. But still!" (Lord 23).

Van Gogh reported to Theo about 12 November: "Gauguin has . . . almost finished his night café" (LT561). *The Night Café* was one of five paintings sent to Theo in Paris on about 4 December (GAC9).

Fig. 60. Paul Gauguin. Sketch of *The Night Café* (Lord 23). Present location unknown

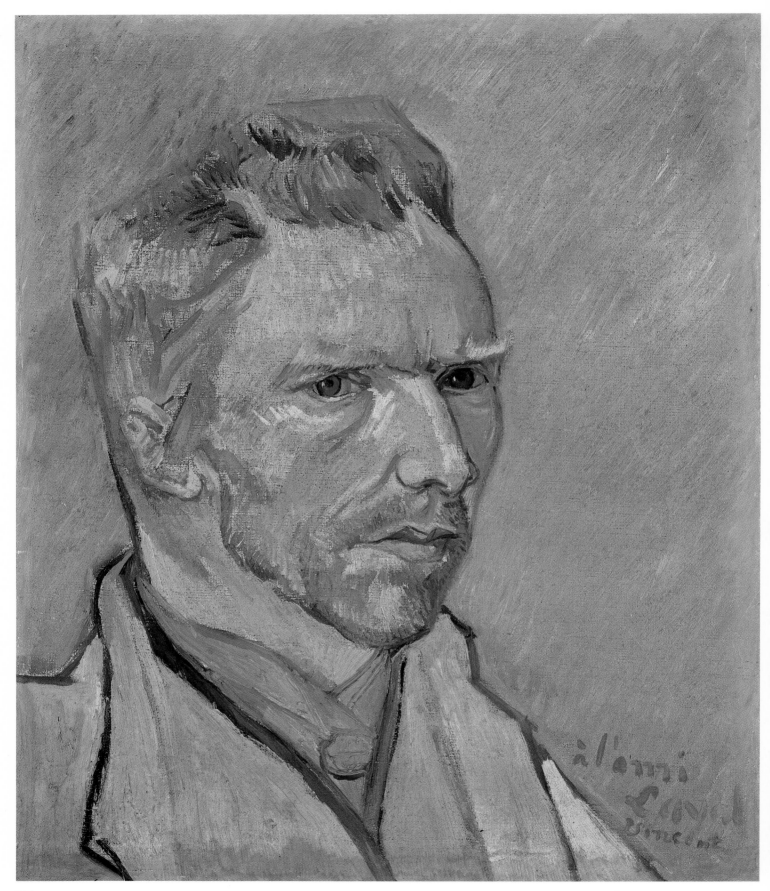

124. Self-Portrait

Oil on canvas, 18⅛ × 15 in. (46 × 38 cm.)
Inscribed and signed, lower right: à l'ami / Laval / Vincent
Private collection

F501 H523 SG139 JH1634

Although the pose is virtually the same, the exaggeratedly Oriental appearance of the self-portrait dedicated to Gauguin (cat. 99) has here been overtly Europeanized. The hair is longer, even though very thinly painted; the beard and brooch remain; the neck is less exposed. Instead of the strikingly ovoid head, van Gogh has introduced more abrupt and angular forms, with the incandescently jutting eyebrow. The green background is similar, but painted here with thin diagonal strokes that remove the strong halo effect of the "bonze" image.

This self-portrait was painted some two months later than the one dedicated to Gauguin. It was probably done soon after van Gogh received Charles Laval's *Self-Portrait*, which Laval sent to him as his contribution to the exchange of canvases between van Gogh and artists at Pont-Aven, and which van Gogh sketched in a letter of mid-November (fig. 61).

Charles Laval (1862–1894) had accompanied Gauguin to Martinique in 1887. In July of the following year he rejoined Gauguin at Pont-Aven and stayed on there after Gauguin left for Arles in October. His work, of which little survives, was greatly influenced by Degas, Gauguin, and Bernard. The self-portrait he sent to van Gogh is in the collection of the Rijksmuseum Vincent van Gogh, Amsterdam. Its mood is gentle and undisturbing, its paint surface discreet and undemonstrative. It seems possible that van Gogh produced his painted response with like intentions, especially tailored for Laval.

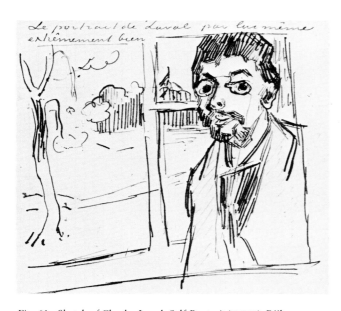

Fig. 61. Sketch of Charles Laval, *Self-Portrait* (LT562). Rijksmuseum Vincent van Gogh, Amsterdam

125. Breton Women and Children (after Emile Bernard)

Pencil and watercolor, 18¾ × 24⅜ in. (47.5 × 62 cm.)
Signed, lower right: Vincent
Inscribed, lower left: d'après un tableau /
 d' E. Bernard
Civica Galleria d'Arte Moderna, Milan. Raccolta Grassi

F1422 JH1654

On 24 October, the day after Gauguin arrived in Arles, van Gogh wrote to Theo: "Gauguin brought a magnificent canvas [fig. 62] which he has exchanged with Bernard, Breton women in a green field, white, black, green, and a note of red, and the dull flesh tints" (LT557).

And in mid-November, he advised Theo: "If ever you could get a good Bernard, I very strongly advise you to. Gauguin has a *superb* one" (LT562). A year later, in mid-November 1889, from the asylum at Saint-Rémy, van Gogh wrote to Bernard of "that picture which Gauguin has, those Breton women strolling in a meadow, so beautifully ordered, so naïvely distinguished in color" (B21). A month or so later, he wrote to his sister Wil: "You ask me who Bernard is—he is a young painter—he is certainly not older than twenty—very original. He is trying to do elegant modern figures in the manner of the ancient Greek and Egyptian art, a gracefulness in the expressive motions, a charm in consequence of the daring colors. I saw a picture of his of a Sunday afternoon in Brittany, Breton peasant women, children, peasants, dogs strolling about in a very green meadow; the clothes are black and red, and the women's caps white. But in this crowd there are also two ladies, the one dressed in red, the other in bottle green; they make it a very modern thing" (W16).

His profound admiration for this painting is therefore fully documented. Never, however, did he think of it as a *pardon*, a painting with religious overtones, or as a rival prototype or catalyst to Gauguin's *Vision After the Sermon: Jacob Wrestling with the Angel* (WC245), painted at Pont-Aven in September 1888.

The Bernard painting was visible in the Yellow House for at least two months. It is not known whether Gauguin took it back to Paris with him, or if van Gogh included it in the batch of paintings he dispatched from Arles in May 1889. Van Gogh's admiration for the painting led him to make this copy in watercolor. The copy, however, is less a transcription than a free translation. Bernard's green field becomes yellow; the red and black costumes of the peasants become brown, with red and blue accents; elements are moved (the two dogs, for example); and the two foreground heads are considerably enlarged. Changes in color, placement, and proportion and the more insistent contour all conspire to give the copy a greater integration.

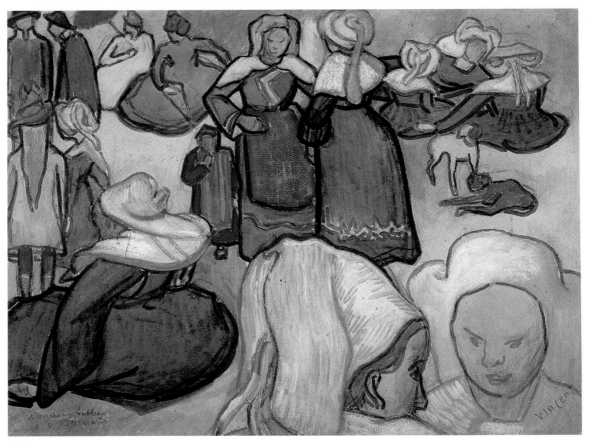

125

From his immediate enthusiasm for the painting, it might seem logical to assume that van Gogh would have executed his copy soon afterward. But it is also possible that he would have done so later on, once the shorter winter days and darker evenings set in and work in the studio became unavoidable.

Breton Women and Children remains van Gogh's only work on paper to have survived from the nine-week period of Gauguin's stay in Arles. The absence of independent drawings is odd; certainly a sketchbook must have been used.

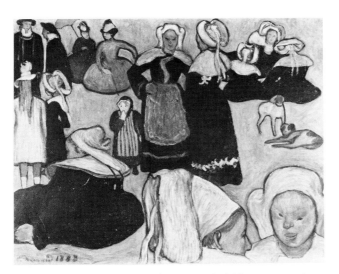

Fig. 62. Emile Bernard. *Breton Women and Children*. 1888. Oil on canvas, 29⅛ × 36¼ in. (74 × 92 cm.). Private collection, Saint-Germaine-en-Laye

126. Memory of the Garden at Etten

Oil on canvas, 29 × 36⅜ in. (73.5 × 92.5 cm.)
Unsigned
The Hermitage Museum, Leningrad

F496 H516 SG135 JH1630

NOT IN EXHIBITION

Gauguin was the first to tell Theo that van Gogh was at work on "a good Dutch garden that you know with the family" (GAC8). This was about 14 or 15 November. Shortly thereafter, van Gogh described the painting to Theo: "A memory of our garden at Etten, with cabbages, cypresses, dahlias, and figures.... Gauguin gives me the courage to imagine things, and certainly things from the imagination take on a more mysterious character" (LT562, c. 16 November).

In a letter to Wil, probably written the same day, he described the painting at considerable length, and included a sketch (fig. 63): "I have just finished painting, to put in my bedroom, a memory of the garden at Etten; here is a scratch of it. It is rather a large canvas. Here are the details of the colors. The younger of the two ladies who are out for a walk is wearing a Scottish shawl with green and orange checks, and a red parasol. The old lady has a violet shawl, nearly black. But a bunch of dahlias, some of them citron yellow, the others pink and white mixed, are like an explosion of color

on the somber figure. Behind them a few cedar shrubs and emerald green cypresses. Behind the cypresses one sees a field of pale green and red cabbages, surrounded by a border of little white flowers. The sandy path is of a raw orange color; the foliage of the two beds of scarlet geraniums is very green. Finally, in the interjacent plane, there is a maidservant, dressed in blue, who is arranging a profusion of plants with white, pink, yellow and vermilion red flowers.

"Here you are. I know this is hardly what one might call a likeness, but for me it renders the poetic character and the style of the garden as I feel it. All the same, let us suppose that the two ladies out for a walk are you and our mother; let us even suppose that there is not the least, absolutely not the least vulgar and fatuous resemblance—yet the deliberate choice of the color, the somber violet with the blotch of violent citron yellow of the dahlias, suggests Mother's personality to me.

"The figure in the Scotch plaid with orange and green checks stands out against the somber green of

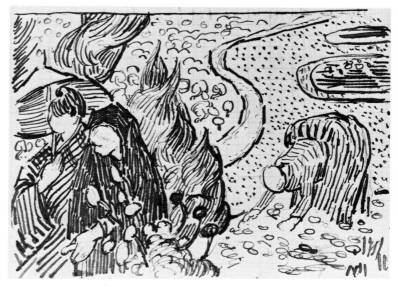

Fig. 63. Sketch of *Memory of the Garden at Etten* (W9). Rijksmuseum Vincent van Gogh, Amsterdam

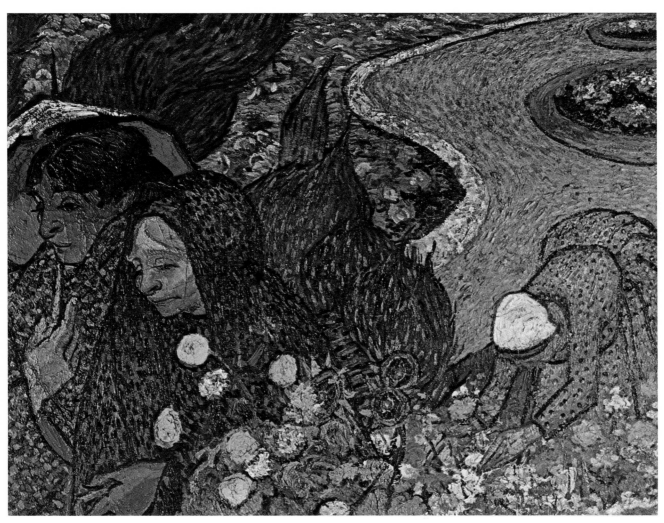

the cypress, which contrast is further accentuated by the red parasol—this figure gives me an impression of you like those in Dickens's novels, a vaguely representative figure.

"I don't know whether you can understand that one may make a poem only by arranging colors, in the same way that one can say comforting things in music.

"In a similar manner the bizarre lines, purposely selected and multiplied, meandering all through the picture, may fail to give the garden a vulgar resemblance, but may present it to our minds as seen in a dream, depicting its character, and at the same time stranger than it is in reality" (W9).

But he wrote to Theo on about 4 December: "I have spoiled that thing that I did of the garden in Nuenen, and I think that you also need practice for work from the imagination" (LT560).

The "memory" is of the family parsonage gardens in Holland, evidently a conflation of those at Etten and Nuenen. Yet the memory of Nuenen seems stronger, recalling drawings of the garden (see especially F1128), as well as figure studies that are reminiscent of the bending maidservant. But overlaying such memories is the more immediate experience of gardens in Arles, depicted in the Public Garden and the Poet's Garden series (see cat. 104–109). This culminating version, however, was destined for his own bedroom rather than Gauguin's.

The painting was produced in rivalry with and under the tutelage of Gauguin (see cat. 127). Such phrases and concepts as "poetic character and style," "deliberate choice of the color," and "bizarre lines, purposely selected and multiplied" reflect Gauguin's thinking. Yet rarely did van Gogh allow a deliberately concocted high viewpoint to enhance the curvilinear and flamelike surface patterns of his paintings. As one of his first "memory" paintings, it is assertive and extreme. How much he reworked it or altered elements in "spoiling" it could perhaps be more easily answered by X-ray examination.

127. Paul Gauguin
Garden at Arles

Oil on canvas, 28¾ × 36¼ in. (73 × 92 cm.)
Signed and dated, lower left: P. Gauguin 88
The Art Institute of Chicago. Mr. and Mrs. Lewis Larned
 Coburn Memorial Collection

WC300

There is no mention of this painting in the letters of either Gauguin or van Gogh. However, some six notebook studies exist: for the Arlésienne and bush, the Arlésiennes, the bench, the fountain and cones, the fountain, and the headdress and heads (fig. 64).

Fig. 64. Paul Gauguin. Studies for *Garden at Arles* a. *Arlésienne and Bush* b. *Arlésiennes* c. *Bench* d. *Fountain and Cones* e. *Fountain* f. *Headdress and Heads*. Arles sketchbook. The Israel Museum, Jerusalem

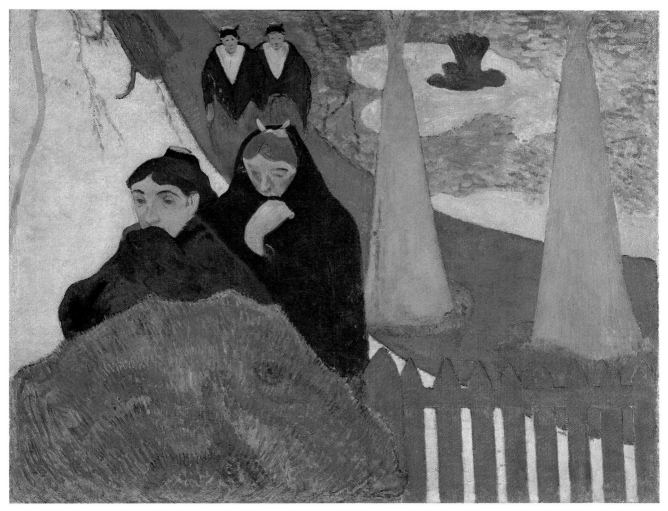

127

The motif is taken from one of the gardens opposite the Yellow House. The path, bench, and pond can be compared with those found in some of van Gogh's drawings (see especially F1513). It is as if Gauguin had observed the scene from his bedroom window; yet the viewpoint is not consistently maintained, especially in the extreme manner in which the path and the bench "stand up" so abruptly. One of the foreground Arlésiennes is surely based on Madame Ginoux.

If Gauguin's *Night Café* (cat. 123) was a response to van Gogh's *Night Café* (cat. 101, fig. 45), if his *Grape Gathering* (cat. 118) demonstrated how to simplify the *Red Vineyard* (cat. 119) by painting from memory, then the *Garden at Arles* takes one of van Gogh's closest and most familiar symbols—the decoration of the Poet's Garden, destined for Gauguin's bedroom—and brings it to a final conclusion. It, too, is an autumn garden: the leaves are falling, and the presence of the mistral is conveyed in the fragile, swaying tree (a late addition to

the painting) and in the defensive poses of the women. Gauguin's own features have been read into the foreground bush, though no such reading can be made in the lithograph that Gauguin made after the painting in January 1889 (Guérin 11).

The painting was most probably done from mid-November on, at the same time van Gogh was working on the *Memory of the Garden at Etten* (cat. 126).

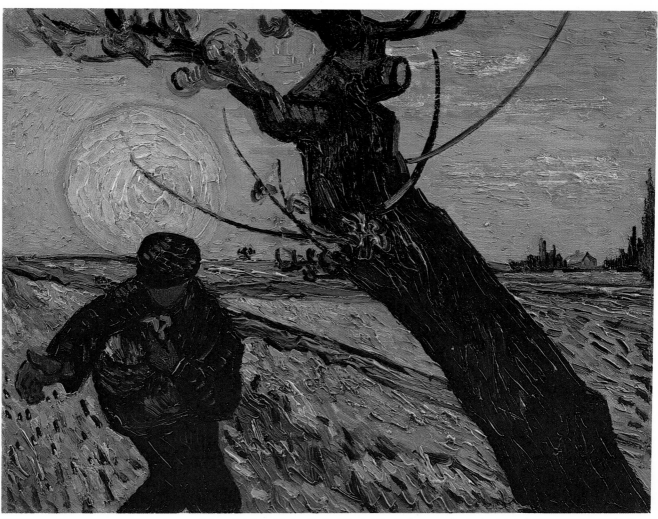

128

128. The Sower

Oil on canvas, 12⅝ × 15¾ in. (32 × 40 cm.)
Unsigned
Rijksmuseum Vincent van Gogh, Amsterdam

F451 H480 SG113 JH1629

129. The Sower

Oil on burlap on canvas, 28⅞ × 36¼ in. (73.5 × 92 cm.)
Signed, lower right: Vincent
Foundation E. G. Bührle Collection, Zurich

F450 H481 SG114 JH1627

About 25 November 1888, van Gogh wrote to Theo: "This is a sketch of the latest canvas I am working on, another Sower[fig. 65]. An immense citron yellow disk for the sun. A green-yellow sky with pink clouds. The field violet, the sower and the tree Prussian blue. Size 30 canvas. Let's quietly postpone exhibiting until I have some thirty size 30 canvases."

Just as *The Red Vineyard* (cat. 119) was based on the experience of a sunset on a Sunday evening walk, so this *Sower* may be based on another evening walk: "Here the weather is cold, notwithstanding which one sees very fine things. For instance, yesterday evening an extraordinarily beautiful sunset of a mysterious sickly citron color—Prussian blue cypresses against trees with dead leaves in all sorts of broken tones without any speckling with bright greens" (LT558a).

It would seem that Theo wrote approvingly of this new *Sower*, helped by the sketch, since van Gogh responded in his next letter of about 4 December: "From time to time, there's a canvas which will make a picture, such as the 'Sower' in question, which I myself also think better than the first" (LT560). He is surely referring back to the June *Sower* (cat. 49), rather than the October one (cat. 114). And, as always, he is making a vital distinction between a study (*étude*) and a picture (*tableau*).

The Sower was sent to Theo among the final batch of Arles paintings in early May 1889 (LT589). Theo

responded on 22 May: "Everything arrived in good condition and without any damage . . . the little sower with the tree" (T9). An ambiguous reference: Does he mean the little (small) painting, or that the figure of the sower is small? There are two versions of the composition, a small painting (cat. 128) and a large one (cat. 129). The reference in the November letter is certainly to the large version (even though the drawing in the letter matches neither version). It was clearly part of van Gogh's campaign to produce thirty size 30 canvases in time for the Paris World's Fair of 1889—although he wanted the pictures exhibited "only once in your [Theo's] apartment for our friends" (LT558a).

The smaller version is surely not a later reprise but the *pochade*—or oil study—for the larger picture, just as the small *Orchard Bordered by Cypresses* (cat. 10) is the *pochade* for its larger version (cat. 11). Yet there are differences. The Amsterdam *pochade* is small, but the sower is bigger, with a disproportionately large right

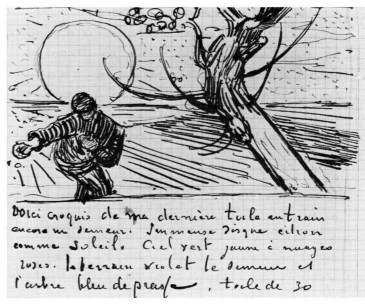

Fig. 65. Sketch of *The Sower* (LT558a). Rijksmuseum Vincent van Gogh, Amsterdam

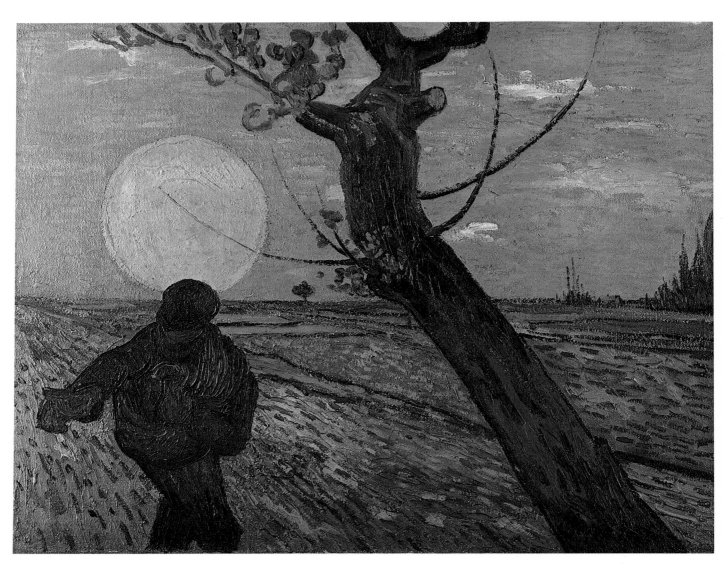

hand; the tree is broader; the distant house and trees are pulled closer to the picture plane; the sun, too, is nearer, the sower's head penetrating more its yellow orb; and the sower is closer to the tree. Everything therefore is more compressed than in the spatially more open Bührle picture.

Compositionally, the picture unites the open field of the October *Sower* with the tree from its pendant, *Trunk of an Old Yew Tree* (F573). However, the diagonal placement of the tree is reminiscent of Gauguin's *Vision After the Sermon: Jacob Wrestling with the Angel* (WC245), already known to van Gogh from a drawing Gauguin had sent him in a letter of September (GAC32), and no doubt discussed with Gauguin once he arrived in Arles. It is painted on the thick, rough canvas specially bought by Gauguin, and there is evidence that van Gogh used the palette knife in certain areas.

No drawings of sowers, as preparatory ideas, survive from the Arles period. Of the three painted designs, however, the Bührle picture clearly meant most to van Gogh, forming a triumphant conclusion to the series; he placed his signature firmly on the tree. This is the only picture to be signed among those painted during Gauguin's stay.

130. Paul Gauguin
Washerwomen

Oil on canvas, 28¾ × 36¼ in. (73 × 92 cm.)
Signed and dated, lower left: P. Gauguin 1888
Collection William S. Paley

WC302

During the spring and early summer of 1888, van Gogh painted washerwomen at work on three of the canals that surround the city of Arles. One group was placed near the Langlois Bridge on the Arles–Bouc Canal (F397, F571), another on the Vigueirat Canal (F396), and a third on the Roubine du Roi (cat. 50). On 8 August, he wrote to Theo: "This morning I was at a washing place with figures of women as big as Gauguin's Negresses [a reference to a Martinique painting of 1887, WC224, which Theo bought from Gauguin], one especially in white, black, red, and another one all in yellow; there were at least thirty of them, old and young" (LT519).

Gauguin himself made no reference in his published letters to painting washerwomen in Arles, but in his Arles sketchbook (p. 72) he listed "2 *blanchisseuses*," which is to be interpreted as two separate paintings.

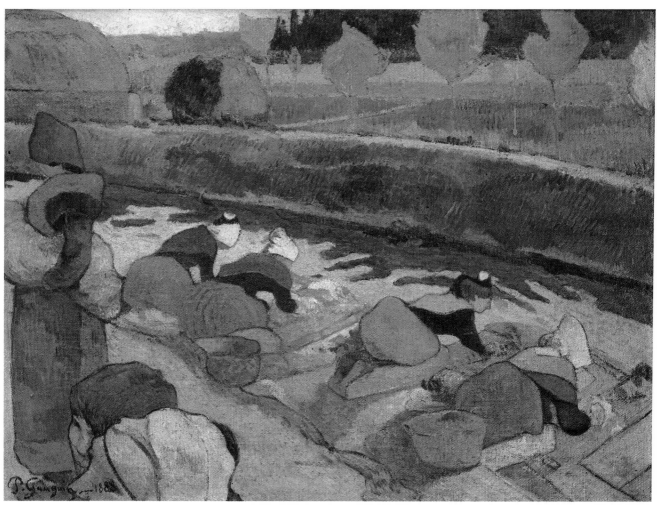

Van Gogh, however, reported to Theo on about 25 November: "Gauguin is working on a very beautiful picture of women washing" (LT558a). And again, about 4 December: "He has a good canvas of women washing, even very good I think" (LT560). These references appear to be to one painting only, though we cannot be sure which version van Gogh is describing.

Just as *Garden at Arles* (cat. 127) is clearly based on the public gardens in front of van Gogh's house in the Place Lamartine, and can be interpreted as Gauguin's summary in one picture of van Gogh's garden series, so his *Washerwomen* can be said to represent a summing up of van Gogh's images of washerwomen. The venue can be named specifically. It is the same Roubine du Roi, viewed strictly from bank level, depicted in van Gogh's June painting.

The image records a picturesque everyday activity, evidently without superimposed symbolic meaning. The only spatially disturbing intrusion is the two heads at lower left, whose placement suggests a viewpoint higher than that of the rest of the composition. The washerwoman without a bonnet may be Madame Ginoux (see cat. 120–122). The picture is painted on the thick, coarse canvas that Gauguin bought at the end of October.

A watercolor (Pickvance V), probably executed after the painting, reproduces part of the design, eliminating most of the landscape and several of the figures.

131. Paul Gauguin
Washerwomen

Oil on canvas, 28¾ × 36¼ in. (73 × 92 cm.)
Signed and dated, lower left: P. Gauguin 88
Museo de Bellas Artes, Bilbao

WC303

Having provided a spacious, open view in the other painting of washerwomen (cat. 130), Gauguin went to the opposite extreme in this composition. The disturbing claustrophobic quality, the deliberate asymmetry, the arbitrary cutting of all the elements, and the lack of a horizon conspire to make this Gauguin's most audacious composition to date. The standing washerwoman is based on a drawing in his sketchbook (p. 16). There is a watercolor on silk (Pickvance 28), done after the painting, that excludes the goat, as well as a lithograph (Guérin 6), produced in Paris in January 1889, that reverses the composition.

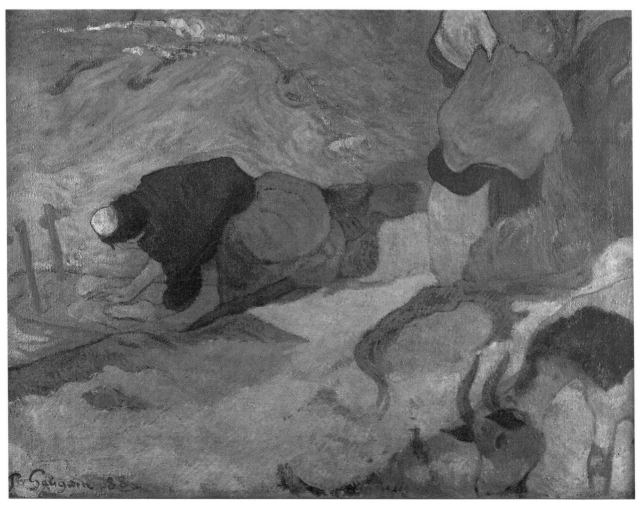

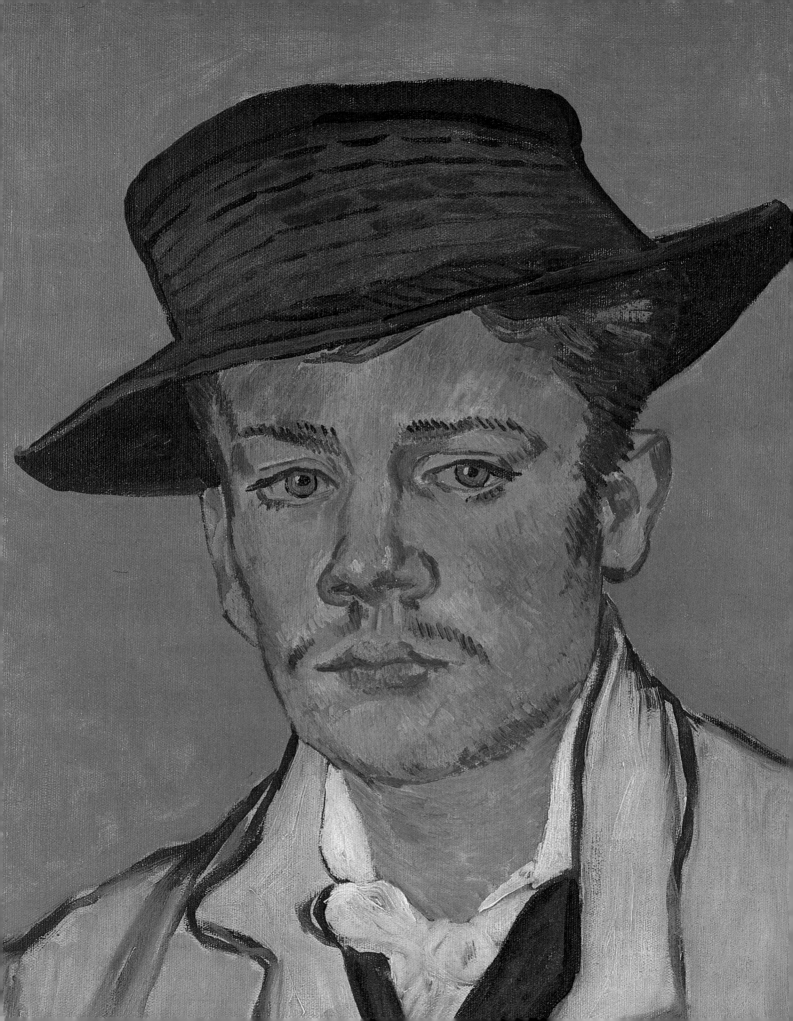

Portraits of the Roulin Family

The first portraits of Joseph Roulin (cat. 87, 88) were done about the time of the birth of his daughter, Marcelle, on 31 July 1888. Some three weeks later, van Gogh wrote to his sister Wil: "If I can get the mother and father to allow me to do a picture of it, I am going to paint a baby in a cradle one of these days. The father has refused to have it baptized—he is an ardent revolutionary—and when the family grumbled, possibly on account of the christening feast, he told them that the christening feast would take place nonetheless, and that he would baptize the child himself" (W6). There is no firm evidence that van Gogh painted the baby—least of all in its cradle—quite as soon as he intended.

Roulin himself is mentioned only rarely in van Gogh's letters between early August and late November. When, for example, van Gogh was considering buying beds for the Yellow House in late August, he told Theo that he had "consulted that postman I painted, who has often furnished and refurnished his little home moving from place to place" (LT528). And when describing his painting *The Yellow House* (cat. 102, fig. 46), he pointed out: "My friend the postman lives at the end of the street on the left, between the two railway bridges" (LT543).

While their friendship clearly remained close during this period, there are no intimations that van Gogh wanted Roulin or any member of his family to sit for him. It was not until early December that he announced to Theo: "I have made portraits *of a whole family*, that of the postman whose head I had done previously—the man, his wife, the baby, the little boy, and the son of sixteen [*sic*], all characters and very French, though the first has the look of a Russian. Size 15 canvases. You know how I feel about this, how I feel in my element, and that it consoles me up to a certain point for not being a doctor. I hope to get on with this and to be able to get more careful posing, paid for by portraits. And if I manage to do this *whole family* better still, at least I shall have done something to my liking and something individual" (LT560).

These portraits were probably begun during the last week of November, and by the time van Gogh wrote to Theo, about 4 December, he appears to have completed some six: Roulin himself (cat. 132); Madame Roulin (cat. 137, fig. 67); *Madame Roulin with Baby* (cat. 136); two of their elder son, Armand (cat. 133, 134); and one of their younger son, Camille (cat. 135). All are painted on standard size 15 canvases (25⅝ × 21¼ in.).

It seems possible that at least one of the three smaller versions of the baby, Marcelle, was done at this period (F440, F441, F441a). A larger portrait of Madame Roulin with Marcelle (cat. 136, fig. 66) was probably painted later in December, before van Gogh began working on the first version of *La Berceuse* (see cat. 146), a much more elaborate portrait of Madame Roulin.

132. Portrait of Joseph Roulin

Oil on canvas, 25⅝ × 21¼ in. (65 × 54 cm.)
Unsigned
Kunstmuseum, Winterthur

F434 H463 SG57 JH1647

This head-and-shoulders study of Joseph Roulin can be compared with the "life-size head" of early August (cat. 88), as well as with the versions against a decorative·background of 1889 (see cat. 147). Stiff and self-conscious in the one, hieratic and emblematic in the other, Roulin seems more at ease here, the slight inclination of the head enhancing the more natural pose. He is neither "postman," nor icon, nor paterfamilias. (He seems always to have worn his cap, perhaps because of his bald crown.) The calm and relaxed mood probably also reflects van Gogh's escape, for a short time at least, from the irksome problems of painting from the imagination.

Forms are simplified and gently flattened; the linear scaffolding is never overinsistent; and the paint surface has an almost exaggerated evenness and overall restraint. The abrupt lighting and the green shadows of the face may be due to the effects of gas-lighting in the studio.

A similar head-and-shoulders formula was used in the two versions of the portrait of Roulin's elder son, Armand (cat. 133, 134).

Joseph-Etienne Roulin was born in Lambesc, some thirty-seven miles east of Arles, on 4 April 1841, and died in Marseilles in September 1903.

133. Portrait of Armand Roulin

Oil on canvas, 26 × 21⅝ in. (66 × 55 cm.)
Unsigned
Museum Folkwang, Essen

F492 HXIII SG131 JH1642

Of the two versions of Roulin's elder son, Armand (see also cat. 134), it was this one that stayed with the family until acquired by the Paris dealer Ambroise Vollard about 1895. It is the more immediately beguiling, with the clear-eyed, candid gaze, the relaxed pose, and the luminous tonality. Seemingly unpondered and nonchalant in handling, it is also undoctrinaire in color, the mimosa yellow jacket and the soft green background played off against the subtle blues of hat, vest, and button.

There is something of Manet's fluid brushwork and bold *mise en page* in this portrait. It is as if van Gogh was transposing into his own pictorial language the words he used to describe Emile Bernard's *Self-Portrait*

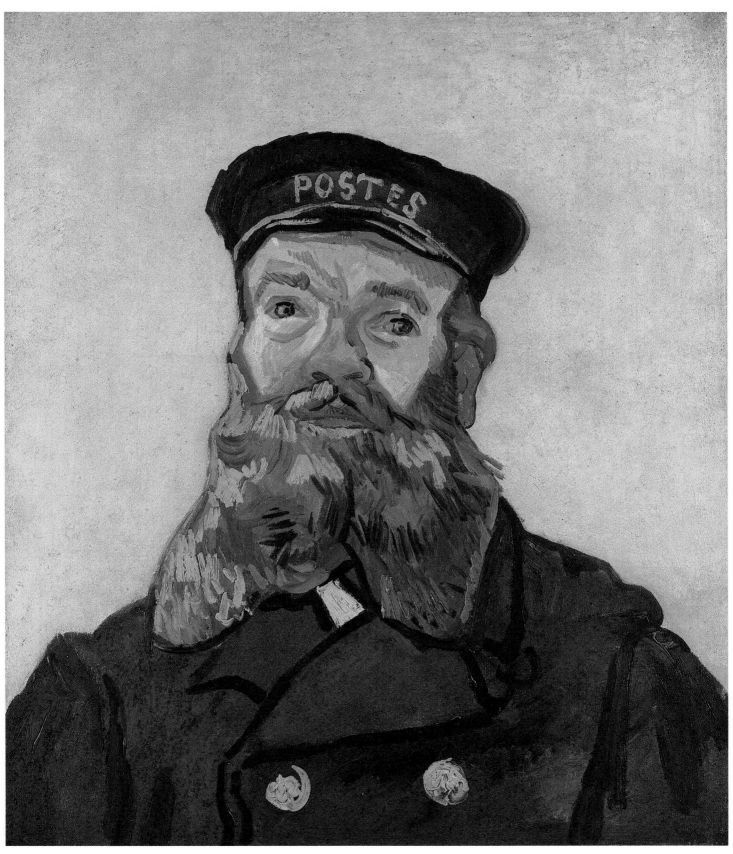

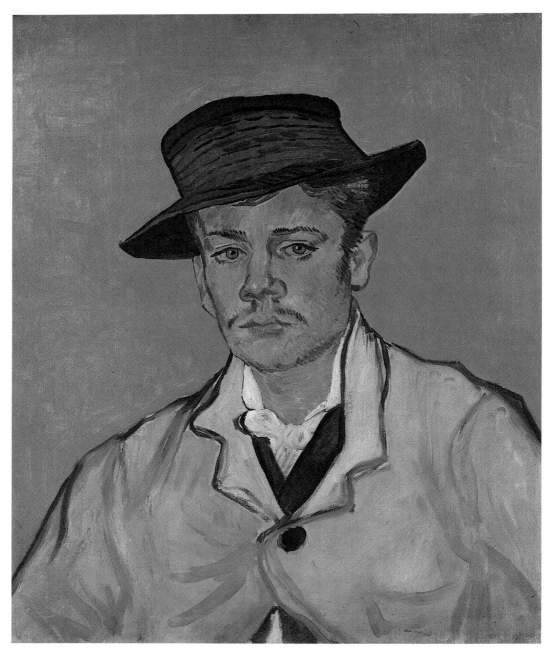

133

(Rijksmuseum Vincent van Gogh, Amsterdam), when he received it in early October: "It is just the inner vision of a painter, a few abrupt tones, a few dark lines, but it has the distinction of a real, real Manet" (LT545).

Armand-Joseph-Désirée Roulin, the Roulins' eldest child, was born in Lambesc on 5 May 1871, and died on 24 November 1945. When van Gogh painted his portrait, he was an apprentice blacksmith in Lambesc. He later became an *officier de paix* in Tunisia.

134. Portrait of Armand Roulin

Oil on canvas, 25⅝ × 21¼ in. (65 × 54 cm.)
Unsigned
Museum Boymans-van Beuningen, Rotterdam
F493 H518 SG132 JH1643

This second portrait of the seventeen-year-old Armand Roulin provides a striking contrast to the version in

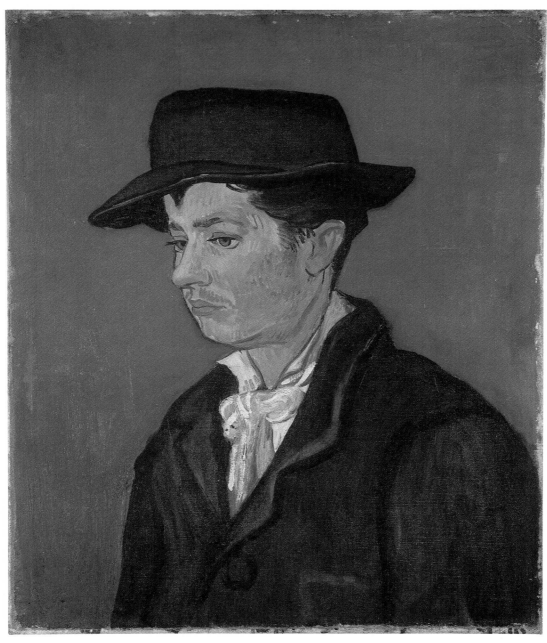

134

Essen (cat. 133). Instead of a frank and open confrontation, there is an introspective reverie; instead of an easy spreading of the forms, there is a diagonalized placement of the shoulders, with the head kept in the same axis rather than turned full-face to the spectator; instead of fluent, light-filled tones, there are predominantly dark but never quite somber blues against the subdued emerald background.

The paint surface is marginally more worked than in the Essen version, its even, almost stained quality being broken only by a few impasto touches in the line of the collar, the shadow of the hat, and the pinks of the cravat.

This portrait never belonged to the Roulin family. It was almost certainly among the large batch of canvases sent to Theo in May 1889.

This is the first time the portraits have been seen together since they left van Gogh's studio in Arles.

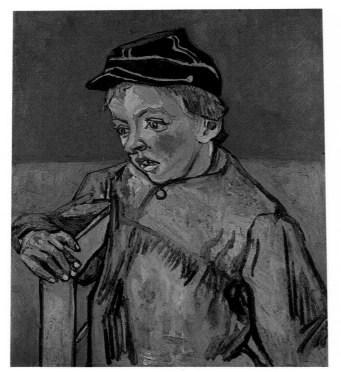

135

135. Portrait of Camille Roulin

Oil on canvas, 25 × 21¼ in. (63.5 × 54 cm.)
Unsigned
Museu de Arte, São Paulo

F665 H678 SG84 (Saint-Rémy) JH1879

The head-and-shoulders formula and the simple one-color background used in the portraits of Joseph Roulin and his elder son (cat. 132–134) are broken in this portrait of the eleven-year-old Camille. Van Gogh also introduced a studio prop, his own chair (see cat. 141), which enabled him to set up the casually seated pose and to allow the prominent display of the boy's hand. He complicated the background by introducing separate bands of orange and red, prefiguring the *Self-Portrait with Bandaged Ear and Pipe* (cat. 145).

The handling, too, differs from that in the portraits of the boy's father and brother. No longer does the paint have a controlled, thin, almost stained quality, with only occasional islands of impasto. The brush's passage is more urgent, cruder, more variegated, as though dictated by the potential restlessness and incipient mobility of the young schoolboy. This more brutal style is comparable with that of *Madame Roulin with Baby* (cat. 136).

Camille Roulin was born in Lambesc on 10 July 1877, and died on 4 June 1922. He was a clerk in the Service des Messageries Maritimes.

136. Madame Roulin with Baby

Oil on canvas, 25 × 20⅛ in. (63.5 × 51 cm.)
Unsigned
The Metropolitan Museum of Art, New York
 Robert Lehman Collection, 1975

F491 H519 SG130 JH1638

Like the preceding four portraits (cat. 132–135), this painting was executed on a size 15 canvas, which suggests that it belongs to the series of portraits of the Roulin family painted by van Gogh in late November–early December 1888 (LT560). This may seem surprising when it is compared with the composed and restrained style of the portraits of Joseph Roulin and his elder son. Its brutal and frenetic handling, with palette knife as well as brush, is in large part due to the subject. It is essentially a portrait of a four-month-old baby held by her mother, a flattened, subsidiary figure. Difficulties in posing demanded the speediest execution. Abrupt elisions of form, discontinuous outlines, and anatomical distortions create a powerful proto-Expressionist image.

Van Gogh painted a larger and more conventionally posed portrait of Madame Roulin and her baby later in December (fig. 66). This was followed by *La Berceuse* (see cat. 146), where he excluded any suggestion of the baby and the cradle.

Madame Roulin was born Augustine-Alix Pellicot

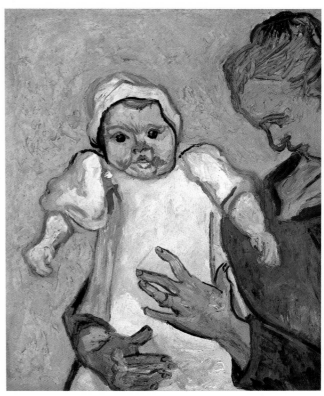

136

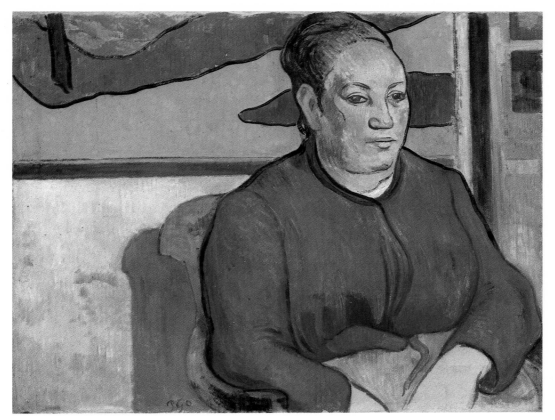

137

in Lambesc on 9 October 1851, and died on 5 April 1930. She was ten years younger than Joseph Roulin, whom she married on 31 August 1868. The baby, Marcelle, was born on 31 July 1888.

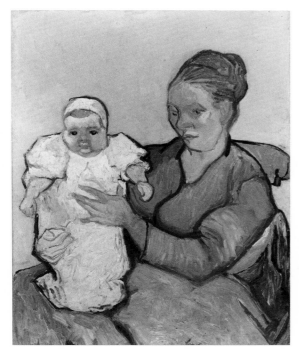

Fig. 66. *Madame Roulin with Baby* (F490). Oil on canvas, 36⅜ × 28⅞ in. (92.4 × 73.3 cm.). Philadelphia Museum of Art. Bequest of Lisa Norris Elkins

137. Paul Gauguin
Madame Roulin

Oil on canvas, 19¼ × 24½ in. (48.8 × 62.2 cm.)
Signed, lower left center: P Go.
The Saint Louis Art Museum. Gift of Mrs. Mark C. Steinberg

WC298

This portrait of Madame Augustine Roulin is often compared with van Gogh's portrait of the same sitter (fig. 67). Costume, however, differs; and while the van Gogh painting suggests a day scene, the Gauguin implies a night scene.

In several respects, this portrait is nearer to van Gogh's *La Berceuse* (cat. 146): costume is similar, and the composed, trancelike pose of the sitter suggests that she may be holding a cradle by a rope and gently rocking it. What is certain is that both the lighting of Madame Roulin's face—with the rather abrupt shadow—and the dark shadow on the doorjamb suggest an artificially lighted scene, in all probability showing the gas-lighting that van Gogh had had specially installed to allow him to work at night during the winter.

"I like the look of the studio, especially in the evening, with the gas burning," he wrote to Theo on 28 October. "And I think that in the evening we will bring along neighbors and friends, and, while chatting

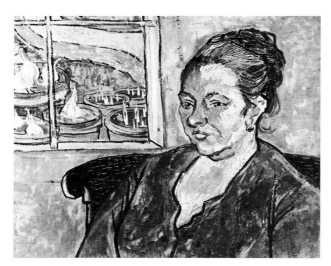

Fig. 67. *Madame Augustine Roulin* (F503). Oil on canvas, 21¼ × 25⅝ in. (54 × 65 cm.). Oskar Reinhart Collection, "Am Römerholz," Winterthur

away, we will work in the evening as in the daytime" (LT558b).

The studio interior is further suggested by the presence on the wall behind Madame Roulin of the lower right section, enlarged, of Gauguin's own painting, *Blue Trees* (WC311). Gauguin included another of his landscapes (unidentifiable) in *Van Gogh Painting Sunflowers* (cat. 142, fig. 70), and part of another (also unidentifiable) painting in his *Self-Portrait* (cat. 142).

It seems probable that this portrait of Madame Roulin was executed in December, possibly about the time van Gogh began his first version of *La Berceuse* (see cat. 146).

138. The Dance Hall

Oil on canvas, 25⅝ × 31⅞ in. (65 × 81 cm.)
Unsigned
Musée d'Orsay (Galerie du Jeu de Paume), Paris

F547 H555 SG93 JH1652

This painting is not mentioned in van Gogh's letters. Clearly, it is one of the paintings from the imagination

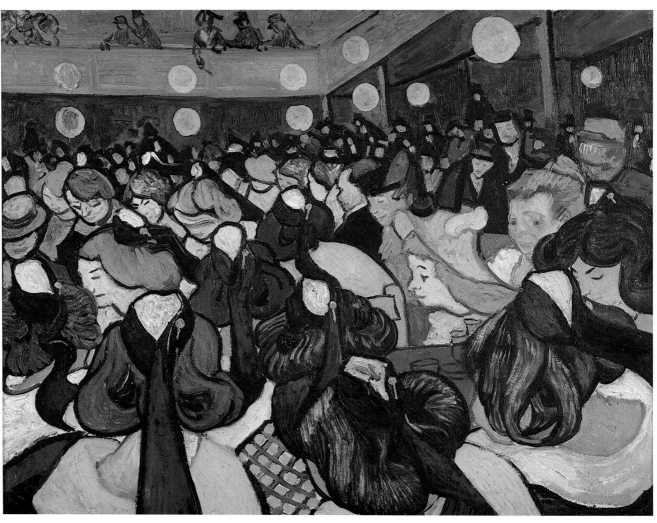

he did with Gauguin's encouragement. It continues the studies of interior night scenes begun with *The Night Café* (cat. 101, fig. 45) and followed by *Gauguin's Chair* (cat. 141, fig. 69). Compositionally, its flat, decorative patterns are indebted to Japanese prints, but may also have been influenced by Emile Bernard, for example his *Breton Women and Children* (cat. 125, fig. 62). Within the severe spatial compression, van Gogh sought to introduce the three pairs of complementaries: blue and orange in the background crowd, red and green on the balcony (with echoes elsewhere), and yellow and violet in the foreground.

The scene is set in the theatre and dance hall of the Folies Arlésiennes, situated on the south side of the Boulevard des Lices. It was demolished in the 1920s.

Van Gogh most likely painted *The Dance Hall* after the *Memory of the Garden at Etten* (cat. 126) and also after the series of portraits of the Roulin family (cat. 132–136). Madame Roulin's features are very clearly present in the figure at right, suggesting that this memory image may be based on a portrait of her (see cat. 137, fig. 67).

139. Spectators in the Arena

Oil on canvas, 28¾ × 36¼ in. (73 × 92 cm.)
Unsigned
The Hermitage Museum, Leningrad
F548 H556 SG101 JH1653
NOT IN EXHIBITION

Like *The Dance Hall* (cat. 138), this painting is not documented in van Gogh's letters. Beginning in April, van Gogh had speculated on doing a series of pictures of the bullfights in the arena (B3, LT474). None, however, was undertaken until the present painting. The swooping bird's-eye view, with implied spaciousness, contrasts with the near-claustrophobia of *The Dance Hall*.

Though made from memory, this painting nevertheless has familiar figures. In middle center are Roulin (his profile pose uncannily close to that in Gauguin's *Night Café*, cat. 123), and Madame Roulin with their baby, Marcelle. It seems likely that van Gogh painted this picture, as he had *The Dance Hall*, after he completed the series of portraits of the Roulin family (cat. 132–136).

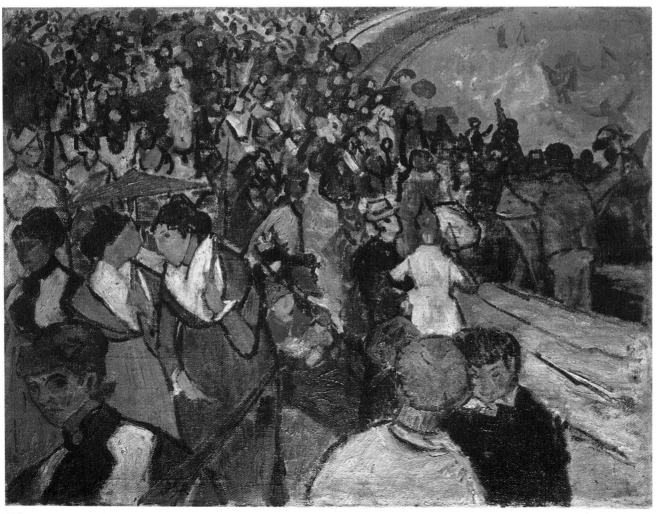

Fig. 68. Paul Gauguin. Studies for *Farmhouse in Arles*
a. *Girl Skipping Rope* b. *Sleeping Dog*.
Arles sketchbook. The Israel Museum, Jerusalem

140. Paul Gauguin
Farmhouse in Arles

Oil on canvas, 28½ × 36¼ in. (72.5 × 92 cm.)
Signed and dated, lower left: P. Gauguin 88
Nationalmuseum, Stockholm

WC309

Gauguin never actually referred to painting landscapes during his nine-week stay in Arles. His notebook contains very few landscape notations. Yet out of the seventeen surviving paintings from Arles, six can be described as landscapes: two of the Alyscamps (WC306; cat. 115, fig. 57), three with farmhouses (WC308, WC310, and the present painting), and one with a much more open view, *Blue Trees* (WC311). The number could be increased to seven if one were to include *Washerwomen* (cat. 130).

Van Gogh, however, twice referred to Gauguin's paintings of landscapes. Soon after Gauguin's arrival in Arles he wrote, on 28 October, "He is busy with a Negress and a large landscape of the region" (LT558b). And then, about 4 December, he noted, "Just now he is doing some landscapes" (LT560).

This may suggest that Gauguin did one landscape early on during his stay simply to become acclimatized and to get the feel of the region, and then concentrated on figure painting until early December. It also prompts the question, Which was the first landscape? The most likely candidate is the *Alyscamps* (cat. 115, fig. 57), which is surely an autumn study and must be contemporaneous with van Gogh's depictions of the same site, and which, if painted in late October–early November, would have been dry enough to send to Theo in early December as one of the batch of five paintings. It would also seem more than likely that Gauguin's other view of the Alyscamps (WC306) was done at about the same time.

By contrast, two of the paintings of farmhouses—the present one and WC310—could date from early December. Gauguin made quick studies for both of them in his sketchbook; for the *Farmhouse in Arles*, they are confined to the skipping girl and the sleeping dog (fig. 68). The Provençal farmhouse, the cypress, and, in the distance, the Alpilles provide the local clues, but they are incorporated into a design that asserts its decorative intentions. Gauguin observed the distinctive shadows caused by the winter sun, but they too are absorbed into his decorative conception.

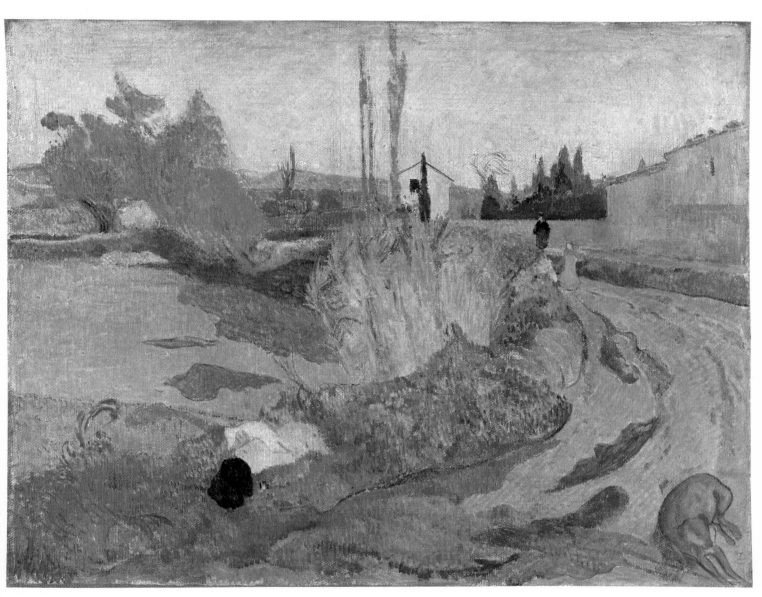

140

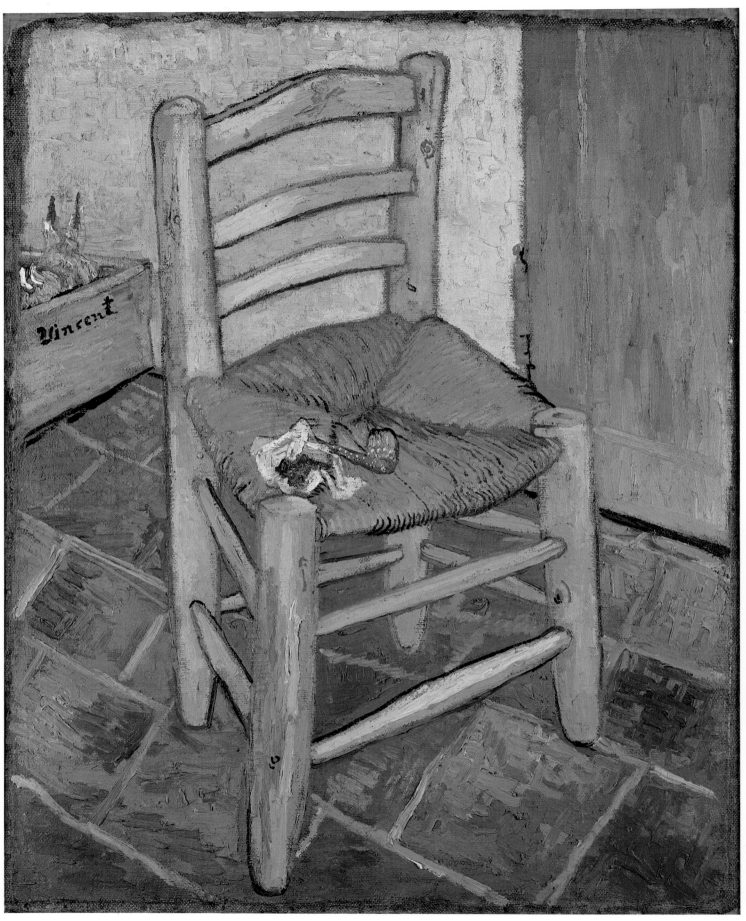

141. Van Gogh's Chair

Oil on canvas, 36¼ × 28¾ in. (92 × 73 cm.)
Signed, upper left, on bulb box: Vincent
The Trustees of The National Gallery, London

F498 H521 SG137 JH1635

In a letter of about 23 November, van Gogh raised the point that those artists and friends of Theo's who had seen the paintings he had sent to Paris in May and again in mid-August had thought them "too hastily done.... Fortunately for me, I know well enough what I want, and am basically utterly indifferent to the criticism that I work too hurriedly. In answer to that, I have done some things *even more* hurriedly these last few days ... the last two studies are odd enough. Size 30 canvases, a wooden rush-bottomed chair all yellow on red tiles against a wall (daytime). Then Gauguin's armchair [fig. 69], red and green night effect, walls and floor red and green again, on the seat two novels and a candle, on thick canvas with a thick impasto" (LT563).

The painting, then, was completed in great haste by about 23 November 1888. But on 17 January 1889, he told Theo: "I should like De Haan to see a study of mine of a lighted candle and two novels (one yellow, the other pink) lying on an empty armchair (really Gauguin's chair), a size 30 canvas, in red and green. I have just been working again today on its pendant, my own empty chair, a white deal chair with a pipe and a tobacco pouch. In these two studies, as in others, I have tried for an effect of light by means of clear color" (LT571).

The two chairs are pendants, painted on the rough, coarse canvas purchased by Gauguin at the end of October. They are also opposites, continuing the contrast between day (yellow and blue-violet) and night (red and green) already established in *The Yellow House* (cat. 102, fig. 46) and *The Night Café* (cat. 101, fig. 45). They are attempts to transfer Rembrandt's effects of light within a color system largely based on Delacroix. About 25 November van Gogh wrote to Theo, having recommended to him that Meyer de Haan read Armand Silvestre on Delacroix, and Charles Blanc's article on color in the *Grammaire des arts du dessin* (1867): "As for me, I am thinking more of Rembrandt than might appear from my studies" (LT558a).

A rather striking omission in the work van Gogh produced during Gauguin's stay in Arles is that of still-life paintings. Gauguin himself evidently produced only one, "a large still life of an orange-colored pumpkin and apples and white linen on a yellow background and foreground" (LT558a), which ironically is lost. The two chairs, however, are in one sense monumental still lifes, inanimate objects seen in a specific light (a candle and gas-lighting in *Gauguin's Chair*), with no human presence. Yet the objects in *Van Gogh's Chair*, the simple rustic chair standing on the red tiles of the studio floor, with the pipe and tobacco on the seat, invoke potently the presence of van Gogh himself. The pipe and tobacco reappear in a still life painted in January 1889 (F604); the pipe can be seen in the *Self-Portrait with Bandaged Ear and Pipe* (cat. 145).

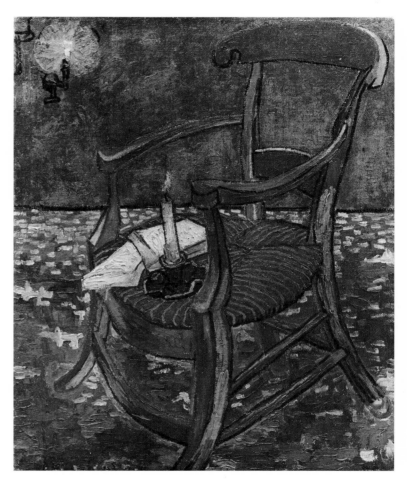

Fig. 69. *Gauguin's Chair* (F499). Oil on canvas, 35⅞ × 28⅜ in. (90.5 × 72 cm.). Rijksmuseum Vincent van Gogh, Amsterdam

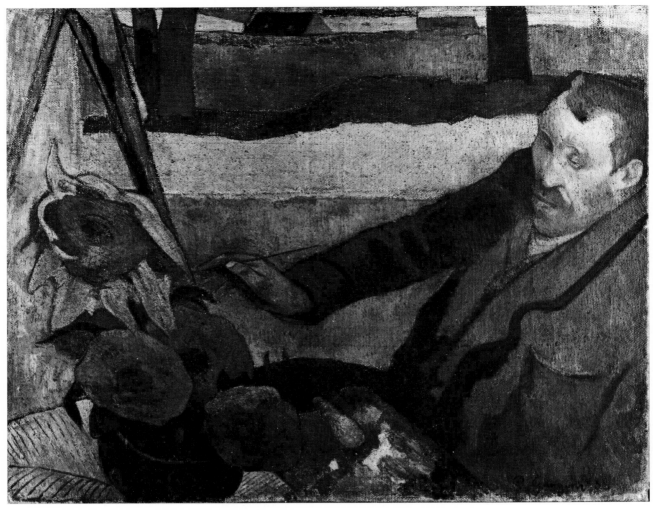

Fig. 70. Paul Gauguin. *Van Gogh Painting Sunflowers* (WC296). Oil on canvas, 28¾ × 36¼ in. (73 × 92 cm.). Rijksmuseum Vincent van Gogh, Amsterdam

142. Paul Gauguin
Self-Portrait

Oil on canvas, 18⅛ × 15 in. (46 × 38 cm.)
Signed, lower left: P Go
Pushkin State Museum of Fine Arts, Moscow

WC297

NOT IN EXHIBITION

On 9 January 1889, van Gogh referred retrospectively to a self-portrait by Gauguin as having been painted toward the end of his stay in Arles, that is, before 23 December 1888: "Have you seen the portrait of me which Gauguin has [*Van Gogh Painting Sunflowers*, fig. 70], and have you seen the portrait which Gauguin did of himself during these last few days?" he asked Theo. "If you compare the self-portrait Gauguin did then with the one that I still have of him, which he sent

me from Brittany in exchange for mine [cat. 99], you will see that on the whole he himself got rested here" (LT570).

This must be the self-portrait van Gogh was referring to. It is painted on the thick, coarse canvas bought specially by Gauguin. The curled-up moustache is typical of Gauguin's appearance in 1888 (compare the *Self-Portrait: "Les Misérables,"* cat. 99, fig. 44, painted for van Gogh in September); from 1890 on, the moustache is always shown drooping in his painted self-portraits.

Behind Gauguin's head is what appears to be a painting. He thus repeats his habit of placing a painting within a painting, as in the portrait of Madame Roulin (cat. 137) and *Van Gogh Painting Sunflowers*. In the last two cases, the paintings are by Gauguin himself; in *Madame Roulin* the picture is identifiable with an existing work. In the *Self-Portrait*, it is impossible to match the background shapes and colors with any of his surviving paintings.

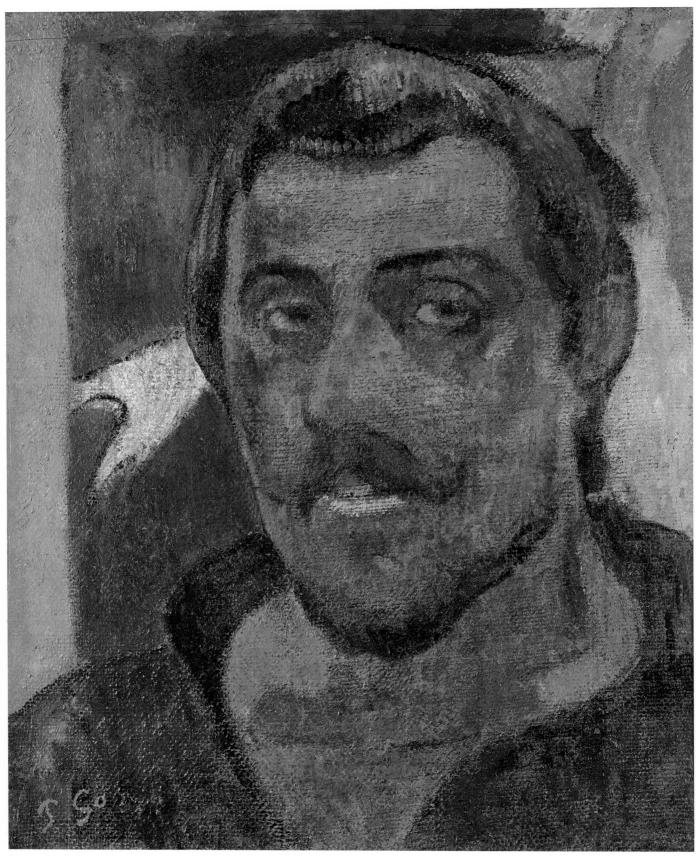

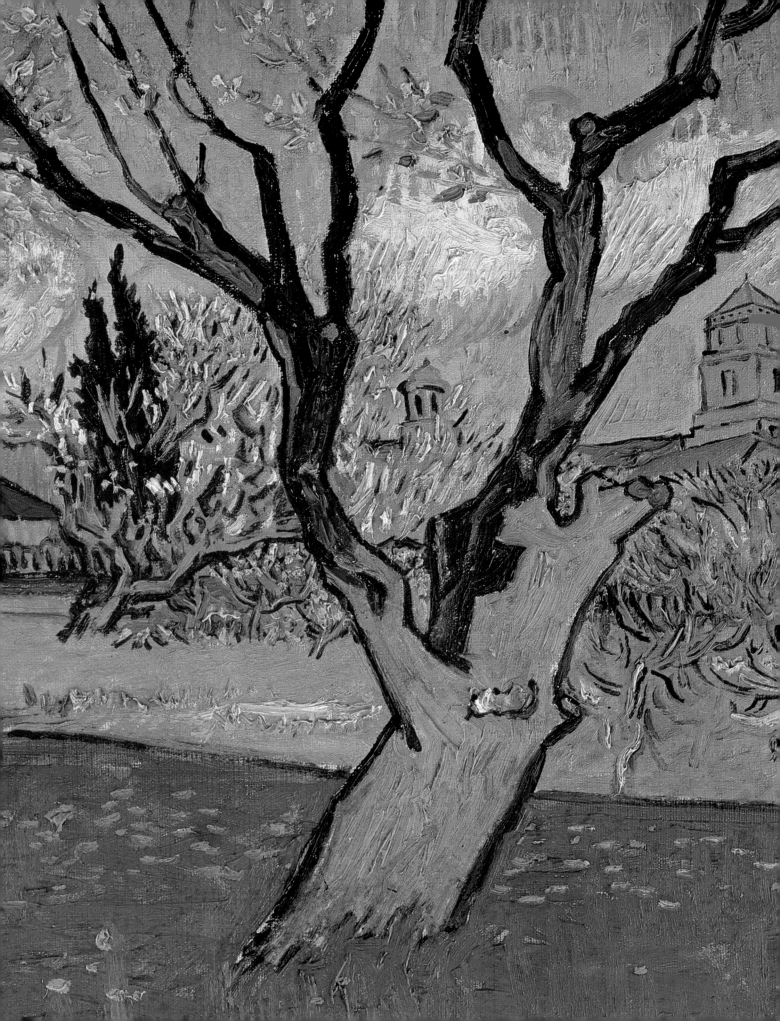

Monday 24 December
Van Gogh is discovered in his bed by the police, "giving almost no sign of life." He is admitted to the Hôtel Dieu, the hospital in Arles, where he is attended by Dr. Félix Rey (1867–1932).

Summoned from Paris by a telegram from Gauguin, Theo arrives in Arles. Probably it is he who seeks out the Reverend Frédéric Salles, pastor of the Reformed Protestant Church at 9 Rue de la Rotonde, quite near the hospital.

Tuesday 25 December
Van Gogh's condition considered critical.

Wednesday 26 December
Theo, almost certainly in the company of Gauguin, returns to Paris. "There is little hope," he writes to his fiancée, Johanna Gesina Bonger (1862–1925). "If it must be that he dies, so be it, but my heart breaks when I think of it."

Thursday 27 December
Visited by Madame Roulin in the hospital. After she leaves he has a serious attack, spends a very bad night, and is put in an isolated room.

Friday 28 December
Joseph Roulin is not allowed to see van Gogh, who is taking no food and refuses to talk. Possibility of his being transferred to a mental hospital in Aix.

Gauguin watches an execution in Paris.

Monday 31 December
After a week of crises, the Reverend Salles writes to Theo: "I found him calm, in a state which revealed nothing abnormal.... He is amazed and even indignant (which could be sufficient to start another attack) that he is kept shut up here, completely deprived of his liberty"; van Gogh is also astonished that Theo has not written.

Wednesday 2 January 1889
Van Gogh writes to Theo: hopes to return to the Yellow House in a few days. Dr. Rey adds a reassuring note: "I am firmly convinced that he will be himself again in a few days."

Thursday 3 January
Roulin writes to Theo: "My friend Vincent is quite recovered.... At present he

can move freely about the hospital; we walked for more than an hour in the courtyard, he is in a very healthy state of mind."

Friday 4 January
"I am truly happy today," Roulin writes, again to Theo. "I went to the hospital to get my friend Vincent and take him for a little fresh air. We went to the house, he was pleased to see his paintings again; we stayed together four hours, he has completely recovered, it is really surprising. I am very sorry my first letters were so alarming."

From the Yellow House, van Gogh scribbles two notes in pencil—to Theo and to Gauguin—before returning to the hospital.

Monday 7 January
Leaves hospital and returns to the Yellow House. Dr. Rey and two colleagues "came to see the paintings ... and were uncommonly quick at understanding at least what complementaries are," he writes Theo in the morning.

Later in the day, writes a reassuring three-page letter to his mother and his sister Wil.

In the evening, writes yet again to Theo: "I am going to set to work again tomorrow. I shall begin by doing one or two still lifes, so as to get back into the habit of painting. Roulin has been splendid to me, and I dare say that he will remain a lasting friend.... We had our dinner together today."

Tuesday 8 January
Begins painting again; hopes to do a number of portraits, including one of Dr. Rey.

Wednesday 9 January
Receives his first letter from Johanna Bonger, announcing her engagement to Theo.

Visits the hospital to get another dressing, and walks for an hour and a half with Dr. Rey.

Writes to Theo: "Physically I am well, the wound is healing very well and the great loss of blood is being made up, because I eat and digest well."

Thursday 10 January
Hopes for a letter from Theo. Has to bor-

row 5 francs. Theo does not write until 17 January, and the Reverend Salles, Dr. Rey, and Roulin do not write to Theo during this week.

Receives first letter from Gauguin since his breakdown: he talks mostly of painting.

Thursday 17 January
Letter from Theo, enclosing 50 francs. In his immediate reply—a twelve-page letter—van Gogh provides a report on the past week's activities: Roulin has often kept him company; broke by 8 January, he has had to borrow 5 francs from Ginoux at the Café de la Gare, and has taken ten meals on credit (7.50 francs); these seven days have been "a most rigorous fast, the more painful because I cannot recover under such conditions"; nevertheless, has started to work again, and already has "three finished studies in the studio, besides the portrait of Dr. Rey [cat. 144], which I gave him as a keepsake"; this very day has been working again on "my own empty chair, a white deal chair with a pipe and a tobacco pouch [cat. 141]"; and, for Theo, has a new self-portrait (cat. 145). Much of the letter discusses, with remarkable objectivity and perspicacity, Gauguin's character, conduct, and motives.

Friday 18 January
Receives another letter from Gauguin: asks van Gogh to send his sketchbook and his two fencing masks and gloves, but not to bother sending his painted studies; is engaged on a series of lithographs, on the advice and under the auspices of Theo; also on a portrait of the Schuffenecker family (WC313).

Van Gogh does not answer immediately.

Saturday 19 January
Writes to Theo: "I am still very weak, and I shall have difficulty getting my strength back if the cold continues.... Roulin is on the point of leaving. His pay here was 135 francs a month, to bring up three children on that and live on it, himself and his wife!"

Monday 21 January
Roulin leaves Arles for his new post in Marseilles.

Tuesday 22 January
Letter from Theo, enclosing 50 francs. Van Gogh replies: has just finished a still life of

"a wicker basket with lemons and oranges, a cypress branch and a pair of blue gloves [F502]"; also working on the portrait of Roulin's wife, which he began before he became ill. This is his first mention of *La Berceuse* (see cat. 146).

Replies to Gauguin, telling him that Roulin has left for Marseilles and describing at length *La Berceuse*, which he has "begun working on again today."

Describes *La Berceuse* yet again in a letter to Koning.

Sunday 27 January
The chief superintendent of police pays him "a very friendly visit."

Goes in the evening to the theatre of the Folies Arlésiennes and sees a Noël or a Pastorale, "reminiscent of the Christian theatre of the Middle Ages."

Monday 28 January
Writes to Theo: "I am furiously at work from morning till night"; has just completed two copies (F455, F458) of two of the August 1888 *Sunflowers* that had hung in Gauguin's room (F454, F456), and also two copies of *La Berceuse*.

Roulin visits Arles for the day and is very pleased with the portraits of his wife.

Wednesday 30 January
Receives "a very friendly letter from Gauguin," to which he replies without delay.

At work on a third copy of *La Berceuse*.

"It has been a magnificent day with no wind, and I have such a longing to work that I am astonished, as I did not expect it anymore."

Sunday 3 February
Letter from Theo, enclosing 100 francs, received a day or so previously. Delays his reply because he is "very tired . . . and the doctor had given me strict orders to go out for a walk without doing any mental work. . . . There are moments when I am twisted by enthusiasm or madness or prophecy, like a Greek oracle on the tripod."

Works on his fourth version of *La Berceuse*.

Thursday 7 February
The Reverend Salles writes to Theo: van Gogh has again been taken to the hospital that afternoon; for three days he imagined he was being poisoned; his charwoman told the neighbors, and they brought the matter to the attention of the superintendent of police, who had him watched; he is now in an isolated room.

A medical report, dated 7 February, issued by Dr. Albert Delon to the superintendent of police, testifies to van Gogh's hallucinations—he hears voices reproaching him—and to his constant fear of being poisoned.

He is kept in the hospital for ten days.

Wednesday 13 February
Telegram to Theo from Dr. Rey: "Vincent much better, hope getting better, keeping him here. Do not worry now."

Sunday 17 February
Van Gogh writes to Theo: "Today I have just come home provisionally, I hope for good. I feel quite normal so often, and really I should think that if what I am suffering from is only a disease peculiar to this place. . . . It seems that people here have some superstition that makes them afraid of painting, and that they have been talking about it in the town."

His neighbors are alarmed at his return to the Yellow House, even though he is sleeping and eating at the hospital. Thirty individuals present a petition to the mayor, claiming that van Gogh is not in command of his mental faculties, that he drinks too much, and that he is a threat to women and children. He should, therefore, return to his family or be admitted to a mental asylum. The mayor passes on the undated petition (probably about 18–25 February) to the superintendent of police, who immediately has van Gogh readmitted to the hospital, probably on 25 February. His house is closed by the police.

Tuesday 26 February
The Reverend Salles writes to Theo of the recent happenings.

Wednesday 27 February
The superintendent of police interviews five petitioners, who repeat the same allegations. The report of his investigation, dated 3 March, concludes: "Vincent van Goghe [*sic*] is mentally deranged and might become a public danger. We feel that this madman should be detained in a special asylum."

Friday 1–Saturday 2 March
The Reverend Salles writes to Theo on successive days: everyone at the hospital is well disposed toward van Gogh; "It should be the doctors and not the superintendent of police who ought to be the judges in a case like this"; nonetheless, van Gogh is isolated in a private cell and allowed neither pipe, book, nor paints.

Saturday 16 March
Theo writes to van Gogh, having been kept informed of his state by Dr. Rey and

the Reverend Salles: the Pointillist painter Paul Signac (1863–1935) will shortly go to the South and will visit him.

Monday 18 March
The Reverend Salles writes to Theo, having just visited van Gogh: "I found him entirely lucid and with a complete awareness of his position. . . . He read [your letter] in my presence." Salles advises that he should leave the Yellow House and live in another part of the town.

Tuesday 19 March
Van Gogh writes to Theo, after almost a month's silence: has been "shut up in a cell all the livelong day, under lock and key and with keepers, without my guilt being proved or even open to proof"; feels it is not Dr. Rey's fault, as he himself was ill at the time; very upset by the neighbors' petition; wants to send Theo his canvases, "but all of them are under lock and key, guarded by police and keepers."

Friday 22 March
Replies to another letter from Theo: the Reverend Salles is looking for another apartment; "As far as I can judge, I am not, properly speaking, a madman. You will see that the canvases I have done in the intervals are calm and not inferior to the others. I *miss* the work more than it tires me. Certainly I should be pleased to see Signac, if he has to pass through here after all. Then they must let me go out with him to show him my canvases."

Saturday 23 March
Signac visits van Gogh, and together they go to the Yellow House. The police have destroyed the lock, and although at first they refuse to allow Signac to force open the front door, he eventually does so. Van Gogh presents him with a canvas of two herrings (cat. 143).

Buys *Ceux de la glèbe* (1889) by Camille Lemonnier—"the first time in several months that I have had a book in my hands."

Sunday 24 March
Takes a walk with Signac in the morning before he leaves for Cassis.

Writes to Theo: describes Signac's visit; reports Dr. Rey's opinion that "instead of eating enough and at regular times, I kept myself going on coffee and alcohol. I admit all that, but all the same it is true that to attain the high yellow note that I attained last summer, I really had to be pretty well keyed up"; hopes to resume his painting soon—with a new series of orchards—and sends Theo an order for paints.

Signac writes to Theo: "I found your brother in perfect health, physically and mentally."

Wednesday 27–Thursday 28 March
"Went into the town to get things to work with."

"I have sent for a few more books so as to have a few sound ideas in my head. I have reread *Uncle Tom's Cabin* [1851–1852], you know Beecher Stowe's book on slavery, Dickens's Christmas stories, and I have given *Germinie Lacerteux* [Goncourt brothers, 1865] to M. Salles."

Friday 29 March
Begins painting again, working on his fifth version of *La Berceuse*.

Saturday 30 March
Van Gogh's thirty-sixth birthday.

Theo leaves Paris for Amsterdam to prepare for his wedding, not intending to return until 21 April.

Early April
Roulin comes to see van Gogh; it is their last meeting.

Working on "an orchard of peach trees beside a road with the Alpine foothills in the background [F514]."

Friday 5 April
Receives a postcard from Signac in Cassis, and writes in reply (cat. 152): "At present I am well, and I work at the sanatorium and its environs. I have just come back with two studies of orchards [F514; cat. 148]."

Mid-April
Writes to Theo: has "six studies of the spring, two of them big orchards"; has taken "an apartment consisting of two little rooms (at 6 to 8 francs per month, water included) *belonging to M. Rey.* It is certainly not expensive but nothing like as nice as the other studio."

Takes his furniture from the Yellow House and stores it at the Café de la Gare.

Buys a new suit for 35 francs and six pairs of socks for 4 francs.

Wednesday 17 April
Theo marries Johanna Bonger in Holland.

Friday 19 April
The Reverend Salles writes to Theo that van Gogh feels unable to leave the hospital and take an apartment in Arles, but prefers to spend two or three months in an asylum.

Sunday 21 April
Letter from Theo, enclosing 100 francs. Van Gogh replies: "At the end of the month I should like to go to the hospital at Saint-Rémy. . . . Certainly these last days were sad, with all the moving, taking away all my furniture, packing up the canvases that are going to you."

Monday 29 April
Letter from Theo, enclosing 100 francs. Van Gogh replies: will send shortly, by freight train, "two cases of pictures, of which you must not hesitate to destroy a good number."

Tuesday 30 April
Writes to Theo, sending birthday greetings for the first of May. "Today I am busy packing a case of pictures and studies. One of them is flaking off, and I have stuck some newspapers on it; it is one of the best, and I think that when you look at it you will see better what my now shipwrecked studio might have been. This study, like some others, has got spoiled by moisture during my illness. The flood water came to within a few feet of the house, and on top of that, the house itself had no fires in it during my absence, so when I came back, the walls were oozing water and saltpeter."

Also writes to Wil: "[I am] going to an asylum in Saint-Rémy, not far from here, for three months. I have had in all four great crises, during which I didn't in the least know what I said, what I wanted and what I did. Not taking into account that I had previously had three fainting fits without any plausible reason, and without retaining the slightest remembrance of what I felt"; describes two canvases he has just finished, one of the hospital ward (F646), the other of the hospital court (F519); says he has only done four orchards this spring.

Wednesday 1 May
Theo's thirty-second birthday.

Thursday 2 May
Sends off by freight train two cases of paintings to Theo. "There are lots of daubs among them, which you will have to destroy. . . . I have put in some fencing masks and some studies of Gauguin's."

Working on a view of an avenue in the park (F517).

Friday 3 May
Begins drawing again with a reed pen, "like last year's views of Montmajour. . . . Today I made a drawing of that sort, which has turned out very dark and rather melancholy for one of spring [cat. 149]."

Reading Balzac's *Le Médecin de campagne* (1833).

Saturday 4–Tuesday 7 May
Packing and preparing for Saint-Rémy.

Wednesday 8 May
Leaves Arles, accompanied by the Reverend Salles, for the asylum of Saint-Paul-de-Mausole in Saint-Rémy-de-Provence.

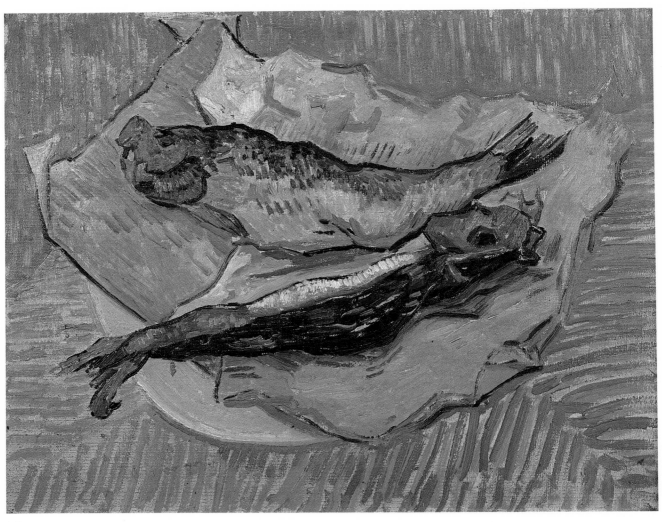

143

143. Plate with Herrings

Oil on canvas, 13 × 16⅛ in. (33 × 41 cm.)
Unsigned
Private collection

F510 H532 SG154 JH1661

When van Gogh left the hospital on 7 January 1889, he resolved to start painting the next day, beginning by "doing one or two still lifes so as to get back into the habit of painting" (LT569). It seems most probable that this still life of two herrings lying in paper, on a plate placed on the rush seat of his chair, was one of these. Its modest scale, simple composition, and restricted palette all suggest this.

On 23 March, Paul Signac visited van Gogh at the hospital in Arles, where he had been kept in solitary confinement for a month, the Yellow House closed by the police, who had even destroyed the lock. When the two artists went to the house, Signac eventually persuaded the police to allow him to break open the door.

As a token of gratitude, van Gogh presented him with this still life, "which...annoyed the good gendarmes of the town of Arles, because it represented two smoked herrings, and as you know, they, the gendarmes, are called that" (LT581, 24 March 1889).

Van Gogh also reminded Theo that he had done similar still lifes of herrings "two or three times in Paris [F283, F285], and exchanged one of them for a carpet."

See also cat. 152.

144. Portrait of Dr. Félix Rey

Oil on canvas, 25¼ × 20⅞ in. (64 × 53 cm.)
Signed and dated, lower right: Vincent / Arles / 89
Pushkin State Museum of Fine Arts, Moscow

F500 H526 SG144 JH1659

NOT IN EXHIBITION

Dr. Félix Rey (1867–1932) was the young house surgeon who looked after van Gogh in the hospital in Arles from 24 December 1888 to 7 January 1889. The day

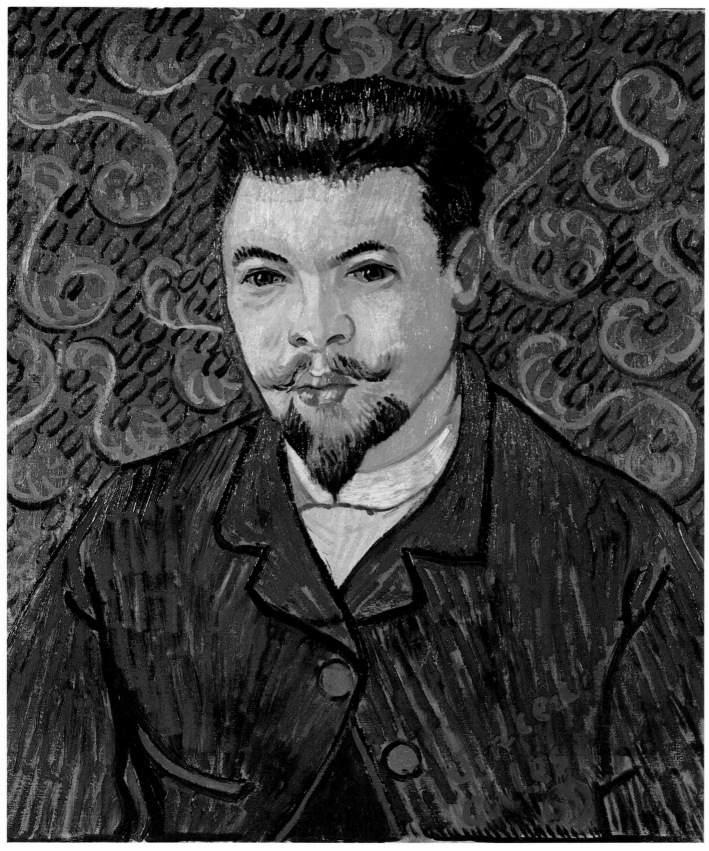

144

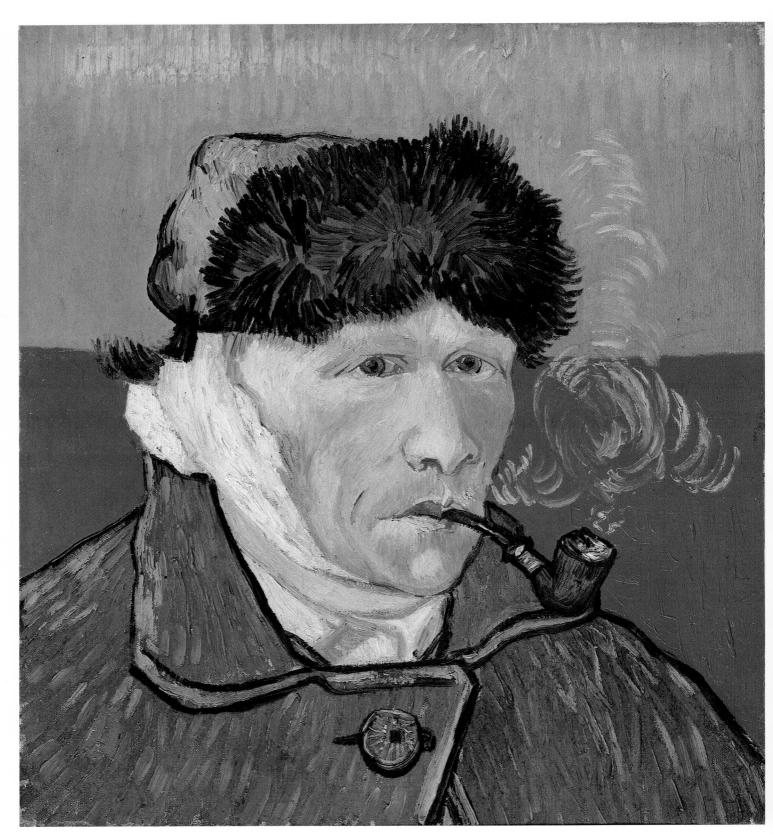

145

he left the hospital, van Gogh reported: "Monsieur Rey came to see the paintings with two of his friends, doctors, and they were uncommonly quick at understanding at least what complementaries are. I now intend to do a portrait of M. Rey" (LT568). He also suggested that Theo send an engraving after Rembrandt's *The Anatomy Lesson of Dr. Tulp* for Dr. Rey to hang in his study (LT569). Two days later, having been to the hospital for another dressing, he walked with Dr. Rey for an hour and a half. "He had already told me before this morning that he was fond of painting, though he knew nothing about it, and that he wishes to learn. I told him he ought to turn *collector*, but that he should not try to paint himself" (LT570). On 17 January, van Gogh told his brother that he had finished the portrait of Dr. Rey, and given it to him as a keepsake.

Curiously, for someone who became a friend as well as being his doctor, Dr. Rey was never described by van Gogh. Nor did he compare him with a historical or fictional character, as was so often his wont (see, for example, his comments on Eugène Boch, cat. 98, and Joseph Roulin, cat. 87, 90). Further, he left no description of this portrait.

The portrait raises four interesting points. First, van Gogh did not use it primarily as a doctrinaire demonstration of the play of complementary contrasts; he left that exercise for his self-portrait (cat. 145). Then, it is the first of the portraits to have a highly decorative background, which became so characteristic of the portraits of Joseph Roulin (see cat. 147) and of Madame Roulin as *La Berceuse* (see cat. 146). Here it is less floral than musical.

Third, the painting has its own painted frame, a continuous thin band of red, obscured by the picture frame. Finally, while the portrait may well have been painted in one sitting, there is a clear change of outline in the right side of the face.

Given to Dr. Rey as a present, the picture was so disliked by the doctor's mother that it was used to stop a gap in a hen house. It was discovered by the artist Charles Camoin in 1901, and sold by Dr. Rey, together with five other canvases by van Gogh, to a dealer in Marseilles almost certainly acting on behalf of Ambroise Vollard.

145. Self-Portrait with Bandaged Ear and Pipe

Oil on canvas, 20⅛ × 17¾ in. (51 × 45 cm.)
Unsigned
Private collection

F529 HXII SG145 JH1658

On 17 January 1889, ten days after leaving the hospital, van Gogh wrote a twelve-page letter to Theo. In it he

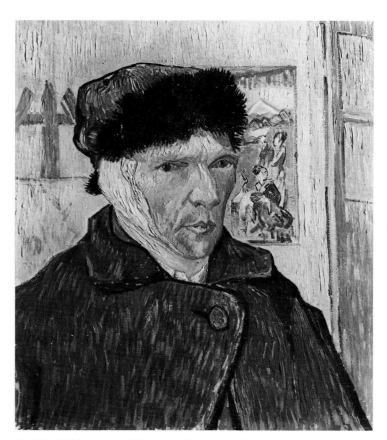

Fig. 71. *Self-Portrait with Bandaged Ear* (F527). Oil on canvas, 23⅝ × 19¼ in. (60 × 49 cm.). Courtauld Institute Galleries, London

discussed his health, his finances, Joseph Roulin, Dr. Rey, and, above all, Gauguin. Only occasionally did he refer to his own painting. He said he had three finished studies besides the portrait of Dr. Rey and had just been retouching the painting of his own empty chair (cat. 141). He also expressed surprise that Gauguin had not taken to Paris the self-portrait dedicated to Charles Laval (cat. 124), adding, "I have another new one for you too" (LT571).

Two self-portraits are usually cited in connection with this bald statement, the present one and the *Self-Portrait with Bandaged Ear* (fig. 71). One line of thought argues that the latter was painted first because van Gogh looks paler and more shaken; that picture would therefore be the one referred to on 17 January, and the present self-portrait would have been painted after that date. Another argues that both existed by 17 January. And a third, that only the present self-portrait was ever done by van Gogh, the other one being a pastiche by another hand.

Whatever the case may be—bringing the two together was not possible because of the fragile condition of the latter version—there can be no doubt that the

Self-Portrait with Bandaged Ear and Pipe was quite deliberately conceived as a demonstration piece.

There was, following van Gogh's illness, no decline in his sense of design or in his touch, no weakening of the artistic will. As he wrote later, on about 22 March 1889: "As far as I can judge, I am not properly speaking a madman. You will see that the canvases I have done in the intervals are steady and not inferior to the others" (LT580).

There is no more potent affirmation of this statement than this self-portrait. Few of van Gogh's paintings proclaim so boldly his use of complementary colors. Having initiated Dr. Rey into their workings, he then provided a practical demonstration. The green coat is placed against a red ground, the blue fur cap against an orange ground; part of the cap contains violet, and yellows are introduced in the upper part of the orange ground and in the rising curls of smoke. The eyes, closely placed and angularly drawn, virtually coincide with the dividing horizontal of the two major color contrasts. The pipe, picked up from the painting of his chair (cat. 141) and a recently completed still life (F604), was added last, heightening the sense of inner calm and stoical resolve. There is no Expressionist angst, no disruptive baring of the soul—just an unsentimental and composed self-appraisal. As he wrote of the *Bedroom* (cat. 113), that other major demonstration of the use of complementaries, color was to do everything, its simplification giving "a grander style to things." The disposition of the orange and red in the background reverses that in the *Portrait of Camille Roulin* (cat. 135).

The picture's first recorded owner was Amédée Schuffenecker, brother of the artist Emile Schuffenecker and friend of Gauguin. There is an undated copy of the painting by Emile Schuffenecker, in pastel on gray paper (20⅞ × 13¾ in.), acquired by the Rijksmuseum Vincent van Gogh, Amsterdam, in 1974.

146. La Berceuse

Oil on canvas, 36½ × 28⅝ in. (92.7 × 72.8 cm.)
Inscribed, lower right: la Berceuse
Museum of Fine Arts, Boston. Bequest of John T. Spaulding

F508 H529 SG152 JH1671

Van Gogh began a painting of Madame Roulin in December 1888. This is twice recalled in letters of about 22 January 1889. First to Theo: "I am working on the portrait of Roulin's wife, which I was working on before I was ill. In it I have ranged the reds from pink to an orange which rises up from the yellows to citron, with light and somber greens. If I could finish it, I should be very glad, but I am afraid she will not want to pose with her husband away" (LT573).

And then to Gauguin: "Today I began again the picture that I had painted of Madame Roulin—the one that because of my accident had remained, for the hands, in a vague state. As an arrangement of colors, the reds going to pure oranges, rising more in flesh colors as far as the chromes merging into pinks and combining with olive and malachite greens. As an impressionist arrangement of colors, I have never invented anything better." Van Gogh then mentioned placing the portrait in an Icelandic fishing boat, and making painting—as Berlioz and Wagner had already done in music—"a consoling art for broken hearts!" (GAC: VG/PG).

Fig. 72. Sketch of a projected triptych, *La Berceuse* flanked by *Sunflowers* (LT592). Rijksmuseum Vincent van Gogh, Amsterdam

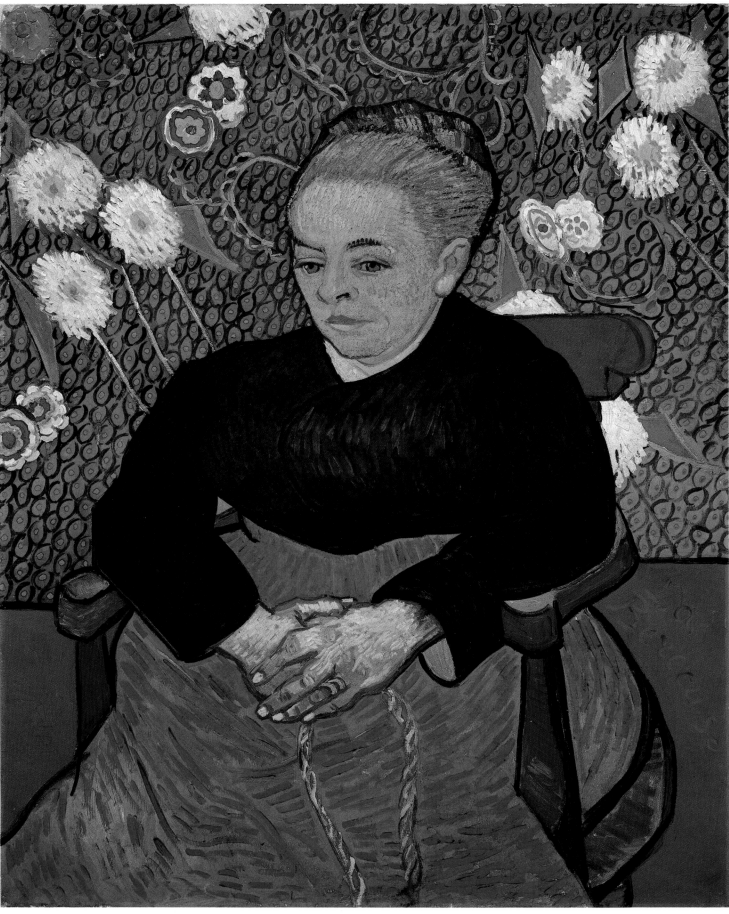

He described the picture again to Arnold Hendrick Koning, about 23 January: "At present I have in mind, or rather on my easel, the portrait of a woman. I call it 'La Berceuse,' or as we say in Dutch (after van Eeden, you know, who wrote that particular book I gave you to read), or in van Eeden's Dutch, quite simply 'our lullaby or the woman rocking the cradle.' It is a woman in a green dress (the bust olive green and the skirt pale malachite green). The hair is quite orange and in plaits. The complexion is chrome yellow, worked up with some naturally broken tones for the purpose of modeling. The hands holding the rope of the cradle, the same. At the bottom the background is vermilion (simply representing a tiled floor or else a stone floor). The wall is covered with wallpaper, which of course I have calculated in conformity with the rest of the colors. This wallpaper is bluish green with pink dahlias spotted with orange and ultramarine. In this I think I have run pretty well parallel with van Eeden and his style of writing, which consequently can be considered analogous to my style of painting in the matter of colors" (LT571a).

And then on 28 January, he wrote to Theo: "Now, it may be said that it is like a chromolithograph from a cheap shop. A woman in green with orange hair standing out against a background of green with pink flowers. Now these discordant sharps of crude pink, crude orange, and crude green are softened by flats of red and green. I picture to myself these same canvases between those of the sunflowers, which would thus form torches or candelabra beside them, the same size, and so the whole would be composed of seven or nine canvases" (LT574).

By the end of January, he had made two copies of *La Berceuse* (LT575). By 3 February, a fourth version was in progress (LT576). And after his prolonged hospitalization, he announced on 29 March 1889 that he was working on a fifth (LT582). Five versions survive (F504–F508). Either F504 or F505 was the first version; the copies show slight variations in color and handling, details of background, signature, and date. The present version is likely to be the third or fourth; it is closest to F506.

Seldom was one image given so many interpretations by van Gogh. References range from a French novel, *Pêcheur d'Islande* (1886), by Pierre Loti, to discussions with Gauguin—himself a seasoned sailor—on fishermen at sea; from a parallel found in the work of a Dutch author, Frederik van Eeden, to analogies in the music of Richard Wagner and Hector Berlioz.

Van Gogh gave one version (F504) to Madame Roulin. Once the others had been sent to Paris, he repeated to Theo his notion of a triptych—*La Berceuse* flanked by two paintings of sunflowers. The arrangement was sketched in a letter of about 22 May from Saint-Rémy (fig. 72; see page 246).

147. Portrait of Joseph Roulin

Oil on canvas, 25¼ × 21½ in. (64 × 54.5 cm.)
Unsigned
Private collection

F436 H464 SG163 JH1675

The earlier portraits of Joseph Roulin of late July–early August (cat. 87, 88) and late November–early December 1888 (cat. 132) are all documented in the letters. By contrast, this version against a flowered wallpaper background is not cited by van Gogh. The use of a decorative background, so absent from the 1888 portraits, relates this version to the portrait of Dr. Rey (cat. 144) and to the portrait of Roulin's wife, *La Berceuse* (cat. 146).

Van Gogh began *La Berceuse* in December 1888 and returned to it in January 1889, but after Roulin himself had left Arles to take up a new post in Marseilles. Roulin would occasionally return to Arles to visit his family, who did not join him in Marseilles until later in the year. He returned on 28 January and again in early April 1889 (LT583). It seems likely that van Gogh began this portrait during the April visit, when he had just begun the fifth version of *La Berceuse*.

Two related versions exist (F435, F439); their sequence is as difficult to determine as that of the five versions of *La Berceuse*.

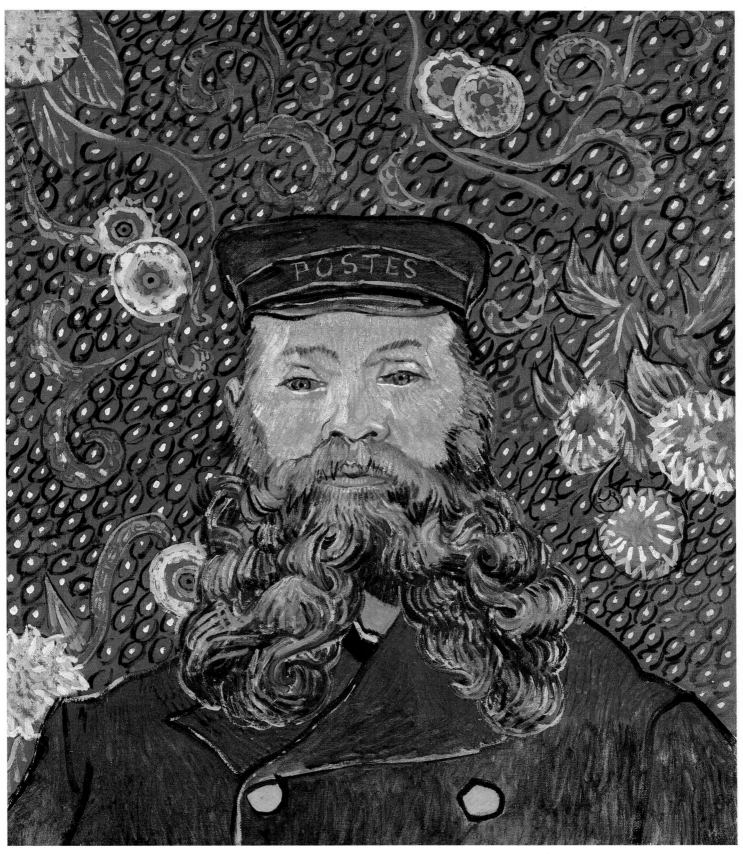

147

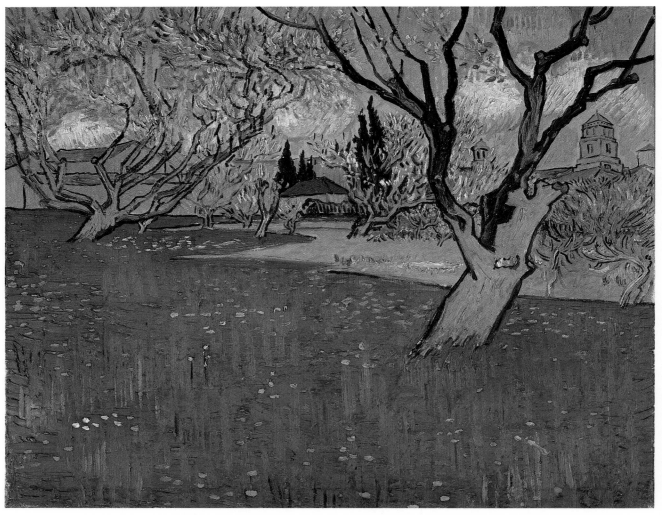

148

148. Orchard in Bloom with View of Arles

Oil on canvas, 19⅞ × 25⅝ in. (50.5 × 65 cm.)
Unsigned
Rijksmuseum Vincent van Gogh, Amsterdam

F515 H533 SG158 JH1683

In his second letter written during his recovery in the hospital in early January 1889, van Gogh told Theo: "When I get out, I shall be able to go my own little way here again, and soon the fine weather will be coming and I shall again start on the orchards in bloom" (LT566, 4 January 1889). In letters of 1888, he had frequently spoken of the new and better series of orchards he planned for the following spring. But he was prevented from doing any orchards in March 1889 by his extended stay in the hospital. On 24 March, he sent Theo an order for paints, hoping to "set to work shortly on the orchards again" (LT581). Before doing so, however, he worked on the fifth portrait of *La Berceuse* (see cat. 146). Only in the early days of April was he able to tell Theo: "Just now I have on the easel an orchard of peach trees [F514]" (LT583). He reported more fully in a letter to Paul Signac: "I have just come back with two studies of orchards. Here is a crude sketch of them." He then described the orchard of peach trees and briefly referred to the sketch of the present painting: "The other landscape is nearly all green with a little lilac and gray—on a rainy day" (LT583b; cat. 152).

The motif is south of the town, a half-mile's walk from the hospital, the towers of Saint-Trophime and the Homme de Bronze establishing the vantage point. (A similar view, taken farther away, can be seen in cat. 27.) Compared with the 1888 series of orchards, this painting is flatter in treatment, less hurried in brushstroke, and more graphic—every building is outlined in blue.

149. View in the Park in Arles

Chalk, pen, reed pen and ink on Whatman paper,
19¼ × 24¼ in. (49 × 61.5 cm.)
Watermark: J. Whatman Manufacturer 1888
Unsigned
The Art Institute of Chicago. Gift of Tiffany
and Margaret Blake

F1468 JH1498

This drawing must be connected with a reference in van Gogh's last letter from Arles of about 3 May 1889: "I am . . . thinking again of beginning to draw more with a reed pen, which, like last year's views of Montmajour for instance, costs less and distracts my mind just as much. Today I made a drawing of that sort, which has turned out very dark and rather melancholy for one of spring, but anyhow whatever happens to me and in whatever circumstances I find myself, it's something which will keep me occupied enough and in some fashion might even make me a sort of livelihood" (LT590).

And once in Saint-Rémy he included the drawing, together with one of the hospital at Arles (F1467), in a batch he sent to Theo on 19 June 1889: "The drawings . . . are a continuation of those old ones of Montma-

jour" (LT595; see cat. 54–58). These were his first large reed pen drawings since August 1888 (see cat. 85). The motif can be clearly identified. It is yet another version of the weeping tree and the small bushes that he observed in one of the gardens of the Place Lamartine and had painted and drawn so often in 1888 (see cat. 60, 79, 84, 104, 107).

149

Surely Monticelli gives us not neither pretends to give us local colour or even local truth. But gives us something passionate and eternal — the rich colour and rich sun of the glorious South in a true colourist way parallel with Delacroix conception of the South. That the South be represented now by contraste simultané of colours and their derivations and harmonies and not by forms or lines in themselves as the ancient artists did formerly by pure forms greeks & michel Ange or by pure line or delineation Rafael Mantegna — Venetian primitives (Botticelli Cimabue Giotto Bellini.) Contrariwise the thing undertaken by P. Veronese & Titian — Colour The thing undertaken by Velasquez and Goya to be continued and more fully or rather more universally done by the more universal knowledge we have a possess of the colours of the prism and their properties Hoping to write to you again and to hear of you pretty soon.

Yours very truly

Vincent

My dear ████ I ought to have answered your letter ever so long ago but working pretty hard every day at night I feel so often too weary to write. As it rains to day I avail myself of the opportunity. Last sunday I have met Macknight and a Danish painter and I intend to go to see him at Fontvieille next monday. I feel sure I shall prefer him as an artist to what he is as an art critic. his views as such being so narrow that they make me smile.

I heartily hope for you that you will be able to leave Paris for good soon and no doubt leaving Paris would do you a worlot of good in all respects. As for me I remain enraptured with the scenery here am working at a series of blooming orchards. And involuntarily thought often of you because you did the same in Sicily. I wished you would one day or another when I shall send over some work to Paris exchange a Sicilian study with me — in case you should have one to spare.

You know I thought and think such a deal of those of yours I don't gainsay that your portraits are more serious and higher art but I think it meritory in you and a rare quality that together with a perfection as appeared to me the fabian and McKnight portraits you are at the same time able to give a Scherzo the adagio con espressione the gay note in one word together with more manly conceptions of a higher order. And I so heartily hope that you will continue to give us simultanément both the grave and elaborate works and those aforesaid scherzos. Then let them say if they like that you are not always serious or that you have done works of a lighter sort — So much the worse for the critics & the better for you.

I have heard nothing of our friend Mr Reid. I felt rather anxious on his account because I feel sure that he was on a false track. my brother has received a letter from him but pretty unsatisfactory.

I was very much taken in by him during the first 6 weeks or 2 months but after that period he was on pecuniary difficulty and in the same acted in a way that made on me the impression that he had lost his wits.

Which I still think was the case and consequently he not responsible even if his doings then were pretty unfair. He is very nervous — as we all are — and can't help being so — he is prompted to act in his crises of nerves to make money whilst painters would make pictures . . .

So much to say that I consider the dealer stronger in him than the artist though there be a battle in his conscience concerning this — of which battle I know that so much — poor old Gauvernes — as I had the pleasure of introducing him to you feel bound to warn you with the same sympathy however for him because I found him artistic in pleading the monticelli cause. In the which I took and take my part witnessing the very scenery which inspired Monticelli I maintain his rights to public though too late appreciation.

150

150. Letter to John Russell

Pen and brown ink on laid paper, 8 × 10¼ in.
 (20.3 × 26 cm.)
The Solomon R. Guggenheim Museum, New York
 The Justin K. Thannhauser Collection

LT477a, c. 21 April 1888

Van Gogh met the Australian-born painter John Peter Russell (1858–1931) in Paris, probably at the atelier of Fernand Cormon in 1886. By the end of 1886, Russell had painted van Gogh's portrait (Rijksmuseum Vincent van Gogh, Amsterdam). He decided to build a house on Belle Ile, off the coast of Brittany, and there he met Claude Monet in September of the same year. He worked in Sicily in 1887, producing some studies of orchards.

After van Gogh left for Arles in February 1888, the two artists kept in touch by letter. Van Gogh probably wrote seven letters to Russell from Arles, of which only two survive, the present one and cat. 151.* In return, Russell probably wrote five letters, of which only a fragment, dated 22 July 1888, survives (LT501b).

Van Gogh admired Russell. He liked his painting, including his own portrait and the Sicilian orchards of 1887; and he was ready to propose exchanges of work. He also saw Russell, who had private means, as a collector. Russell had bought work by Emile Bernard and Armand Guillaumin, and van Gogh hoped he would buy a Gauguin in the summer of 1888; such a purchase would help pay Gauguin's debts in Pont-Aven and his train journey south. To a large degree, this is what motivated van Gogh to send a dozen drawings to Russell in Belle Ile in early August 1888 (see cat. 73–81).

Van Gogh rarely dated his letters from Arles; and only one of his correspondents, Eugène Boch (see cat. 98), preserved an envelope, which is postmarked 2 October 1888 (LT553b). The dates of the two letters to Russell have to be inferred from internal evidence. The present one is dateable to about 21 April 1888.

A transcription of the letter follows below.

* The two surviving letters to Russell have been punctiliously catalogued by Vivian Endicott Barnett, *The Justin K. Thannhauser Collection*, The Solomon R. Guggenheim Museum, New York, 1978, pp. 64–73.

My dear Russell,

I ought to have answered your letter ever so long ago but working pretty hard every day at night I feel so often to weary to write. As it rains to day I avail myself of the opportunity. Last Sunday I have met Macknight and a Danish painter and I intend to go to see him at Fonvieille next Monday. I feel sure I shall prefer him as an artist to what he is as an art critic his vieuws as such being so narrow that they make me smile.

I heartily hope for you that you will be able to leave Paris for good soon and no doubt leaving Paris will do you *a world of good* in all respects. As for me I remain enraptured with the scenery here am working at a series of blooming orchards. And unvoluntarily I thought often of you because you did the same in Sicily. I wished you would one day or another when I shall send over some work to Paris exchange a Sicilian study with me—in case you should have one to spare—

You know I thought and think such a deal of those of yours I don't gainsay that your portraits are more serious and higher art but I think it meritory in you and a rare quality that together with a perfection as appeared to me the fabian and McKnight portraits you are at the same time able to give a Scherzo the adagio con expressione the gay note in one word together with more manly conceptions of a higher order. And I so heartily hope that you will continue to give us simultanément both the grave and elaborate works and those aforesaid scherzos.—Then let them say if they like that you are *not always* serious or that you *have* done work *of a lighter sort*—So much the worse for the citics [critics] & the better for you.

I have heard nothing of our friend Mr. Reid. I felt rather anxious on his account because I feel sure that he was on a false track. My brother has received a letter of him but pretty unsatisfactory.

I was very much taken in by him during the first 6 weeks or 2 months but after that period he was in pecuniary difficulties and in the same acted in a way that made on me the impression that he had lost his wits.

Which I still think was the case and consequently he not responsable even if his doings then were pretty unfair. He is very nervous—as we all are—and can't help being so—He is prompted to act in his crisis of nerves to make money———whilst painters would make pictures.....

So much to say that I consider *the dealer stronger* in him than *the artist* though there be a battle in his conscience concerning this—of the which battle I do not yet know the result. So much—pour votre gouverne—as I had the pleasure of introducing him to you feel bound to warn you with the same sympathy however for him because I found him artistic in pleading the monticelli cause. In the which I took and take my part Witnessing the very scenery which inspired Monticelli I maintain this artists rights to public though too late appreciation.

Surely Monticelli gives us not neither pretends to give us local colour or even local truth. But gives as something passionate and eternal—the rich colour and rich sun of the glorious South in a true colourists way parallel with Delacroix conception of the South Viz that the South be represented now by contraste simultané of colours and their derivations and harmonies and not by forms or lines in themselves as the ancient artists did formerly by pure *form* greeks & Michel Ange or by pure *line* or delineation Rafael Mantegna Venetian *primitifs* (Botticelli Cimabue Giotto Bellini.)

Contrariwise the thing undertaken by P. Veronese & Titian—Colour. The thing undertaken by Velasquez and Goya to be continued and—more fully or rather more universally done by the more universal knowledge we have & possess of the colours of the prism and their properties.

Hoping to write to you again and to hear of you pretty soon!

Yours very truly,
Vincent

I heard Rodin had a beautiful head at the Salon.

I have been to the seaside for a week and very likely am going thither again soon.- Flat shore sands - fine figures there like Cimabue - straight stylish

Am working at a Sower.

The great field all violet. The sky & sun very yellow. It is a hard subject to treat.

Please remember me very Kindly to Mrs Russell - and in thought I heartily shake hands.

Yours very truly

Vincent

My dear ■■■ for ever so long I have been wanting to write to you - but then the work has so taken me up. We have harvest time here at present and I am always in the fields.

And when I sit down to write I am so abstracted by recollections of what I have seen that I leave the letter. For instance at the present occasion I was writing to you and going to say something about Arles as it is - and as it was in the old days of Boccaccio. -

Well instead of continuing the letter I began to draw on the very paper the head of a dirty little girl I saw this afternoon whilst I was painting a view of the river with a greenish yellow sky.

This dirty 'mudlark' I thought yet had a vague florentine sort of figure like the heads in the Monticelli pictures. and reasoning and drawing this wise I worked on the letter

I was writing to you - I enclose the slip of scribbling. That you may judge of my abstractions and forgive my not writing before as such.

Do not however imagine I am painting old florentine scenery - no I may dream of such - but I spend my time in painting and drawing landscapes or rather studies of colour.

The actual inhabitants of this country often remind me of the figures we see in Zola's work.

And Manet would like them as they are and the city as it is?

Bernard is still in Brittany and I believe he is working hard and doing well.

Gauguin is in Brittany too. but has again suffered of an attack of his liver complaint.

I wished I were in the same place with him or he here with me.

My brother has an exhibition of 10 new pictures by Claude Monet - his latest works. for instance a landscape with red sun set and a group of dark firtrees by the seaside

The red sun casts an orange or blood red reflection on the blue green trees and the ground. I wished I could see them.

How is your house in Brittany getting on - and have you been working in the country.

I believe my brother has also another picture by Gauguin which is as I heard say very fine two negro women talking. It is one of those he did at martinique.

McKnight told me he had seen at Marseilles picture by Monticelli flowerpiece.

Very soon I intend sending over some studies to Paris and then you can, if you like, choose one for our exchange.

I must hurry off this letter for I feel some more abstractions coming on and if I did not quickly fill up my paper I would again set to drawing and you would not have your letter.-

151. Letter to John Russell

Ink on wove paper, 8 × 10⅜ in. (20.3 × 26.3 cm.)
Watermark: L-JD L & Co
The Solomon R. Guggenheim Museum, New York
 The Justin K. Thannhauser Collection

LT501a, c. 17 June 1888

Hitherto, this letter has been dated to about 27 June 1888. It must, however, precede the outbreak of torrential rain on 20 June that brought a sudden halt to the harvest. It must also follow very soon after LT498, written on 16 June at latest and more likely 15 June, where van Gogh told Theo: "I'm going to write a short note to Russell."

This letter is the result. A date of Sunday 17 June is suggested here, partly because of van Gogh's reference to painting that afternoon *The Trinquetaille Bridge* (cat. 71, fig. 38), where the many figures and two sailboats on the river suggest a Sunday afternoon by the Rhône. This letter is also likely to be the first that describes—and includes a sketch of—*The Sower* (cat. 49), preceding that to Bernard of about 18 June (B7; cat. 49, fig. 28).

Van Gogh enclosed with this letter the drawing of the mudlark (cat. 51), on the back of which is a fragment of a first version of the present letter.

A transcription of the letter follows below.

My dear Russell

for ever so long I have been wanting to write to you—but then the work has so taken me up. We have harvest time here at present and I am always in the fields.

And when I sit down to write I am so abstracted by recollections of what I have seen that I leave the letter. For instance at the present occasion I was writing to you and going to say something about Arles as it is—and as it was in the old days of Boccaccio.—

Well instead of continuing the letter I began to draw on the very paper the head of a dirty little girl I saw this afternoon whilst I was painting a view of the river with a greenish yellow sky.

This dirty "mudlark" I thought yet had a vague florentine sort of figure like the heads in the monticelli pictures, and reasoning and drawing this wise I worked on the letter I was writing to you. I enclose the slip of scribbling that you may judge of my abstractions and forgive my not writing before as such.

Do not however imagine I am painting old florentine scenery—no I may dream of such—but I spend my time in painting and drawing landscapes or rather studies of colour.

The actual inhabitants of this country often remind me of the figures we see in Zola's work.

And Manet would like them as they are and the city as it is.

Bernard is still in Brittany and I believe he is working hard and doing well.

Gauguin is in Brittany too but has again suffered of an attack of his liver complaint. I wished I were in the same place with him or he here with me.

My brother has an exhibition of 10 new pictures by Claude Monet—his latest works. for instance a landscape with red sun set and a group of dark firtrees by the seaside. The red sun casts an orange or blood red reflection on the blue green trees and the ground. I wished I could see them.

How is your house in Brittany getting on—and have you been working in the country.

I believe my brother has also another picture by Gauguin which is as I heard say very fine two negro women talking. it is one of those he did at Martinique.

McKnight told me he had seen at Marseilles a picture by Monticelli, flowerpiece.

Very soon I intend sending over some studies to Paris and then you can, if you like, choose one for our exchange.

I must hurry off this letter for I feel some more abstractions coming on and if I did not quickly fill up my paper I would again set to drawing and you would not have your letter.

I heard Rodin had a beautiful head at the salon.

I have been to the seaside for a week and very likely am going thither again soon. Flat shore sands—fine figures there like Cimabue—straight stylish.

Am working at a Sower:
the great field *all violet* the sky & sun very yellow. it is a hard subject to treat.

Please remember me very kindly to Mrs. Russell—and in thougt I heartily shake hands.

 Yours very truly
 Vincent

152. Letter to Paul Signac

Pen and brown ink, 8¼ × 10⅝ in. (21 × 27 cm.)
Private collection

LT583b, c. 5 April 1889

Van Gogh met the Neo-Impressionist painter Paul Signac (1863–1935) in Paris in 1887. The two artists may have painted together by the Seine at Asnières and Clichy, northern suburbs of Paris. At Theo's suggestion, Signac visited van Gogh in Arles on 23–24 March 1889, when he was traveling to Cassis, a small Mediterranean fishing port. After meeting van Gogh and taking him from the hospital to the Yellow House, where van Gogh gave him a still life of herrings (cat. 143), Signac moved on to Cassis. He sent van Gogh a postcard, postmarked 4 April 1889:

My dear friend,
After having rambled along the coast, I settled in Cassis. I am sending you my address so that you can let me know how you are getting on. I have written to your brother, but he has not answered me at all. With a cordial handshake,
Yours, P. Signac
2 Place de la République—Cassis

Van Gogh replied with the present letter, most probably immediately after he received the postcard. Hence, a date of 5 April 1889 is suggested. The date "Mars 1889," added at the end of the letter, is not in van Gogh's hand; in any case, it is demonstrably incorrect. Signac replied on "Friday" (12 April), this time by letter (LT584a). Van Gogh appears not to have answered; and the exchange of letters ceased.

The translation of the letter reads thus:

My dear friend Signac,
Many thanks for your postcard and the information it contained. As to my brother's not having replied to your letter, I am inclined to think that it is hardly his fault. I myself have not heard from him for a fortnight. The fact is that he is in Holland, where he is getting married one of these days.

Well, look here, without denying the least bit in the world the advantages of marriage, once it has been contracted, and of being quietly settled down in one's own home, when I think of the obsequial pomp of the reception and the lamentable congratulations on the part of the two families (still in a state of civilization), not to mention the fortuitous appearances in those chemist's jars where the antediluvian civil and religious magistrates are kept—goodness gracious—mustn't one pity the poor wretch who is obliged, after having provided himself with the necessary documents, to repair to a locality, where, with a ferocity unequaled by the cruelest cannibals, he is married alive at a slow fire of receptions and the aforesaid funereal pomp.

I remain greatly obliged to you for your friendly and beneficial visit, which contributed considerably to raising of my spirits. At present I am well, and I work at the sanatorium and its environs. I have just come back with two studies of orchards.

Here is a crude sketch of them—the big one is a poor landscape with little cottages, blue skyline of the Alpine foothills, sky white and blue. The foreground, patches of land surrounded by cane hedges, where small peach trees are in bloom—everything is small there, the gardens, the fields, the orchards, and the trees, even the mountains, as in certain Japanese landscapes, which is the reason why the subject attracted me.

The other landscape is nearly all green with a little lilac and gray—on a rainy day.

I was very pleased to hear that you have settled down now, and I am longing for news about the progress of your work and about the character of the seaside scenery there.

Since your visit my head has just about returned to its normal state, and for the time being I desire nothing better than that this will last. Above all it will depend on a very sober way of living.

I intend to stay here for the next few months at least; I have rented an apartment consisting of two very small rooms.

But at times it is not easy for me to take up living again, for there remain inner seizures of despair of a pretty large caliber.

My God, those anxieties—who can live in the modern world without catching his share of them? The best consolation, if not the best remedy, is to be found in deep friendships, even though they have the disadvantage of anchoring us more firmly in life than would seem desirable in the days of our great sufferings.

Once more many thanks for your visit, which gave me so much pleasure. A hearty handshake in thought,
Yours sincerely,
Vincent
Address until the end of April:
Place Lamartine 2, Arles

[not in van Gogh's hand] March 1889

Ma tête est depuis encore beaucoup
revenu à l'état normal provisoirement
je ne demande pas mieux que ... pour
que cela dure. Cela dépendra d'un régime
très sobre surtout.
Pour les premiers mois au moins
je me propose de rester encore ici, j'ai loué
un appartement de deux très petites pièces.
Mais par moments il ne m'est pas
tout à fait commode de recommencer à
vivre car il me restent des désespérances
intérieures d'assez gros calibre.
Ma foi ces inquiétudes là ... qui
peut vivre dans la vie moderne sans en
attraper sa part.
La meilleure consolation sinon le
seul remède c'est à ce qu'il me semble
encore les amitiés profondes même
si celles là ont le désavantage de
nous ancrer dans la vie plus solidement
que dans les jours de grande souffrance
il puisse nous paraître désirable
Merci encore une fois de votre
visite qui m'a tant fait plaisir
en pensée bonne poignée
de main à
 Vincent.

adresse jusqu'à ... avril place Lamartine 2
 Arles

Mars 1889

mon cher ami Signac merci bien de
votre carte postale qui me donne de
vos nouvelles. Pour ce qui est que mon frère
n'ait point encore répondu à votre lettre
je suis porté à croire qu'il n'y ait pas de
sa faute je suis aussi depuis une
quinzaine sans ses nouvelles - c'est
qu'il est en Hollande où il se marie de
ces jours ci - Or, tout en ne niant pas
le moins du monde les avantages d'un
mariage une fois qu'il est conclu et
que l'on soit tranquillement installé
chez soi, les pompes funèbres de réception
que les félicitations lamentables de deux
familles (civilisées encore) à la fois, sans
compter les comparutions fortuites
dans ces bocaux de pharmacie où siègent
des magistrats antidiluviens civils ou
religieux - ma foi - n'y a-t-il pas
de quoi plaindre le pauvre malheureux
obligé de se rendre muni des papiers
nécessaires sur les lieux où, avec une
férocité non égalée par les antropophages
les plus cruels, on vous marie à petit feu
de réceptions pompes funèbres susmentionnées tout
vivant.

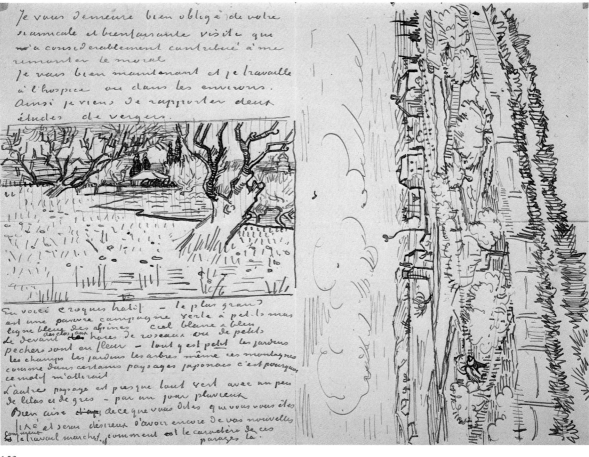

Je vous demeure bien obligé de votre
amicale et bienfaisante visite qui
m'a considérablement contribué à me
remonter le moral
Je vais bien maintenant et je travaille
à l'hospice ou dans les environs.
Ainsi je viens de rapporter deux
études de vergers.

En voici croquis hâtif - le plus grand
est une pauvre campagne verte à petits mas
ligne bleue des alpines ciel bleu à blanc.
Le devant des ... haies de roseaux ou de petits
pêchers sont en fleur - tout y est petit les jardins
les champs les jardins les arbres même ces montagnes
comme dans certains paysages japonais c'est pourquoi
ce motif m'allèchait.
L'autre paysage est presque tout vert avec un peu
de lilas et de gris - par un jour pluvieux.
Bien aise de ce que vous êtes que vous vous êtes
fixé et serai désireux d'avoir encore de vos nouvelles
la travail marche, comment est le caractère de ces
 parages là.

Appendix I:
The Dating of van Gogh's
Letters from Arles

Appendix II: Related Works

Selected Bibliography

Works in the Catalogue

Photograph Credits

Detail, cat. 72

Appendix I: The Dating of van Gogh's Letters from Arles

Van Gogh's letters to his brother Theo (1857–1891) were preserved by Theo himself; ordered and edited first in 1914 by Theo's wife, Johanna van Gogh-Bonger (1862–1925); and enlarged and edited from 1952 on by their son, Dr. Vincent W. van Gogh (1890–1978). Van Gogh's letters to Emile Bernard were published in 1911, and appeared in an English translation in 1938 (see Selected Bibliography).

Since van Gogh himself dated only three of his Arles letters (LT567, LT569a, LT579); since only one envelope exists—from a letter to his artist-friend Eugène Boch postmarked 2 October 1888; since none of Theo's replies from before 19 October 1888 survive and only six (all dated) survive from the remainder of the Arles period, the task of any editor, first in ordering the letters in a convincing chronological sequence and then in dating them, is clearly a formidable one.

For the past thirty years, Dr. Jan Hulsker has concerned himself with the ordering and dating of all of van Gogh's letters (see Selected Bibliography). In the Arles period, he has changed the published order and suggested dates for each letter. For example, Hulsker has established beyond doubt that LT475 is before LT474, LT523 after LT525, LT558b before LT558, and LT567 before LT566. He has also proposed the following sequence: LT503, LT504, LT507, LT508, LT505, LT506, LT509. And for November–December 1888, he has suggested: LT559, LT561, LT558a, LT562, LT563, LT560, LT564, LT565.

The order and dating of the letters in this catalogue (see list below) postulates a series of changes. These vary from changes that are incidental (a shift of one day) to changes that are significant (a change in sequence), radical (a change of three months in one instance), and more radical (recasting a sequence of events from late May to late July, and another from November to December). The reasons for these changes are given briefly here.

Significant

LT521 before LT520
Reference in LT521 to a drawing of a "little cottage garden" sent "yesterday" is to LT519 of 8 August 1888. LT521 must therefore follow LT519.

LT536 before LT535
Letter from Gauguin reported as received in LT536; van Gogh replies, and reports this to Theo in LT535.

LT571a after LT573
References to *La Berceuse* seem to follow those in GAC VG/PG and LT573, both probably of 22 January 1889.

LT565 before LT564
LT565 surely refers to Gauguin's letter to Theo of about 14 or 15 December 1888, announcing his decision to return to Paris (GAC11). LT565 was probably written a day or so later, before the trip to Montpellier.

Radical

LT504 after LT498 and LT535a
References, *inter alia*, to Gauguin's plan for an association of artists, and to fifty paintings.

LT535a after LT498
Compare also W4. References relate to those in LT496 (Gauguin's plan), and to LT498 and LT504 (fifty paintings), and establish that LT535a must date from mid-June rather than mid-September.

LT551 after LT556
Several references (to resting and not painting; to autumn and falling leaves) suggest this, but above all van Gogh writes that he is expecting Gauguin "from one day to the next," which can only be after Gauguin's confirmation that he has sent his trunk in LT555.

LT522
Pages 5 and 6 belong to LT523. LT522 is a four-page letter.

Last week of September 1888
Order should be adjusted to LT540, LT542, B17, LT541a, LT541, LT543.

Four pages of LT543 actually belong to LT541a (which can no longer be called an unfinished letter). This therefore reduces LT543 to a four-page letter.

More Radical

Van Gogh's references to rain in three of his letters from May and June 1888 provide crucial evidence in the radical revision of the sequence of events from late May to late July 1888:

Today we have a gale and rain, but it will only do good. [LT492, 28 May 1888]

We have had torrential rain these last two days, which has gone on all day, and will change the appearance of the fields. It came absolutely unexpectedly and suddenly, while everyone was harvesting. [LT501, c. 21 June 1888]

It is still raining heavily here, which is doing a great deal of harm to the wheat that is still standing. [LT502, 23 June 1888]

A local Arles weekly newspaper, *L'Homme de Bronze*, provided a retrospective monthly weather report, a "Bulletin Météorologique." This was based on consistent day-by-day observations over a period of twenty years by a one-man weather bureau, complete with his *pluviomètre*, his rain-measuring machine. His initials were H.C., and he was most likely H. Cornillon, born in 1819, author of *La Mer à Arles* (1853), and in 1888 first treasurer of the Arles Félibres, the group of poets and writers intent on reviving the language, literature, and customs of Provence. His bulletins do not give a day-by-day account, but they describe the weather in such categories as the "state of the sky," the "state of the day," the wind conditions, the lowest and highest temperatures, and the rainfall. Unusual happenings, such as a gale or days of continuous rain, are often highlighted and given dates. So, for example, the day of rain and gale mentioned in LT492 was reported as occurring on Monday 28 May. This letter is usually dated to 29 May: a one-day shift may seem unimportant, but it becomes significant once the dates of the torrential rain in June have been fixed.

In fact, H.C. was preempted by a report in the "Chronique locale" in the issue of Saturday 24 June 1888 of *L'Homme de Bronze*: "Rain: Summer has begun badly; since Wednesday [i.e., 20 June], water, water, and more water. The temperature recalls rather the end of April than the end of June." And H.C. confirmed this in his retrospective report on the weather in June, published in *L'Homme de Bronze* of 8 July: "We cannot find a month of June as wet as that of 1888"—and his records went back to the 1860s. He referred to the "violent storm" of 20 June, in which 6½ inches of rain fell, and to the four days' rain that fell from 20 to 23 June.

The dates of van Gogh's letters can therefore be fixed with reasonable precision. LT501 must be of Thursday evening 21 June; LT502 is undoubtedly of Saturday 23 June. Hitherto these letters have been dated to "about 29 June" and "about 1 July."

The effects of these redatings are considerable:

1. Van Gogh's visit to Saintes-Maries is usually said to be from 17 to 23 June. It clearly cannot be so.

2. The series of harvest paintings must also be redated. And in so doing, it will be seen to represent a single campaign, not a two-part exercise divided by the visit to Saintes-Maries.

3. During the four days' rain from 20 to 23 June, van Gogh worked in his studio from a model, the Zouave.

4. Datings of letters—and of works—in July have to be adjusted. Most important, this establishes that the fifteen drawings van Gogh sent to Emile Bernard (see cat. 62–72) were done between 15 and 17 July rather than a week later (LT510, LT511, B10). And LT516 and W6 can be dated precisely to 31 July, because of the report in W6 of the birth of Roulin's daughter "today."

The question remains: When did van Gogh go to Saintes-Maries? To answer this, one has to return to LT492 and its redating to Monday 28 May. It was a day of rain and gale. Van Gogh was confined to his studio. He received a letter from Theo in the morning, and he answered at great length—his first ten-page letter from Arles. Not only that: he wrote again in the evening—about Gauguin (LT493)—enclosing a draft of a letter to Gauguin (LT494a). And for the first time, on 28 May, he talked of visiting Saintes-Maries.

On 29 May, he wrote two more letters, one to Theo (LT495) and one to the Dutch artist A. H. Koning (LT498a), who had been staying with Theo since mid-March but who was about to leave Paris for Holland. (An unpublished letter from Koning to Theo, of 4 June 1888, now in the collection of the Rijksmuseum Vincent van Gogh, Amsterdam, clearly shows that Koning left before the end of May, almost certainly on Wednesday 30 May. This, therefore, helps to establish the date of van Gogh's letter to him.) In both letters, van Gogh said he was leaving for Saintes-Maries "tomorrow." Hitherto these two letters (LT495 and LT498a) have been dated to 9 June.

In LT499, written from Saintes-Maries, van Gogh talked of returning "soon." And in LT494, he repeated his wish to *revisit* Saintes-Maries. Clearly, when he wrote LT496 he had already been there. How could he have written "If you saw the Camargue and many other places, you would be surprised, as I was, to find that they are exactly in Ruisdael's style," if he himself had not seen it?

The other "more radical" adjustment centers on letters written from mid-November to 23 December. Hulsker's proposed order is LT558a, LT562, W9, LT563, LT560, LT564, LT565. The order proposed as a working hypothesis in section IV of the present volume is LT562, W9, LT563, LT558a, LT560, LT565, LT564.

If one excludes W9 (which almost certainly was written the same day as LT562), then three pairs of let-

ters need to be discussed. The major argument is that LT558a and LT560 are an indivisible pair, and that LT562 and LT563 are also indivisible.

The only letter that can be securely dated is LT560—to about 4 December—since Theo reported some of its contents in a letter to his sister Wil, dated 6 December. It is therefore proposed that LT558 is dateable to about 25 November, allowing van Gogh almost ten days to paint his various portraits of the Roulin family.

The question then is: Does the other indivisible pair—LT562 and LT563—come before 25 November or after 4 December? Since LT562 mentions the *Memory of the Garden at Etten* (cat. 126), which Gauguin cited as in progress in a letter that cannot be later than 15 November (GAC8), then LT562 would seem to be a day or two later, and a dating of about 16 November is therefore suggested (together with W9, which was written on the same day). A dating of about 23 November for LT563 is proposed. (A more cautious dating might be 16–18 November for LT562 and 19–23 November for LT563.) At any rate, they are now placed in the third

week of November, as against early December. And this implies that *Van Gogh's Chair* (cat. 141) and *Gauguin's Chair* (cat. 141, fig. 69) were begun between 19 and 23 November, rather than in early December.

The other major change concerns LT565 in relation to LT564. Hitherto dated to 23 December, and thought to be the last letter before the "catastrophe," more probably it was written about 16 or 17 December, a day or two after Gauguin wrote to Theo saying that he must return to Paris (GAC11). In LT565, van Gogh acknowledged Theo's having sent 100 francs and a money order for 50 francs. That this sum of 150 francs was received about mid-December rather than on 23 December is supported by van Gogh's retrospective reference in LT571 (of 17 January) to his having received 100 francs on 23 December, the accounting of which, in terms of his intervening expenditure, excludes the 50-franc money order. The 100 francs received on 23 December, therefore, was not acknowledged by van Gogh on that day; and his last surviving letter to Theo before his self-mutilation was evidently written on 18 or 19 December, after the visit to Montpellier (LT564).

Letters

LT	Letter to his brother Theodorus (Theo)
W	Letter to his sister Wilhelmien (Wil)
B	Letter to Emile Bernard
GAC VG/PG	Letter to Paul Gauguin
T	Letter from his brother Theodorus (Theo)

1888		LT476		c. 11 April	LT491	27 May
LT463	21 February	LT477		c. 13 April	LT492	28 May
LT464	c. 25 February	LT477a		c. 21 April	LT493	28 May
LT465	c. 26 February	B4		c. 21 April	LT494a	28 May
W2	c. 28 February	LT478		c. 21 April	LT495	29 May
LT466	c. 3 March	LT479		c. 24 April	LT498a	29 May
LT467	c. 9 March	LT480		1 May	LT499	c. 2 June
LT468	10 March	LT481		c. 3 May	LT500	c. 4 June
LT469	c. 14 March	LT482		c. 4 May	LT494	c. 5 June
LT470	18 March	LT483		c. 7 May	B6	c. 5 June
B2	18 March	LT484		c. 7 May	LT496	12 June
LT471	24 March	LT485		c. 10 May	LT497	c. 13 June
LT472	30 March	LT486		10 May	LT498	c. 15 June
W3	30 March	LT487		12 May	LT535a	c. 15 June
LT473	c. 2 April	LT488		c. 15 May	W4	c. 16 June
LT475	c. 4 April	LT489		c. 20 May	LT504	c. 16 June
LT474	9 April	B5		c. 20 May	LT501a	c. 17 June
B3	9 April	LT490		26 May	B7	c. 18 June

LT501	c. 21 June	LT533	8 September	T3a	13 November		
LT502	23 June	LT534	9 September	LT562	c. 16 November		
B8	23 June	W7	9 and 16 September	W9	c. 16 November		
B9	24 June	LT536	c. 11 September	LT563	c. 23 November		
LT503	c. 26 June	LT535	c. 12 September	LT558a	c. 25 November		
LT507	29 June	LT537	c. 16 September	LT560	c. 4 December		
LT508	c. 5 July	LT538	c. 17 September	LT565	c. 16 or 17 December		
LT505	8 July	LT538a	c. 17 September	LT564	c. 18 or 19 December		
LT506	c. 9 July	LT539	c. 17 September				
LT509	c. 13 July	B16	c. 18 September	**1889**			
LT510	15 July	LT540	c. 22 September	LT567	2 January		
B10	15 July	LT542	24 September	LT566	4 January		
LT511	15 July	B17	c. 24 September	LT568	7 January		
B11	c. 17 July	LT541a	c. 26 September	LT569a	7 January		
LT512	c. 19 July	LT541	c. 27 September	LT569	7 January		
LT513	c. 22 July	LT543	c. 29 September	LT570	9 January		
B12	c. 23 July	LT553b	2 October	LT571	17 January		
LT514	c. 25 July	LT544	3 October	LT572	19 January		
B13	c. 25 July	LT544a	3 October	GAC VG/PG	c. 22 January		
LT515	c. 26 July	B18	3 October	LT573	c. 22 January		
W5	31 July	LT545	4 October	LT571a	c. 23 January		
LT516	31 July	B19	4 October	LT574	28 January		
LT517	c. 3 August	LT546	8 October	LT575	30 January		
B14	c. 4 August	LT547	8 and 9 October	LT576	3 February		
LT518	6 August	LT548	c. 9 October	LT577	c. 17 February		
LT519	8 August	LT549	10 October	LT578	c. 22 February		
LT521	9 August	LT550	10 October	T4	16 March		
LT520	11 August	LT552	13 October	LT579	19 March		
LT522	c. 13 August	LT553	14 October	LT580	c. 22 March		
LT524	c. 14 August	LT554	16 October	LT581	24 March		
LT524a	15 August	B22	17 October	LT582	29 March		
LT525	15 August	LT555	17 October	LT583	early April		
LT523	c. 18 August	T1	19 October	LT583b	c. 5 April		
B15	c. 18 August	LT556	c. 21 October	LT584	c. 13 April		
LT526	c. 21 August	LT551	c. 22 October	LT585	c. 21 April		
W6	c. 21 August	T2	23 October	T5	24 April		
LT527	c. 26 August	LT557	24 October	LT586	c. 24 April		
LT528	c. 27 August	T3	27 October	LT587	c. 28 April		
W8	c. 27 August	LT558b	28 October	LT588	30 April		
LT529	c. 29 August	LT558	28 October	W11	30 April		
LT530	1 September	B19a	c. 2 November	T6	2 May		
LT531	3 September	LT559	c. 6 November	LT589	c. 2 May		
LT532	4 September	LT561	c. 12 November	LT590	c. 3 May		

Appendix II: Related Works

Works by Vincent van Gogh in the present volume cited by their de la Faille (F) number (see Selected Bibliography).

F82. *The Potato Eaters*
Oil on canvas, 32¼ × 45 in. (82 × 114 cm.)
Rijksmuseum Vincent van Gogh, Amsterdam

F250. *Bowl with Sunflowers and Other Flowers*
Oil on canvas, 19¾ × 24 in. (50 × 61 cm.)
Städtische Kunsthalle, Mannheim

F255. *A Pair of Shoes*
Oil on canvas, 14¾ × 18 in. (37.5 × 45.5 cm.)
Rijksmuseum Vincent van Gogh, Amsterdam

F264a. *Shelter on the Hill of Montmartre*
Oil on canvas, 14 × 10½ in. (35.5 × 27 cm.)
The Fine Arts Museums of San Francisco

F274. *Moulin de la Galette*
Oil on canvas, 18 × 15 in. (46 × 38 cm.)
Glasgow Art Gallery and Museum

F283. *Still Life with Red Herrings*
Oil on canvas, 8¼ × 16½ in. (21 × 42 cm.)
Kunstmuseum, Basel (on loan from the Rudolf Staechelin Foundation)

F285. *Still Life with Mackerels, Lemons, and Tomatoes*
Oil on canvas, 15¼ × 22¼ in. (39 × 56.5 cm.)
Oskar Reinhart Collection, "Am Römerholz," Winterthur

F290. *Landscape with Snow*
Oil on canvas, 15 × 18⅛ in. (38 × 46 cm.)
The Solomon R. Guggenheim Museum, New York. The Justin K. Thannhauser Collection

F299. *Riverside Walk near Asnières*
Oil on canvas, 19¼ × 26 in. (49 × 66 cm.)
Rijksmuseum Vincent van Gogh, Amsterdam

F303. *Pont de Clichy*
Oil on canvas, 21⅝ × 18⅛ in. (55 × 46 cm.)
Collection F. H. Hirschland, Harrison, New York

F319. *Self-Portrait with a Japanese Print*
Oil on canvas, 17¼ × 13¾ in. (44 × 35 cm.)
Kunstmuseum, Basel (on loan from the Dr. Emile Dreyfus Foundation)

F331. *A Pair of Shoes*
Oil on pasteboard, 13 × 16¼ in. (33 × 41 cm.)
Rijksmuseum Vincent van Gogh, Amsterdam

F332. *Three Pairs of Shoes*
Oil on canvas, 19¼ × 28¼ in. (49 × 72 cm.)
Fogg Art Museum, Harvard University, Cambridge, Massachusetts

F332a. *A Pair of Shoes*
Oil on canvas, 14¾ × 18 in. (37.5 × 45.5 cm.)
Collection E. Schumacher, Brussels

F343. *Portrait of Alexander Reid*
Oil on pasteboard, 16¼ × 13¼ in. (41.5 × 33.5 cm.)
Glasgow Art Gallery and Museum

F344. *Self-Portrait in a Gray Felt Hat*
Oil on canvas, 17¼ × 14¾ in. (44 × 37.5 cm.)
Rijksmuseum Vincent van Gogh, Amsterdam

F359. *Still Life with Books*
Oil on canvas, 28¾ × 36½ in. (73 × 93 cm.)
Private collection, Baden

F363. *Portrait of Père Tanguy*
Oil on canvas, 36¼ × 29½ in. (92 × 75 cm.)
Musée Rodin, Paris

F370. *Woman Sitting in the Café du Tambourin*
Oil on canvas, 21¾ × 18¼ in. (55.5 × 46.5 cm.)
Rijksmuseum Vincent van Gogh, Amsterdam

F371. *Japonaiserie: The Flowering Plum Tree*
Oil on canvas, 21¾ × 18 in. (55 × 46 cm.)
Rijksmuseum Vincent van Gogh, Amsterdam

F372. *Japonaiserie: The Bridge in the Rain (after Hiroshige)*
Oil on canvas, 28¾ × 21¼ in. (73 × 54 cm.)
Rijksmuseum Vincent van Gogh, Amsterdam

F377. *Still Life with Sunflowers*
Oil on canvas, 8 × 10½ in. (20.5 × 26.5 cm.)
Rijksmuseum Vincent van Gogh, Amsterdam

F388v. *Garden with Sunflowers*
Oil on canvas, 16¾ × 14 in. (42.5 × 35.5 cm.)
Rijksmuseum Vincent van Gogh, Amsterdam

F389. *A Pork Butcher's Shop Seen from a Window*
Oil on canvas mounted on cardboard, 15¾ × 13 in. (39.5 × 32.5 cm.)
Rijksmuseum Vincent van Gogh, Amsterdam

F392. *Blossoming Almond Branch in a Glass*
Oil on canvas, 9½ × 7½ in. (24 × 19 cm.)
Rijksmuseum Vincent van Gogh, Amsterdam

F393. *Blossoming Almond Branch in a Glass with a Book*
Oil on canvas, 9½ × 7½ in. (24 × 19 cm.)
Private collection, Switzerland

F394. *Pink Peach Trees in Blossom (Souvenir de Mauve)*
Oil on canvas, 28¾ × 23⅝ in. (73 × 59.5 cm.)
Rijksmuseum Kröller-Müller, Otterlo

F396. *The Gleize Bridge over the Vigueirat Canal*
Oil on canvas, 18 × 19¼ in. (46 × 49 cm.)
Private collection

F397. *The Langlois Bridge with Women Washing*
Oil on canvas, 21¼ × 25½ in. (54 × 65 cm.)
Rijksmuseum Kröller-Müller, Otterlo

F398. *Avenue of Plane Trees near the Station*
Oil on canvas, 17¾ × 19¼ in. (45 × 49 cm.)
Musée Rodin, Paris

F399. *Apricot Trees in Blossom*
Oil on canvas, 16⅛ × 13 in. (14 × 33 cm.)
Collection Continental Art Holdings, Ltd., Johannesburg

F400. *The Langlois Bridge with Road Alongside the Canal*

Oil on canvas, 21¼ × 25⅝ in. (54 × 65 cm.)
Rijksmuseum Kröller-Müller, Otterlo

F403. *The White Orchard*
Oil on canvas, 23½ × 31½ in. (60 × 80 cm.)
Rijksmuseum Vincent van Gogh, Amsterdam

F405. *Blossoming Pear Tree*
Oil on canvas, 28¾ × 18¼ in. (73 × 46 cm.)
Rijksmuseum Vincent van Gogh, Amsterdam

F413. *Fishing Boats on the Beach*
Oil on canvas, 25⅝ × 31⅞ in. (64.5 × 81 cm.)
Rijksmuseum Vincent van Gogh, Amsterdam

F416. *View of Saintes-Maries-de-la-Mer*
Oil on canvas, 25¼ × 20¾ in. (64 × 53 cm.)
Rijksmuseum Kröller-Müller, Otterlo

F429. *A Flowering Garden*
Oil on canvas, 28¼ × 35¾ in. (72 × 91 cm.)
Gemeentemuseum, The Hague (on loan from the state)

F435. *Portrait of Joseph Roulin Against a Flowery Background*
Oil on canvas, 26½ × 22 in. (67.5 × 56 cm.)
The Barnes Foundation Museum of Art, Merion, Pennsylvania

F438. *Coal Barges*
Oil on canvas, 21¼ × 25¼ in. (53.5 × 64 cm.)
Thyssen-Bornemisza Collection, Lugano-Castagnola, Switzerland

F439. *Portrait of Joseph Roulin Against a Flowery Background*
Oil on canvas, 25½ × 21¼ in. (65 × 54 cm.)
Rijksmuseum Kröller-Müller, Otterlo

F440. *The Baby Marcelle Roulin*
Oil on canvas, 13¾ × 9½ in. (35 × 24 cm.)
National Gallery of Art, Washington, D.C.

F441. *The Baby Marcelle Roulin*
Oil on canvas, 14⅛ × 9⅞ in. (35.5 × 24.5 cm.)
Rijksmuseum Vincent van Gogh, Amsterdam

F441a. *The Baby Marcelle Roulin*
Oil on canvas, 14⅛ × 9⅞ in. (36 × 25 cm.)
Collection Mr. and Mrs. Louis Franck, Gstaad, Switzerland

F443. *Portrait of Patience Escalier*
Oil on canvas, 25¼ × 21¼ in. (64 × 54 cm.)
Norton Simon Foundation, Los Angeles

F445. *Encampment of Gypsies with Caravans*
Oil on canvas, 17¾ × 20⅛ in. (45 × 51 cm.)
Musée d'Orsay (Galerie du Jeu de Paume), Paris

F446. *Railway Carriages*
Oil on canvas, 17¾ × 19⅝ in. (45 × 50 cm.)
Present location unknown

F447. *Thistles*
Oil on canvas, 23¼ × 19¼ in. (59 × 49 cm.)
Collection Stavros S. Niarchos

F449. *Quay with Men Unloading Sand Barges*
Oil on canvas, 21⅝ × 26 in. (55 × 66 cm.)
Museum Folkwang, Essen

F453. *Three Sunflowers in a Vase*
Oil on canvas, 28¾ × 22⅞ in. (73 × 58 cm.)
Private collection, U.S.A.

F454. *Fourteen Sunflowers in a Vase*
Oil on canvas, 36⅝ × 28¾ in. (93 × 73 cm.)
Tate Gallery, London

F455. *Twelve Sunflowers in a Vase*
Oil on canvas, 36¼ × 28¾ in. (92 × 72.5 cm.)
Philadelphia Museum of Art

F456. *Twelve Sunflowers in a Vase*
Oil on canvas, 35⅞ × 28 in. (91 × 71 cm.)
Bayerische Staatsgemäldesammlungen, Munich

F458. *Fourteen Sunflowers in a Vase*
Oil on canvas, 37⅜ × 28¾ in. (95 × 73 cm.)
Rijksmuseum Vincent van Gogh, Amsterdam

F459. *Five Sunflowers in a Vase*
Oil on canvas, 38⅝ × 27⅛ in. (98 × 69 cm.)
Destroyed; formerly in Yokohama, Japan

F467. *Café Terrace at Night*
Oil on canvas, 31⅞ × 26 in. (81 × 65.5 cm.)
Rijksmuseum Kröller-Müller, Otterlo

F472. *An Autumn Garden*
Oil on canvas, 28¼ × 36½ in. (72 × 93 cm.)
Private collection

F474. *The Starry Night*
Oil on canvas, 28½ × 36¼ in. (72.5 × 92 cm.)
Private collection

F475. *The Green Vineyard*
Oil on canvas, 28¼ × 36¼ in. (72 × 92 cm.)
Rijksmuseum Kröller-Müller, Otterlo

F483. *Van Gogh's Bedroom*
Oil on canvas, 22¼ × 29 in. (56.5 × 74 cm.)
Musée d'Orsay (Galerie du Jeu de Paume), Paris

F484. *Van Gogh's Bedroom*
Oil on canvas, 28¾ × 36¼ in. (73 × 92 cm.)
The Art Institute of Chicago

F485. *The Lovers: Poet's Garden IV*
Oil on canvas, 29½ × 36¼ in. (75 × 92 cm.)
Present location unknown

F497. *The Novel Reader*
Oil on canvas, 28¾ × 36¼ in. (73 × 92 cm.)
Collection Mr. and Mrs. Louis Franck, Gstaad,
Switzerland

F502. *Still Life with Oranges, Lemons, and
Blue Gloves*
Oil on canvas, 18⅞ × 24⅜ in. (48 × 62 cm.)
Collection Mr. and Mrs. Paul Mellon, Upperville,
Virginia

F504. *La Berceuse*
Oil on canvas, 36¼ × 28¾ in. (92 × 73 cm.)
Rijksmuseum Kröller-Müller, Otterlo

F505. *La Berceuse*
Oil on canvas, 36½ × 29¼ in. (93 × 74 cm.)
Collection Walter H. Annenberg, Rancho
Mirage, California

F506. *La Berceuse*
Oil on canvas, 36½ × 29 in. (93 × 73.4 cm.)
The Art Institute of Chicago

F507. *La Berceuse*
Oil on canvas, 35¾ × 28¼ in. (91 × 71.5 cm.)
Stedelijk Museum, Amsterdam

F514. *La Crau with Peach Trees in Bloom*
Oil on canvas, 25¾ × 32 in. (65.5 × 81.5 cm.)
Courtauld Institute Galleries, London

F517. *Red Chestnuts in the Public Garden at
Arles*
Oil on canvas, 28¾ × 36¼ in. (72.5 × 92 cm.)
Private collection, U.S.A.

F519. *The Courtyard of the Hospital at Arles*
Oil on canvas, 28¾ × 36¼ in. (73 × 92 cm.)
Oskar Reinhart Collection, "Am Römerholz,"
Winterthur

F533. *Portrait of a Man*
Oil on canvas, 25½ × 21½ in. (65 × 54.5 cm.)
Rijksmuseum Kröller-Müller, Otterlo

F535. *Girl with Ruffled Hair*
Oil on canvas, 14 × 9¾ in. (35.5 × 24.5 cm.)
Private collection, Switzerland

F540. *L'Arlésienne: Madame Ginoux Against
a Cherry-Colored Background*
Oil on canvas, 23½ × 19¾ in. (60 × 50 cm.)
Galleria Nazionale d'Arte Moderna, Rome

F541. *L'Arlésienne: Madame Ginoux Against
a Light Violet-Pink Background*
Oil on canvas, 25½ × 19¼ in. (65 × 49 cm.)
Rijksmuseum Kröller-Müller, Otterlo

F542. *L'Arlésienne: Madame Ginoux Against
a Rose-Colored Background*
Oil on canvas, 25½ × 21¼ in. (65 × 54 cm.)
Museu de Arte, São Paulo

F543. *L'Arlésienne: Madame Ginoux in a Light
Dress Against a Cream-Colored Background
with Flowers*
Oil on canvas, 26 × 21¼ in. (66 × 54 cm.)
Collection Dr. Ruth Bakwin, New York

F544. *A Pair of Lovers*
Oil on canvas, 13 × 19 in. (32.5 × 23 cm.)
Collection J. E. Werenskiold, Lysaker, Norway

F555. *The Pink Orchard*
Oil on canvas, 26 × 31⅞ in. (65.5 × 80.5 cm.)
Rijksmuseum Vincent van Gogh, Amsterdam

F556. *Apricot Trees in Blossom*
Oil on canvas, 21¾ × 25¾ in. (55 × 65.5 cm.)
Private collection, Switzerland

F558. *Harvest in Provence*
Oil on canvas, 19¾ × 23½ in. (50 × 60 cm.)
The Israel Museum, Jerusalem

F567. *Side of a High Road*
Oil on canvas, 24 × 19¾ in. (61 × 50 cm.)
The City of Coburg, West Germany

F569. *Les Alyscamps*
Oil on canvas, 36¼ × 29 in. (92 × 73.5 cm.)
Collection Mrs. A. Mettler-Weber, Zollikon,
Switzerland

F571. *The Langlois Bridge*
Oil on canvas, 23¼ × 25½ in. (60 × 65 cm.)
Private collection, Paris

F573. *Trunk of an Old Yew Tree*
Oil on canvas, 35¾ × 28 in. (91 × 71 cm.)
Collection Mr. and Mrs. Paul Mellon, Upperville,
Virginia

F574. *Ploughed Field*
Oil on canvas, 28¾ × 36¼ in. (72.5 × 92 cm.)
Rijksmuseum Vincent van Gogh, Amsterdam

F594. *Oleanders*
Oil on canvas, 22 × 14⅛ in. (56 × 36 cm.)
Present location unknown

F600. *Majolica Jug with Wildflowers*
Oil on canvas, 21¾ × 18 in. (55 × 46 cm.)

The Barnes Foundation Museum of Art, Merion,
Pennsylvania

F604. *Plate with Onions, Annuaire de la santé,
and Other Objects*
Oil on canvas, 19¾ × 25¼ in. (50 × 64 cm.)
Rijksmuseum Kröller-Müller, Otterlo

F646. *The Hospital in Arles*
Oil on canvas, 29⅛ × 36¼ in. (74 × 92 cm.)
Oskar Reinhart Collection, "Am Römerholz,"
Winterthur

F780. *Thatched Sandstone Cottages at
Chaponval*
Oil on canvas, 25½ × 32 in. (65 × 81 cm.)
Kunsthaus, Zurich

F845. *Marsh with Water Lilies*
Pencil, pen, reed pen and ink, 9½ × 12¼ in.
(23.5 × 31 cm.)
Present location unknown

F846. *Marsh*
Pencil, pen and ink, 16⅞ × 22½ in.
(42.5 × 56.5 cm.)
Collection Mrs. M. Feilchenfeldt, Zurich

F914. *The Bakery on the Geest, The Hague*
Pencil, pen and ink, 8¼ × 13⅜ in.
(20.5 × 33.5 cm.)
Private collection, The Hague

F924. *Gas Tanks of The Hague*
Chalk and pencil, 9½ × 13⅜ in.
(24 × 33.5 cm.)
Private collection, The Hague

F925. *A Factory in The Hague*
Pencil, pen and ink, 9½ × 13 in. (24 × 33 cm.)
Private collection, Zurich

F1090. *Peasants Working*
Pencil, 3¼ × 5¼ in. (8 × 13.3 cm.)
Rijksmuseum Vincent van Gogh, Amsterdam

F1128. *The Parsonage Garden at Nuenen in
Winter*
Pencil, pen and ink on wove paper,
15¼ × 20¾ in. (39 × 53 cm.)
Rijksmuseum Vincent van Gogh, Amsterdam

F1411. *Shelter on the Hill of Montmartre with
Sunflowers*
Pencil, pen, and blue and green watercolor on
heavy drawing paper, 12 × 9½ in.
(30.5 × 23.9 cm.)
Rijksmuseum Vincent van Gogh, Amsterdam

F1417. *A Ruin, Montmajour*
Chalk or pencil, reed pen and lilac ink on
yellowed Ingres paper, 12¼ × 18¾ in.
(31 × 47.5 cm.)
Rijksmuseum Vincent van Gogh, Amsterdam

F1425. *Haystacks*
Pen and wash, 19¾ × 24½ in. (50 × 62 cm.)
Collection M. Meirowsky, Berlin

F1426. *Haystacks*
Pen, reed pen and ink, 9½ × 12½ in.
(24 × 31.5 cm.)
Mücsarnok, Budapest

F1430b. *Little Seascape*
Reed pen and ink, 9½ × 12½ in. (24 × 31.5 cm.)
Musée d'Art Moderne, Musées Royaux des
Beaux-Arts de Belgique, Brussels

F1431. *Sea with Sailing Boats*
Reed pen and ink, 9½ × 12½ in. (24 × 32 cm.)
Collection Werner Vowinckel, Cologne

F1439. *View of Saintes-Maries-de-la-Mer*
Pen and ink, 17 × 23½ in. (43 × 60 cm.)
Oskar Reinhart Collection, "Am Römerholz,"
 Winterthur

F1448. *The Plain of La Crau*
Reed pen and ink, 11¾ × 18¼ in.
 (30 × 46.5 cm.)
Present location unknown

F1456. *Flowering Garden*
Reed pen and ink, 24 × 19¼ in. (61 × 49 cm.)
Private collection, Zurich

F1460. *Portrait of Patience Escalier*
Pencil, pen, reed pen and brown ink,
 19½ × 15 in. (49.5 × 38 cm.)
Fogg Art Museum, Harvard University, Cam-
 bridge, Massachusetts

F1462. *Quay with Men Unloading Sand Barges*
Pen, reed pen and ink, 19 × 24½ in.
 (48 × 62.5 cm.)
Present location unknown

F1467. *The Courtyard of the Hospital at Arles*
Pencil, reed pen and brown ink on Ingres paper,
 18 × 23¼ in. (45.5 × 59 cm.)
Rijksmuseum Vincent van Gogh, Amsterdam

F1469. *Flowering Tree*
Charcoal and watercolor on canvas,
 18⅛ × 12¼ in. (45.5 × 30.5 cm.)
Rijksmuseum Vincent van Gogh, Amsterdam

F1480. *The Langlois Bridge*
Watercolor on paper, 11¾ × 11¾ in.
 (30 × 30 cm.)
Private collection

F1483. *The Harvest (Blue Cart)*
Pen and ink washed with watercolor,
 19 × 23¾ in. (48 × 60 cm.)
Collection Mrs. J. B. A. Kessler, London

F1484. *The Harvest (Blue Cart)*
Pen and ink, brush and watercolor,
 15½ × 20½ in. (39.5 × 52.5 cm.)
Fogg Art Museum, Harvard University, Cam-
 bridge, Massachusetts

F1486. *The Harvest (Blue Cart)*
Pen and ink, 9½ × 12½ in. (24 × 32 cm.)
Collection Mr. and Mrs. Paul Mellon, Upperville,
 Virginia

F1490. *Arles: View from the Wheat Fields*
Pen and ink, 12½ × 9¼ in. (31.5 × 23.5 cm.)
Collection Mr. and Mrs. Leigh B. Block, Chicago

F1491. *Arles: View from the Wheat Fields*
Pen and ink, 12½ × 9½ in. (32 × 24 cm.)
Present location unknown

F1493. *Slope of a Hill with Bushes*
Chalk, reed pen and violet ink on Ingres paper,
 12¼ × 18¾ in. (31 × 47.5 cm.)
Rijksmuseum Vincent van Gogh, Amsterdam

F1509. *Trunk of a Tree*
Pencil, reed pen and ink, 9¾ × 13½ in.
 (25 × 34 cm.)
Collection Mrs. George F. Baker, New York

F1513. *The Pond in the Park with the Yellow
 House in the Background*
Pencil, reed pen and brown ink on wove paper,
 12½ × 19½ in. (31.5 × 49.5 cm.)
Rijksmuseum Vincent van Gogh, Amsterdam

F1514. *Summer Evening*
Pen, reed pen and ink, 9½ × 12⅝ in.
 (24 × 31.5 cm.)
Kunstmuseum, Winterthur

F1517. *Landscape with Farm and Two Trees*
Pencil, reed pen and ink, 9¾ × 13½ in.
 (25 × 34 cm.)
Collection Mr. and Mrs. Paul Mellon, Upperville,
 Virginia

F1518. *Three Trees, the Road to Tarascon*
Reed pen and ink, 10 × 13¾ in.
 (25.5 × 35 cm.)
Present location unknown

F1518a. *Road with Trees near a House*
Pencil, reed pen and brown ink, 9½ × 13½ in.
 (24 × 34 cm.)
Albertina, Vienna

F1554. *Rocks with Oak Tree*
Pen, reed pen and ink, 9½ × 12¼ in.
 (24 × 31 cm.)
Collection Mrs. M. L. Caturla, Madrid

F1720. *Couple Strolling Under Sunflowers on
 a Hill Overlooking the City*
Pencil on wove paper, 5¼ × 8¼ in.
 (13.5 × 21 cm.)
Rijksmuseum Vincent van Gogh, Amsterdam

Selected Bibliography

The literature on van Gogh is vast. This bibliography is limited to essential works of reference—catalogues raisonnés and letters in particular—and to books and articles that contain material and illumination on the Arles period. The most comprehensive bibliography on Vincent van Gogh, Paul Gauguin, and Post-Impressionism can be found in John Rewald's *Post-Impressionism: From van Gogh to Gauguin* (1978).

Abbreviations used in this catalogue precede the listing of the relevant publication. The arrangement is by van Gogh, Gauguin, and Arles.

VAN GOGH

Catalogues Raisonnés

F Faille, J.-B. de la. *L'Oeuvre de Vincent van Gogh: Catalogue raisonné.* 4 vols. Paris–Brussels, 1928. Rev. ed. *The Works of Vincent van Gogh: His Paintings and Drawings.* New York, 1970.

H Faille, J.-B. de la. *Vincent van Gogh.* Translated by P. Montagu-Pollock. Paris–London–New York, 1939.

SG Scherjon, W., and W. J. de Gruyter. *Vincent van Gogh's Great Period: Arles, Saint-Rémy and Auvers-sur-Oise.* Amsterdam, 1937.

JH Hulsker, J. *The Complete van Gogh: Paintings, Drawings, Sketches.* Oxford–New York, 1980.

Letters

The Complete Letters of Vincent van Gogh. 3 vols. Introduction by V. W. van Gogh. Preface and Memoir by J. van Gogh-Bonger. London–New York, [1958]. The author of the present volume has made emendations to the following letters: LT490, LT497, LT500, LT501, LT502, LT531, LT548, LT561, LT563, LT581, B15.

LT Letter to his brother Theodorus (Theo)

W Letter to his sister Wilhelmien (Wil)

B Letter to Emile Bernard

T Letter from his brother Theodorus (Theo)

LORD Lord, D., ed. and trans. *Vincent van Gogh: Letters to Emile Bernard.* London–New York, 1938.

Letters of Vincent van Gogh, 1886–1890: A Facsimile Edition. Preface by J. Leymarie. Introduction by V. W. van Gogh. London, 1977.

Karagheusian, A. *Vincent van Gogh's Letters Written in French: Differences Between the Printed Versions and the Manuscripts.* New York, 1984.

General

Barnett, V. E. *The Guggenheim Museum: Justin K. Thannhauser Collection.* New York, 1978.

Cooper, D. *Drawings and Watercolours: A Selection of 32 Plates in Colour.* New York, 1955.

Coquiot, G. *Vincent van Gogh.* Paris, 1923.

Galbally, A. *The Art of John Peter Russell.* Melbourne, 1977.

Hulsker, J., ed. *Van Gogh door Van Gogh: De brieven als commentaar op zijn werk.* Amsterdam, 1973.

Løvgren, S. *The Genesis of Modernism: Seurat, Gauguin, Van Gogh and French Symbolism in the 1880's.* Stockholm, 1959.

Lubin, A. J. *Stranger on the Earth: A Psychological Biography of Vincent van Gogh.* New York, 1972.

Mauron, C. *Van Gogh: Etudes psychocritiques.* Paris, 1976.

Pollock, G., and F. Orton. *Vincent van Gogh: Artist of His Time.* Oxford–New York, 1978.

Rewald, J. *Post-Impressionism: From van Gogh to Gauguin.* 3rd rev. ed. New York–London, 1978.

Rijksmuseum Kröller-Müller. *A Detailed Catalogue with Full Documentation of 272 Works by Vincent van Gogh.* 4th ed. Otterlo, 1980.

Rijksmuseum Vincent van Gogh. *Japanese Prints Collected by Vincent van Gogh.* Introduction by W. van Gulik. Essay by F. Orton. Amsterdam, 1978.

Roskill, M. W. *Van Gogh, Gauguin and the Impressionist Circle.* New York, 1970.

Schapiro, M. *Vincent van Gogh.* New York, 1950.

Sheon, A. *Monticelli: His Contemporaries, His Influence.* Exhibition catalogue. Museum of Art, Carnegie Institute. Pittsburgh, 1978.

Tralbaut, M. *Vincent van Gogh.* New York, 1969.

Van Uitert, E. *Vincent van Gogh in Creative Competition: Four Essays from Simiolus.* Zutphen, The Netherlands, 1983.

Walker, J. A. *Van Gogh Studies: Five Critical Essays.* London, 1981.

Welsh-Ovcharov, B., ed. *Van Gogh in Perspective.* Englewood Cliffs, N.J., 1974.

———. *Vincent van Gogh: His Paris Period, 1886–88.* Utrecht–The Hague, 1976.

———. *Vincent van Gogh and the Birth of Cloisonism.* Exhibition catalogue. Art Gallery of Ontario. Toronto, 1981.

Articles

Arikawa, H. "La Berceuse: An Interpretation of Vincent van Gogh's Portraits," *Annual Bulletin of the National Museum of Western Art*, Tokyo (no. 15, 1981), pp. 31–75.

Heelan, P. A. "Toward a New Analysis of the Pictorial Space of Vincent van Gogh," *Art Bulletin* 54 (December 1972), pp. 478–492.

Hulsker, J. "Critical Days in the Hospital at Arles: Unpublished Letters from the Postman Joseph Roulin and the Reverend Mr. Salles to Theo van Gogh," *Vincent* 1 (no. 1, 1970), pp. 20–31.

———. "Vincent's Stay in the Hospitals at Arles and St. Rémy: Unpublished Letters from the Reverend Mr. Salles and Doctor Peyron to Theo van Gogh," *Vincent* 1 (no. 2, 1971), pp. 24–44.

———. "Van Gogh's Ecstatic Years in Arles," *Vincent* 1 (no. 4, 1972), pp. 2–17.

———. "The Poet's Garden," *Vincent* 3 (no. 1, 1974), pp. 22–32.

———. "What Theo Really Thought of Vincent," *Vincent* 3 (no. 2, 1974), pp. 2–28. Unpublished letters by Theo van Gogh.

———. "The Intriguing Drawings of Arles," *Vincent* 3 (no. 4, 1974), pp. 24–32.

Johnson, R. "Vincent van Gogh and the Vernacular, I: His Southern Accent," *Arts Magazine* 52 (June 1978), pp. 131–135; "Vincent van Gogh and the Vernacular, II: The Poet's Garden," *Arts Magazine* 53 (February 1979), pp. 98–104.

Millard, C. W. "A Chronology for van Gogh's Drawings of 1888," *Master Drawings* 12 (no. 2, 1974), pp. 156–165.

Nordenfalk, C. "Van Gogh and Literature," *Journal of the Warburg and Courtauld Institutes* 10 (1947), pp. 132–147.

Novotny, F. "Reflections on a Drawing by van Gogh," *Art Bulletin* 35 (March 1953), pp. 35–43.

Orton, F. "Vincent's Interest in Japanese Prints: Vincent van Gogh in Paris, 1886–87," *Vincent* 1 (no. 3, 1971), pp. 2–12.

Pickvance, R. "The New de la Faille," *Burlington Magazine* 115 (March 1973), pp. 174–180.

Pollock, G. "Artists' Mythologies and Media Genius: Madness and Art History," *Screen* 21 (no. 3, 1980), pp. 57–96.

Priou, J.-N. "Van Gogh et la famille Roulin," *Revue des P.T.T. de France* (May–June 1955), pp. 26–32.

Rewald, J. "Van Gogh en Provence," *L'Amour de l'Art* 17 (October 1936), pp. 289–298.

———. "Van Gogh: The Artist and the Land," *Art News Annual* 19 (1950), pp. 64–73.

———. Theo van Gogh, Goupil and the Impressionists," *Gazette des Beaux-Arts*, ser. 6, 81 (January–February 1973), pp. 1–108.

Roskill, M. "Van Gogh's Blue Cart and his Creative Process," *Oud Holland* 81 (no. 1, 1966), pp. 3–19.

———. "Van Gogh's Exchanges of Work with Emile Bernard in 1888," *Oud Holland* 86 (no. 2–3, 1971), pp. 142–179.

Sheon, A. "Monticelli and van Gogh," *Apollo*, n.s. 85 (June 1967), pp. 444–448.

Tellegen, A. "Geen panoramalandschap bij Van Gogh," *Bulletin Rijksmuseum* 12 (no. 2, 1964), pp. 57–61.

———. "Vincent et Gauguin," and "Vincent en de Chamaillard," *Museumjournaal* 11 (no. 1–2, 1966), pp. 42–43, 44–45.

———. "Van Gogh en Montmajour," *Bulletin Museum Boymans-van Beuningen* 18 (no. 1, 1967), pp. 16–33.

Thannhauser, H. "Van Gogh and John Russell: Some Unknown Letters and Drawings," *Burlington Magazine* 73 (September 1938), pp. 98–102.

Walker, J. A. "Van Gogh's Drawing of La Crau from Mont Majour," *Master Drawings* 20 (no. 4, 1982), pp. 380–385.

Ward, J. L. "A Re-examination of van Gogh's Pictorial Space," *Art Bulletin* 58 (December 1976), pp. 593–604.

Weiller, P. "Nous avons retrouvé le Zouave de van Gogh," *Lettres Françaises* (24–31 March 1955).

Wylie, A. S. "Coping with a Dizzying World," *Vincent* 3 (no. 1, 1974), pp. 8–18.

GAUGUIN

Catalogues Raisonnés

GUÉRIN Guérin, M. *L'Oeuvre gravé de Gauguin*. 2 vols. Paris, 1927.

WC Wildenstein, G. *Gauguin*. Catalogue I. Edited by D. Wildenstein and R. Cogniat. Paris, 1964.

Letters

GAC Cooper, D. *Paul Gauguin: 45 Lettres à Vincent, Theo et Jo van Gogh: Collection Rijksmuseum Vincent van Gogh, Amsterdam.* 's Gravenhage, 1983.

Malingue, M., ed. *Lettres de Gauguin à sa femme et à ses amis*. Paris, 1946.

Roger-Marx, C. "Lettres inédites de Vincent van Gogh et de Paul Gauguin," *Europe* (15 February 1939), pp. 163–174.

Sketchbooks and Writings

Huyghe, R. *Le Carnet de Paul Gauguin*. 2 vols. Paris, 1952.

Gauguin, P. *Avant et après*. Written in the Marquesas Islands in 1903. Leipzig, 1918. Paris, 1923. Condensed English edition, *The Intimate Journals of Paul Gauguin*. Translated by Van Wyck Brooks. New York, 1921.

General

Alexandre, A. *Paul Gauguin: Sa Vie et le sens de son oeuvre*. Paris, 1930.

Andersen, W. *Gauguin's Paradise Lost*. New York, 1971.

Bodelsen, M. *Gauguin's Ceramics: A Study in the Development of His Art*. London, 1964.

Cachin, F. *Gauguin*. Paris, 1968.

Goldwater, R. *Paul Gauguin*. New York, 1957.

Jirat-Wasiutynski, V. *Paul Gauguin in the Context of Symbolism*. New York, 1978.

Leymarie, J. *Paul Gauguin: Water-colours, Pastels and Drawings in Colour*. London, 1961.

PICKVANCE Pickvance, R. *The Drawings of Gauguin*. London–New York, 1970.

Rewald, J. *Gauguin Drawings*. New York–London, 1958.

Rotonchamp, J. de. *Paul Gauguin 1848–1903*. Weimar, 1906.

Vollard, A. *Recollections of a Picture Dealer*. Translated by V. M. Macdonald. Boston, 1936.

Articles

Amishai-Maisels, Z. "A Gauguin Sketchbook: Arles and Brittany," *Israel Museum News* 10 (April 1975), pp. 68–87.

DORRA Dorra, H. "Gauguin's Dramatic Arles Themes," *Art Journal* 38 (no. 1, 1978), pp. 12–17.

Meyerson, A. "Van Gogh and the School of Pont-Aven," *Konsthistorisk Tidskrift* 15 (no. 3–4, 1946), pp. 135–149.

Svenaeus, G. "Gauguin and Van Gogh," *Vincent* 4 (no. 4, 1976), pp. 20–32.

ARLES

Various nineteenth-century editions of guidebooks by Baedeker, Joanne, and Murray.

Charles-Roux, J. *Arles: Son Histoire, ses monuments, ses musées*. Paris, 1914.

Clébert, J. P., and P. Richard. *La Provence de van Gogh*. Aix-en-Provence, 1981.

Garagnon, R. *Arles dans la littérature*. Arles, 1975.

Hare, A. J. C. *South-Eastern France*. London, 1890.

James, H. "En Province VI: The Country of Arles," *Atlantic Monthly* 53 (February 1884), pp. 217–228.

———. *A Little Tour in France*. Boston, 1884.

Preston, H. W. "A Provençal Pilgrimage," *The Century Illustrated Monthly Magazine* 40 (July 1890), pp. 323–339.

Works in the Catalogue

Titles followed by an F number in parentheses refer to works by Vincent van Gogh in the 1970 catalogue raisonné by J.-B. de la Faille. Titles followed by a WC number in parentheses refer to works by Paul Gauguin in the 1964 catalogue raisonné by Georges Wildenstein and edited by Daniel Wildenstein and Raymond Cogniat (see Selected Bibliography). In the column at the right are catalogue numbers.

Photograph Credits

Reproductions are by permission of the owners of the original works, who supplied color transparencies and black-and-white photographs, except in the following cases: